MATERIAL CHOICES

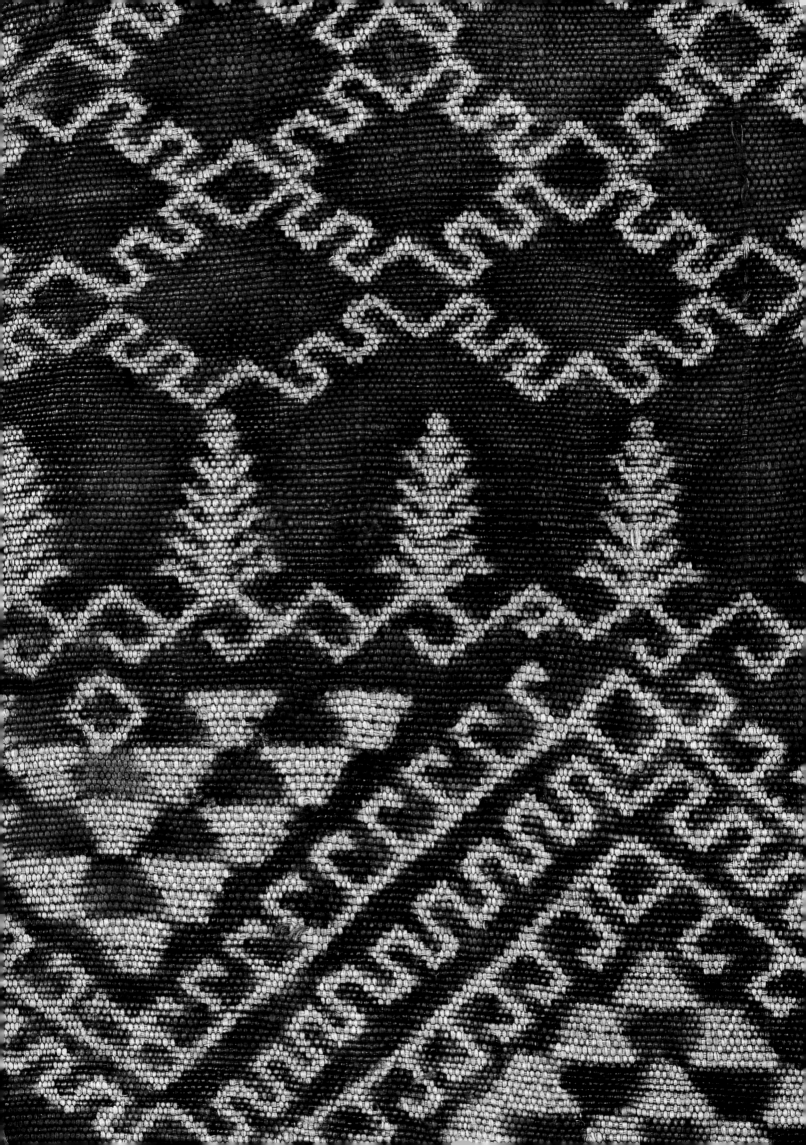

MATERIAL CHOICES

REFASHIONING BAST AND LEAF FIBERS IN ASIA AND THE PACIFIC

Roy W. Hamilton and B. Lynne Milgram, editors

CONTRIBUTORS

Sylvia Fraser-Lu

Roy W. Hamilton

Bu-ja Koh

Sophiano Limol

B. Lynne Milgram

Elizabeth Oley

Melissa M. Rinne

Donald H. Rubinstein

Amanda Mayer Stinchecum

Ma Thanegi

Trần Thị Thu Thủy

FOWLER MUSEUM AT UCLA

LOS ANGELES

Fowler Museum Textile Series, No. 8
Published with the assistance of the Getty Grant Program

FOWLER
MUSEUM
Textile Series

Funding for this publication has been provided by

The Getty Foundation
R. L. Shep Endowment Fund, Fowler Museum
Pacific Rim Research Program, University of California
Asian Cultural Council
Fowler Museum Textile Council
Manus, the support group of the Fowler Museum

The Fowler Museum is part of UCLA's School of the Arts and Architecture

Lynne Kostman, *Managing Editor*
Danny Brauer, *Designer and Production Manager*
Don Cole, *Principal Photographer*
David L. Fuller, *Cartographer*

Fowler Museum at UCLA
Box 951549
Los Angeles, California 90095-1549

Requests for permission to reproduce material from this volume should be
sent to the Fowler Museum Publications Department at the above address.

Printed and bound in Hong Kong by South Sea International Press, Ltd.

Library of Congress Cataloging-in-Publication Data

Material choices : refashioning bast and leaf fibers in Asia and the Pacific
/ Roy W. Hamilton and B. Lynne Milgram, editors; Contributors : Sylvia
Fraser-Lu ... [et al.].
 p. cm. — (Fowler museum textile series ; no. 8)
 Includes bibliographical references and index.
 ISBN-13: 978-09748729-8-8 (soft cover)
 ISBN-10: 0-9748729-8-9 (soft cover)
1. Plant fibers—Asia. 2. Plant fibers—Pacific Area. 3. Textile fibers—Asia.
4. Textile fibers—Pacific Area. I. Hamilton, Roy W. II. Milgram, B. Lynne
(Barbara Lynne), 1948– III. Fraser-Lu, Sylvia. IV. Fowler Museum at UCLA.
 TS1541.M38 2007
 677'.1095—dc22

 2006033706

FRONT COVER: Detail of robe. Ryuku Islands (Okinawa Prefecture), Japan,
late nineteenth century. Banana fiber. Fowler Museum x86.4441; Gift of
Dr. Harvey C. Gonick and Gloria Granz Gonick.
BACK COVER: Detail of blanket. Li peoples. Hainan Island, China, early
twentieth century. Hemp (?). Collection of Thomas Murray.
BACK COVER INSET: A Hmong weaver splits hemp fiber with hands stained
blue from working with indigo vats. Photograph by Claire Burkert, Sa Pa,
Vietnam, 1997.
PAGE 1: Detail of fig. 1.10.
PAGES 2–3: Detail of fig. 1.18.
PAGES 4–5: Detail of robe. Japan, late nineteenth to early twentieth century.
Ramie. Collection of Thomas Murray.
PAGE 166: Detail of woman's zone-dyed abaca tube skirt (*tabi nihok*). B'laan
peoples, Mindanao, Philippines, early twentieth century. Fowler Museum
x96.1.37; Peabody-Barker Collection, Gift of Ventura County Museum of
History and Art.
PAGE 188: Detail of robe. Ryukyu Islands (Okinawa Prefecture), Japan, late
nineteenth century. Banana fiber. Fowler Museum x86.4442; Gift of Dr.
Harvey C. Gonick and Gloria Granz Gonick.

Contents

Foreword

ASIA IS RENOWNED FOR THE PRODUCTION of fine handwoven cottons and luxurious silks—important items of trade for centuries. In addition to these celebrated fabrics, weavers throughout the region have long produced cloth from ramie, hemp, piña, and banana fibers (including Philippine abaca and Okinawan *ito bashō*), as well as a number of lesser-known plant fibers. Over the course of the twentieth century, many of these Asian plant fiber weaving traditions became marginalized or hovered on the brink of extinction, given the advent of synthetic fabrics, growing industrialization, and increased international textile trade. As the essays in this book testify, however, they have not vanished altogether. Rather, in recent times weavers have purposefully chosen to pursue various efforts directed at their preservation, revival, or reinvention. In many cases, the production of bast and leaf fiber textiles is now thriving in newly globalized situations. This volume presents eight individual case studies of such weaving traditions, bringing to light the processes that have nurtured or buffeted them in their contemporary contexts.

The Fowler Museum's loyal textile audience is sure to appreciate the quiet beauty of these natural plant materials and the skills of the women who have fashioned them into cloth. This book not only reveals these works of creative genius but also considers how it is that bast and leaf fiber weaving has survived into the modern era. The actions of weavers who continue to engage with enduring materials and methods, even as they expand their markets, are examined with regard to issues of gender, identity, and authenticity. The persistence of bast and leaf fiber weaving is also considered from the point of view of consumers in the global marketplace, who may create new uses or meanings for products once they journey beyond the place where they were made.

This book is the eighth title in the Fowler Museum Textile Series, which was established in 1998 with support from the Getty Foundation. Although it is the last volume to receive funding under the original Getty grant, it is the first to be supported additionally by a new funding source, the R. L. Shep Endowment Fund. Mr. Shep established this fund for the Museum in 2003 specifically to support textile publications. Due to his generosity, the Fowler Museum Textile Series will now continue long into the future. It should also be noted that the Museum has recently appointed a Textile Council Board, which has as its mission the support of the Fowler's textile-related activities, including research, acquisitions, conservation, exhibitions, and public programming.

The University of California's Pacific Rim Research Program generously provided funds that allowed us to bring our contributing authors together from across the United States, Canada, Australia, and Asia for a symposium in Los Angeles in May 2005. This not only resulted in an exceptional public program but also allowed the authors to share ideas and develop interpretive strategies for their essays. We are extremely grateful for this support. The Asian Cultural Council generously provided the funding that allowed contributing author Trần Thị Thu Thủy to participate in an internship at the Fowler Museum in 2001. Her essay in this book is one of the results of that internship.

Although this project originated as a publishing effort rather than an exhibition, the Fowler Museum will take the opportunity presented by the release of the book to present a selection of the Museum's bast and leaf fiber textiles in one of our exhibition galleries. *Material Choices: Bast and Leaf Fiber Textiles* will run from August 26 to December 30, 2007. While the essays in the book had to be limited to Asian and Pacific subjects and loom-woven cloth, as the editors discuss in the preface, the greater freedom of the exhibition format will allow us to include some of our finest bast and leaf fiber textiles from other parts of the world, as well as a fascinating selection of non-loomed material from the Pacific. A variety of these textiles will subsequently travel to the East-West Center Gallery at the University of Hawai'i in Honolulu in 2008. We thank Michael Schuster for this collaboration.

We would also like to express our thanks to the members of the Fowler Museum staff for their many and varied contributions to this book and the accompanying exhibition. As always, they have fulfilled their responsibilities to the highest standard and are to be commended for their dedication and hard work. A complete list of Fowler staff appears at the back of this volume. Special mention is due to Managing Editor Lynne Kostman for transforming the writings of eleven diverse authors (in seven time zones!) into a unified whole. The work of Don Cole, Photographer, and Danny Brauer, Designer and Director of Publications, assured the final transformation into this beautiful book.

Marla C. Berns
DIRECTOR

Roy W. Hamilton
CURATOR OF ASIAN AND PACIFIC COLLECTIONS

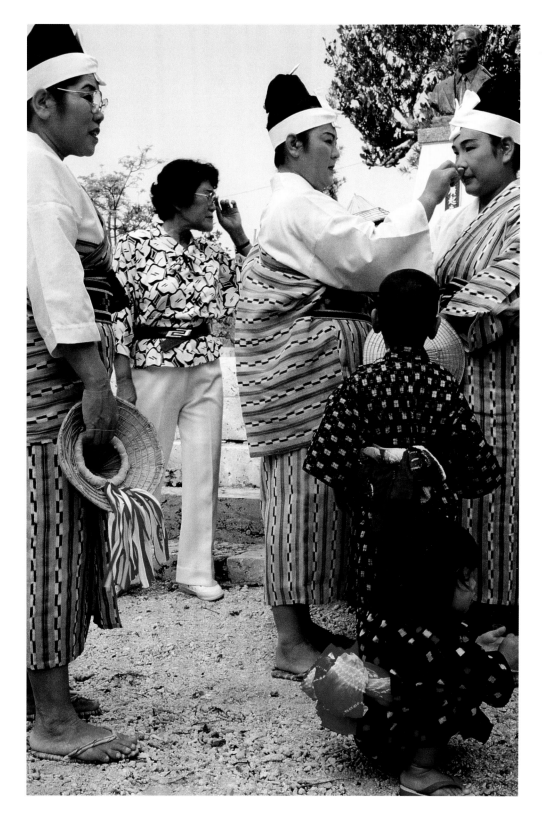

A Dancers Nitta Hatsuko, Uesedo Tomoko, and Nitta Hitomi prepare to perform in the Tanedori Festival on Taketomi Island. They wear *bashōfu* robes with cotton ikat stripes. The dance celebrates a village woman whose "care and effort allowed her to raise ten children in spite of their poverty" (symbolized by the one-sleeved garments). The use of *bashōfu* garments contributes to the perception of "tradition" desired for the festival, contrasting with the modern everyday clothing worn by Nemoto Hatsu, behind the three dancers (see fig. 6.6, p. 108).

Photograph by Amanda Mayer Stinchecum, Okinawa Prefecture, Japan, 1989.

Preface

AS EDITORS OF THIS VOLUME, we have had to establish some parameters, both as a matter of practicality and as a means of developing a specific thematic focus. First of all, we deal here solely with loom-woven textiles. Only in this way can we avoid sliding down a slippery slope where no clear line separates loom-woven cloth from other products such as the fine garments Maori women twine by hand from fibers of New Zealand flax or the plaited pandanus leaf mats of Samoa (so delicate that they can be worn as garments), or, for that matter, the entire world of mats and basketry. We have also ruled out beaten barkcloth, made in the Pacific primarily from the bast of the paper mulberry (*Broussonetia papyrifera*). We have drawn these distinctions with some regret, for as authors including Annette Weiner (1989) and Lissant Bolton (1996) have shown, many of the textile products of the Pacific made without benefit of looms are highly relevant to the study of Asian loom-woven textiles when considered in terms of their cultural significance.

We have also had to restrict the geographical scope of the book. We find that the similar forms of bast and leaf fiber weaving in East and Southeast Asia reflect the close cultural relationships between these two regions. Likewise, the inclusion of an essay covering a textile tradition from Micronesia (chapter 9) underscores the inexorable link between weaving in the Pacific and its Asian precursors. Loom weaving penetrated the Pacific only as far as Vanuatu, but wherever the loom went in the open Pacific, it was used exclusively for bast or leaf fibers (fig. C). The distinction between loom-woven cloth and beaten barkcloth is indeed one of the great divides between Southeast Asian and Polynesian cultural spheres.

To the west, we have somewhat arbitrarily used the standard dividing line between Southeast and South Asia as a cutoff point. The weaving of such bast fibers as jute (*Corchorus* spp.) and giant nettle (*Girardinia diversifolia*) is widespread in northeastern India, Bangladesh, Bhutan, and Nepal, and it would

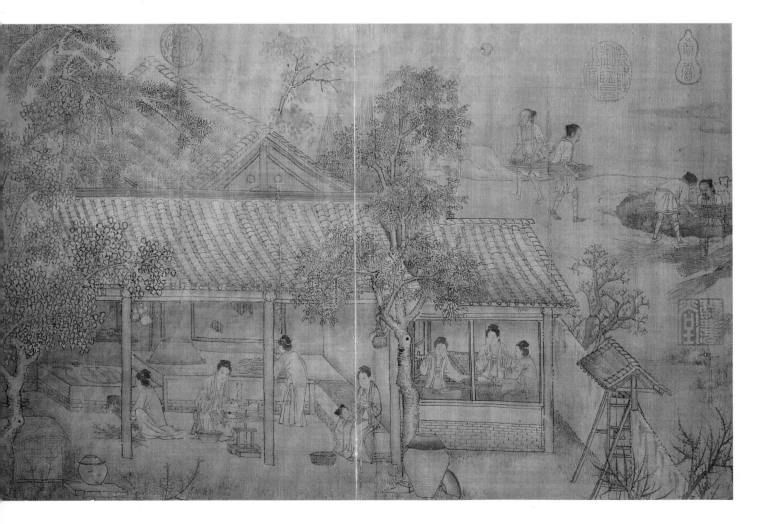

have been possible to develop essays similar to the ones in this book for those regions. India and Bangladesh are, in fact, the world leaders in bast fiber production due to their jute industries, although most of this fiber is used for industrial purposes.

Finally, the fact that there is no essay covering material from China has more to do with the practical realities of the development of this book than with any lack of suitable subject matter. A fragment of woven cloth made of kudzu (*Pueraria montana* var. *lobata*) bast fiber has been found in a Chinese archaeological site dating to the fourth millennium BCE (Kuhn 1988, 39). Ramie and hemp (fig. B) were also woven into cloth in ancient China, and the cultivation and processing of ramie were described in Chinese literature as early as the third century CE (Kuhn 1988, 31). Today, China is a major producer of commercially woven hemp and ramie cloth, while handwoven fabrics of hemp and other bast or leaf fibers continue to be produced in minority communities mostly in the far south of the country.

Nearly ten years have passed since the idea for this book was first proposed, and the manuscript has gone through various permutations. A considerably wider network of participants was involved at the beginning of the project before the final, sharply focused topic was determined. For their efforts, each of which helped the project along in one way or another, we offer our heartfelt thanks to Sharon Barber, Monica Bethe, Lois Ziff Brooks, Robert C. Clarke, Brenda Collins, Ross Cordy, Eric Crystal, Ann C. Deegan, Helen Bradley Foster, Nobuko Hiroi, Robert Hoffpauir, Michael C. Howard, Irmgard W. Johnson, Gorō Nagano, Nguyễn Văn Huy, Lillis Ó Laoire, Margaret Ordoñez, Toshiyuki Sano, Teri L. Sowell, Linda Welters, Dai Williams, and Gabrielle Yablonsky.

Finally, it was a great pleasure to work with our distinguished group of coauthors, who have freely shared their ideas and expertise throughout the project.

Roy W. Hamilton and B. Lynne Milgram

B **Hand scroll showing the processing of hemp (detail)**
Liu Sung-Nien
(Chinese, c. 1150–1225)
Ink on paper
Collection of the National Palace Museum, Taiwan, Republic of China

C **Man's loincloth (detail)**
Santa Cruz Group, Solomon Islands, early twentieth century
Banana fiber.
Fowler Museum x65.8892: Gift of the Wellcome Trust

Santa Cruz loincloths were woven on back-strap looms using supplementary-weft decoration (see Graebner 1909, 123–25).

9

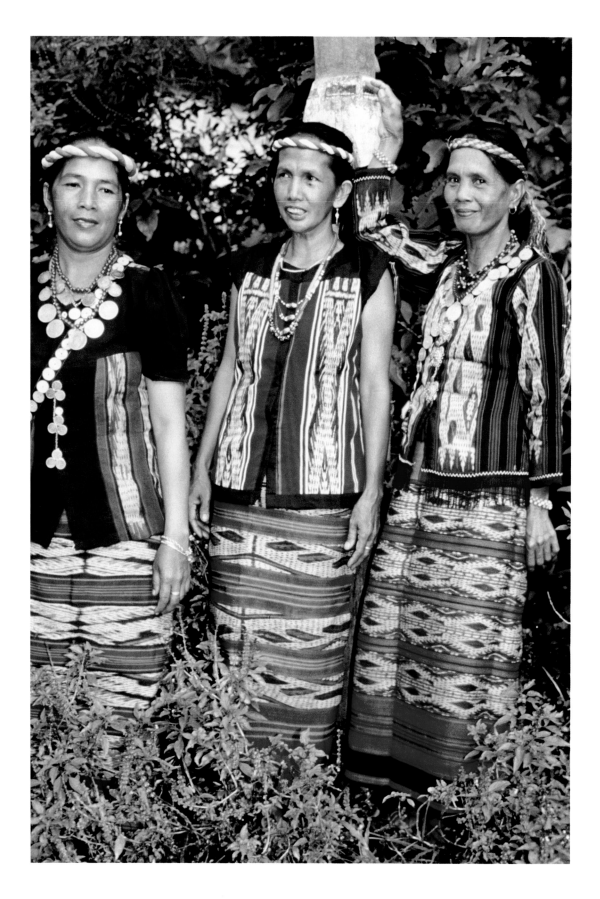

Introduction
Considering Bast and Leaf Fiber Textiles in a Globalized Context

B. Lynne Milgram and Roy W. Hamilton

THE BAST AND LEAF FIBER WEAVING TRADITIONS that form the subject of this volume originated as subsistence activities. Most often weavers made durable, functional garments of bast or leaf fiber for everyday wear, and in some cases, they created more elaborately patterned or dyed items for special occasions or ceremonial purposes. Only the lotus fiber weaving of the In-tha of Burma (see chapter 5) represents an exception to the subsistence pattern, as it appears to have been invented (or perhaps reinvented) as a devotional activity in the early twentieth century.

A time-consuming activity requiring skill and experience, weaving can be readily developed as a specialization. Thus, some weavers seek to realize income by focusing on the production of a surplus of cloth for barter or sale. Specialization and localized trade in textiles are very widespread features of even small-scale economic systems around the world (see, for example, Hamilton 1990 and Milgram 2003b), and they have existed side-by-side with subsistence production in all of the situations detailed in the chapters that follow.

Internationalization of the textile trade has the potential to disrupt such well-established patterns. The textbook case is British interference with the local organization of cloth production in India in the eighteenth century (Arasaratnam 1996; Subramanian 1998).[1] Following the invention of synthetic fibers in the mid-twentieth century and the development of global trade on a massive scale, the level of international intervention in local systems of textile production has become much more pronounced, ultimately leaving a large segment of the world's population clothed in mass-produced, imported textiles.

Among the case studies presented in this volume, only the Hmong hemp weavers of Yên Bái Province in northern Vietnam (fig. 2) have continued to engage in subsistence production essentially unabated up to the present (see chapter 2). In the other cases (again excepting the In-tha), the weaving of bast or leaf fiber either declined significantly or ceased entirely until some form of intervention brought about a revival. Weavers have typically chosen to revive their production of bast or leaf fiber textiles because changing economic environments have led them once again to view such work as a productive investment of their labor. Channels may have opened allowing weavers access, either directly or indirectly, to markets beyond their local trade networks. Or perhaps outsiders, such as tourists or regional traders, have begun arriving in the local area to purchase products. These processes may be seen as two sides of the globalization coin.

Economic factors are not the only motives that may spur a revival, however, and often issues of identity and cultural pride play a role. In the In-tha case, religious motives have been a major factor. Intervention may also occur in the form of purposeful policies or programs instituted by governmental or nongovernmental agencies. Readers will find examples of all of these motivations in the chapters that follow.

GENDER AND MARGINALITY

In each of the various traditions considered in this volume, weaving is regarded as women's work (figs. 3, 4). Indeed, it is a key cultural axiom in these societies that weaving is the archetypal occupation for women. In China weaving by women

1. Benuaq women proudly model locally made *lemba* fiber garments as symbols of their cultural identity. *Lemba* weaving underwent a revival in the 1990s as Benuaq communities sought to preserve their cultural heritage and at the same time create an image that would attract tourists. Similar skirts would have been common in the community up until the time of their near demise in the mid-twentieth century, but the jackets meld traditional fabrics with imported concepts of propriety and modernity (see chapter 3).
Photograph by Elizabeth Oley, Tanjung Isuy, East Kalimantan (Borneo), Indonesia, 1999.

2. A Black Hmong woman dries hemp yarn produced from local fields after it has been washed in a nearby stream. Women in this community engage in the subsistence production of hemp clothing for their families. Note that the woman wears the characteristic hemp skirt of the Black Hmong (see fig. 2.30, p. 52), and three of the children wear local hemp cloth. A fourth child, at the right, wears mass-produced clothing.
Photograph by Trần Thị Thu Thủy, Mù Cang Chải District, Yên Bái Province, Vietnam, 1997.

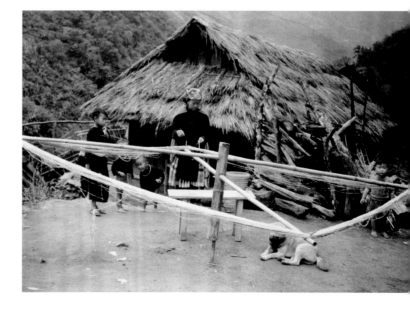

was seen as the counterpart to farming practiced by men. The *Gengzhi tu* (Agriculture and sericulture illustrated), attributed to Lou Chou (1090–1162), is a famous set of illustrations pairing the phases of the ideal male labor, rice farming, with the phases of the ideal female labor, the production of silk cloth. The Confucian ideals implicit in these illustrations influenced Korean, Japanese, and Vietnamese society as well. A similar ideology prevails even more strongly in Southeast Asia and in all areas of Austronesian settlement. In Iban communities in Borneo, for example, women's dyeing and weaving are described as "the women's warpath." Just as Iban men once achieved prestige through successful leadership in war, so a senior woman achieved her standing through her mastery of weaving and in particular through leadership in the ritual aspects of the mordanting processes for red dyeing (Gavin 1991; 1996). On the island of Sumba, the dyeing of yarn with indigo is linked to women's reproductive powers (Hoskins 1989). Throughout East and Southeast Asia, then, the classification of textile making as women's work constitutes a key provision in the conceptualization of the complementarity of the sexes.

Gender, however, is not the only marker of difference that surrounds the women who weave bast and leaf fibers in contemporary Asia and the Pacific. The In-tha are a recently arrived minority group living in Shan State, itself a minority administrative region within Burma. The Benuaq community of Tanjung Isuy has a population of 3,000, compared to the Indonesian total of 244 million, and it is inaccessible by road,

located far upriver in Borneo. The Ifugao are a distinctive minority group living within the folds of the most extensive mountain chain in the Philippines, while the Flower Hmong of Yên Bái Province occupy a similar position in the Vietnamese state. Okinawa, though once the center of the independent and culturally distinctive Ryukyu Kingdom, was forcibly annexed by Japan in 1879. As all of these cases demonstrate, today's bast and leaf fiber textiles are overwhelmingly produced in physically remote and economically marginal areas by weavers who belong to minority groups within larger regions or nations. Among the groups of textile producers discussed in this book, only Korean hemp weavers and Japanese ramie weavers do not represent distinctive minority groups within a nation-state. Even in these cases, however, the people engaged in bast fiber weaving come from decidedly rural segments of society, far from the view of the urban majority.

What are we to make of such weavers who work on peripheries and who choose not only to persist in their occupation but also to expand their reach into a growing international marketplace? This question goes directly to the heart of current theoretical developments in cultural studies and anthropology that have opened new ways of thinking about margins. The case studies in this volume clearly demonstrate the ways in which women actively engage their marginal positions by protesting, reinterpreting, and embellishing their exclusion. Weavers invent new opportunities in cloth production by engaging the three processes that shape their marginal positions: (1) state or chiefly

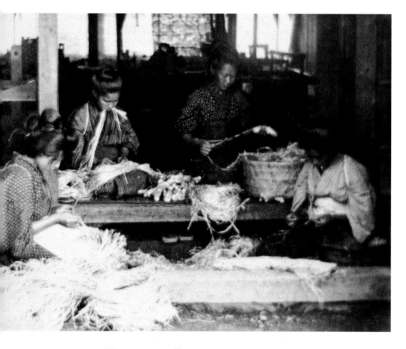

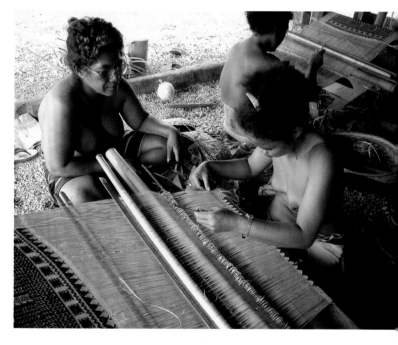

3. Women process fiber from the kudzu plant (*Pueraria montana* var. *lobata*), known as *kuzu* in Japan. Kakegawa, Shizuoka Prefecture, c. 1914.
Reproduced from a photograph album in Kakegawa.

4. Weaving instructor Teres Peyelifar observes her student Margarita Iyoth learning to weave a Fais Island *machi* cloth. In former times, young women on Fais learned weaving skills from their mothers or aunts when they were confined to the women's menstrual house for three months at the onset of menarche. This traditional form of instruction and the menstrual houses themselves have now disappeared, and when a project to revive production of the *machi* began in 2003, it became acceptable for an elder women to teach a younger women without regard to family relationships (see chapter 9).
Photograph by Sophiano Limol, Fais Island, Yap State, Federated States of Micronesia, 2003.

rule; (2) the formation of regional, ethnic, and national identities; and (3) gender differentiation (Tsing 1993, 1).

Recent scholarship suggests a new, more fruitful avenue of inquiry directed at understanding the circumstances of social change for those at the margin. This approach reframes the idea of marginality into one of border zones or borderlands (Rosaldo 1989, 208; Spyer 1998). As Anna Tsing suggests, "Borders are a particular kind of margin; they have an imagined other side" (1993, 21).

The image of the border enables actors at the margins to undertake creative projects of self-definition. This shift in perspective focuses on the agency of actors to realize multiple possibilities but considers as well the constraints that power and knowledge place on their actions (Tsing 1993, 21). Tsing later argues in her discussion of the "global situation" that although the global flows of people and things are well established, the "recarving of channels and the remapping of possibilities" are not (2000, 327).

Globalization has brought a previously unimaginable proliferation of new pathways and opportunities to geographically disparate corners of the world. Authors including Arjun Appadurai (1996; 2000), Néstor García Canclini (1995), and Jonathan Inda and Renato Rosaldo (2002) demonstrate that the negotiation of marginality works through different economic and cultural modes and is effected not only by large-scale actors, such as governmental and business institutions, but also by "marginal" individuals engaged in a complex of activities that are embedded within and at the same time transforming practices of global capitalism. The case studies of bast and leaf weavers presented in this book demonstrate that while "global processes enact themselves on local ground…local processes and small-scale actors might be seen as the very fabric of globalization" (Freeman 2001, 1008). Writers on the international marketing of "handicrafts," for example—many assuming feminist perspectives—have shown the different ways in which rural woman have seized and reconfigured such opportunities in order to better their social and economic positions (see, for example, Milgram 2003b; Tice 1995; Zorn 2004).

Viewed from such a conceptual framework, the essays that follow illustrate the ways that women engaged in bast and leaf fiber weaving today build on their past skills to access new work options within the context of dramatic social, political, and economic change. They expand the scope of their roles as producers and traders by nurturing their ongoing relationships with community members and with local artisans while simultaneously fostering new connections with national and transnational buyers. In so doing, these women incorporate cultural parameters in an economic arena (bast and leaf fiber weaving) that is marginal to state influence. Through their risk-taking ventures, they fashion spaces of agency, innovation, and compromise to consolidate the intersecting, albeit contradictory and often ambiguous, positions they occupy (Gibson-Graham 1997). They add their experience and knowledge as producers to their new trading initiatives and present themselves in the marketplace as capable of fulfilling both roles. To realize their goals, these weavers mobilize whatever assets are at their disposal, including financial resources and social networks that

grant access to information. They operate according to the constraints and standards prevailing within their groups but fashion personalized strategies along the way.

Current research clearly demonstrates that women work across different spheres including household and market, rural and urban spaces, and local-to-national-to-global arenas (e.g., Babb 1989; Brenner 1998; Zorn 2004). Their multifaceted activities dissolve determinist ideas about discrete and bounded socioeconomic categories. Studies of women's work in rural and urban spheres reveal how household and market interact dialectically; women borrow social and economic relationships and practices from one sphere, adapting and reapplying them to the other. As Wazir Karim argues for Southeast Asia, women secure a "continuous chain of productive enterprises" for family and personal well-being by establishing "a repertoire of social units" linked to household, market, and environmental resources; and they "unlink" themselves when situations change. Women thus create an "open-ended" and "multi-focal" system of socioeconomic relations with "undifferentiated boundaries" and "varying connotations of 'space'" (Karim 1995, 28).

The concept of multiply rooted activities is useful in understanding the opportunities women can realize and the constraints they experience in contemporary bast and leaf fiber production. Women strategize to strengthen and extend their producer-buyer connections by simultaneously using social and market skills at different points in and at different levels of their broader-than-local activities. By reconfiguring economic enterprises through culturally informed practice, many of these bast and leaf fiber weavers negotiate "the uneven and contested terrain" of global market forces to craft innovative and often surprising careers (Tsing 2000, 330).

The accomplishments of the groups of weavers detailed in this volume can be described from such relatively celebratory perspectives. The rural Hmong weavers (see chapter 2), for example, balance the demand for their labor in agriculture with the needs of their weaving businesses, while Ifugao women (see chapter 7) combine work in cultivation, collaboration with Manila merchants to design new products, and negotiation with development bureaucracies for capital. The Fais Island weavers (see chapter 9) have organized a group to benefit from grants and to overcome objections to new ways of teaching; furthermore, they have celebrated their success with the first-ever official public oration by a woman in their community (see fig. 13).

Yet not all social scientists agree with such positive characterizations of global processes. Jonathan Friedman reminds us that "Cultural processes in global systems cannot be understood without considering the phenomenon of hegemony, of countervailing identities, of dominant and subaltern discourses" (1994, 25). Similarly, Stuart Hall asserts that "We need to situate the debates about identity within all those historically specific developments and practices which have disturbed the relatively 'settled' character of many populations and cultures, above all in relation to the processes of globalization" (1996, 4).

Would the women who painstakingly produce bast and leaf fiber textiles in the informal sector for an international market continue to choose this work if there were better-paying alternative forms of labor available in their communities? As

Linda Seligmann has shown, when policy makers for political reasons promote the potential of the informal economy for women's work, they may actually be rationalizing their own failure to initiate infrastructural changes that could facilitate women's access to resources, whether from the informal or formal sectors (2001, 21). Ultimately, many weavers remain poor and low paid, producing goods that are often destined for relatively more wealthy consumers beyond the confines of their communities. They may be bettering their lot somewhat within their own communities, but they are hardly keeping up with expanding global wealth.

With regard to Southeast Asia, Shelly Errington cautions that although women may predominate in market trade and control household finances, such economic control does not confer high status (1990, 5). Rather, skill in public oratory and election to political or religious office—spheres in which men primarily hold sway—remain the most prestigious forums. Such customary notions of hierarchy contribute to the contradictions and ambiguity women may experience as they reconfigure their work options in new more commercially oriented bast fiber textiles. Indeed, women's control over the sale of their new *machi* cloths in Fais Island has encountered just such a challenge as weavers must continue to negotiate with their chief about which cloths can be offered for sale and who holds power over these sales (see chapter 9).

Research on women's small-scale work also explores their agency in determining the nature of their survival tactics. As Annelou Ypeij points out, although women seamstresses in Lima, Peru, may gain access to resources and challenge particular ideologies, they are still somewhat constrained in realizing opportunities because of the isolated nature of household- and street-based work and because of the class-based economic differences that divide them (2000, 13–16). In addition, power structures within households, the gender division of work, and women's "double" workday (combining wage work and domestic responsibilities) may also constrain their choices. Social actors, as Norman Long argues, can and do make decisions, but the degree of choice they have is not unlimited and is asymmetrical (1992, 22–23). In many of the chapters of this book, the decisions made by weavers may certainly be empowered by their command over economic and cultural resources, but at the same time, their agency or potential to exploit opportunities, including the labor of their workmates, is constrained by their lack of power over community cultural expectations and state-imposed parameters, as well as by the risk to social networks that certain decisions may entail.

IDENTITY AND THE NATION

Weavers innovate in their contemporary production not only to achieve economic gain and enhanced standing but also to reproduce cultural identity. In order to explore this more fully, we must consider issues surrounding identity and authenticity, which can be specifically related to the arena of bast and leaf fiber textiles. Clothing and textiles "mediate between self and society" in ways that make visible how people reposition themselves in times of dramatic change (Hansen 2000, 4). This is a potent explanation of why people have chosen to preserve

or revive the production of particular bast or leaf fiber textiles, which they feel better represent their identity than other objects they might choose to make. The distinctive hemp garments of the Flower Hmong or the ikat-dyed *lemba* fiber skirts of the Benuaq, for example, are cited by their makers as expressions of their cultural identity that set them apart from neighboring groups (fig. 1). Such statements become particularly appealing in times of rapid change, when one's sense of identity might otherwise seem at risk. Thus, identification emerges as an ongoing process—never completed. As such, "Identities are never unified and, in late modern times are increasingly fragmented and fractured; never singular but multiply constructed across different, often intersecting and antagonistic, discourses, practices and positions" (Hall 1996, 2, 4).

Within the current global framework where the transnational flows of persons, things, and ideas have become the norm, it is often asserted that people increasingly anchor their identity in their relation to the nation-state. National governments commonly attempt to unite people through reference to a shared common past, albeit an invented one, by employing mainstream symbols of citizenship such as the flag, national anthem, and historic myths of military conquests, as well as through elements of so-called "high" culture—major works of art, notable religious or state monuments, and so forth. These reified notions of culture and identity, while still relevant to some degree, comprise only a small part of the mix of things that people use to situate themselves within regions. Many of the chapters in this book demonstrate that such mainstream visions of the "nation" are not the preeminent entity around which people shape identity. Rather, people increasingly craft personalized forms of identity by drawing on the material culture of everyday life, such as the specialized practice of bast and leaf fiber cloth production.

National identity is most often constituted out of a broad "cultural matrix" that provides "innumerable points of [inter]connection" through which different players can fix meaning to a variety of cultural forms (Edensor 2002, vii). One's identity is grounded in the embodied habits and in the forgotten reminders of daily social life rather than in mainstream symbols (Edensor 2002, viii). The Asian artisans and traders featured in this book have nurtured the revival of bast and leaf fiber cloth, a historically rooted yet everyday cultural form, by distributing it through contemporary popular culture, in such forms as new garment styles, functional goods, and clothing worn at celebratory occasions. In this way, such textiles mingle with other iconic elements (e.g., music, food) that signify the nation in multiple and contested ways and thus mitigate against exclusive and singular "authentic" representations.

Benedict Anderson's concept of an "imagined" nationhood suggests how the state has been complicit in manipulating a country's constructed identity. While Anderson identifies the crucial role of print media in the formation of nations (1991, 33–35), Richard Handler suggests a broader role for cultural phenomena by tracing the construction of a distinctive regional ideology in the French-Canadian province of Québec (1985). Specifically, Handler demonstrates how the provincial government, through a series of initiatives in heritage legislation,

"sacralized" particular monuments and objects of art in order to establish a naturalized "culture-bearing" nation, or in this case, province. In so doing, "cultural content becomes the very body of the nation" (e.g., Québec) attributing an inclusive identity to those within provincial boundaries and excluding people and elements from outside as "not authentic" (Handler 1985, 209, 211).

New research explores how previously overlooked spheres of material and popular culture, once situated in borderlands, are emerging as essential components of national identity constructions. For Tim Edensor, national identity does not reside in "high" or "official[ly sanctioned]" creations but rather emerges out of the objects that people use in everyday life and in performance—dance, sport, and carnival (2002, vi–vii, 2). In Melissa Schrift's study of the history and contemporary revival of Chairman Mao badges in China, she similarly demonstrates the power of material goods to parallel, intersect, and eventually subvert a centralized national voice (2001). The Chinese government believed that by requiring its citizens to wear standardized Mao badges, people would internalize the dogmatic nationalist ideology of the Cultural Revolution (Schrift 2001, 4). Instead, individuals diverted this ubiquitous item of dress from its intended use as a piece of state-inspired propaganda, employing it instead as a personalized statement meant to "resist an essentialized Chinese national identity" (Schrift 2001, 201). The chapters of the present volume similarly demonstrate that artisans mobilize a variety of local cultural bast and leaf textile forms to construct an eclectic national identity that dispels any notion of nations as natural uncontested entities.

In this light, Mike Featherstone argues that the values expressed by the old cultural guardians are currently being challenged by what he terms "new cultural intermediaries," a segment of the contemporary middle class that possesses knowledge of popular and material culture and claims status on the basis of this expertise (1991, 22). The national-cultural terrain is thus now characterized by a plethora of interest groups—experts, aficionados, consumers, and nongovernmental organizations who champion a range of cultural forms and practices. This is particularly relevant to the case studies in this book, which trace how artisans, on their own and with the assistance of emergent grassroots organizations, are developing new products for global markets and new venues through which to sell them. By challenging and transforming imposed ideologies and policies, these players decenter mainstream symbols of nationhood and move alternative cultural forms such as bast and leaf textiles to the forefront of popular attention. The current popularity of newly designed piña textiles from the central Philippines provides practical illustrations of many of the theoretical issues involved in this shift from margin to mainstream to national identity marker.

PIÑA: A CASE STUDY OF CLOTH AND IDENTITY

Piña, a diaphanous textile woven in the central Philippines from the fibers of the leaves of the pineapple plant (fig. 5), is a fabric deeply associated with the country's Spanish colonial period (1565–1898).[2] The current revival of piña garments designed for different economic classes dynamically illustrates a refashioning of national identity and "authenticity" by way of a functional material culture form. Through an interregional system of specialization, the cloth was, and continues to be, woven in Aklan and Iloilo Provinces on the island of Panay and then shipped to the southern Luzon province of Laguna (particularly the community of Lumban), where elaborate embroidered designs are added by hand (figs. 6, 7).

Women's blouses, skirts, and shawls and men's shirts made of piña represented the height of fashion from the late eighteenth to the late nineteenth century (fig. 8). Although the men's elegant piña shirt, the *barong Tagalog*, which is considered part of the national dress, never went completely out of style, by the early twentieth century, and increasingly in the postwar period, evolving ideas of modernity and growing imports of inexpensive factory-produced clothing drove other piña garments out of fashion and reduced weaving of the fabric to a small cottage industry that responded to irregular orders (Davis 1991; Montinola 1991; Welters 1997).

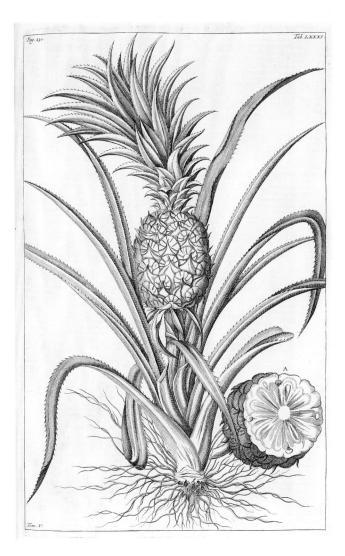

5. Piña fiber is obtained from the leaves of the pineapple plant (*Ananas comosus*). Reproduced from Rumphius (1750, 5: pl. 81).
Courtesy of Louise M. Darling Biomedical Library, University of California, Los Angeles.

It was not until 1988 that the Patrones de Casa Manila, a group of businesspeople and designers, spearheaded the revival of the piña industry by working with government and nongovernment associations.[3] Photographs of fashionable events from the late twentieth century show elaborate women's gowns of piña and men's innovatively patterned *barong* that testify to the vibrancy of this revival (Vegara 2002). Analyzing such transformations in piña clothing, a dress style with its own unique history, makes visible how textiles and garments, material goods that have often been considered "minor" arts, can, in fact, manifest national identity, albeit one that is polysemic and contested.

Designers using contemporary piña cloth choose it because it is a textile that is perceived as unique to Filipinos. At the same time, it is an expensive item that retains its value as a status symbol that must to some extent continue to be supported by the upper class if it is to survive. The challenge for designers is to resolve how to use piña and make it the Filipino textile par excellence when only a minority can afford it. The Philippine elite of the 1990s were interested in dressing in haute couture; thus, in order to revive piña, designers had to elevate it to the status of clothing emanating from famous European fashion houses. Philippine designers succeeded in reviving piña cloth not only by reinventing it as haute couture but also by producing a more economical, albeit hybrid, widely accessible, ready-to-wear line of garments.

One of the main strategies of Philippine designers is to build on the predilection for interrelated dress forms by grounding their designs in both mainstream fashion styles and indigenous Philippine fabrics. In so doing, they create a "conflated" (Causey 1999, 432–33), yet culturally distinct, clothing statement. As Philippine journalist Ching Alano explains, designers seek to "balance innovative adaptations and clothing heritage preservation" (2000, 39). Thus they formulate new aesthetic standards that, while remaining rooted in fabrics and styles with a distinctive historical and cultural heritage, selectively incorporate regional and non-Philippine elements to proclaim broader appeal and availability.

Many of the most prominent Philippine fashion personalities, for example, work in both Filipiniana and mainstream silhouettes, and they commonly use easily recognizable embellishments such as the distinctive Lumban-style hand embroidery and beadwork on both forms of dress. They take a "this plus that" approach in their design strategy—the "this of global modernity plus the that" of timeless indigenous tradition (Silverstein 2001, 23)—the same formula that characterizes the

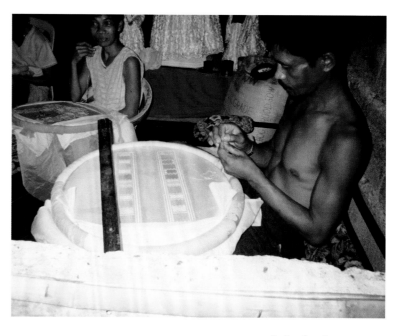

6.　　A piña weaver skillfully creates a pattern by using the supplementary-weft, or *suksuk*, technique. Here she trims excess yarn on the back of the cloth.
Photograph by B. Lynne Milgram, Heritage Arts and Crafts, Kalibo, Aklan Province, Philippines, 2002.

7.　　In Lumban, Laguna Province, a man and a woman hand embroider intricate designs on piña cloth woven in Aklan Province. Men and women in Lumban often work at home on a piecework basis embroidering piña and *piña-seda* cloth that will be sewn into garments for men and women.
Photograph by B. Lynne Milgram, Philippines, 2002.

nation-building projects of recognized states (Chattergee, 1993, 6; Löfgren 1993, 169).

Piña cloth has long been subject to cross-cultural influences by virtue of its role as a commodity in international trade. The revival of piña must therefore be situated within the social and political movements in which such border crossings take place. When we focus on national identity as envisioned, for example, by piña designers, we see how it is the agency and creativity of individuals at various levels that determines how mixed expressive forms may be "reassessed, redrawn and at times, overturned" (Spyer 1998, 3).

Designer Patis Tesoro, for example, works closely with small workshops in Kalibo, Aklan Province, to produce piña fabrics specifically suited to the design and style of her garments, including unique color and pattern combinations. After securing the woven piña yardage from Aklan, Tesoro ships the fabric to Lumban where artisans embellish the cloth with her versions of classic Philippine embroidery motifs. The fabrics are then sent back to her Manila workshop where still other craftswomen apply beads and sequins to her Filipiniana, as well as to her garments featuring a more Western silhouette. A collection of five square piña shawls, or *pañuelo*, the characteristic stole of Visayan women, featured in an exhibition held at the

Textile Museum of Canada in 2003 displays Tesoro's innovative designs. Maintaining the square shawl form in contemporary pieces enables women today to wear this cloth around their shoulders, either folded into a triangle or into the traditionally pleated accordion-style. These new shawls further assert their composite nature through the embroidered and woven patterns that are drawn from a variety of Philippine cultural sources but rendered within the customary center-field border layout of earlier nineteenth-century cloths (Milgram 2003a).

Promoting a discourse on national identity through textiles, Patis Tesoro explains that she "believes in the quality of the natural materials here in the Philippines" and is thus continually looking for different ways to incorporate these elements in her work. To this end, in 1998 she initiated a practice of coloring piña cloth, which in its natural state is an off-white or beige, with synthetic and natural dyes, the latter obtained from the northern Luzon Cordillera provinces of Ifugao and Abra (fig. 9). She also started to work with the Philippine Textile and Research Institute (PTRI) to organize a series of natural dye workshops in Aklan for local piña manufacturers, using natural dyestuffs she had collected from northern Cordillera sources. This conflated style of piña cloth—woven in Aklan, embroidered in Lumban, and dyed either in the Cordillera, Manila,

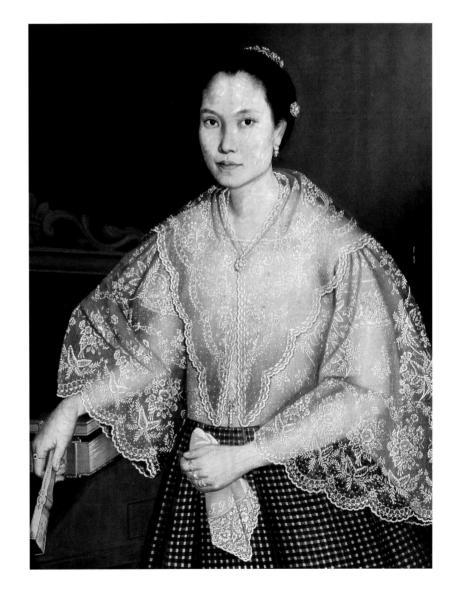

8. *Portrait of Teodora Devera Ygnacio*
Justiniano Asuncion
Oil on canvas, circa 1880
87 x 68 cm
Private Collection, Manila, Philippines

For her portrait, the subject selected a blouse (*camisa*) and shawl (*pañuelo*) of piña.

or Aklan with Cordillera natural dyes—made its acclaimed national debut in the late 1990s. The mosaic-like dresses hanging in Tesoro's boutique bespeak a national identity that simultaneously disputes the idea of a stable or fixed "authentic" cloth. While anchored in the tradition of piña production and style, these new cloths suggest border crossing as integral to their meaning.

In a similar initiative, husband-and-wife team India de la Cruz-Legaspi and Javier Legaspi established their piña-weaving business, Heritage Arts and Crafts, in Kalibo, Aklan Province, in 1989. In response to the chronic shortage of piña fibers for weaving and to meet the growing demand for piña cloth from young designers, the Heritage workshop introduced the idea of mixing silk fibers with those of piña in 1995 (fig. 10). This innovation, using imported and Philippine-grown silk as the warp yarns to create what is now termed *piña-seda*, or pineapple-silk, revolutionized the piña weaving industry. *Piña-seda* is easier to weave, more adaptable, and less expensive to produce than pure piña. The practice of combining pineapple and silk yarns has now been widely adopted by other small Aklan producers resulting in the cloth's enhanced popularity and wider availability (Milgram 2003a).

Piña textile designers such as Patis Tesoro and India de la Cruz-Legaspi and Javier Legaspi bring together varied regional resources to mold personalized versions of an "authentic national identity." In so doing, they demonstrate how bast and leaf fiber textiles, once marginal goods, continue to mediate between self and society to craft a multifaceted symbol of identity, locality, and nationhood.

AUTHENTICITY AND CONSUMPTION

Examples of processes similar to those transforming the Philippine piña industry can be found throughout the region. For example, handwoven abaca textiles from the southern Philippine island of Mindanao have appeared on Manila fashion show runways and in the costuming of Philippine folkloric dance troupes—both in the Philippines and abroad—over the last twenty years. The same cloth also appears in galleries and shops worldwide, either as yardage or cut up and reworked into garments, bags, pillow covers, and place mats. In Indonesia, Benuaq *lemba* fiber cloth is made into bags sold to wealthy customers in shops in Jakarta and to tourists in Bali. Items made of Hmong hemp fabric, including elements of traditional dress, are popular in the burgeoning tourist trade in Hanoi as well as in Sa Pa, a district center that is a leading hotspot of "cultural" tourism in Vietnam. In Korea and Japan, where labor costs are higher, handwoven bast fiber textiles are extravagantly expensive, making garments that were once intended for everyday wear available today only to the very wealthy, who find a transcendent value in them. Some Japanese bast fiber fabrics have even been officially declared "Important Intangible Cultural Property" by the Agency for Cultural Affairs of the

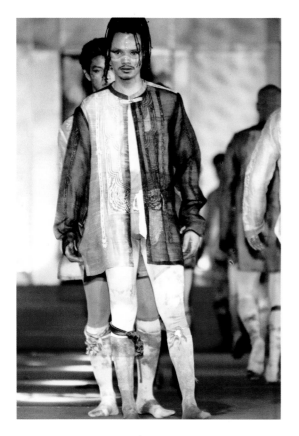

9. The space-dyed and embroidered piña *barong*, or shirt, worn by the model in the fashion show "Tesoro De Ornamentos," held in 2000, highlights Patis Tesoro's contemporary design innovation using piña textiles. The black color was obtained by immersing the cloth in a dyebath comprised of iron-rich mud obtained from Ifugao Province. The light orange was also obtained from a natural source, the seeds of the *achuete* (*Bixa orellana*) tree.
Designed by Patis Tesoro, Manila, Philippines. Private Collection. Photograph by Patis Boutique, Manila, Philippines, 2000.

10. This detail of *piña-seda* yardage, designed by Heritage Arts and Crafts, illustrates a contemporary rendering of the classic bamboo pattern. The fabric was woven in the Heritage Arts and Crafts workshop in Kalibo, Aklan Province.
Photograph by Heritage Arts and Crafts, Kalibo, Aklan Province, Philippines, 2002.

national government, transforming humble cloth into an element of the state apparatus.

Scholars and the public have often decried such crossing of "aesthetic boundaries" as indicative of cultural contamination (Kapchan and Strong 1999, 239), which is thought to cause the decline of the once "authentic" product. Recent studies, however, in conjunction with the expanding literature on globalization, welcome such cultural graftings by employing different analytical terms. These include "hybridity," "syncretism," "bricolage" (Kapchan and Strong 1999, 239–40), "creolization" (Howes 1996, 5–8), and "conflation"(Causey 1999, 432–33). Concepts such as "border zones" celebrate the "piecing together [of things] out of heterogeneous elements"; they highlight the ongoing oscillations in objects that mark material relations between people, things, and broader identities (Spyer 1998, 3; see also Friedman 1999, 247).

In an early seminal paper, Richard Handler (1986, 2–4) argues that "authenticity" is a cultural construct of the modern Western world in which the "individual" places his or her thoughts at the center of culture and of understanding so-called reality. He suggests that, "Our search for authentic cultural experience—for the unspoiled, pristine, genuine, untouched and traditional—says more about us than about others" (Handler 1986, 2). The contemporary marketing of Asian travel vacations or of ethnographic goods in specialty retail stores, for example, continues to promote this "myth of the primitive" (Hiller 1991). It presents a "Western appetite for exotica" and a "Western nostalgia for a pre-industrialized way of life, widely perceived by Westerners as still existing in most of the 'Third World.'" Moreover, "the evident Western desire to perceive Third World peoples as 'primitive' indicates an interest on the part of the West in locating 'Third World' peoples in the South in a subordinate position" (Classen and Howes 1996, 186).

Shelly Errington's research on the issue of "authenticity" with regard to Indonesian indigenous arts and architecture resonates with this argument. She outlines that the European "metanarrative of progress" was invented in the discourse of "authenticity" and "the primitive" in the mid-nineteenth and early twentieth centuries to signify the "traditional" practices of "Southern" communities as opposed to the modernity of Europeans (1998, 5). Europeans then collected and displayed in galleries, museums, and at world fairs a variety of arts as material evidence of the "authentic traditions" of those they colonized. As early examples of such arts became increasingly scarce, Euro-American art historians and dealers reproduced and constructed in varying permutations new notions of the "primitive" and the "authentic" in order to maintain the power differential between "us" and "them" (Errington 1998; see also Bruner and Kirshenblatt-Gimblett 2005; Spooner 1986).

The current status of bast and leaf fiber weaving traditions thus poses provocative questions with regard to the nature of identity and authenticity. The chapters of this volume clearly demonstrate the varied channels through which identity may be constructed, in particular the making and wearing of clothing that marks people as members of a particular group and at the same time sets them apart from other groups. When objects such as textiles and clothing begin to cross cultural boundaries from sites of production to those of consumption, however, issues of identity, authenticity, and meaning rapidly become much more complex. What exactly is being consumed when a tourist, whether from Europe, North America, or a more industrialized part of Asia, visits a more physically remote community in Southeast Asia and buys a garment of a type that weavers have long made as markers of their identity but now also produce to sell to tourists? The consumption in this case will not consist of wearing the garment within the local community or perhaps at a regional market or fair. Rather, when the buyer returns from abroad, the garment may be hung on a wall or, if the buyer is a serious collector, carefully stored in an acid-free box awaiting eventual donation to a museum. In this way, such objects of consumption become what Beverly Gordon identifies as mementos or souvenirs of "extra-ordinary" experiences (1986, 135). The identity that the textile or garment in this case constructs is that of a worldly traveler, knowledgeable about "exotic" cultures, economically successful enough to have flown around the world, intimately familiar with the "other" in the form of village textile producers, and perhaps a savvy bargainer as well to have acquired such a laboriously crafted garment for so little money. In short, it is the identity of a master of an increasingly globalized world culture, a culture that represents, in the words of Ulf Hannerz, not a replication of uniformity but the "organization of diversity" (1990, 237).

Because commodities often travel beyond their sites of production, they develop what anthropologists have termed a "social life"; their value and meanings change as they move through time and space. In the process, such commodities develop a cultural biography (Kopytoff 1986). Recent scholarship on material culture and consumption examines the ways in which people shape and create their self-image and worldview through their involvement with objects. Because consumption concerns what individuals do with things and how things fit into their lives, we need to consider the issue of agency, rather than predetermined market forces, in order to understand how objects acquire meaning. Given this approach, consumption concerns how people use things, how their cultural beliefs and practices shape the meaning of things, and how the consequences of their actions impact the wider contexts of their lives.

At the same time, we need to consider the interplay between consumption and production, namely, how social and economic factors and trends in consumption can actually shape production. Ben Fine and Ellen Leopold suggest seeing this relationship through a "vertical approach" that recognizes differences arising from the consumption of distinct commodities by different consumers over time within different social and economic circumstances (1993, 23). Their "system of provision" invites us to explore a "comprehensive chain of activities between the two extremes of production and consumption, each link of which plays a potentially significant role in the social construction of the commodity both in its material and cultural aspects" (Fine and Leopold 1993, 33). In the northern Philippines, for example, the artisans who work with urban retailers to design products for contemporary functional goods such as carrying bags are, in turn, changing the technology of production in order to weave the wider fabrics required. In

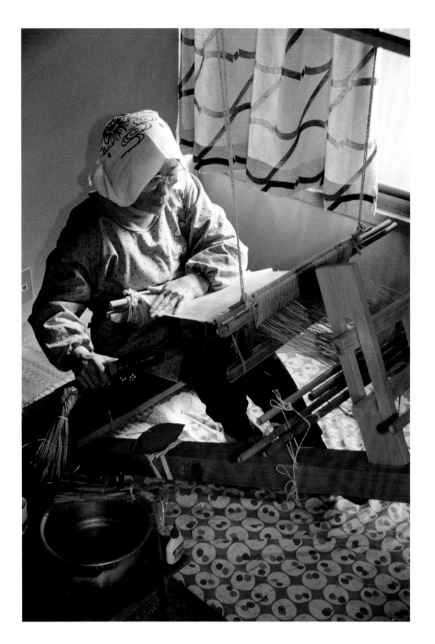

11. An elderly weaver works at her loom weaving a length of cloth from paper mulberry fiber in Kitō, a remote community in the central mountains of Shikoku where a lack of employment has caused many young people to move away to urban areas. The community and its unique craft are kept alive partly through governmental efforts, including the local senior citizens organization. When the *kōzo* stems are cut and steamed in mid-winter, a focal point of the annual calendar of activities, groups of school children are bussed to the community to participate as a learning activity. It is doubtful that this kind of production could continue if left to market forces.
Photograph by Roy W. Hamilton, Kitō, Tokushima Prefecture, Japan, 1998.

12. Participants in the Wisteria Weaving Training Course (Fujiori Kōshūkai) on the Tango Peninsula of Kyoto Prefecture strip wisteria vines that they harvested earlier in the day from nearby mountains. The group meets eight times a year and undertakes all the production processes from plant to woven cloth.
Photograph by Melissa M. Rinne, Kamiseya, Kyoto, Japan, 1994.

some cases, this impacts the social relations of production as some weavers take action to resist such change (see chapter 7).

If the buyers of bast and leaf fiber textiles come from the urban elite of the same country as the producers, the consumption patterns may resemble those of foreign buyers while being subsumed under the practice that Carla Jones and Ann Marie Leshkowich identify as "re-orienting" (2003). When ethnic fashions appear in high-society Manila, for example, they are likely to be accompanied by talk about the common cultural roots of all Filipinos. A garment may be imagined to represent something that was created by a common ancestor, and through it, the buyer rediscovers a common Filipino heritage. This representation may be highly ironic. Pillows scattered on a white sofa in a Manila mansion may be covered in fabric handwoven in a dirt-floored bamboo hut. The wealthy buyer may use them as a springboard for waxing nostalgic about the loss of an imagined rural paradise, all the while maintaining a safe distance from the harsh realities of the community in which the textiles were produced. Folkloric dance troupes comprised entirely of Metro-Manilans don abaca garments from Mindanao to express their solidarity with all Filipinos, while national policies generated in Manila displace and disenfranchise the indigenous inhabitants of Mindanao.

Ultimately fashion may come full circle, as when Okinawans secondarily adopt garments that fit Japanese stereotypes of an authentic Okinawa (see chapter 6). A similar example can be found in Mindanao, where it appears that T'boli men in some cases wear suits made of ikat-dyed abaca cloth to express their cultural identity, although in the past this type of cloth was apparently never intended for men's clothing (Hamilton 1998, 45–46). In Japan, the process of declaring the production of a certain type of textile an "Important Intangible Cultural Property" sets in motion a vast and complex bureaucratic response: only certain processes and materials can be used, particular persons have to be designated as exemplary practitioners, the process has to be documented by video, and so on. A handcrafted, local product that has been chosen for protection because of its "authenticity" may end up being a rarefied luxury with international fame. The machinery of the bureaucracy may ultimately create idealized images of products and of production processes that are no longer sustainable without being artificially propped up by the state for its own purposes (figs. 11, 12).

A formerly marginal and "ethnic" production (e.g., bast and leaf fiber cloth), therefore, moves into majority consumer arenas through the new work of artisans who may now include high-end designers and entrepreneurs. By reconfiguring styles for a varied clientele, producers successfully forge their own cultural spaces and identities, while symbols of their minority ethnic culture diffuse into majority life and make it "hip" to consume such previously obscure goods. That such production consists of "recoding and reimagining previously denigrated domains" of indigenous cultural production resonates with other studies that similarly document a "trickle-up" of goods from margin to mainstream as they are widely adopted across race and class (Bhachu 2004, 4; Jones and Leshkowich 2003; Miller 1995).

MATERIAL CHOICES

What does all of this mean in terms of the weaver of bast and leaf fiber textiles? Is she a pioneer creatively forging pathways through treacherously shifting landscapes of new opportunities? Or is she an exploited and marginal producer of commodities that once represented her cultural identity but have now been appropriated by wealthier and more powerful buyers to suit their own agendas? This debate is likely to continue with ample evidence to support both sides. Perhaps in the long run, we will be able to see whether weavers of bast and leaf fiber textiles have been able to improve their standard of living and continue to make, use, and sell products that are redolent of their identity. In all likelihood, this will occur in some instances, while in others, products will quietly disappear and weavers will find other occupations.

Perhaps a more productive line of analysis can be modeled upon the ideas of Alfred Gell, who considers the production of works of art to be "a system of action, intended to change the world" and is concerned above all with the "practical mediatory role of art objects in the social process" (1998, 6). The artist and the art object (once it has been created), as well as anything that may be represented in the work of art and also its audience, become enmeshed in a reverberating "nexus" of social interactions in which "agents" (in Gell's terminology) bring about reactions in "patients." These processes and reactions in themselves then become new agents in an endless "involution" of the nexus (Gell 1998, 28–65). While Gell has been criticized for perhaps unnecessarily creating an elaborate new vocabulary (Bowden 2004), he has profoundly refocused attention on the *action* of artistic creativity and its consequences and away from the semiotic interpretation of works of art.

Ruth Phillips and Christopher Steiner's rebuke of the historic division between the "high" and "lesser," or decorative, arts—linked to the Renaissance notion of the "artist as genius"—resonates with Gell's position (1999). They challenge the art-artifact-commodity triad and in so doing enable discussion of the communicative power of goods, such as textiles, beyond their earlier "lowly" position as purely functional objects. Current studies of "non-Western" objects intended largely for trade and export now acknowledge the "artistic nature" of such goods previously classified as artifact and commodity. Rather than being simply commercial crafts, many forms of tourist or export art "have been shown to exhibit all the communicative and signifying qualities of "legitimate" or "authentic" works of art (Phillips and Steiner 1999, 15). At the same time, research on mainstream Western artworks and artists demonstrate that commerce indeed plays (and played in the past) a central role in production and consumption. Thus the fragile "membrane" thought to separate the category "art" from "contamination" from commercial commodities dissolves from both sides (Phillips and Steiner 1999, 15).

When a weaver makes a textile, she is an agent not only creating a work of art but also launching an endlessly reverberating chain of social processes. If she chooses to weave a textile made from locally produced bast or leaf fibers, or makes an item that she regards as a marker of her identity, or wears the object within her own community—these actions launch different

sets of processes than would have occurred if she had used store-bought commercial yarn, or made a new sort of object, or carried it over the hill to market in a nearby town. In short, the weaver's choices matter. She lives surrounded by the results of her actions and responds to them in turn. In this sense, she is the creative pioneer that many global theorists have described. But she cannot know how far her creation may eventually travel or what social processes her actions may ultimately unleash. These processes may indeed turn out to recast her object by creating new identities for consumers she never imagined or, as the critics of global capitalism might remind us, deprive her of a reasonable share of the wealth that her product eventually accumulates. In Gell's analysis, these are all permutations of similar processes, not fundamentally opposed interpretations of creativity or powerlessness.

What is happening around the world at this point in history is that both textile makers and purchasers (at various distances from one another) are choosing to make or buy items made from natural bast and leaf fiber materials, and made according to processes that had very nearly gone out of existence in the mid-twentieth century. June Nash points out the irony of this situation (1993). At a time when industry and mass production present the market with an infinite array of manufactured goods priced at all economic levels, Northern consumers are consciously choosing to seek out and purchase indigenous goods. For some consumers these goods speak of sustainability; for others, they present a symbol of the "exotic." Still others may find "the marks of authenticity in diversity, in small scale and in artisanal modes of production" (James 1996, 87). Although Allison James wrote these words to describe the burgeoning adoption of foreign foods in Britain, they seem equally apt for our discussion of textiles. What could be more artisanal (like the production of French farmhouse cheeses) than gathering local plants and transforming them into the rarest of textiles? In her examination of catalog marketing practices for Guatemalan textiles in the United States, Carol Hendrickson remarks how marketers draw upon the cachet of the rare, the exotic, and the eco-friendly, using exaggerated or even illusionary phrases such as "handmade in a tiny town high above the Guatemalan rainforests" (1996, 106–7). While none of the textiles discussed in the chapters of this book are as yet marketed as widely as Guatemalan textiles are in the United States, they win hands down in environmental cachet, made not in but *of* the imagined rain forest.

This analysis should not obscure the far different processes that may also be going on in the communities where the bast and leaf fiber items are produced. Members of a community may seize upon these items that they have invested with special meaning and use them in brave and forceful expressions of their cultural identity (fig. 13). In such circumstances, weavers have made the changes necessary to promote the success of their enterprises regardless of how small-scale they may be. Artisans express their ethnic identity in the continued use of local materials, albeit sometimes in new textile forms. This acts as an integrative mechanism that mitigates the shifting demands of external trends in fashion. By entering into new circuits of commoditization while drawing inspiration from the achievements of the past, the artisans featured in this book have achieved in some cases new creative syntheses that resonate with the cultural climate of the twenty-first century.

In the case studies in this book where bast and leaf fiber textiles have been made for sale, new buyers can find the entire spectrum of commoditization that Pierre Bourdieu defines as the commodity status of artisan production (1977). Some of these goods, such as Ifugao bast fiber garments (see chapter 7) and Okinawan *bashōfu* yardage (see chapter 6), have had a long history of being produced for market exchange or as payment for taxes, respectively. Other textiles such as lotus fiber cloth, made exclusively at first for the robes of Buddhist monks have moved into commoditized exchange within the memory of

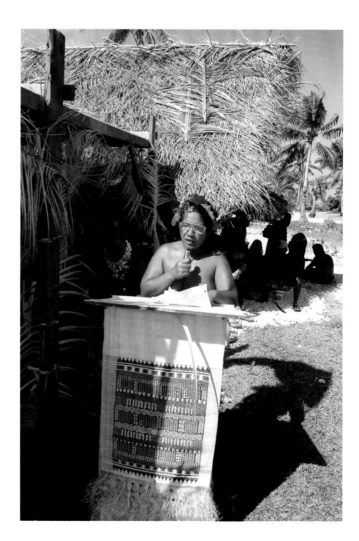

13. Teres Peyelifar speaks on behalf of the Fais Island *machi* revival project's women instructors at the project's first graduation ceremony. Public oration is traditionally a male leadership skill in Micronesia, and this event marked the first public oration by a woman.
Photograph by Sophiano Limol, Fais Island, Yap State, Federated States of Micronesia, 2004.

living weavers (see chapter 5). Still others enter the commodity chain through "nativist" spectacles and performances produced for travelers, regardless of whether these productions and the objects associated with them form part of a people's contemporary life (Classen and Howes 1996, 187; see also Bruner and Kirshenblatt-Gimblett 2005; Nicks 1999). The Benuaq women who put on demonstrations of their *lemba* fiber weaving while dressed in *lemba* skirts for the benefit of their visitors surely do not normally wear these skirts while engaged in such messy processes as scraping or dyeing fiber (see chapter 3). As Nash argues, "Tourism epitomizes the newly monetized yet culturally embedded encounters that characterize the value of these exchanges as the culture of the artisans is packaged along with the product" (1993, 12).

Of course not only the "West" or Northern consumers are implicated in these transformations of goods as our earlier discussion of "re-orienting" fashion demonstrated and as some of the essays in this book further attest. We would argue that each of the textiles in this volume is a production of a subaltern group in a situation where a more dominant group, whether near or far, seeks to imagine and to exploit the exotic. As the objects get farther and farther removed from their points of origin (and therefore more and more expensive), the buyers may find, as James did with artisanal foods, that "Simplicity and tradition" can only be bought at great expense (1996, 89)—re-creating, reordering, and sustaining older class distinctions. Even the tourist who goes to Bali and comes home with an inexpensive bag made of Benuaq woven *lemba* fiber (though he or she may have no idea of where it was produced) reaps in status the cost benefit not only of the bag but of the journey to the far side of the globe and back again.

Ultimately the bast and leaf fiber textiles that are produced bear different meanings in different places and in whatever hands hold them. Because of the very *nature* (in both senses) of the materials from which they are made, makers and consumers find bast and leaf fiber textiles to be powerful bearers of the multiple meanings they imagine. The extent to which these artisans can continue to reproduce the spirits of their cultures in the products they make will depend upon the relationships among artisans, intermediaries, and consumers. The growth of alternative trading organizations (Grimes 2005; Milgram 2005a) or the increased assistance of government and nongovernment programs may contribute to a nonexploitative basis for this relationship. In this postmodern world of amalgamated cultures and the search for identity through consumerism, the strange alliance of a politically conscious consuming elite and culturally rooted producing communities may continue to generate new and varied textures in artisan products.

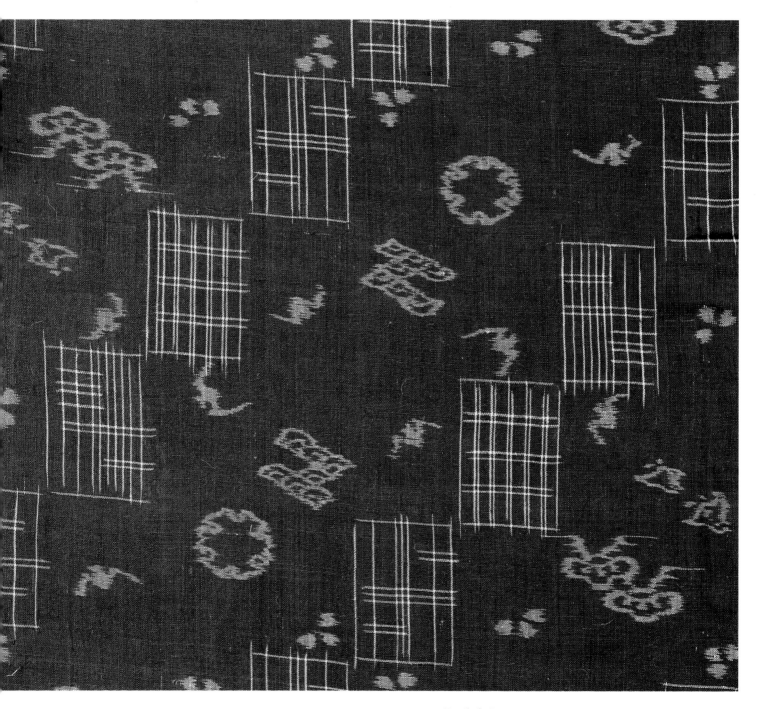

1.1 Detail of a Japanese summer
kimono (see fig. 8.1, p.132).

1. Bast and Leaf Fibers in the Asia-Pacific Region
An Overview

Roy W. Hamilton

PLANT FIBERS CAN BE DIVIDED into three categories depending on their source of origin: seed, bast, or leaf. Cotton is the sole seed fiber of any importance for woven cloth. The development of seagoing trade between Europe and South Asia in the sixteenth century, the establishment of slave-labor plantations in the Americas in the seventeenth century, and the invention of the cotton gin in 1793 are among the major historical factors that led to cotton becoming the dominant plant fiber used for textiles on a worldwide basis. Today cotton represents 98 percent of the total natural plant fiber market for textiles.[1]

It is with the two other categories, bast fibers and leaf fibers, nearly forgotten in a world swathed in cotton and synthetic cloth, that this book is concerned. Bast fibers are obtained from dicotyledonous plants. Technically, the term "bast" refers to a complex tissue layer located under the bark, which serves multiple functions of fluid transport, nutrient storage, and structural support. "Phloem" and "inner bark" are approximate synonyms. The structures of the bast layer include sieve tubes (the nearly hollow pathways of the phloem that transport nutrients throughout the plant), parenchyma cells, and fiber cells. The fiber cells are grouped together in bundles or fibers. In plants that have been selected and cultivated for their fiber yield, the fibers tend to form a continuous layer under the outer bark of the plant. When processing bast, especially by hand using simple tools, weavers cannot completely remove extraneous cells. Furthermore, processing tends to break apart individual bundles of fiber cells. Therefore the "fibers" that a weaver works with are not precisely equivalent to fibers as botanical components of the plant. Typically the bast fiber is removed (either by scraping or with the assistance of retting or steaming) as a ribbon-like layer that can then be split into varying degrees of fineness according to the texture desired for the woven fabric (fig. 1.2).

Bast fibers may be taken from the herbaceous stems of annuals or perennials or from the persistent stems of woody plants. Annuals are planted anew from seed each year and harvested by pulling or cutting the entire stalk at the end of the growing season. The best-known bast fiber in the West, flax (*Linum usitatissimum*), is an annual, as are hemp (*Cannabis sativa*) and jute (*Corchorus* spp.). Ramie (*Boehmeria nivea*) is a perennial that sends out new stems each season and remains productive for several years. Bast fibers taken from persistent woody stems tend to be less well-known. Those discussed in this volume include paper mulberry and hibiscus fiber. Stems of woody plants may be left to grow for several years before the fiber is stripped off. In some cases, however, woody plants are coppiced, and only new growth is harvested annually, a procedure that somewhat blurs the distinction between herbaceous and woody bast.[2]

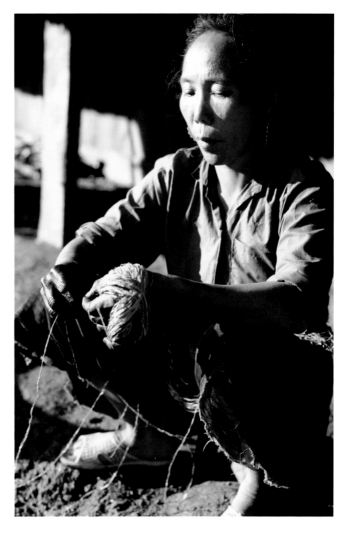

1.2 A woman with indigo-stained hands splits hemp fiber into finer strands.

Photograph by Claire Burkert, Sa Pa, Lào Cai Province, Vietnam, 1997.

Unlike bast fibers, leaf fibers are typically processed from monocotyledonous plants.[3] In most cases the fibers occur in association with the vascular bundles that transport fluids through the leaf and into the plant as a whole. Some common examples from around the world include piña (*Ananas comosus*), sisal (*Agave sisalana*), henequen (*Agave fourcroydes*), and New Zealand flax (*Phormium tenax*). The fibers taken from plants in the banana family (Musaceae) represent a special case, as they are taken not from the blades of the leaves but from the leaf base. Finally, the African leaf fiber raffia (*Raphia* spp.) is atypical in that it is processed from the surface cuticle of the leaf rather than the vascular tissues.

While the list of plants bearing usable bast or leaf fiber is quite long, most of these produce only coarse fiber used for cordage or netting. A much smaller number of plants produce fiber fine enough for weaving cloth, and the use of many of these has spread far beyond their original area of cultivation. As the laboratory identification of fibers is a highly specialized endeavor well beyond the scope of this book, our authors have identified the fibers with which they are concerned through field research in the communities where the textiles are produced, rather than in the laboratory. In some cases the correct taxonomy for closely related fibers used in different places remains problematic. Many of the written sources describing bast fibers date from the late nineteenth and early twentieth centuries when these fibers were important items of international trade. As they lost their economic importance, following the development of synthetic fiber, interest in them from a scientific point of view also waned. In few other areas of cultural studies would we be forced to rely with some frequency on hundred-year-old sources, as we do in the case of some standard references for bast fiber information (e.g., Dodge 1897; Mathews 1913). The main fiber plants discussed in this volume are briefly described below.

- *Ananas comosus* (pineapple or piña)—Fiber is processed from the leaves of this American native, which could not have been cultivated in Asia prior to the sixteenth century (see fig. 5, p. 15). Historically, its greatest importance as a textile fiber plant has been in the Philippines, but it has also been used in other countries and was once an export commodity from Singapore to China (Logan 1848, 528). Plants cultivated for fiber belong to the same species as fruiting pineapples, but the single variety grown for fiber in the Philippines, the "Red Spanish," does not bear commercially desirable fruit (Montinola 1991, 58). Piña fiber is lustrous and can be so finely split and woven that it produces a gossamer fabric. These qualities contributed to its position at the apex of fashion in the colonial Philippines.

1.3 Ramie grows lush in the warm, humid summers of Japan.
Photograph by Melissa M. Rinne, 2004.

1.4 **Summer kimono (*katabira*)**
Japan, circa 1875–1925
Ramie
146 cm
Collection of Lynn S. Gibor.

This indigo-dyed ramie kimono has "small ikat" (*kogasuri*) patterning in the warp and weft.

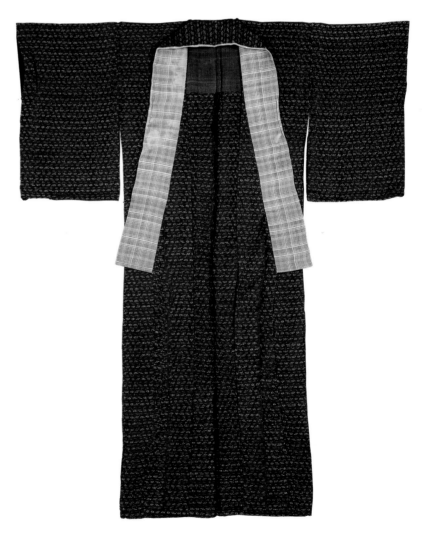

- *Boehmeria nivea* (ramie; fig. 1.3)—Chinese sources list at least five species of the genus *Boehmeria* that have been used for bast fiber (Kuhn 1988, 27), although perhaps not all for loom-woven cloth. Two varieties of *B. nivea* are recognized, *B. nivea* var. *nivea* and *B. nivea* var. *tenacissima*. The former, sometimes called "China grass," is a temperate to subtropical plant grown primarily in East Asia; while the latter, sometimes called true ramie or rhea, is a plant of the tropics (Burkill 1935, 341). J. Merritt Mathews, however, points out the impracticability of distinguishing between these two plants and considers both to be ramie (1913, 411), a practice that has been followed by more recent authors. The genus is in the nettle family (Urticaceae), and the closely related nettles have also been used as bast fiber sources, especially in Japan. The name ramie is derived from the Malay *rami*, and this fiber has been used in woven and twined textiles in Indonesia (Hamilton 1994, 114; Summerfield and Summerfield 1999, 204). Today, however, it is associated primarily with China, Korea, and Japan (fig. 1.4).

The ramie plant produces many usable stalks over a long growing season, allowing up to three cuttings a year. Hand scraping is usually required to completely remove the cortex and gums, a laborious process that has hampered the commercial development of ramie.

The cleaned fiber is strong and lustrous and can be finely split, making it suitable for high-quality textiles such as the snow-bleached ramie fabric of Niigata Prefecture in Japan (see chapter 8).

- *Broussonetia* spp. (paper mulberry; fig. 1.5)—The genus *Broussonetia*, which includes about seven species of small woody trees and shrubs native to eastern Asia, is part of the mulberry family (Moraceae). The best-known species is *B. papyrifera*, which was carried by humans across the Pacific due to its usefulness as a source of bast fiber for beaten barkcloth (the famous Polynesian *tapa* or *kapa*). Paper mulberry was formerly used for loom-woven cloth in China (Kuhn 1988, 56), and in Japan two species, *B. papyrifera* (*kōzo* in Japanese) and *B. kazinoki* (*kazinoki* in Japanese), remain in use today. Paper mulberry is also used by Ifugao weavers in the mountains of Luzon, where many variant local names are in use for several different bast fiber plants (see chapter 7). Some of these may be varieties of *B. papyrifera*, but others might well be different *Broussonetia* species or even plants from other genera.[4]

1.5 Paper mulberry (*Broussonetia papyrifera*). Reproduced from Andrews (1797, 8: pl. 488).
Courtesy of Louise M. Darling Biomedical Library, University of California. Los Angeles.

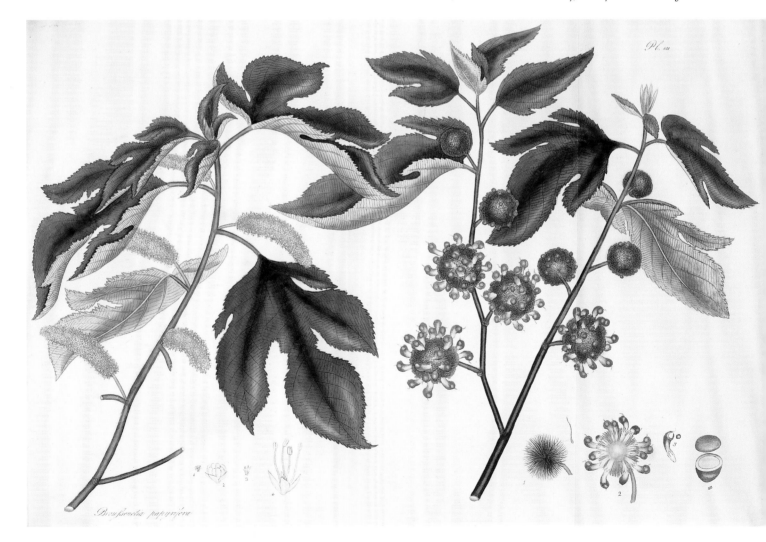

Broussonetia papyrifera

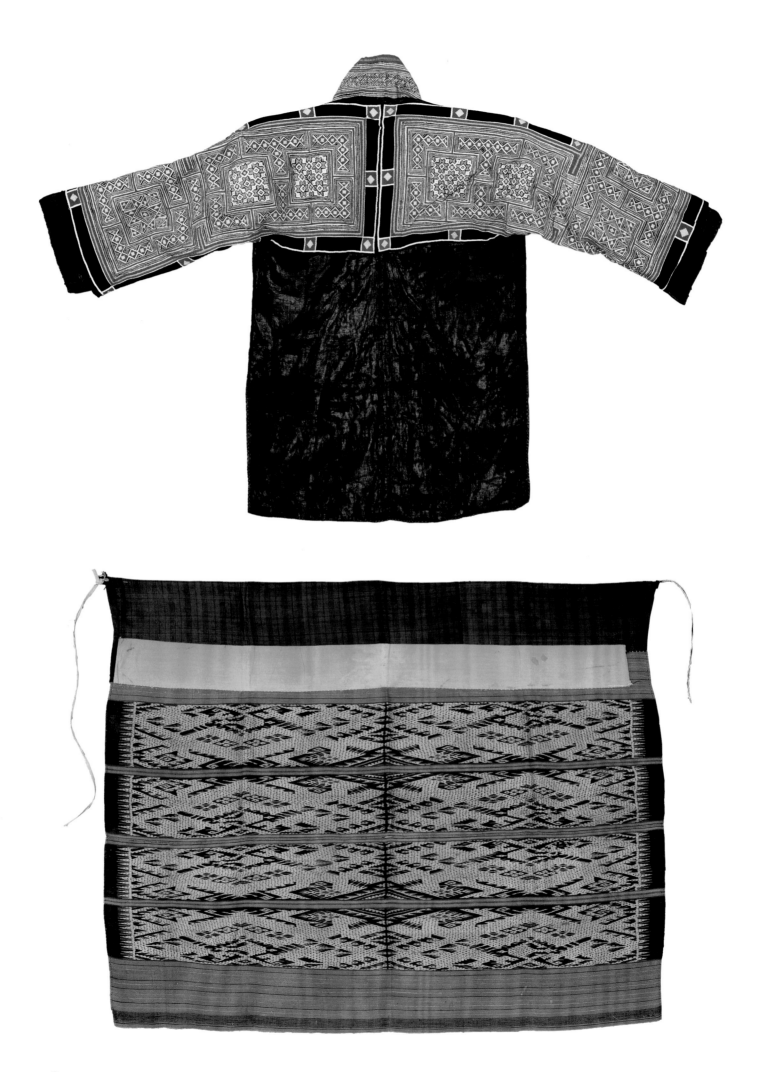

1.6　Woman's blouse
Flower Hmong peoples, Mù Cang
Chải District, Yên Bái Province,
Vietnam, late twentieth century
Hemp, cotton
139 cm
Fowler Museum X2001.5.6

The body of this blouse is made
of hemp saturated with indigo
dye. After weaving, the cloth was
polished by rubbing it with a stone.
The collar and sleeves are patterned
using the batik process, with addi-
tional cotton appliqué.

1.7　Woman's skirt (*ulap doyo*)
Benuaq peoples, East Kalimantan
(Borneo), Indonesia, mid-twentieth
century
Lemba fiber, cotton
103 cm
Fowler Museum X2002.37.13;
Gift of E. M. Bakwin

The added waistbands are com-
mercial cotton cloth, but the body
of the skirt, including the warp-
ikat patterned bands, is entirely
of *lemba* fiber.

1.8　The *lemba* plant (*Curculigo
latifolia*). Reproduced from *Curtis's
Botanical Magazine* (1818, 44–45:
pl. 2034).
Courtesy of Louise M. Darling Biomedical
Library, University of California, Los Angeles.

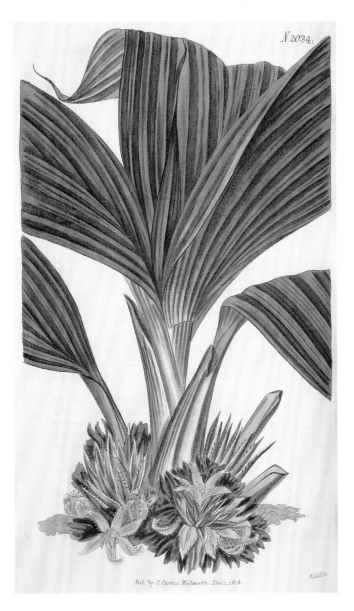

- *Cannabis sativa* (hemp)—This annual, useful medici-
nally and for oil seed, as well as for fiber, is one of the
most widespread cultigens in the world. It is the only
bast fiber that was of equal importance in Asia and
Europe. The fiber is usually processed by retting and
is not as fine or lustrous as ramie, but hemp cloth was
nevertheless widely woven in Japan, Korea, China, and
the northern parts of Southeast Asia. It tends to be rustic
in nature, employed for items of traditional dress in the
mountains of Vietnam (fig. 1.6; see also chapter 2), for
example. Elsewhere, it sometimes had specific cultural
connotations such as its use for prescribed mourning
dress in Korea (see chapter 4). Hemp cloth also has
industrial applications, such as the traditional use of
hemp bags in Japan for straining the lees in the sake-
making process. In Europe it was once used for ships'
sails, but industrially produced hemp in the West has
long been in decline, a trend that has only recently been
countered as a result of its growing popularity as an
"alternative" fabric.

- *Curculigo latifolia* (*lemba*; fig. 1.8)—This low-growing
plant with leaves resembling a miniature palm is native
to Borneo (see chapter 3). The fiber is removed from the
leaf by scraping, and it was widely used in Borneo for
cordage. Only the Benuaq people of East Kalimantan
appear to have excelled in the use of *lemba* fiber for
loom-woven cloth (fig. 1.7).

- *Hibiscus* spp. (hibiscus)—Several species of this genus
have been used for their bast fiber, many of them in the
Americas. The best-known fiber species, *Hibiscus tiliaceous*,
is a small tree native to South America and the Pacific.
Like paper mulberry, it was widely employed as a fiber
plant in the Pacific, although in most places it was valued
primarily for cordage. In Micronesia (see chapter 9), it
was commonly used as a fiber for loom weaving.

- *Musa* spp. (banana)—The taxonomy of bananas is
complicated due to the large number of local cultivars
grown for food in tropical and subtropical latitudes
around the world. The use of banana plants for fiber is
more restricted, but still covers a large geographical area
in Asia and to a lesser extent in Africa.[5] Written Chinese
sources show that that the weaving of banana fiber
textiles was well established there at least two thousand
years ago (Kuhn 1988, 48). This fiber really comes into
its own in offshore areas, however, and the weaving of
banana fiber cloth is well documented for Okinawa (fig.
1.9), Taiwan, Hainan, Mindanao, the Sangihe-Talaud
Islands (fig. 1.10), and Sulawesi. Use of the fiber also
spread into the Pacific.

　　Most older sources have designated all fiber
bananas as *Musa textilis*, perhaps more on the basis of
use than on proven botanical relationships. More
recently the fiber banana of Okinawa (see chapter 6),
known in Japanese as *ito bashō*, has been designated

Musa balbisiana.[6] No similar reclassification is available for other areas. The name *Musa textilis* is still in use, therefore, for the banana fiber of the Philippines, otherwise known as abaca or "Manila hemp," which has been the most important type of banana fiber historically as a trade commodity. In other regions, such as Micronesia (see chapter 9), there is simply no available taxonomic treatment for fiber banana plants, although local people may have a very well-developed ethnobotany describing the cultivars they grow.

Banana fiber is technically a leaf fiber, found in the "trunk" of the banana "tree" rather than in the blades of the leaves. This seeming contradiction has to do with the structure of the banana plant, the "trunk" of which actually consists of a series of inter-nesting leaf bases (figs. 1.11, 1.12). For this reason, botanists prefer to call the "trunk" a pseudo-stem. To harvest the fiber, the entire pseudo-stem is felled and the leaf bases separated one-by-one. The outer leaf bases will contain relatively coarse fiber and the inner ones finer fiber. The fiber is scraped to remove it from the surrounding tissue of the leaf base, producing wide ribbon-like strips. These can be split into any desired degree of fineness.

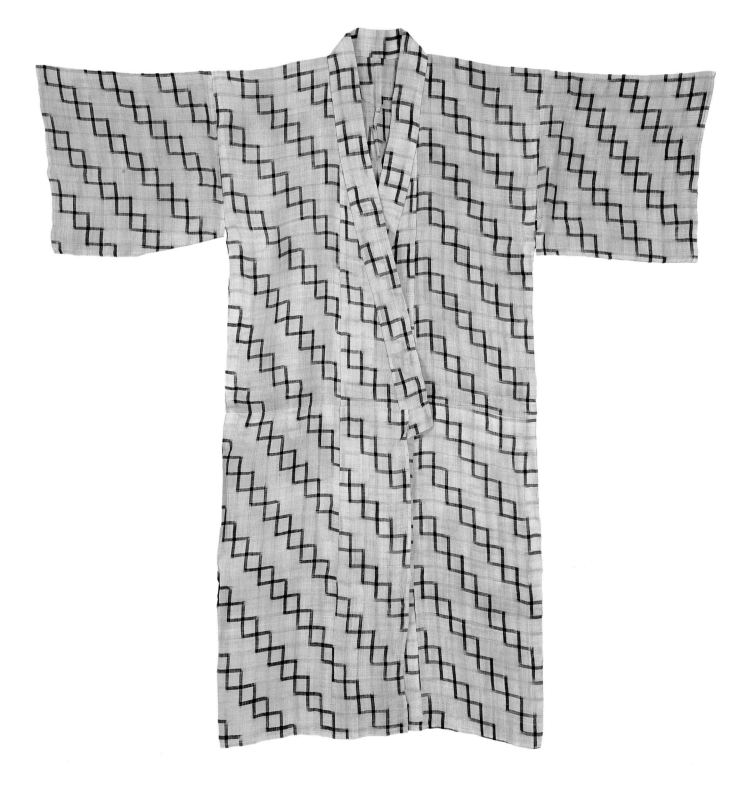

1.9 Robe
Kijoka, Okinawa Island, Okinawa
Prefecture, Japan, 1958–1960
Banana fiber
135 cm
Collection of Lynn S. Gibor.

This robe features a double-ikat
pattern known as *kumibaujo* (car-
penter's scale), which is popular in
Kijoka. The robe was made for the
Majikino Dance Group by Taira
Toshiko or one of the members of
her workshop (see chapter 6).

1.10 Curtain fragment
Sangihe-Talaud Islands, Indonesia,
nineteenth century
Banana fiber
163 cm
Fowler Museum x2002.37.168;
Gift of E. M. Bakwin

This rare textile is probably one
of three panels that once made up
a room divider or curtain. The
patterning is created with the
supplementary-weft technique,
using banana fiber yarn that has
been dyed red on an undyed banana
fiber ground. In Sangihe-Talaud,
banana fiber is known by the term
koffo, from the Minahassa language
of nearby northern Sulawesi.

• *Nelumbo nucifera* (sacred lotus)—The leaf stalks of the lotus contain fine, long fibers that can be removed only with painstaking care. In recent times, women in Burma have mastered the processing of these fibers and the weaving of lotus fiber cloth (see chapter 5). Until this became known outside of the region in the 1980s, however, there appear to have been few descriptions of the use of lotus fiber other than a couple of mythological references and brief mentions of lamp wicks made of lotus fiber and medicinal uses of lotus fiber cloth in India (Watt 1891, 5: 344). Nor do there appear to be any botanical descriptions of the fiber structures in the leaf stems of lotuses. They are presumably associated with the vascular tissues as in other leaf fibers, but the lotus is dicotyledonous, whereas the better-known sources of leaf fiber are all monocotyledons.

Although that completes the list of fibers that are discussed in this volume in detail, it is by no means a comprehensive accounting of all of the leaf or bast fibers used for loom-woven cloth in Asia. Weavers in Japan in particular have made use of a broader range of bast fibers (Yoshida and Williams 1994, 74–110). These include several types of nettles, which like ramie, are members of the nettle family (Urticaceae).[7] Bast fiber was also processed in Japan from woody plants including

Manchurian elm (*Ulmus laciniata*; fig. 1.13) and Japanese linden (*Tilia japonica*) and from two vining plants, silky wisteria (*Wisteria brachybotrys*; figs. 1.14–1.16) and kudzu (*Pueraria montana* var. *lobata*).[8] The use of some, if not all, of these fibers in Japan had precedents in China and Korea. As many other plants were used for cordage in these countries, and an even wider range of plant fibers was used in Southeast Asia, it is more than likely that some of them were employed from time to time or in limited localities for loom-woven cloth.

No matter what their source, certain similarities apply to all of these leaf and bast fibers as they are used in Asia and the Pacific. In Europe, the preference was to spin bast fibers into yarn in essentially the same manner that wool and cotton were spun. As anyone who has tried spinning flax can attest, this is no easy task as the bast fiber lacks the ideal short staple and wooly texture that make the spinning of cotton or wool progress readily. Flax and hemp can be spun with difficulty in this manner after the fiber is suitably prepared, and for this reason, these were the only bast fibers that were widely used by home weavers in Europe. The Asian solution was fundamentally different. Rather than spinning the individual fibers into yarn, Asian women (and historically this has almost always been women's work, as was spinning in Europe) formed a continuous yarn by individually knotting, twisting, or splicing each successive length of fiber to the next (fig. 1.17).[9] This would

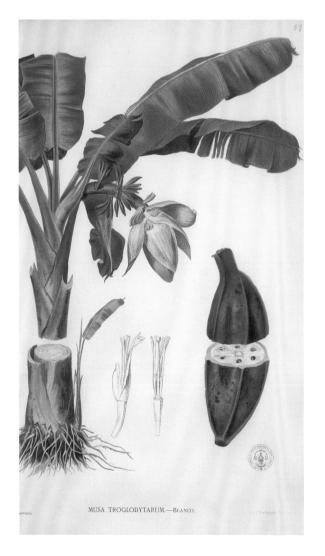

MUSA TROGLODYTARUM.—BLANCO.

1.11 This botanical print of a banana plant clearly shows how the pseudo-stem is composed of inter-nested layers of leaf bases. Reproduced from Blanco (1877, 1: pl. 89).

Courtesy of Bancroft Library, University of California, Berkeley.

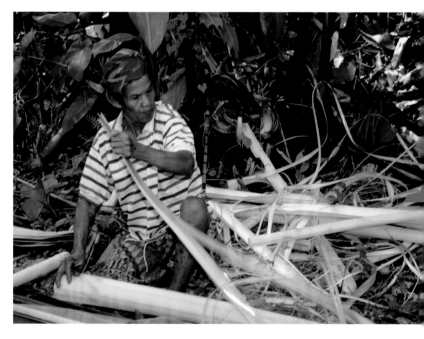

1.12 A T'boli man strips a layer of fiber from a leaf base of a banana plant. He has gradually worked his way toward the center of the felled pseudo-stem, or "trunk," of the plant, and only the inner core of leaf bases remains intact in front of him. Debris from the outer layers of leaf bases, from which he has removed the fiber, lies behind him.

Photograph by Roy W. Hamilton, Lake Sebu, Mindanao, Philippines, 1998.

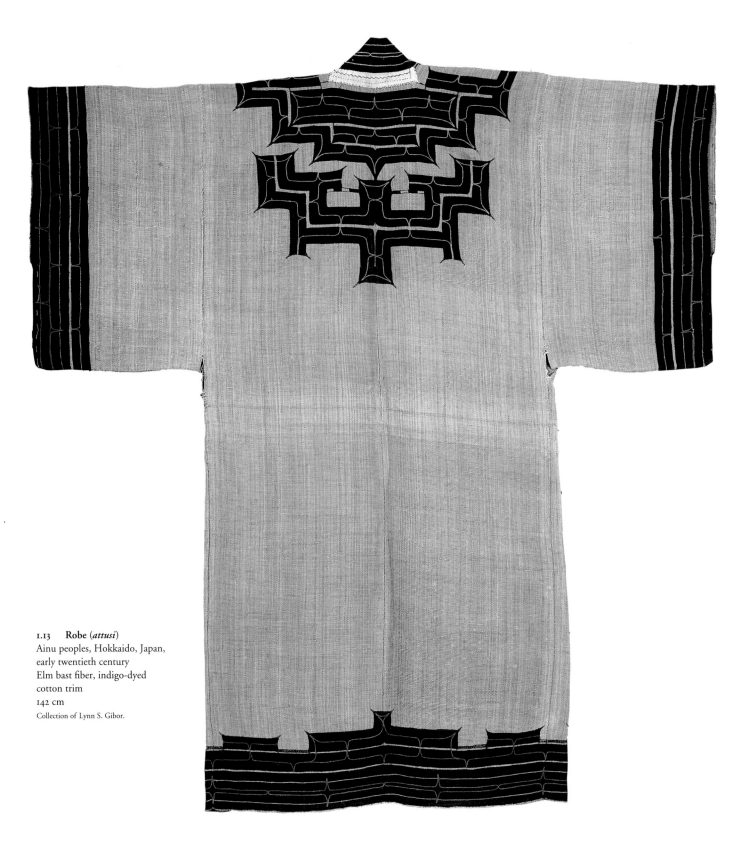

1.13 Robe (*attusi*)
Ainu peoples, Hokkaido, Japan,
early twentieth century
Elm bast fiber, indigo-dyed
cotton trim
142 cm
Collection of Lynn S. Gibor.

have been impossible with short fibers like cotton, but with the relatively longer length of leaf or bast fibers (up to several feet in the case of banana fiber), this method is practicable though painstaking.

Japanese authors Gorō Nagano and Nobuko Hiroi have conducted extensive studies of the ways in which bast and leaf fibers are handled in Asia (1999). They point out that the women who process the plant material always keep the fibers in their proper orientation "from base to tip"; in other words, the fibers are always oriented in the same direction. This basic procedure aids in each step of the process, from splitting the fibers into finer strands, sometimes with the aid of some kind of combing device, to forming a continuous filament. Experienced women can join one fiber to the next with great speed, and so precisely that it is typically difficult to detect any knot, twist, or splice in the finished cloth without a magnifying device, though there are, of necessity, many thousands of them in a single loom-length of cloth.[10]

Bast and leaf fibers also share certain textural and aesthetic qualities. The finished fabric tends to be somewhat stiff or "crisp," a characteristic often considered desirable in hot, humid climates. This was the reason for the popularity of ramie or banana fiber garments for summer wear in Japan and China, whereas cotton or silk was preferred for winter. Leaf and bast fibers are stronger than cotton or protein fibers and typically do not lose their strength when wet (which is why "Manila hemp" was the internationally desired fiber for marine roping). From the point of view of aesthetics, most leaf and bast fibers have an appealing, warm cream to golden tone in their natural state, and some of them (notably piña, ramie, and banana fiber) can have a lustrous sheen nearly comparable to that of silk. Dyeing leaf and bast fibers presents a challenge. As they are more difficult to dye than silk, wool, or even cotton, they are often simply left in their natural state. In other cases, considerable effort has been expended to create saturated colors (see, for example, fig. 1.6). Many of the most ingeniously patterned bast fiber textiles rely on various resist-dye processes (figs. 1.18–1.21). These aesthetic characteristics of bast fiber cloth play a role in their suitability as bearers of identity and ultimately in their survival in the modern world.

1.14 The outer bark and bast fiber layer are stripped off together from the core of a wisteria vine.
Photograph by Melissa M. Rinne, Kamiseya, Kyoto Prefecture, Japan, 1994.

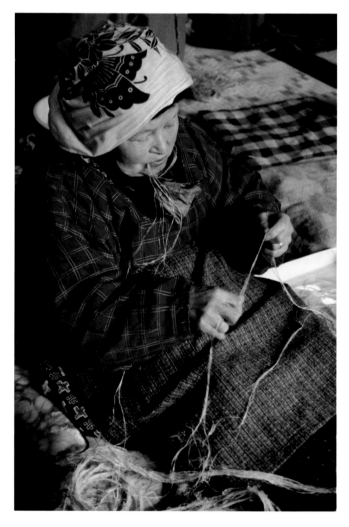

1.15 Japanese weaver Mizuno Tame splits wisteria fiber by hand into finer strands.
Photograph by Melissa M. Rinne, Kamiseya, Kyoto Prefecture, Japan, 1994.

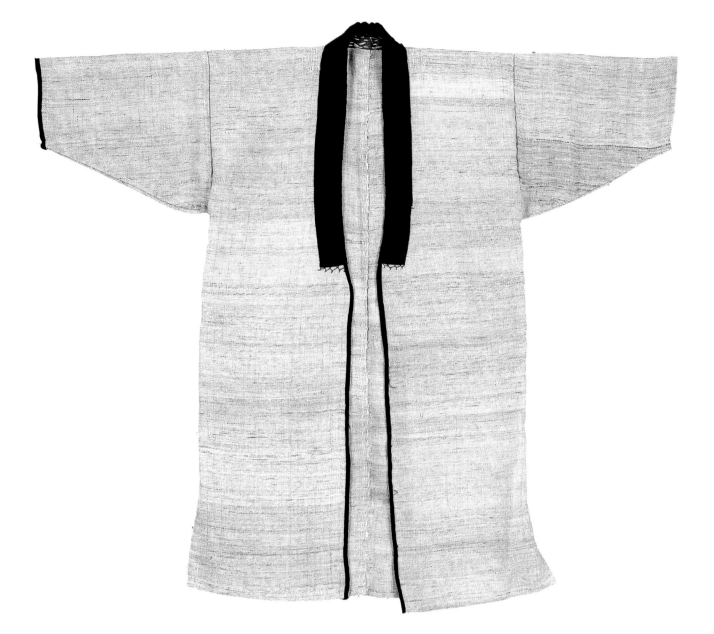

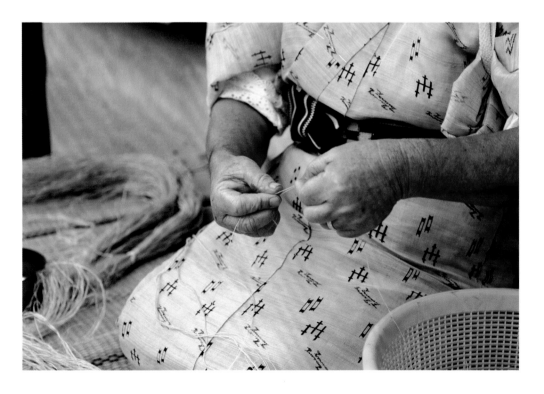

1.16 Robe
Japan, mid-twentieth century
Wisteria bast fiber, indigo-dyed
cotton trim
128 cm
Collection of Lynn S. Gibor.

1.17 The late Yonemori Tokuko,
dressed in a banana fiber kimono,
splices strands of ramie yarn
together to make a continuous
thread. Both ramie and banana fiber
weaving are practiced in Okinawa.

Photograph by Amanda Mayer Stinchecum.
Maezato Village, Ishizaki Island, Okinawa
Prefecture, Japan, 1983.

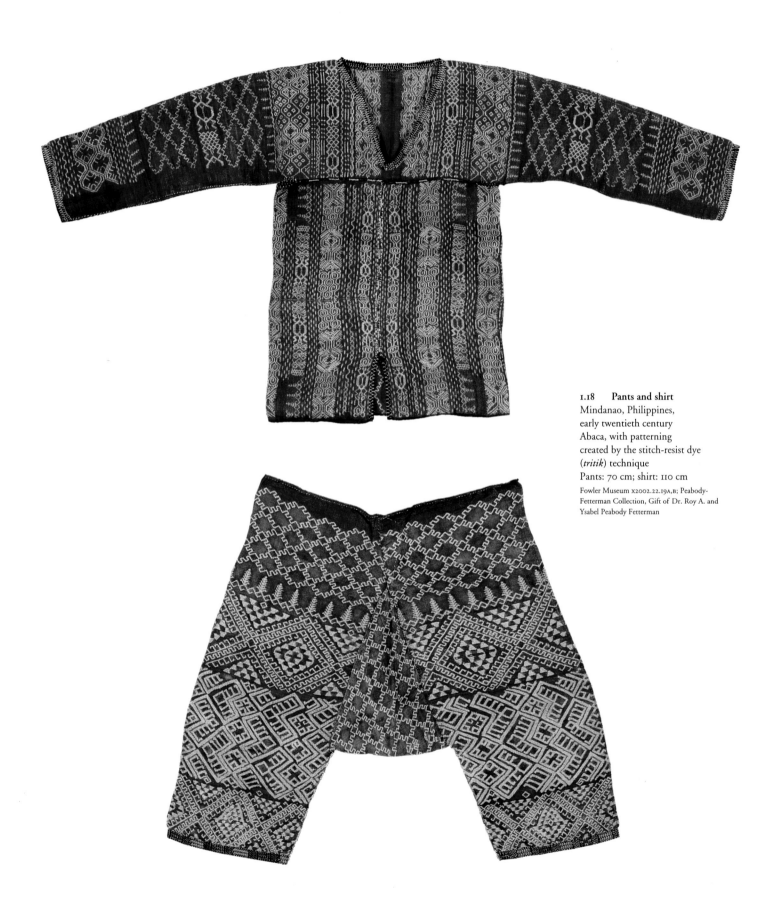

1.18 Pants and shirt
Mindanao, Philippines,
early twentieth century
Abaca, with patterning
created by the stitch-resist dye
(*tritik*) technique
Pants: 70 cm; shirt: 110 cm

Fowler Museum X2002.22.19A,B; Peabody-
Fetterman Collection, Gift of Dr. Roy A. and
Ysabel Peabody Fetterman

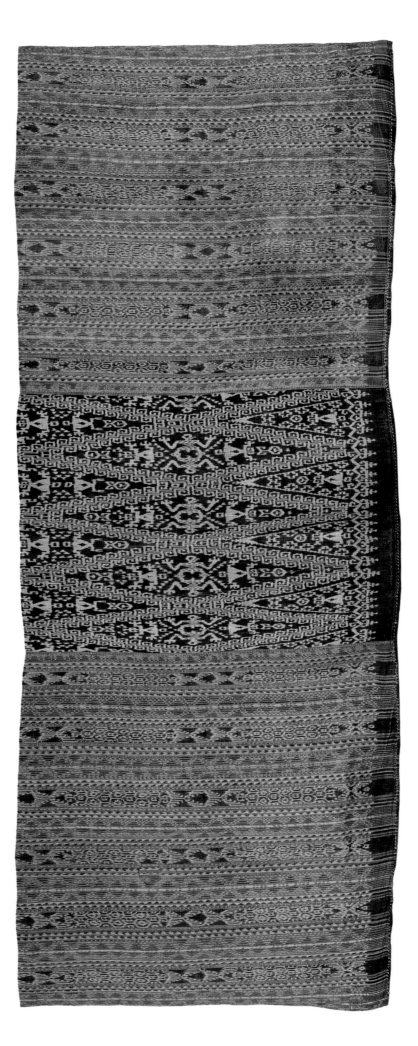

1.19 Woman's tube skirt
Bagobo peoples, Mindanao,
Philippines, early twentieth century
Abaca, with patterning created by
the warp-ikat technique
193 cm

Fowler Museum x96.1.9; Peabody-Barker
Collection, Gift of Ventura County Museum
of History and Art

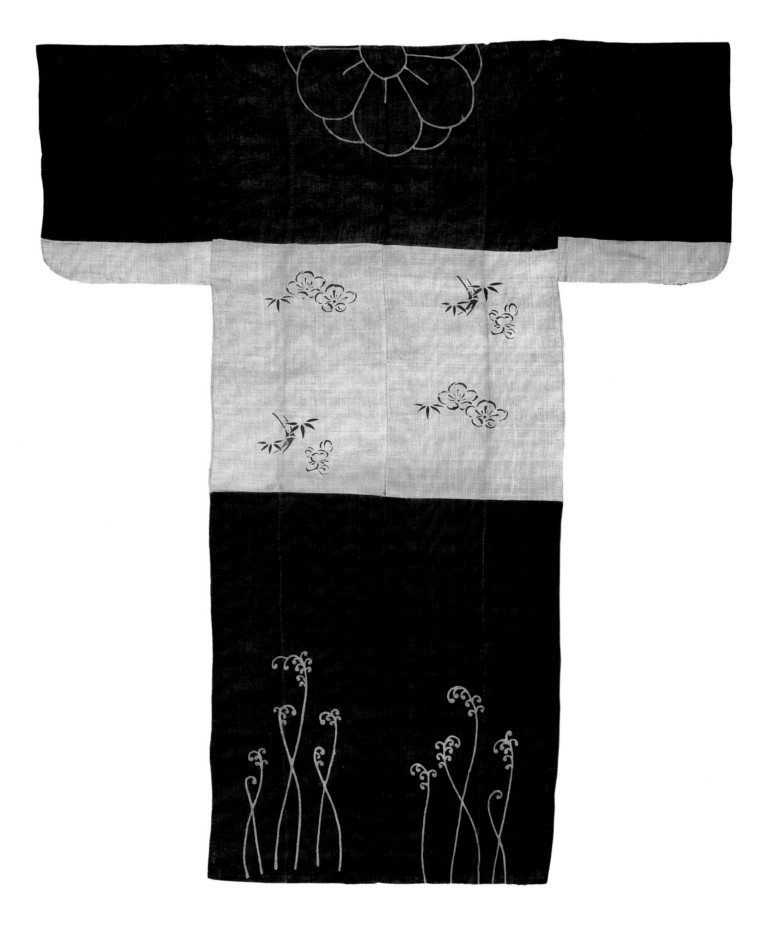

1.20 Woman's veil (*kazuki*)
Northern Honshu, Japan, late Edo
period (1600–1868)
Ramie
152 cm
Fowler Museum x2000.28.1

The fern-shoot pattern at the
bottom of this veil was created using
the freehand paste-resist technique
(*tsutsugaki*) with rice paste applied
with a cone that resembles a cake-
decoration tube. The patterns in the
lighter center panel, however, were
created using a stencil technique
(*katazome*) to apply the paste (Mori-
oka and Rathbun 1993, 138–39).

1.21 Wrapping cloth (*uchikui*)
Okinawa Island, Okinawa Prefecture,
Japan, late nineteenth century
Ramie
118 cm
Fowler Museum x86.4436; Gift of Dr. and Mrs.
Harvey Gonick

This wrapping cloth is dyed using a
hand-drawn paste-resist technique
that is similar to Japanese *tsutsugaki*
and is known as *nuifichi* in Okinawa.
The motif, *sho-chiku-bai* (pine,
bamboo, plum), is executed in a
circular format that is characteristic
of Okinawa. The characters in one
corner indicate the name of the
original owner.

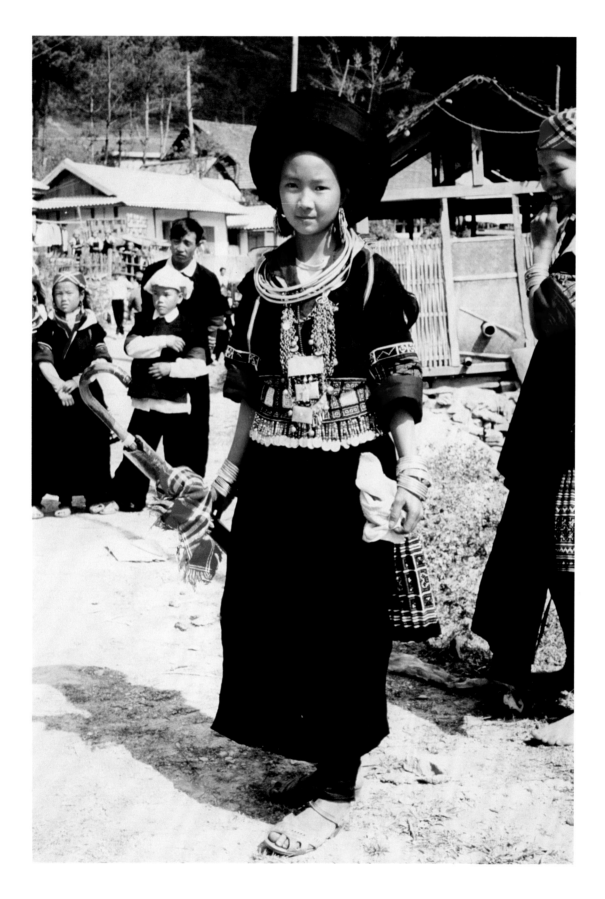

2. Hemp Textiles of the Hmong in Vietnam

Trần Thị Thu Thủy

THE HMONG PEOPLES BEGAN MIGRATING into Vietnam from southern China in the eighteenth century and subsequently established themselves in the border regions of Laos, Thailand, and Burma as well. In China they are recognized as a subgroup of a larger population known as the Miao.[1] The census of 1999 identified 787,604 Hmong in Vietnam. They typically live on steep, high mountains in the northernmost provinces and as far south as the northern part of central Vietnam.[2] Various Hmong groups practice both shifting cultivation of dry hillside fields and permanent farming of irrigated rice terraces. They live in village communities in houses built on the ground, and while the village defines the basic community, lineage and clan membership are for many purposes considered more important. These social and economic patterns coupled with differences in language and dress distinguish the Hmong from the fifty-three other officially recognized ethnic groups in Vietnam.

Within Vietnam the Hmong are divided into the following subgroups: Black Hmong (Hmôngz Đuz), White Hmong (Hmôngz Đơưz), Green Hmong (Hmôngz Njuôz), Flower Hmong (Hmôngz Lênhl), Red Hmong (Hmôngz Siz), Chinese Hmong (Hmôngz Suar), and Na Miảo.[3] A Hmong legend claims that the present-day subgroups were first created after the collapse of a Hmong Kingdom, when the Chinese ordered the Hmong to wear clothes of different colors. Those required to wear black clothes were called the Black Hmong, those who wore white clothes were called the White Hmong, and so on. This legend makes evident the importance of textiles and dress in subgroup identity, but as a classification system, it is not entirely consistent.[4]

Although the named Hmong subgroups demonstrate obvious differences in language and dress, the Hmong themselves do not attribute much importance to these groupings. Membership in named clans is far more important to them. The "family" name of a Hmong individual is in fact his or her clan name. Each clan has its own leader, its own laws, and its own manner of worshipping ancestors. Some of the most important Hmong social practices are played out within the clan system. Hmong peoples are, for example, expected to be born and to die in a house belonging to their clan. When a young woman marries, she becomes a member of her husband's clan. If she is pregnant and returns to the home of her parents for a visit, she must not give birth there. In cases of extreme emergency, her parents may be required to build a special small house in which her baby can be born.

HMONG TEXTILE TRADITIONS

Although recent archaeological finds indicate that people in the northern delta of Vietnam were using hemp cloth two thousand years ago, only the Hmong currently rely primarily on hemp fiber for their most important garments. This is true for all Hmong subgroups except the Chinese Hmong and the Na Miảo, who make their traditional garments of cotton. The basic forms of the garments are similar among all of the Hmong subgroups, but differences in color and design serve to distinguish them. As elsewhere in Southeast Asia, textiles play an extremely important role in Hmong culture. The only heirlooms a young woman takes into her marriage are textiles and jewelry. Her taste and upbringing are judged by their number and quality. Prior to her wedding she has to weave cloth and make garments for herself and her parents, and in her married life she does the same for her parents-in-law, her husband, and her children.

This essay will focus on the textiles of one Flower Hmong group from Mù Cang Chải District, in western Yên Bái Province (figs. 2.2, 2.3).[5] This district has the highest concentration of Hmong in Vietnam. Given a total district population of 38,267 people, over 90 percent are Hmong. The local Hmong population includes four of the subgroups: Flower Hmong, Red Hmong, Black Hmong, and White Hmong. Sixty percent are Flower Hmong, and thirty percent are Red Hmong, according to the census of 1999.[6] I have elected to focus upon the Flower Hmong of Mù Cang Chải District because they employ the widest range of decorative techniques in their textiles and maintain more of their textile and dress traditions than other groups (fig. 2.4).

In recent years, Hmong dress within Vietnam has undergone the most rapid change in the border areas near China. The availability of Chinese woolen and synthetic yarns and industrially printed, imitation batik cloth, also imported from China, in border markets is largely responsible for this. Mù Cang Chải District, however, lies deeper within Vietnam and does not share a border with China, so the pace of change has been slower there. The women of each Flower Hmong village in Mù Cang Chải still grow hemp plants, weave hemp cloth, and practice the decorative techniques of batik, embroidery, and appliqué. The presence of three other Hmong subgroups in the district also makes Mù Cang Chải an ideal research site for comparing differences in dress among the subgroups.

2.1 A Flower Hmong woman wears a traditional blouse, skirt, apron, waistband, and headdress.
Photograph by Trần Thị Thu Thủy, Mù Cang Chải District, Yên Bái Province, 1998.

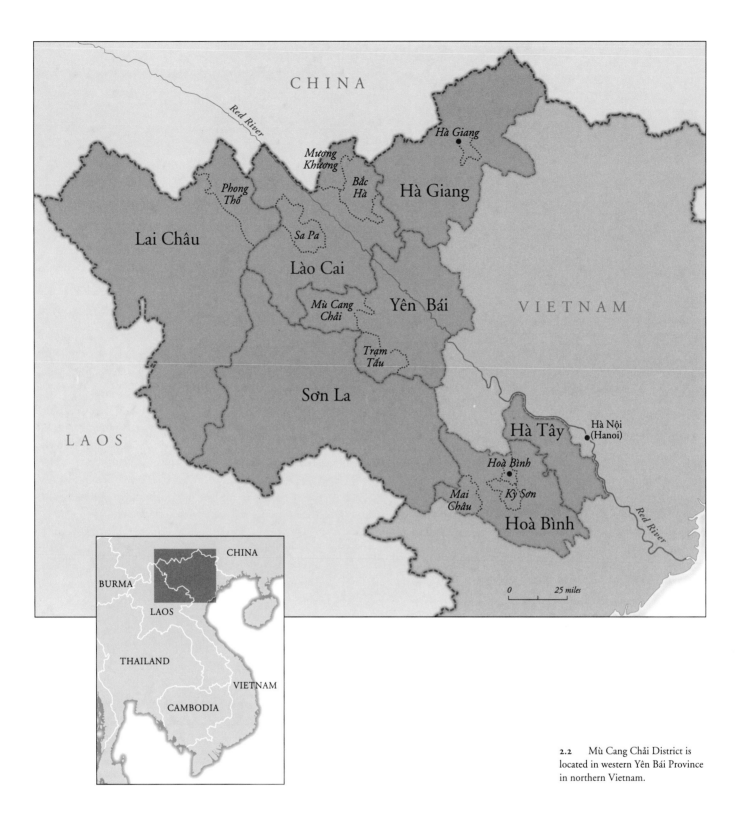

CHINA

Red River

Mường Khương

Phong Thổ

Bắc Hà

Hà Giang

Hà Giang

Lai Châu

Sa Pa

Lào Cai

Mù Cang Chải

Yên Bái

VIETNAM

Trạm Tấu

Sơn La

Hà Tây

Hà Nội (Hanoi)

LAOS

Hoà Bình

Kỳ Sơn

Mai Châu

Hoà Bình

Red River

0 25 miles

CHINA

BURMA

LAOS

THAILAND

VIETNAM

CAMBODIA

2.2 Mù Cang Chải District is located in western Yên Bái Province in northern Vietnam.

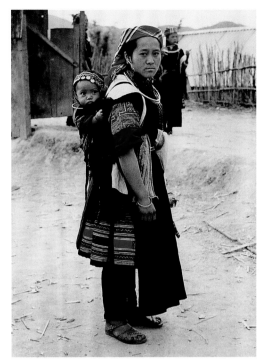

2.3 Hmong farmers transplant rice in a terraced landscape.

Photograph by Trần Thị Thu Thủy, Mù Cang Chải District, Yên Bái Province, 2000.

2.4 A Flower Hmong woman from Mù Cang Chải District wears traditional hemp dress.

Photograph by Võ Mai Phương, Yên Bái Province, 1997

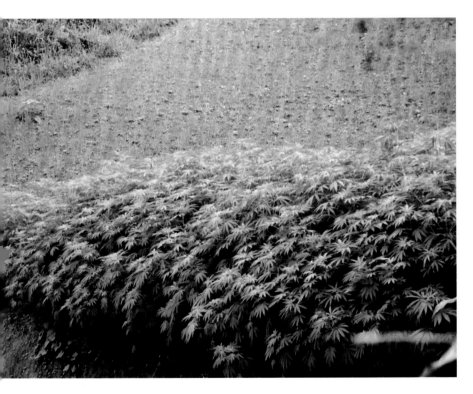

2.5 This hemp field, surrounded by a planting of dry hillside rice, was photographed ten days before harvest.

Photograph by Trần Thị Thu Thủy, Mù Cang Chải District, Yên Bái Province, 2000.

2.6 The bundles of hemp stalks are brought into the house after being exposed to the dew overnight.

Photograph by Trần Thị Thu Thủy, Mù Cang Chải District, Yên Bái Province, 2000

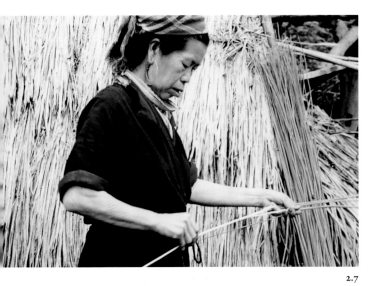

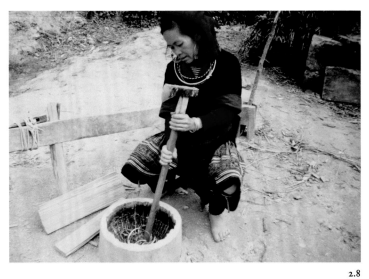

2.7

2.8

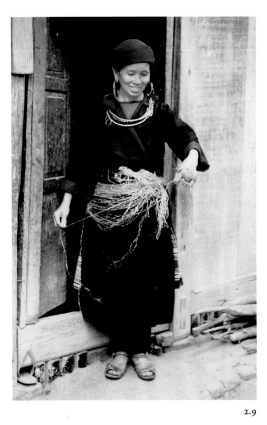

2.10

2.9

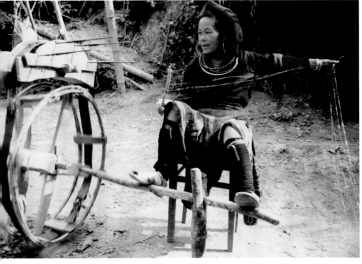

2.11

2.12

HEMP FROM FIELD TO CLOTH

Typical altitudes in Mù Cang Chải District range from 800 to 1200 meters with the highest peak reaching 2771 meters. The rainy season stretches from April to September, and the heaviest rain occurs in June and July. The dry season, which runs from October to March, occasionally brings frost or snow in the coldest months. This climate is not well suited for growing cotton or raising silkworms, but hemp thrives in the warm, moist summers. Warm in the winter and cool in the summer, garments of hemp cloth are well suited to the region, and they are very durable for work in the high mountains.

The ideal hemp field is situated close to the village, receives ample sunlight, and is protected from strong winds (fig. 2.5). Hemp must be planted densely to discourage branching of the stalks. This ensures that the plants will produce long fibers. Depending on the weather, the hemp will be planted from mid-February to mid-March, and the harvest will take place in June or July. Hmong farmers rely upon certain traditional practices to determine a good day for planting hemp seed. They may, for example, scatter seed from the middle to the end of the month but never at the beginning. The seed will germinate within three days.

At harvest time, Hmong women choose a sunny day to cut the hemp stalks (*mangx*) and tie them into small bundles. The leaves are removed, and the stalks are dried in the sun for three or four days. During the night they are carried into the house. Following this, the stalks are exposed to the dew for two nights and carried into the house during the day (fig. 2.6). Finally, they are dried one additional day in the sun.

Before the arrival of the winter wind from the north, the stalks must be processed into fiber (*ntuôs*). If this is not done in a timely manner, the resulting fiber will be dry, less durable, and difficult to twist. The processing is done by hand, and women break the hemp stalks in the middle and pull off the outer layer, which contains the hemp fiber (fig. 2.7). The

remaining stalk is discarded. The loose fiber is tied into small bunches and pounded in a mortar for about half an hour (fig. 2.8). This makes the fiber stronger and more flexible, decreasing the likelihood of tangling. Next the worker wraps the mass of loose fiber around her waist, and drawing one strand of fiber at a time, she begins the work of joining the individual fibers into a continuous length (fig. 2.9). The individual lengths of fibers are joined end-to-end with a simple twist rather than a full knot. Hmong women can often be seen beside their fields, along the roads, or in marketplaces performing this work during spare moments.

The resulting continuous filament is wound loosely by hand into balls (fig. 2.10). Using a large wheel turned by foot (*yuôz mangx*), additional twist is applied to the filament to transform it into a strong and flexible continuous yarn (fig. 2.11). Next the yarn is wound into balls and bleached by boiling it in a lye solution made of ash and water (fig. 2.12). After each boiling, the fiber is covered with ash, wrapped in a cloth, and set near the fire to keep it warm for three days. Then it is brought to a nearby stream to be washed (fig. 2.13), formed into skeins (*khâuz lis*), and dried in the sun (see fig. 2, p. 11). The boiling and warm ash treatment is repeated two more times, but the last time the yarn is wrapped and kept warm for only one day and one night. Some beeswax is added to the last boiling to make the yarn smoother and more durable. To make it softer, it is pressed under the weight of a heavy wooden roller (see fig. 2.29). Finally the bleached and waxed yarn (*xur*) is wound onto bobbins using a small hand-turned wheel (*yuôz cxâu xur*; fig. 2.14), after which it is ready for weaving.

The Hmong use a body-tension (or back-strap) loom (*ndêx ntuk*). A long warp is wound onto the warp beam, which is mounted between two upright wooden posts about 150 centimeters tall (fig. 2.15). The cloth beam, instead of being fixed to a frame as in the Tai or Muong frame loom, is attached to the back strap. The weaver sits on a bench and applies tension to

2.7 A woman breaks the hemp stalks in the middle in order to pull off the outer layer containing the hemp fiber.
Photograph by Trần Thị Thu Thủy, Mù Cang Chải District, Yên Bái Province, 1997.

2.8 The loose hemp fiber is tied into small bunches and pounded in a mortar for about half an hour. This eliminates knots and makes the fiber stronger and easier to twist.
Photograph by Trần Thị Thu Thủy, Mù Cang Chải District, Yên Bái Province, 1997.

2.9 A Hmong woman ties loose hemp fiber around her waist. She will draw forth one strand at a time and join the individual fibers end to end.
Photograph by Trần Thị Thu Thủy, Mù Cang Chải District, Yên Bái Province, 1997.

2.10 The continuous filament is wound by hand into loose rolls.
Photograph by Võ Mai Phương, Mù Cang Chải District, Yên Bái Province, 1997.

2.11 Drawing the fiber from rolls, strands are twisted using a large wheel turned by foot.
Photograph by Trần Thị Thu Thủy, Mù Cang Chải District, Yên Bái Province, 1997.

2.12 The rolls of hemp yarn are boiled three times in water mixed with ash for a period of between thirty and sixty minutes. Four or five rolls are boiled at a time.
Photograph by Trần Thị Thu Thủy, Mù Cang Chải District, Yên Bái Province, 1997.

2.13 The fiber is brought to a nearby stream to be washed.
Photograph by Trần Thị Thu Thủy, Mù Cang Chải District, Yên Bái Province, 1997.

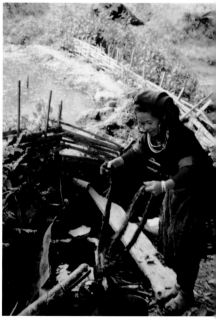

2.13

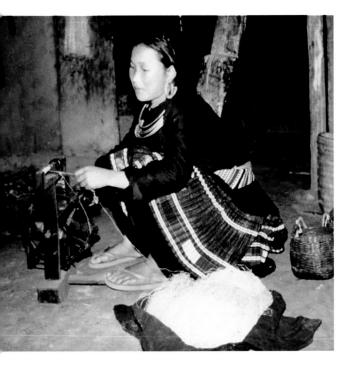

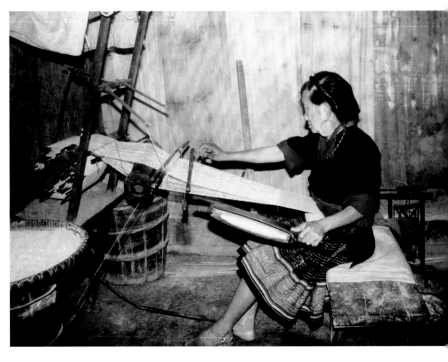

2.14 The bleached and waxed
yarn is wound onto bobbins using
a small hand-turned wheel.

Photograph by Trần Thị Thu Thủy, Mù Cang
Chải District, Yên Bái Province, 1998.

2.15 A Hmong woman weaves on
a body-tension loom.

Photograph by Trần Thị Thu Thủy, Mù Cang
Chải District, Yên Bái Province, 1997.

2.16 The hemp cloth is dyed in
a vat of indigo.

Photograph by Trần Thị Thu Thủy, Mù Cang
Chải District, Yên Bái Province, 1997.

2.17 A Hmong woman dries the
hemp cloth after dyeing.

Photograph by Trần Thị Thu Thủy, Mù Cang
Chải District, Yên Bái Province, 1997.

the warp by leaning back against the back strap, which is often made of water buffalo hide. The Hmong loom has no foot treadle to raise and lower the heddles. Instead, a rope tied around the leg of the weaver is used to activate a lever that raises the heddles. When the weaver pulls her foot back, the heddles are raised; to lower the heddles, she slides her foot forward. This system is identical to that used by Pathen and San Chay weavers in highland Vietnam and was widespread elsewhere in Asia as well (Korean and Japanese examples are published in Broudy 1979, 114; Roth 1977, 93; and Nagano and Hiroi 1999, fig. 40).

This type of loom is very practical for Hmong weavers who engage in shifting cultivation, because it is easy to transport as they move from place to place. The women can weave any time they are free, but they normally concentrate this activity in September. At this time of year the new crop of hemp fiber has been processed, labor is not much needed in the rice fields, and new garments can be prepared for the upcoming New Year Festival in late November or early December (as determined by the lunar calendar). The women weave inside or outdoors depending on the weather. When using the loom indoors, the weaver has to tie the warp beam to a post inside the home; outside, the loom may be attached to a tripod.

DYEING AND DECORATION

Indigo (*gangx*) is by far the most important dye of the Hmong, and it is used to give most of the hemp cloth they weave a blue-black color. Hmong dyers make use of three different kinds of indigo: big leaf indigo (*Strobilanthes cusia*), small leaf indigo,[7] and wild indigo (*Indigofera galegoides*). The indigo is planted in February or March and harvested in July or August. After the harvest, the stalks and leaves of the indigo plants are put into a large wooden bucket of boiled water that has been cooled, and they are allowed to ferment for three to five days. When the fermentation is completed, a lye solution is made by mixing ash and lime with water. When the lye is mixed with the fermented indigo liquid, indigo solids settle to the bottom. The water is poured off and a basket or a cloth is used to filter out the indigo paste. This condensed paste will keep for up to one year.

There is an alternative, although less-common, method for making indigo paste. The indigo plants are cleaned and put into a bucket of water for about a week. Then the old plant matter is removed and fresh indigo plants are put into the bucket. A little rice wine is added, and the bucket is left to ferment for about two weeks. Eventually, a black precipitate appears at the bottom of the bucket. When the water is poured off, the indigo paste remains.

Whichever method is used, the dye vat is prepared by mixing some of the indigo paste with a little rice wine in a bucket of water. Bubbles rising to the surface indicate that fermentation is underway (this creates the oxygen reduction necessary for indigo vat dyeing). Hmong women test the dye by tasting it (which gives an idea of the state of fermentation) and judging its color (they look for a chocolate color with yellow sheen in the surface bubbles). If they are not satisfied with the appearance, they prepare a porridge from four ounces of sticky rice cooked with three or four branches of red leaf indigo (*gangx laz*) cut in small pieces. This mixture is then added to the indigo bucket and stirred until the proper coloration appears. The cloth is prepared for dyeing by first soaking it in plain water. The cloth is then placed in the dye vat and allowed to soak near the warmth of the fire overnight (fig. 2.16). If the cloth has not properly taken the dye, another cup of wine is added. In the morning the cloth is rinsed and dried (fig. 2.17). This process is repeated eight to ten times, and the color deepens with each immersion until it is nearly black.

The Hmong use indigo to dye most of their plain cloth and also for batik cloth, both of which are made from hemp. Other colors are reserved primarily for dyeing silk embroidery thread. Although, as noted, the high altitude of Hmong regions is not ideal for raising silkworms, Hmong communities produce enough silk for this limited use. In recent times synthetic dyes purchased in markets have been used to dye silk thread. Natural dye is currently used for yellow only. This yellow dye is made from the roots of a tree known as *hmăngz dăngx*. The roots are cut into very small pieces and boiled in water. When water has boiled down to become a thick liquid, it is filtered through a piece of cloth, and the bits of root are discarded. The liquid that remains is the dye. To dye silk embroidery yarn, the dye is mixed with water, and the yarn is soaked in this mixture for two days.

According to legend, when the Hmong lived in China, they had their own kingdom and their own alphabet. When the Chinese invaded the Hmong Kingdom, they burned Hmong books and began killing the population, thus forcing the Hmong to flee from the fertile lowlands to the high mountains. While escaping from the Chinese, the Hmong king encountered a Hmong woman weaving beside a stream and was inspired to save the Hmong alphabet by painting its letters on her skirt. It is thus that Hmong women came to adorn their skirts. Unfortunately, however, because the general populace was illiterate, the meaning of the "letters" was lost. Although only a legend, this account contains some historical truths regarding the relationship between the Chinese and the Hmong.

Flower Hmong women use three different techniques to decorate cloth: batik, embroidery, and appliqué. All three techniques are typically combined on the same garment. The Flower Hmong are perhaps the only group in Vietnam to use such an exuberant decorative scheme, which they apply to women's skirts, blouses, and vests. Women's waistbands are decorated solely with embroidery. Women's aprons, belts, leggings, headdresses, and all men's everyday garments are plain.

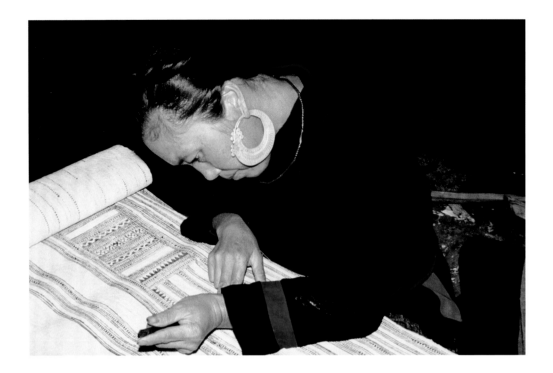

2.18 A Hmong woman draws elaborate motifs in beeswax on cloth.

Photograph by Trần Thị Thu Thủy, Mù Cang Chải District, Yên Bái Province, 2000.

2.19 This design has been drawn on cloth with beeswax prior to dyeing.

Photograph by Trần Thị Thu Thủy, Mù Cang Chải District, Yên Bái Province, 1998.

2.20 After the cloth is dyed, it is boiled to remove the wax. The design is then revealed, in this case featuring a snail motif.

Photograph by Trần Thị Thu Thủy, Mù Cang Chải District, Yên Bái Province, 1998.

· Batik (*Đrăngx Lâus*)

Batik patterns are drawn on cloth with melted wax, using a pen-like tool (*dar đrăngx lâus*). The point of the pen is constructed from a piece of copper folded into a spout and attached to a piece of bamboo. This copper spout acts as a reservoir to hold the hot wax. When it is applied to the cloth, intricate designs can be drawn with the wax (fig. 2.18). When the wax pattern is completed (fig. 2.19), the cloth is dipped numerous times into vats of indigo. The portions of the cloth not covered with wax are dyed a dark, rich blue. The cloth is then boiled, and the wax melts away, revealing the drawn design in white against the indigo blue background (fig. 2.20). If yellow motifs are desired, the white motifs may be painted over with yellow dye. Depending on the type of decorative motifs desired, the size of the pen will vary: small pens are used for flowers; medium pens for fringe design; large pens for straight lines, circles, and spirals. Most Hmong patterns consist of rows of small motifs, and the most important of these is a spiral. The Hmong describe this as a snail motif and relate it to legends concerning their history (see fig. 2.20). Other common motifs include the calabash flower, fern, pine, mountain, butterfly, star, sleeping dog, dog footprint, skein, and bean or rice

· Embroidery (*Uô Lâus*)

Hmong women produce their own silk thread (*xur cangz*), which is favored for embroidery because of its beauty and durability (fig. 2.21). A Hmong woman can create numerous embroidery patterns from memory. She always carries her embroidery thread with her and will embroider at any free moment (fig. 2.22). The most common cross-stitch motifs are the silkworm, skein, snail, mattock, and rack. The most beautiful women's blouses and vests are additionally decorated with chain stitching (fig. 2.23). This time-consuming technique is highly admired and is often found on blouses and vests intended as funeral clothing for the deceased.

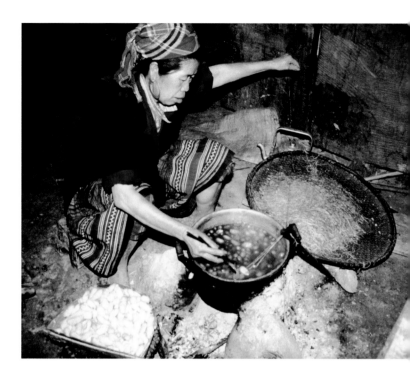

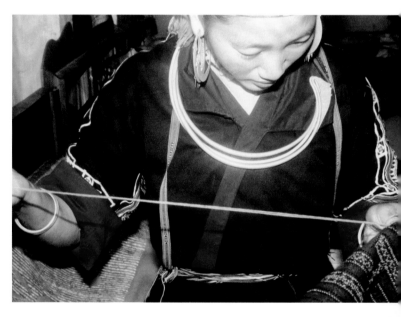

2.21 A Hmong woman reels silk thread to be used later for embroidery. The cocoons are simmered in water to soften the gum, allowing the individual filaments of silk to be unwound. Filaments from several cocoons are reeled together to form a stronger thread.

Photograph by Trần Thị Thu Thủy, Mù Cang Chải District, Yên Bái Province, 2000

2.22 A Hmong woman embroiders during a free moment.

Photograph by Trần Thị Thu Thủy, Mù Cang Chải District, Yên Bái Province, 1999.

2.23 This embroidery design demonstrates Hmong use of chain-stitch technique.

Photograph by Trần Thị Thu Thủy, Mù Cang Chải District, Yên Bái Province, 1998.

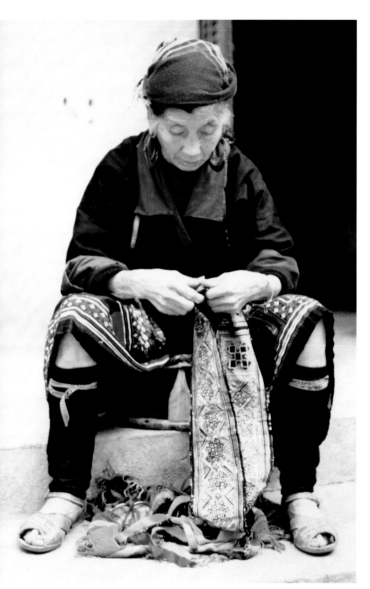

2.24

2.25

2.26

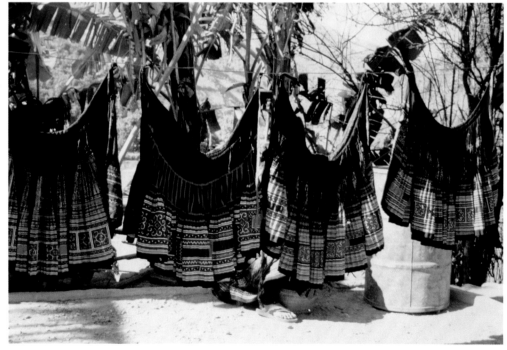

2.27

• Appliqué (*Txuôs Ntâuz*)

There are many different kinds of appliqué. The simplest type involves cutting colored cloth into small geometrically shaped pieces and sewing them to garments (fig. 2.24). The most difficult process, sometimes called "reverse appliqué," entails sewing together many different-colored layers of cloth; creating the pattern by cutting away the layers until the desired color is reached in each part; and then stitching everything in place. The Hmong often appliqué cloth for women's skirts and blouses, for the sleeves and collars of men's shirts or vests, and especially for children's caps and the back of elderly men's shirts (fig. 2.25). Common appliqué motifs include the calabash flower (fig. 2.26), mountain, and star.

HMONG GARMENTS

Traditional Hmong garments are made primarily of hemp cloth. Once the cloth is woven and dyed, it is cut into the appropriate pieces and sewn into garments. Men's shirts, vests, belts, and pants are made of plain indigo-dyed hemp cloth. The loose-fitting pants fold across the waist, tucked in at the top, and are often secured with a narrow woven belt. The only decoration is usually found on the back of shirts worn by elderly men, which bear an appliqué motif of two crossed sticks, a symbol of longevity.

The most elaborate Hmong garments, and the most important culturally, are women's pleated, knee-length skirts, or *taz* (figs. 2.27, 2.28). The pleats in these skirts symbolize hills and valleys and relate to Hmong myths concerning the creation of the earth. The pleats are anchored with herringbone stitches, and a thread is run through them as they are made, holding them together in three or four places. The skirt is stored that way until used. The patterning and colors of the skirts differ from group to group. The Flower Hmong skirt is divided into four horizontal sections. The top of skirt (*dôuz taz*) is made of plain indigo-dyed hemp cloth. The second section (*nthu taz*) bears white batik motifs on the indigo-dyed ground. The third section (*tangz taz*) is richly decorated with embroidery and appliqué in many colors. The bottom of the skirt (*tơ̛ư taz*) is plain indigo-dyed hemp cloth for everyday wear or red commercial cloth for special events such as festivals, weddings, or funerals. The skirts are voluminous, consisting of 5 to 6 meters of cloth.

2.24 A Hmong woman adorns cloth with appliqué.
Photo by Võ Mai Phương, Mù Cang Chải District, Yên Bái Province, 1998.

2.25 An elderly Hmong man wears a shirt with two crossed sticks appliquéd on the back. This is a symbol of longevity.
Photograph by Trần Thị Thu Thủy, Mù Cang Chải District, Yên Bái Province, 2000.

2.26 The calabash flower, a common appliqué motif, is combined here with batik designs (sleeping dog and mountain).
Photograph by Trần Thị Thu Thủy, Mù Cang Chải District, Yên Bái Province, 1998

2.27 Flower Hmong skirts hang to dry in the sun after washing.
Photograph by Trần Thị Thu Thủy, Mù Cang Chải District, Yên Bái Province, 1998.

2.28 Pleated skirt
Flower Hmong peoples,
Mù Cang Chải District,
Yên Bái Province, 2000
Hemp with silk embroidery floss,
commercial cotton cloth, and batik
patterning
107 cm
Fowler Museum X2000.17.2; Field Collected by Eric Crystal

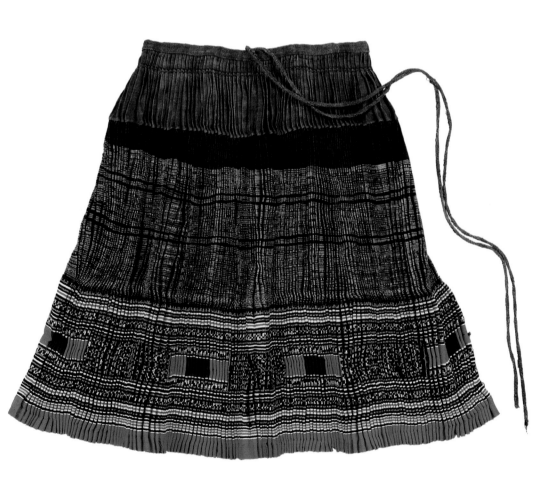

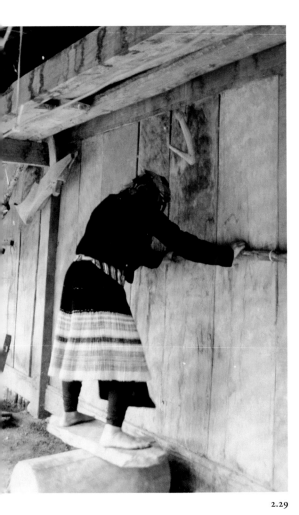

2.29

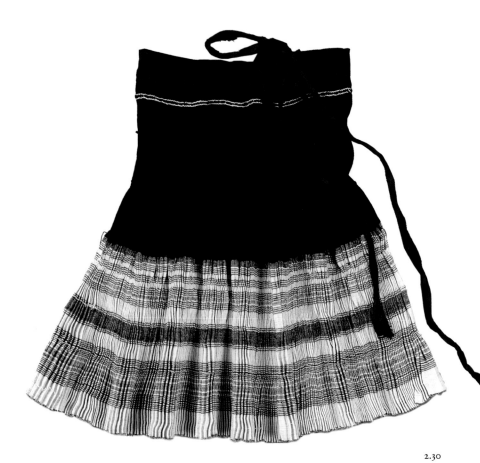

2.30

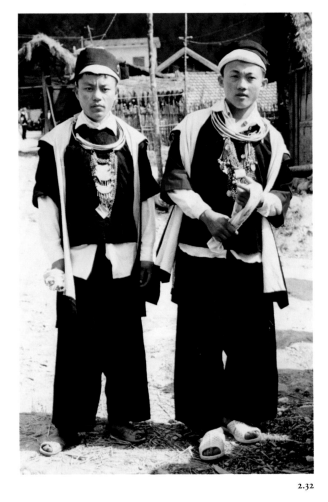

2.31

2.32

2. HEMP TEXTILES OF THE HMONG IN VIETNAM

Flower Hmong and Red Hmong skirts are decorated with batik, appliqué, and embroidery, but the Red Hmong often appliqué narrow strips of red cloth in the second section of skirt. The most traditional Black Hmong skirt is indigo and white, with a simple pattern that is woven into the cloth rather than applied by batik (figs. 2.29, 2.30). Currently some Black Hmong women wear indigo skirts with batik and appliqué decoration, but no embroidery. White Hmong women wear plain white skirts.

Flower Hmong women wear two types of blouses. Both are dyed with indigo and are hip length, open down the front, and have long sleeves. One type (*yao têl pux*) has no decoration except for a small amount of batik, appliqué, and embroidery at the collar, while the other type (*yao kuôk*) has more batik or embroidery decoration at the back and along the sleeves (see figs. 2.38 and 1.6, p. 28). The Flower Hmong vest (*yao khôuv*) is long, indigo-dyed, sleeveless, and features batik and embroidery decoration at the collar. It is worn over the blouse for warmth in wintertime. Formerly, only the Flower Hmong wore vests, but today Red Hmong in Mù Cang Chải and Trạm Tấu, Yên Bái Province, and Black Hmong in Sa Pa, Lào Cai Province, also wear vests.

Flower Hmong women in Mù Cang Chải District wear a long indigo waistband (*hlangz*) without decoration and a plain indigo-dyed apron (*paor tưv*) over the front of the skirt. The apron is longer than the skirt, reaching below the knee. The final items in a Flower Hmong woman's everyday attire are plain, indigo-dyed leggings (*nrôngz*) that cover the leg from the knee to the ankle (see fig. 2.24). The leggings are made of triangular pieces of hemp cloth, with a very narrow woven band wrapped around to keep them in place. For special occasions, Flower Hmong women wear a heavy headdress (*fuôv*) of coiled hemp cloth and a richly embroidered waistband (*paor tưv*; fig. 2.1) over their skirt and apron. Other than the skirt, this is the most elaborately decorated woman's garment, and it is not ordinarily worn for daily dress.

According to Hmong custom, the suitability of a young woman for marriage is assessed by her skill in weaving, embroidery, batik, and appliqué. Every young woman spends time making her own bridal attire as well as beautiful new clothing for the annual New Year festival. Garments also play a key role in the exchanges that accompany a wedding. When a young woman marries, her mother makes and gives her a full outfit as an heirloom (figs. 2.1, 2.31). Similarly, the mother of the groom makes a wedding outfit for her son (fig. 2.32). After the wedding, the bride makes outfits as gifts for her mother and her mother-in-law.

As garments and jewelry are the only property that a young woman brings to her husband's family, a wealthy woman is one who has many valuable skirts and ornaments. Indeed, the wealth and status of the bride's family are primarily measured by the number of garments that her mother can provide for her. This is also why a visitor who spends a night in a Hmong house is provided with a beautiful skirt to use as a blanket. Although Hmong brides wear the same basic types of garments for their weddings as for everyday wear, some aspects of the clothing have special significance. Flower Hmong brides often wear hemp skirts that are red at the bottom because this color is regarded as protective and joyful (see fig. 2.31). Today, however, some wedding skirts lack this red border (see fig. 2.1). The bride wears her wedding skirt only once during her life, but she will keep it so that she may be buried in it and wear it in the afterlife. Her loom is a gift from her husband, presented after their wedding. A Hmong woman must never sell her loom and will keep it until she dies. For the Hmong, hemp is not only the main material for weaving necessary garments, it is also a symbol of long life and expresses the connections between partners.

2.29 A Black Hmong woman from Mù Cang Chải District, presses yarn under a heavy wooden log to make it softer. Her skirt is the typical indigo and white of the Black Hmong.
Photograph by Trần Thị Thu Thủy, Yên Bái Province 1997.

2.30 **Pleated skirt**
Black Hmong peoples, Mù Cang Chải District, Yên Bái Province, 2000
Hemp
96.5 cm
Fowler Museum X2000.17.1; Field Collected by Eric Crystal

The patterning of the typical Black Hmong pleated skirt is created using only plain weave in indigo and undyed hemp.

2.31 A Flower Hmong bride wears a headdress, blouse, vest, skirt, apron, and waistband. According to Flower Hmong tradition, the red color at the bottom of the skirt symbolizes happiness and protection.
Photograph by Trần Thị Thu Thủy, Mù Cang Chải District, Yên Bái Province, 2000.

2.32 The Hmong groom and the groom's assistant each wear a headdress, shirt, vest, and loose-fitting black hemp pants.
Photograph by Võ Mai Phương, Mù Cang Chải District, Yên Bái Province, 1998.

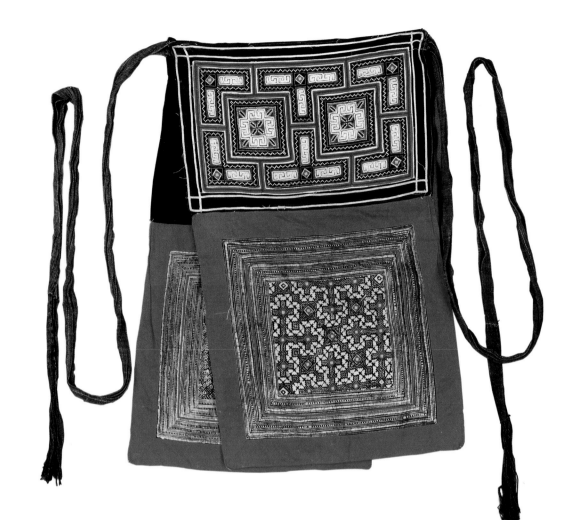

2.33 Baby carrier
Flower Hmong peoples,
Mù Cang Chải District,
Yên Bái Province, 1990s
Hemp and cotton with embroidery,
appliqué, and batik
71 cm
Fowler Museum X2000.17.12;
Field Collected by Eric Crystal

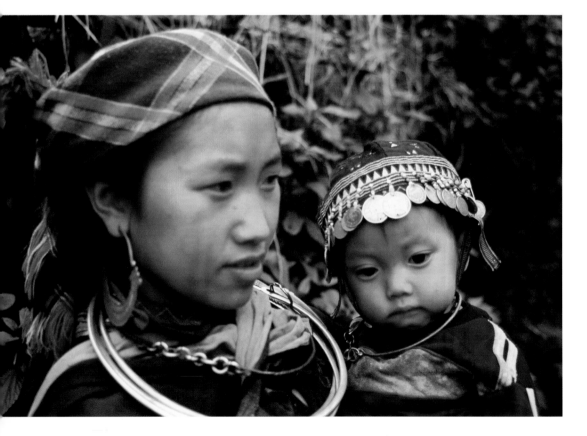

2.34 A Flower Hmong woman
carries her baby who wears a special
cap believed to be the place where
the child's spirit resides. The cap
is decorated with motifs and silver
coins intended to protect the child's
spirit from evil. In Mù Cang Chải,
the Hmong often add deer whiskers
on a child's cap, because they are
also thought to be effective in keep-
ing evil at bay.
Photograph by Trần Thị Thu Thủy, Yên Bái
Province, 2000.

When a baby is born, it is wrapped in one of its mother's old aprons. After three days, a ceremony called *grênhs plis* is organized to give the baby a name and clothing. Only after this ceremony is completed is the baby regarded as human. A stranger who happens to visit during the newborn's initial three days is required to return after the ceremony and tie a length of hemp fiber to the baby's hand, indicating a wish for good health. For a first child, the maternal grandmother provides her daughter with a baby carrier (*nhak*) a month after the birth. This consists of two rectangular cloths joined together and decorated with protective motifs executed in embroidery, appliqué, and batik (fig. 2.33). The motifs are believed to entrap evil and prevent it from entering the baby's body. Evil is said to travel solely in straight lines and therefore cannot extricate itself from the contours of the motifs. A year after the baby's birth, the parents organize another ceremony to thank the maternal grandmother for the baby carrier. At this time, the child is also given a new middle name that will be used henceforth.

A special cap (*maov mir nhuôs*) is also provided for the baby, as it is believed that the child's spirit resides in the cap (fig. 2.34). It is decorated with mountain and sun motifs, coins, and a small triangular cloth bag containing a variety of seeds intended to protect the child's spirit from evil. The Flower Hmong in Mù Cang Chải often add deer whiskers to the child's cap, because evil spirits are believed to fear them. In other places some Hmong parents add many small red balls to the cap, which symbolize the rainbow and are believed to protect the child from snakes and wild animals. Or they may make the cap in the shape of a cock's comb because they believe the cock can fight evil.

Among the Hmong there are both male and female shamans. The more advanced of these can see spirits and the less advanced cannot. There are no special garments reserved for the shaman, but the face of a high-level shaman is covered with a cloth (fig. 2.35) or sometimes with a piece of paper (fig. 2.36) when performing ritual ceremonies. The covering indicates the shaman's supernatural vision. A high-level shaman must officiate at the ceremony held for a new shaman. The more-skilled practitioner builds an altar for the new shaman using three strands of hemp fiber to connect the altar to three bamboo trees. The bamboo and hemp symbolize a road for the ancestors of the new shaman to use in visiting the altar and for the new shaman's spirit to travel in visiting the other world.

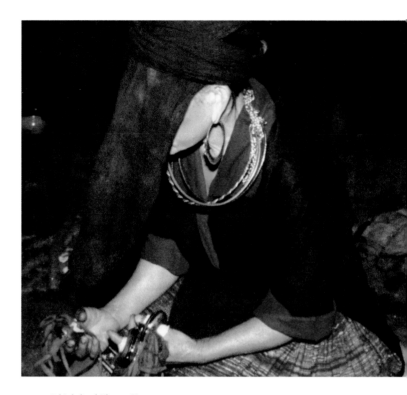

2.35 A high-level Flower Hmong shaman wears a black hemp cloth in front of her face.
Photograph by Trần Thị Thu Thủy, Mù Cang Chải District, Yên Bái Province, 1998.

2.36 A Black Hmong shaman from Sa Pa District wears paper in front of his face.
Photograph by Trần Thị Thu Thủy, Lào Cai Province, 2002.

Hemp also plays several roles in shamanic funeral rites, symbolizing the link between the deceased and the world of the ancestors and the afterlife. According to Hmong conceptions, each mortal has three souls: the principal one contained in the fontanel; a second one contained in the navel, which is responsible for the body and its internal organs; and a third one in the chest. All three souls are necessary for good health. If one of them should leave the body, the person will fall sick, and if it cannot be induced to return, the person will die. When a person dies, all three souls separate from the body and depart in different directions. The first soul flies to heaven to see the ancestors. The second one goes first to heaven and then returns to look after the tomb. As for the third soul, it will be born again into the body of a new human infant.

Kinsfolk are responsible for organizing funerals, and a family that fails to take care of the necessary arrangements in a scrupulous manner will be held up to ridicule by its neighbors. The chief mourner, who makes the basic decisions, may be the head of the lineage or another man conversant with funeral rites. The corpse is washed and then dressed in hemp clothing. A wife has the responsibility of making burial clothing for herself and for her husband. The woman's burial blouse (*yao tsôngl lâul*) must bear the snail motif, which the Hmong people associate with their lowland origins and their subsequent exile to the mountains by the Chinese. The deceased is also provided

with handmade cloth shoes (*khâu lâul*), which were everyday wear in the early twentieth century but are now seen only at funerals (fig. 2.37). These are said to resemble the cock's comb in shape and are made of cotton on the outside and hemp on the inside. As prescribed by oral tradition, additional special textiles must be presented to the corpse. These include square hemp cloths (*hlôngz ndungk*) of about 30 to 35 centimeters, which are placed under the head of the body. These cloths are made by the kinswomen of the deceased and are heavily decorated with embroidery and batik. The deceased do not wear jewelry, as the Hmong believe that it would prevent their journey to the afterlife.

Hmong men are dressed in women's skirts, blouses, and aprons when their bodies are prepared for the funeral (fig. 2.38). In cases where these garments are not all available, however, an apron, which is regarded as symbolic of women, will suffice. This interesting practice is traced to Hmong legends regarding their long-standing enmity with the Chinese. According to the Hmong, they were able to defeat the Chinese due to their superior horsemanship and weaponry, but they were, nonetheless, subsequently overcome by Chinese trickery. After being defeated, the Chinese told the Hmong that the two groups could live in peace, and they celebrated this by inviting the Hmong to drink wine. When the Hmong were drunk, the Chinese killed many of them. Afterward a fixed boundary was

2.37 The shape of these Hmong shoes is thought to resemble a cock's comb. They are lined in hemp with an exterior and sole made of cotton. At the beginning of the twentieth century, the Hmong still wore shoes of this type on an everyday basis, but they are now reserved for the dead.
Photograph by Võ Mai Phương, Mù Cang Chải District, Yên Bái Province, 1998.

2.38 Woman's blouse intended as a man's burial robe
Hmong peoples, Mù Cang Chải District, Yên Bái Province, 2000
Hemp with silk embroidery floss
134 cm
Fowler Museum X2001.5.5; Field Collected by Eric Crystal

Hmong men are buried wearing women's blouses. Hmong legends trace this practice to the former centuries of persecution in China, which led Hmong men to wear women's garments to disguise their gender so that they would not be killed.

established between Hmong and Chinese territory, marked with rocks by the Chinese and trees by the Hmong. The Chinese burned the trees and drove the Hmong into exile, killing the men but sparing the women and children. Many men escaped, however, by donning women's clothing, and this is said to be the origin of the funeral practice of dressing deceased men in women's garments.

Shots are fired (three for a young person, and nine for an old), and a horn is blown to inform villagers of the bereavement. The washed and dressed corpse is laid on a bamboo stretcher or in a coffin (both of which symbolize a horse to transport the dead) and placed in front of the altar for the house spirit. Loose hanks of hemp fiber are used to secure the body to the stretcher, and a line of hemp connects the stretcher with the roof of the house. This hemp fiber is said to take the spirit of the deceased to join the ancestors. An oil lamp and a calabash bowl filled with rice are placed beside the head of the deceased. Additional items are suspended on both sides of the stretcher: a bow and arrows, a bottle of wine, and a chicken for a man; a spindle, a knife, and a chicken for a woman. Depending on the clan to which the deceased belonged, the head of the corpse may be turned to face the hearth. The altar for the spirit of the house is draped with garments belonging to the head of the family, because it is believed to bring bad luck if the house spirit sees the spirit of the deceased.

A shaman is then requested to "show the way" (*kruôz cê*) to the deceased by telling the story of the origin of the universe. In Hmong religion, the cosmos consists of three levels: a celestial level, the abode of the gods and ancestors where fragrant blossoms and delicious herbs abound; a middle level, which is the world of mortals; and an underground level plunged in darkness. The shaman tells the cause of death and recounts the dangers confronting the deceased on the journey to join the ancestors. He also tells of a cock that serves as a guide for the dead and recites additional legends and customs concerning funeral practices. He then places a stick wound with a long length of hemp cordage in the hand of the deceased and explains that the dead cannot pass through to the level of the ancestors without this hemp cord. The shaman puts the hemp shoes on the deceased's feet and recounts how each person has to walk to find the land of his or her ancestors. He explains as well that the ancestors will not recognize the corpse unless the deceased arrives dressed in hemp clothing. Similarly, the soul of the dead cannot see the ancestors without being "shown the way." Afterward musicians perform a mourning piece on a drum and long bamboo tubes. This represents the soul of the deceased saying farewell to the spirits of the home: the house spirit, the door spirit, the house post spirit, the kitchen spirit, and the room spirit.

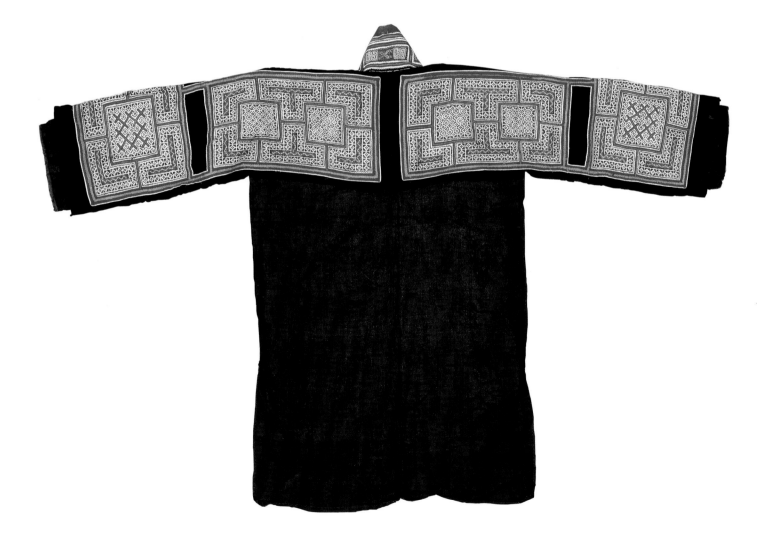

Late at night, some Hmong perform a rite to "drive back the enemy," based on the idea that Hmong individuals may be chased away by Chinese aggressors, even after death. The enemy is driven back by seven men running seven circuits if the deceased is a male, and nine men making nine circuits in the event that the deceased is a female. The man who leads the way holds a torch and is followed by others holding a knife, a cutlass, a gun, etc. A shot must be fired and a horn blown after each circuit. The following morning, before the body is carried out of the house, a man stands next to the door and shoots an arrow with a small bow. The purpose is to shoot the sun so that it cannot shine into the eyes of the dead, blinding the deceased from seeing the way. The body is carried to an open area where a platform 1 meter high has already been set up (fig. 2.39). In the middle of this open space, a small tree is erected and hung with a drum and a wind instrument made of a cluster of bamboo tubes (*kênhx*), best known by its Chinese name, *sheng*. The tree symbolizes the connection between the living and the dead, between earth and sky. The hemp cord held in the hand of the corpse is unwound and the other end is tethered to a buffalo or ox that is to be sacrificed in order to provide the deceased with

livestock. Without the hemp tie, the deceased cannot receive the sacrificed animal in the world of the ancestors. The chief mourner dedicates the animal to the deceased with an oration, and the mallet that will be used to kill the animal is passed to a relative. After the sacrifice, a feast is prepared with the meat and served near the temporary resting place of the body. This is the last opportunity for the living to share a meal with the deceased.

The shaman chooses an auspicious time for a further oration to precede the burial, and the band performs two mourning pieces to see the soul off. Some strong young men carry the stretcher on which the corpse lies, running as hard as they can to the grave (the Hmong conceive of the stretcher as a galloping horse). The corpse is placed in a coffin, and the eldest son and others fill the grave. If the family suffers ill luck in subsequent years, it may be assumed that the dead person has returned to request a pig or another offering. A ceremony (*buô dăngz*) is then arranged. If the deceased was a man, a blouse is used; and if the deceased was a woman, a skirt. These articles of clothing invite the spirit of the dead person. A length of hemp is attached to the clothing and the pig. Without this the deceased cannot receive the offering.

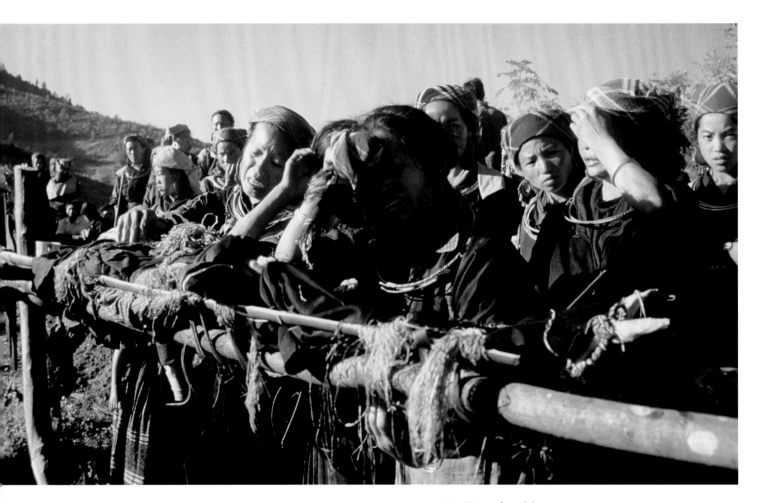

2.39 At a Hmong funeral, loose hanks of hemp fiber secure the body to the stretcher. This hemp fiber is said to take the spirit of the deceased to join the ancestors.
Photograph by Trần Thị Thu Thủy, Mù Cang Chải District, Yên Bái Province, 2000.

In recent years, Hmong who live near Tai populations have increasingly adopted handwoven Tai cotton cloth, which they buy and make into their own garments. In areas bordering China, Hmong adopt Chinese industrial cloth, including batik, and use imported Chinese thread for embroidery. They also substitute commercially available synthetic dyes for their own indigenous natural dyes.

Similarly, Hmong people in many districts have modified their dress. In Bắc Hà and Mương Khương Districts in Lào Cai Province, for example, a shorter blouse is worn for daily dress, open on the side rather than in the middle, and a second apron has been added. The decorative motifs used are simpler but more colorful, and the garments are made of new materials and machine sewn. Traditional styles of hemp clothing are worn in this district only for funerals. In Sa Pa District, Lào Cai Province, Black Hmong and Flower Hmong wear short trousers and shirts with no decoration, while White Hmong wear long trousers. In some areas of Yên Bái and Lai Châu Provinces, White Hmong have adopted the skirts and shirts of neighboring groups of Flower or Red Hmong. In Sơn La Province, the White Hmong use Tai headdresses but add more red trim.

In Mù Cang Chải, the White Hmong wear long trousers with two aprons and the Tai headress, while Black Hmong wear shirts that open on the side. Most Flower Hmong and Red Hmong in Mù Cang Chải still wear their traditional style of dress, although they may adopt new materials for certain items. Typically, men are the first to modify their dress, beginning with the use of industrial cotton or Tai handwoven cotton for their shirts. They often continue to wear pants made of hemp, because it is more durable for work in the mountainous environment. Hmong women may also wear blouses and aprons made of these new fabrics. These changes lessen the amount of time that they must spend producing hemp fiber and weaving, leaving them with more freedom to devote to other tasks. Most Hmong women no longer wear their traditional headdress except for weddings and festivals. Because the traditional headdress is heavy and uncomfortable, they prefer cheaper and lighter woolen cloth imported from China. The woman's skirt is the most conservative item of Hmong dress, but recently it too has undergone some changes. Women now often use cotton cloth for the batik portion of the skirt, because the batik motifs appear clearer on closely woven cotton than on hemp. They continue to use hemp for the embroidered portion of the

COMMENTS BY HMONG ON CHANGES IN TRADITIONAL DRESS

"Hmong women have to work very hard from early morning to evening to make textiles. In the past, when there was no commercial cloth, Hmong had to make cloth themselves, but now there is a lot of cloth for sale in the market, so Hmong women have more time to relax."

Shu Zangx, fifty-five-year-old man,
Trạm Tấu District, Yên Bái Province

"Wearing hemp is cool in the summer and warm in the winter, but in the rainy season it is very heavy. The indigo in the cloth stains our skin, and it is so humid that our clothes will not dry in a month's time. Cotton and industrially produced textiles are lighter and easier to dry, so we prefer them. But embroidery is more beautiful on hemp cloth, and if we don't wear hemp when we die, we cannot see our ancestors, so every family has to keep hemp in the house."

Nhưl Lir, fifty-year-old woman, Dế Su Phình
Commune, Mù Cang Chải District, Yên Bái Province.

"We see that Hmong dress is now much more beautiful than before. In the past we had to make fiber and dyes ourselves, so we didn't have as many colors as now. But now there are many kinds of cloth: woolens, colored cloth, gold and silver lamé. We can buy any of these cheaply in one day in the market without taking a long time to plant the hemp, go to the forest to find dye materials, weave the cloth. We have more free time to do other things to earn money, and we can use the money to buy clothes. Women are now freer than before."

Muôv Vangx, forty-five-year-old woman,
Bản Phố Commune, Bắc Hà District, Lào Cai Province

skirt, because the cross-stitch embroidery technique is easier to execute on hemp cloth and the results are more beautiful. The finished skirt will also be easier to pleat. Recently, some Hmong families in Mù Cang Chải who are well off have continued to produce their own hemp fiber but now employ Tai weavers to make it into cloth. Sewing machines are also used by some to assemble their garments.

Despite these changes, Hmong traditional beliefs remain strong, and almost all Hmong women still grow hemp and practice weaving, batik, cross-stitch embroidery, and appliqué. For everyday wear, imported industrial materials may be acceptable, but hemp is still required for funeral garments because of the belief that the ancestors will not accept the deceased unless they are dressed in traditional clothing. Thus hemp textiles not only protect a person from the environment but also represent an expression of the social and cultural life of the Hmong, including the world of the spirits.

PROSPECTS FOR THE FUTURE

The growing of hemp and the weaving of hemp cloth are ancient traditions in East Asia. Experts believe that hemp was cultivated by 4500 BCE in China and was subsequently brought under cultivation in Korea and Japan, where it became the most important textile fiber and took on important ritual meanings. After the seventeenth century, when the production of cotton in Japan surpassed that of hemp, the use of hemp declined. Hemp was increasingly used for two specialized markets, fine garments sought after by the elite and utilitarian items such as cordage and hats (Roulac 1997).

In 2000, archaeologists from the Center for East Asian Prehistory in Vietnam discovered hemp cloth in a 2,500 year-old grave site in Hà Tây Province in the northern Red River Delta region. It seems likely, therefore, that the use of hemp cloth was once widespread in Vietnam, as it was elsewhere in East Asia, and was not limited to minority groups such as the

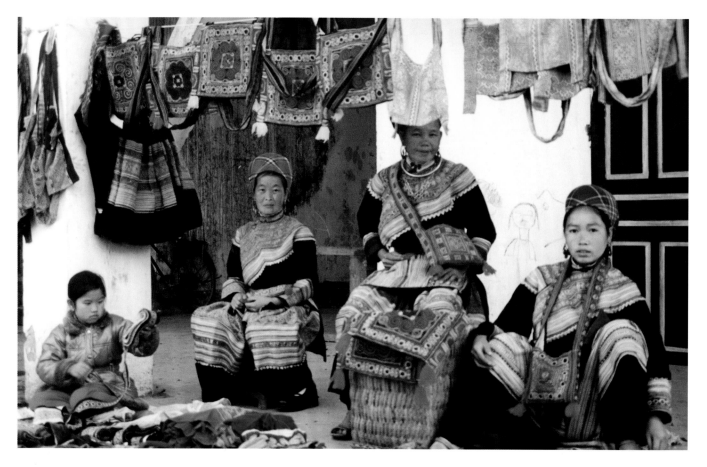

2.40 Hmong women sell garments, bags, and other products to Hmong and non-Hmong buyers at a market in Bắc Hà District, Lào Cai Province. These items have been made in imitation of traditional Hmong articles but use imported cotton or synthetic materials instead of hemp.
Photograph by Trần Thị Thu Thủy, 2002.

Hmong. It appears that today the Hmong hemp traditions may be changing in a manner similar to what took place in Japan after cotton cultivation became prevalent. Currently, hemp cloth is still highly valued from a cultural perspective in Hmong communities, but this is beginning to change even in more conservative communities such as Mù Cang Chải. Unless policies are put in place to assist Hmong communities in developing hemp products, hemp cloth may eventually be reduced to a specialized component of funerary ritual as has occurred in Korea (see chapter 4).

Perhaps the most promising policy would be to develop new markets for products that emphasize the beauty, design, and special techniques of Hmong hemp production, focusing on traditional products as well as new products utilizing traditional materials and methods. Currently, there are two large organizations in Vietnam interested in Hmong textile production. One is Craft Link, an organization under Vietnamese management that was established in 1996. A steering committee comprised of representatives of Vietnamese NGOs and businesses advises the organization. In collaboration with the Vietnam Museum of Ethnology, Craft Link has coordinated research, publications, exhibitions, and demonstrations by artisans to promote the understanding and appreciation of Vietnamese artisans and their skills.

Craft Link has two separate arms, Craft Link Development (CLD) and Craft Link Business (CLB). With a staff of two project directors and seven designers, CLD is an NGO with the following goals:

· To help craft production groups, especially the poor, improve their livelihoods through sustainable craft production;
· To revive and promote traditional culture and skills;
· To raise the ability of small craft-production groups to manage labor and finance and to develop products and markets, through training programs lasting three to four years, seven to ten days per month.

Such a long-term training effort is deemed necessary due to the difficulty of developing new attitudes and instituting product changes. A not-for-profit business that assists CLD by providing financial support, CLB finds markets and educates the public about the producers and their products. Craft Link Business buys 60 percent of its products from Hmong producers, selling them in its Hanoi shop as well as exporting products to North America and Europe. One of the shortcomings of Craft Link, however, is that it is only able to develop projects in a limited number of communities. Currently it focuses on four Hmong communities, in Sa Pa, Hoà Bình, Kỳ Sơn, and Hà Giang. Another drawback is that the production of similar products is supported in all four communities, rather than focusing on specialized local products from each. This has a homogenizing effect that ignores local cultural differences.

The other organization currently working with hemp development in Vietnam is the Center for East Asian Prehistory, which established the "Vietnamese Project for Cannabis and Other Bast Fiber Plants" shortly after its aforementioned discovery of hemp in an ancient grave site. This project conducts research concerning hemp cultivation and has established experimental plantings of hemp in Hà Giang, Hoà Bình, and Hà Tây Provinces. The best planting sites are those located in the Red River Delta. In 2004 the project cooperated with the Vietnamese Ministry of Technology, Science, and the Environment to experiment with using hemp stalks to make paper, fine fiber, and hemp oil. Currently these efforts been restricted to the laboratory stage and remain focused on a small area of cultivation.

In popular tourist districts such as Sa Pa, Lào Cai Province, and Mai Châu, Hoà Bình Province, Hmong individuals with production and entrepreneurial skills have opened textile shops or founded textile cooperatives. These efforts may be supported by district- or provincial-level People's Committees; by the Agricultural and Rural Development Ministry; or by organizations such as the UNDP or NGOs, including Oxfam Hong Kong, which support various projects of the Vietnemese government aimed at developing handicrafts in order to alleviate poverty. The textiles produced by these means are sold to tourist and souvenir shops in Hanoi or at a special handicraft fair organized once a year in Hanoi by Craft Link.

Less-skilled traders in Sa Pa, the most popular destination for "cultural" tourism in Vietnam, have also developed a market for reworked Hmong hemp garments. They travel to districts where traditional garments are still commonplace, including Mù Cang Chải and also Phong Thổ in Lai Châu Province, where they buy up inexpensive used garments. These they cut up into pieces, reassembling the scraps to form new products such as bags or shirts. The reworked products are then sold along the roads in tourist areas.

Not all of the new marketing endeavors have been targeted at tourists. Recently textile traders from Sa Pa (some of them Hmong, but others Kinh[8] or Tai) have also begun traveling to Mù Cang Chải and Phong Thổ to purchase newly made, high-quality traditional garments. While some of these garments are sold to tourists, others are being sold to Hmong consumers in other communities, such as the Mường Khương and Bắc Hà Districts in Lào Cai Province, where hemp is no longer woven or worn on a daily basis but is still needed for special occasions. Similarly, Hmong producers in Bắc Hà District are now making lower-cost versions of traditional garments, using cotton and synthetic fabrics rather than hemp, to meet the demand created by the decline of hemp weaving in their own district. These are sold to local Hmong consumers for their own use (fig. 2.40).

Hmong hemp textiles are currently undergoing many forms of development, some initiated by Hmong themselves and others by governmental and nongovernmental organizations. How to preserve and develop traditional hemp products, as well as to promote higher value for them, remains a problem. Solutions will require cooperation among researchers, agricultural and industrial organizations, government agencies, and foreign trade companies.

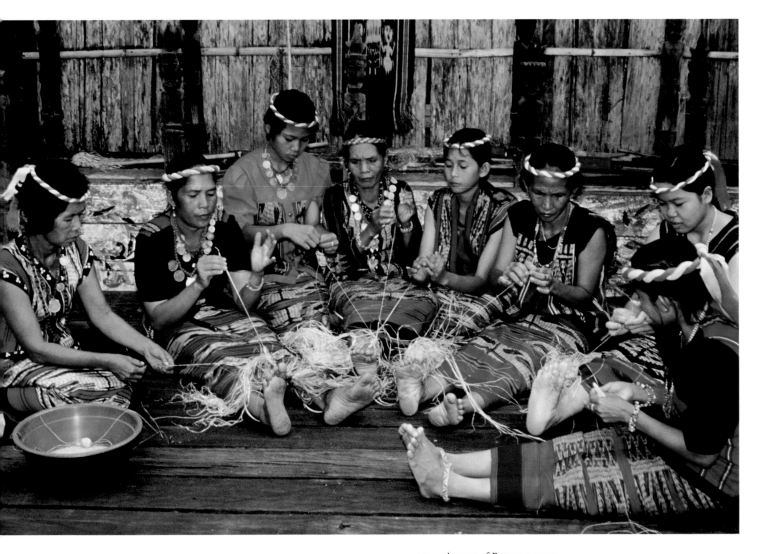

3.1 A group of Benuaq women transform *doyo* fiber into thread.

Photograph by Elizabeth Oley, Tanjung Isuy, East Kalimantan, 1999.

3. *Ulap Doyo*
Woven Fibers of East Kalimantan

Elizabeth Oley

Western culture, which has killed the art of
weaving, supplies a substitute! A Singer sewing-
machine in the wilderness.

Tillema ([1938] 1989, 188)

ETHNOGRAPHERS TRAVELING in the Mahakam River region
of eastern Borneo in the early twentieth century confirmed
that a previously thriving weaving practice had declined and in
some cases completely died out. The quotation cited above—
originally a caption appearing beneath a photograph taken in
1934—demonstrates the powerful effect that industrialization
had even in remote areas of Borneo. The Singer sewing machine
reminds us that the repercussions of the Industrial Revolution
in Europe were far-reaching and multifaceted. The importation
of commercial cloth was accompanied by the arrival of mecha-
nized means of production.

Despite these changes, traditional weaving persisted in
one area of eastern Borneo in villages centered around Tanjung
Isuy, south of the Mahakam River in the Lake Jempang area of
West Kutai Regency in East Kalimantan (fig. 3.2). In the early
1980s, the complete demise of this weaving knowledge was
predicted within ten years because there was no interest from
the younger generation (Maulana 1982, 39). At that point, the
few remaining women who knew how to weave ranged in age
from forty to eighty-seven. Within the same decade, however,
cultural tourism would prompt a weaving revival. In this essay
I will examine the history of weaving by the Benuaq peoples,
its revival, and the transformations that it has undergone.

BENUAQ SOCIETY

The Benuaq peoples are a subgroup of the Barito Dayak, "Dayak"
being the term used for the non-Islamic, indigenous people or
"inland" dwellers of Borneo. The Barito people speak related
languages, share certain religious beliefs, and practice elaborate
funerary rituals (Sellato 1989, 21). Inhabiting the region between
the middle Barito River and the middle Mahakam River, the
Benuaq are a subgroup of the larger Luangan ethnic group and
in turn classify themselves into seven geographic divisions.[1]
Mentioned only rarely in the literature as a Dayak subgroup,
the Benuaq and their textiles have received scant attention.[2]

Until the time of Indonesian independence at the end
of World War II, Benuaq society was hierarchical and rigidly
stratified with a ruling class, commoners, and slaves. The Ben-
uaq grow rice and practice swidden agriculture. Formerly, they
derived income from the sale of forest products and fishing but
are now increasingly involved in commercial farming and rub-
ber tapping. Traditional Benuaq law is unwritten and has been
handed down from one generation to the next, supervised by
the traditional village chief (Indonesian: *kepala adat*) and other
elders (Gönner 2002, 55). The history and traditions of the
Benuaq have also been transmitted orally, often through myths
and legends, which have only recently been documented.[3] These
contain much of the ancient history and cultural lore of the
ethnic group and are recited during the major ceremonies of life
and death.

THE HISTORY OF WEAVING AMONG THE BENUAQ

A reference to weaving in Benuaq legend suggests that it was
a significant aspect of community life in times past. The story
known as "The Origins of the Coconut" tells of a young girl
calling her mother for help while trying to escape her father's
unwelcome advances. The mother, seated at her loom, springs
to her daughter's aid using her weaving sword as a weapon to
beat her husband. The myth concludes with the metamorphosis
of the daughter into the coconut palm; the father into the *aren*
palm; and the mother into the *tiwau* palm (Hopes, Madrah,
and Karaakng 1997, 168–70).

In *The Head-Hunters of Borneo* (1881), an account of his
journey up the Mahakam River, Norwegian explorer Carl Bock
described Dayak handicrafts as "fancy work for the ladies," not-
ing that "the women make from the fibre of a plant the thread
with which the bark fabrics forming their home-made garments
are sewn together, bound, or embroidered: and some of them
can weave" ([1881] 1991, 208). Reflecting Victorian sensibilities,
he further remarked that "some of the tribes do not adopt any
more extensive wardrobe than was considered necessary by Adam
and Eve in Paradise before the well-known apple dispute took
place." Bock's description of female attire and his sketches of
women wearing everyday skirts in plain cloth closely resemble
the apron-like skirts known from more recent times (figs. 3.3,
3.4): "The ladies' wardrobe is not much more elaborate than
that of the men at home. The upper part of the body is usually
uncovered; but a sarong, or petticoat or some bright-colored
cloth is hung round the waist, sometimes barely reaching to the
knee, sometimes nearly touching the ground" ([1881] 1991, 183,
pls. 5, 13, 16, 26).

Examples of intricately patterned handwoven textiles
dating from the late nineteenth and early twentieth centuries
and found in museum collections demonstrate the highly
developed skills of Benuaq weavers.[4] These textiles are known
locally as *ulap doyo* (lit., "cloth from *doyo*"). They feature warp-
ikat designs and are made from the fiber of the *doyo* plant, also
known as *lemba* in Malay and Indonesian dialects. While bark
cloth was used for daily wear, *doyo* textiles were used for festive
wear and rituals.

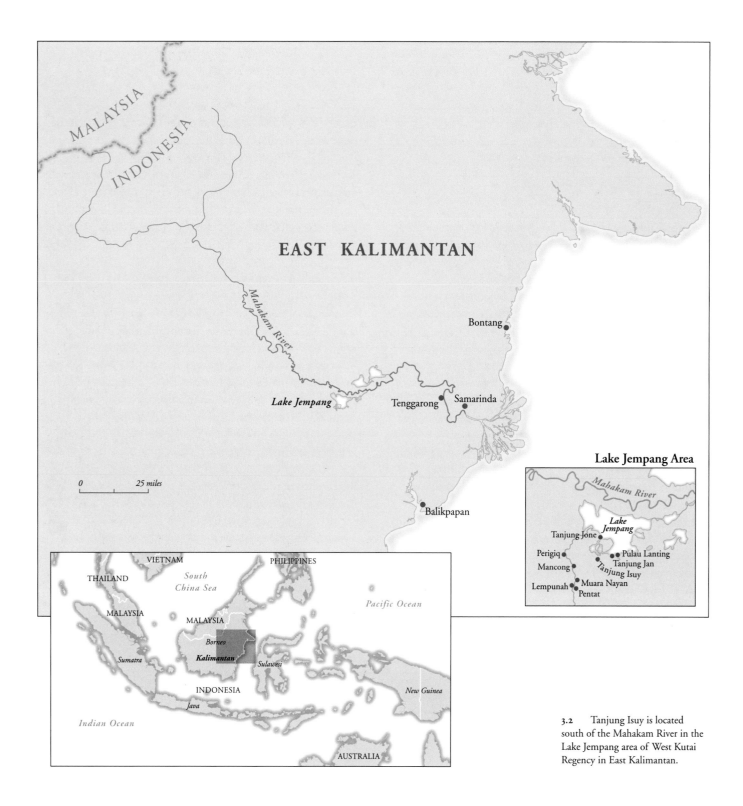

Lake Jempang Area

Mahakam River

Lake Jempang

Tanjung Jone

Perigiq

Mancong

Lempunah

Pentat

Pulau Lanting

Tanjung Jan

Tanjung Isuy

Muara Nayan

3.2 Tanjung Isuy is located south of the Mahakam River in the Lake Jempang area of West Kutai Regency in East Kalimantan.

Botanical notes concerning the *lemba* plant also suggest the wider use of this material prior to the introduction of cotton cloth. In 1927 K. Heyne pointed out that Dayaks wove sarongs from *lemba* but "after a time it was seldom used" (Heyne 1950, 451). In his discussion of *lemba*, Isacc Henry Burkill observed that "the Dyaks [Dayaks] of Borneo use it a good deal, and it is probable that formerly their reliance on it was greater than it has been since cotton was made available" (1935, 704).

The increasing availability of imported cloth during the twentieth century clearly reduced the need to produce textiles for personal use and contributed to the decline in weaving. Following Indonesian independence, the supply of ready-made cloth and clothing became even more plentiful, and this, together with increased pressures from the central government to modernize, accelerated the decline in traditional textile production to the point where weaving skills were virtually lost.

THE BENUAQ BELIEF SYSTEM AND THE RITUAL USE OF TEXTILES

An examination of Benuaq culture and ritual reveals numerous instances where textiles have played and continue to play important ceremonial and symbolic roles. Although most of the three thousand inhabitants of Tanjung Isuy have converted to Christianity, many still adhere to their traditional religion with its associated ritual healing ceremonies and secondary mortuary rites.[5] The inclusion of cloth at many stages of these healing and funerary rituals indicates how *doyo* textiles may have been used before the decline of the weaving tradition.

Traditional healing ceremonies remove evil from individuals and communities and restore the balance between them and the cosmos. During healing rituals trained male and female specialists (*pemeliatn*) act as mediators between the human and the spiritual sphere. Funerary ceremonies involve considerable

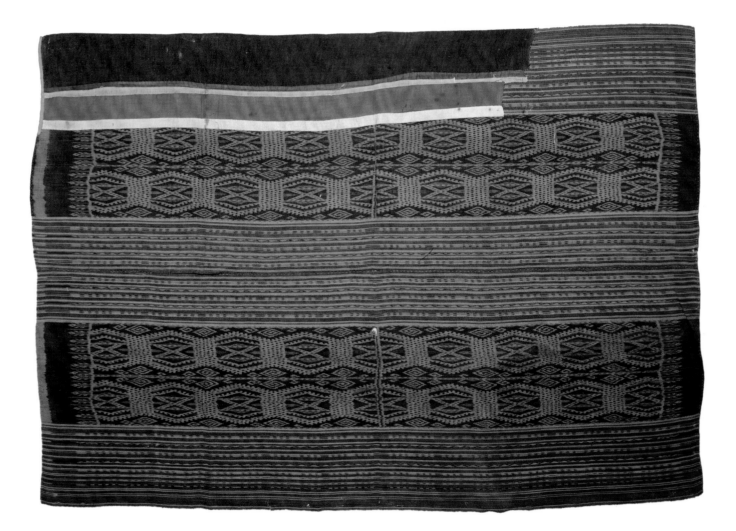

3.3 Skirt (*ulap doyo*)
Benuaq peoples, East Kalimantan, nineteenth century
Lemba (*doyo*) fiber
101 cm
University of Pennsylvania Museum (image no. 151831)

This skirt was collected in Dutch East Borneo in 1897–1898 by Hiram M. Hiller and A. C. Harrison and was donated to the University of Pennsylvania Museum by Horace H. F. Jayne.

outlays of money in order to allow the spirits of the deceased to enter the realm beyond death in a worthy fashion (Massing 1983, 86). These rites involve three separate stages culminating in the final ceremony (Kwangkai) held years later when the family has saved sufficient means to provide a large feast (Massing 1983, 89).

In Kwangkai ceremonies numerous ritual objects serve to receive the ancestral spirits. These objects include a blowpipe (*sumpit*) with seven "steps" marked on it in chalk for the spirit (*kelelungan*) to descend from heaven (Massing 1983, 92).[6] A red cloth symbolizing the spirit is tied to this blowpipe "stairway." Signifying the spirits of the dead, the colors red and white feature in various ways in funerary rituals (Massing 1983, 92).[7] Two rice containers, one covered with red cloth and the other with white, are intended as a place for the spirits to sit down and rest.[8] The spirits are provided with a set of new clothes to be worn on the journey to the afterlife. At the final Kwangkai ceremony, the sacrificial buffalo is decorated with red ribbons on its horns. The sacrifice is performed by two young men using lances to which a red flag and a white flag are tied, again representing the spirits (Massing 1983, 97).

Formerly, *doyo* textiles were worn by dancers and ritual specialists during the final funerary ceremony. They also adorned a carved wooden statue (*blontang*) to which a buffalo was tied prior to being sacrificed (Noor, Djebar, Sukarni, and Darda 1990, 113–18). Since the revival of the weaving tradition in the 1980s (see below), *doyo* textiles have once again assumed their prominent role in these rituals and as gifts for the afterlife. Village heads of customary law wear *doyo* vests at ceremonies such as Kwangkai and at weddings (Christian Gönner, personal communication, 2001). *Doyo* textiles also play a role during other rites of passage. They are presented to newborn children, used during the traditional naming ceremony, and worn by the child's parents. They also function as exchange items between families of the bride and groom at weddings.

In reports of his travels during 1913–1915, Carl Lumholtz commented on the use of a woman's skirt attached to a spear as a message used to urge men to prepare to fight an approaching enemy:

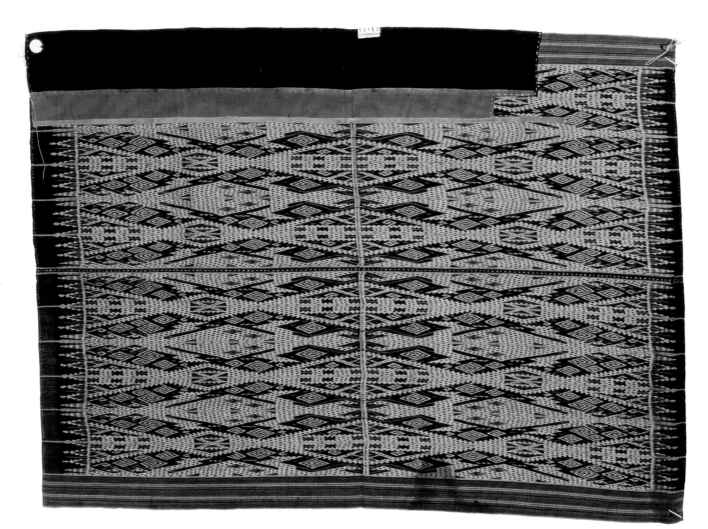

3.4 Skirt (*ulap doyo*)
Benuaq peoples, East Kalimantan,
mid to late nineteenth century
Lemba (*doyo*) fiber
115 cm
Collection Wereldmuseum, Rotterdam, no. 13153
Photograph Courtesy of the Wereldmuseum
Rotterdam © 2006

Formerly when an enemy approached a curious message was sent from kampong to kampong. To the top of a spear was tied a tail feather of the rhinoceros hornbill, symbolising rapid movement, and also a woman's skirt of fibre with a bunch of odoriferous leaves attached. Women used to fasten these to the skirt in addition to those placed in the hair. This meant an urgent order for people to gather quickly for the fight, and in the event of failure to obey the call promptly the leaves and skirt signified unworthiness to wear masculine attire. [Lumholtz (1920) 1991, 354]

This pairing of male and female symbols, spear and cloth, has wide symbolic meaning throughout Indonesia.[9] In western Borneo, the spear and the loom are used as symbols in Iban society "to evoke the differentiation of male and female gender roles" (Mashman 1991, 231).

A special ceremonial *doyo* textile, still in use in Tanjung Isuy, is 5 meters long and 1.4 meters wide. This large *doyo* textile is used as a covering or canopy-like shield when bathing the deceased (Sumiyati, personal communication, 2001). The shield has a dual function: protecting against malevolent spirits and attracting benevolent ones during important rituals (Maxwell 1990, 134).[10]

Doyo textiles are also used in a special ceremony following transgression of an incest taboo. The guilty couple, who, according to local customary law, are in a nonlegal marriage, must step eight times through a circular piece of *doyo* cloth known as *ulap los* in a purification ritual known as Melas Tautn.[11] This ritual item is stitched together with a thread, and the threads are cut after the ceremony. The *ulap los* is one of a range of ritual elements required for this purification rite (Christian Gönner, personal communication, 2001).[12]

While weavers have resumed the practice of making textiles for festive wear and ritual use, most contemporary textiles are in fact produced as commodities for sale and are intended for use in a secular context. Whereas antique textiles, which were made originally for sacred use, became commodities "by metamorphosis and diversion" at the moment when they were acquired for museum collections, contemporary examples are commodities "by destination" (Appadurai 1986, 16).

THE WEAVING REVIVAL AMONG THE BENUAQ

Until the 1980s, oil, gas, and timber were the principal revenue-producing industries in East Kalimantan. The decline in oil prices from 1982 to 1986, however, prompted the East Kalimantan government to promote other economic activities in the area. Tanjung Isuy—one of the more accessible places on the Mahakam River where tourists could observe Dayak culture—and nearby Mancong, which has a two-story longhouse, thus became the focus of a tourist development program.[13] The plan was to promote the distinctive culture and arts of the area and to enhance economic opportunities for the village of Tanjung Isuy. It was designed to appeal to tourists looking for an "authentic" experience. As Erik Cohen has explained, "Since modern society is inauthentic, those modern seekers who desire

to overcome the opposition between their authenticity-seeking self and society have to look elsewhere for authentic life. The quest for authenticity thus becomes a prominent motif of modern tourism" (1988, 373). The elements of "cultural otherness"—exotic peoples, dances, ceremonies, and handwoven fabrics—were all present in the region (Smith 1989, 4). The marketing of Borneo as a tourist destination capitalized on its natural and cultural diversity. The flora and fauna of the rain forest and the varied customs, dress, and artifacts of the Dayak groups promised an exotic experience designed to satisfy what John Urry terms the "tourist gaze" (1990, 1).

The anticipated influx of tourists represented a potential market for handicrafts unique to the area. Enterprising individuals, along with the small nucleus of remaining weavers, encouraged other members of the community to learn how to weave and to produce textiles for traditional dress (Indonesian: *pakaian adat*) and as souvenirs for tourists. This initiative had the dual objective of reviving local interest in material culture and providing income-generating opportunities within the Benuaq community. Government support for the weaving revival was provided through the Provincial Department of Industry in a number of ways. It provided a longhouse for communal production and display of textiles, as well as training courses to increase efficiency. It also helped selected weavers to participate in national and international tourism exhibitions and produced glossy booklets and brochures promoting the textiles along with other Dayak handicrafts from the region.[14]

Marketing strategies were also established targeting domestic and international tourists. Starting in 1983 visitors began to arrive in East Kalimantan in increasing numbers. Visiting tourist groups were welcomed at the Tanjung Isuy longhouse with rituals and dances featuring performers wearing *ulap doyo* skirts and vests. Overnight visitors to Tanjung Isuy were able to stay in a longhouse where they could buy *ulap doyo*, woodcarvings, rattan baskets, and other artifacts. Carving, which had been on the wane, also experienced a revival.[15] Cohen has suggested that "commoditization" often hits a culture when it is already in decline, with the result that the emergence of a tourist market frequently facilitates the "preservation of a cultural tradition" that would otherwise perish. A tourist market "enables its bearers to maintain a meaningful local or ethnic identity which they might otherwise have lost" (Cohen 1988, 382). The development of tourism certainly averted the demise of carving skills and revived Benuaq weaving in the vicinity of Tanjung Isuy.

By the late 1990s there were 350 women weaving in nine villages: Tanjung Isuy, Mancong, Lempunah, Pentat, Muara Nayan, Perigiq, Tanjung Jan, Pulau Lanting, and Tanjung Jone.[16] A further fifty Benuaq weavers were living in Tenggarong, the former seat of the Kutai Sultanate near the provincial capital of Samarinda. At that stage *doyo* textiles were also available for sale from approximately thirty different outlets including art shops located in Samarinda, Bontang, Balikpapan, and Tenggarong. Of note, the resource industries of East Kalimantan—oil, gas, mining, and forestry—employ large numbers of professional Indonesians and expatriates who comprise an affluent community representing a significant market.

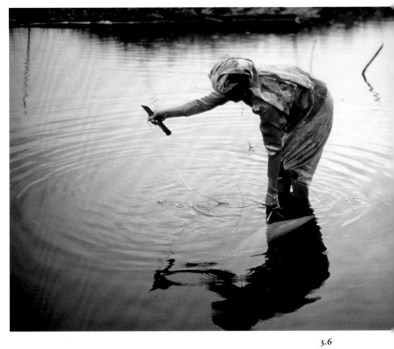

3.5

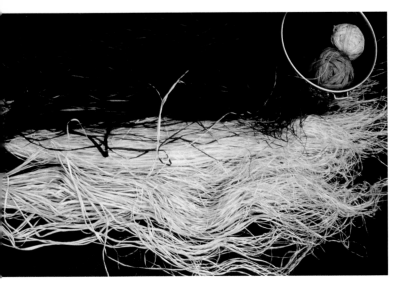

3.6

3.7

3.5 The *doyo* plant (*Curculigo latifolia*) is widely known as *lemba* in Indonesia and Malaysia.

Photograph by Elizabeth Oley, near Tanjung Isuy, East Kalimantan, 1997.

3.7 Hanks of dried *doyo* fibers are shown here prior to being made into thread. The upper hank is dyed a maroon brown derived from durian bark. It could be used for warp yarn or border stripes.

Photograph by Elizabeth Oley, Tanjung Isuy, East Kalimantan, 1996.

3.6 The fiber of the *doyo* plant is separated from the leaf base using a bamboo knife.

Photograph by Elizabeth Oley, Tanjung Isuy, East Kalimantan, 1999.

3.8 Ikat tying frame
Benuaq peoples, East Kalimantan, 1990s
Wood, *lemba* (*doyo*) fiber, plant fiber, plastic
91 cm
Fowler Museum X2002.37.14;
Gift of E. M. Bakwin

The warp yarns for an *ulap doyo* skirt are stretched on the tying frame, and selected portions are wrapped and tightly bound. When the yarns are removed from the frame and dyed, the bindings will prevent the dye from penetrating those portions of the yarn.

3.8

BENUAQ WEAVING PRACTICE AND PRODUCTS

The raw material that provides thread for the *doyo* textiles is fiber extracted from leaves of the *doyo* plant, *Curculigo latifolia* (fig. 3.5). The leaves measure 80–120 centimeters in length and 10–20 centimeters in width (Taihuttu 1994/1995, 12). While textile production is almost exclusively the domain of women, men are usually responsible for collecting the *doyo* leaves.[17]

The *doyo* plant grows wild, often in old rice fields, and until the 1990s had been plentiful. Two factors, however, have contributed to shortages resulting in a doubling of the fiber price within three years (Christian Gönner, personal communication, 1999). An oil palm plantation of 16,500 hectares, established near the weaving villages in 1996, has claimed land where *doyo* once grew, and in 1997 forest fires devastated areas of East Kalimantan leading to further loss of vegetation. Since that time people have begun cultivating the plants in their gardens to guard against future shortages.

The process of extracting the *doyo* fiber is labor intensive. The desired fiber is separated from the leaf in water using a bamboo knife (fig. 3.6). It is then dried in the sun before being bound into hanks. The fiber for the warp section that will contain the motif is left natural (an ecru color), while other hanks may be dyed before further processing (fig. 3.7). Individual strands are split into suitable widths to be formed into thread. These single strands are twisted by rubbing between the hands, then knotted end-to-end, trimmed with a knife, and wound into balls ready for use. The villagers often make yarn preparation a social activity (fig. 3.1).

The warp threads are measured and wound on a warping frame prior to the tying of the pattern. The desired motif is created on the warp threads by the ikat process, a resist-dye method where tied portions of the warp remain undyed (fig. 3.8). *Doyo* fiber itself was traditionally used for tying until plastic tape, which is now preferred, became available. Following the dyeing process, the tied sections of the warp threads are opened revealing an emerging pattern, and these threads are then placed on the loom in preparation for weaving.

· *The Loom*

Benuaq weavers use the body-tension loom with a continuous warp. A board for the feet gives support for the weaver to create the required tension that she provides with her body by leaning back or forward. The completed *doyo* textile is a continuous loop with one section unwoven. This can be cut to create a long flat fringed textile or left joined. As elsewhere in Indonesia, pieces that are uncut—proof that they have not been used—are sometimes reserved for gifts or are used in life-cycle rituals. Being uncut, such pieces are believed to have special power associated with the continuity of generations (Gittinger 1990, 27–29).

· *Product Range*

The width of the textile that can be woven on the back-strap loom is limited. If it is to be made into a woman's skirt, it is cut in half, stitched together along the selvage edge, and attached to a decorative cotton cloth waistband with ties (fig. 3.9). These apron-like wrap skirts, worn with ties crossed at the back and tied at the front, differ in shape and style from those now made in most other weaving areas of Indonesia where a skirt of tubular form is more common.[18] The standard size for a *doyo* textile is approximately 70 centimeters wide and 220 centimeters long. It is estimated that if one woman dedicated herself to making a standard-sized textile—from the initial process of fiber extraction through to the finished product—the task would require one month.

As well as being made into apron-like wrap skirts, *ulap doyo* is also used for sleeveless vests for men and tops and jackets for women in sleeveless, as well as short- and long-sleeved versions (fig. 3.10). While Bock commented on the brevity of Dayak clothing, his sketches from 1881 include one of a woman wearing a short-sleeved jacket, a practice he attributed to Malay influence ([1881] 1991, pl. 26, 183). Bock described two types of jackets worn by women, comparing one to a "ladies' jersey lately so fashionable in this country," which implies that it had long sleeves ([1881] 1991, 185). In 1927 William Krohn referred to "a simple, jacket, with or without sleeves, for women" ([1927] 1991, 241), and Anton Nieuwenhuis also noted this garment type (1914, 24).

Following the 1980s revival, weavers have developed their product range to attract a wider market. Contemporary *doyo* textiles are made as decorative items or accessories to appeal to potential buyers. The majority of these are wall hangings of the full textile as it comes off the loom, either as a continuous piece or cut and fringed. These are sold with an optional carved wooden hanging frame and base. The inclusion of metallic thread in *ulap doyo* as a modern decorative touch is an example of product design intended to meet contemporary tastes and increase market appeal. *Ulap doyo* has been incorporated into accessories such as handbags, small purses, wallets, shoes, boots, and hats. Men living in the Kutai region, especially those in government, like to wear a type of hat trimmed with *ulap doyo* that is modeled after caps worn by former Kutai sultans (Maulana 1982, 38). In a display of Benuaq identity and cultural pride, officials at the opening of the new administrative center in West Kutai for the Benuaq Regent (Bupati) took the innovative step of wearing waist-length *doyo* shawls around their necks (Christian Gönner, personal communication, 2005).

The "commoditization" of ethnic cultures for the purpose of touristic display is a contested issue and is regarded by some as "phony" ethnicity that results in lowered standards of production (Dahlan 1990, 142). Sellato has noted the decline in standards in traditional art production in Borneo during the last fifty years (1989, 24),[19] while Philip McKean has similarly remarked on a lack of standards in some handicrafts in Bali (1989, 123). Presumably surviving antique textiles are representative of the best quality available at the time they were collected. Inevitably the quality of textiles made as commodities is not as high as those in museum collections. In the Benuaq case several factors contribute to this variation in standards. Many weavers learned as adults and may not have the dexterity of those who learned much earlier. Their objective, moreover, is to produce quickly so the time and care taken in production is less than was the case with the antique textiles. The textiles are destined for sale, not to be retained as prized objects along with other family heirlooms. Furthermore, many travelers lack an appreciation of

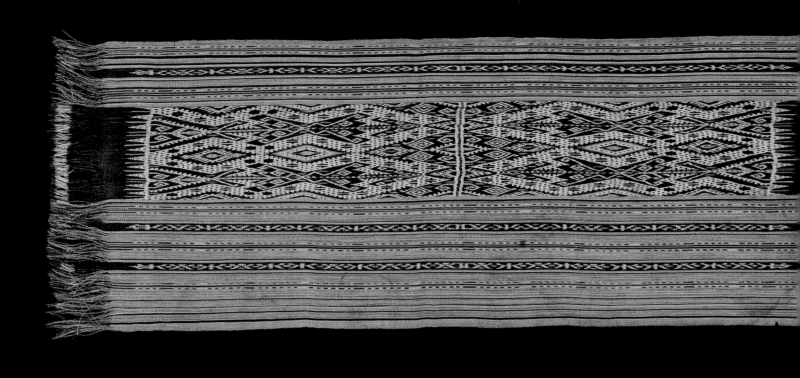

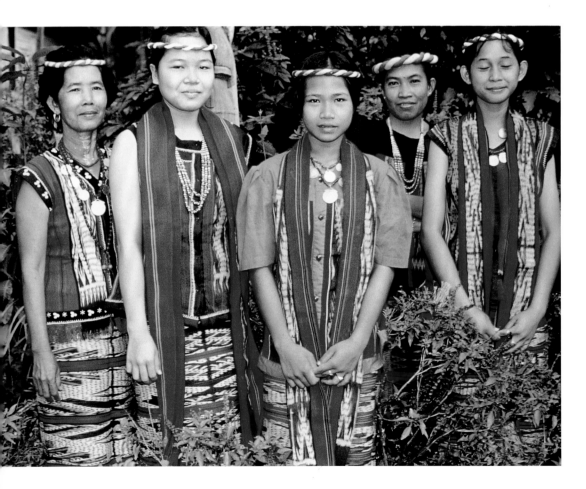

3.9 *Ulap doyo* **textile**
Benuaq peoples, East Kalimantan
Lemba (doyo) fiber
Collection of Tom Murray

This long textile may have been intended to be cut in two horizontally. The two segments would then have been sewn together so that the top and bottom of the skirt when worn would have symmetrical wide borders. Current Benuaq skirts, however, are made of only one panel of cloth and are normally finished with two waistbands of commercial cloth.

3.10 These women wear vests and jackets made of *doyo* textiles.
Photograph by Elizabeth Oley, Tanjung Isuy, East Kalimantan, 1999.

3.11 **Skirt (*ulap doyo*)**
Benuaq peoples, East Kalimantan, 1990s
Lemba (doyo) fiber, cotton
104 cm
Fowler Museum x2002.37.15;
Gift of E. M. Bakwin

The brightly colored ikat work was created with modern synthetic dyes.

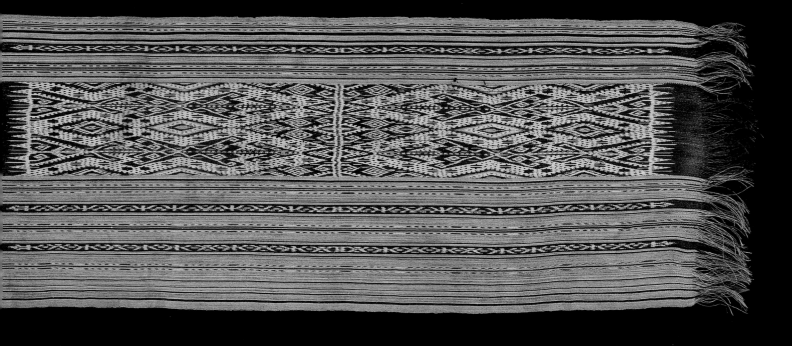

the general standards of ikat making and want a reasonably priced souvenir of their visit rather than a high-quality art object. Today, production aims to be as efficient as possible to gain a profit for the time invested, while formerly production time was not a cost factor. Quality also varies depending on the skill, experience, and care taken by the individual weaver.

· Dyes

Before the availability of synthetic dyes, the Benuaq relied totally on dyes derived from organic and mineral materials. Sources included plants, seeds, tree bark, and minerals from the region. During his visit in 1927, Krohn noted that "The Dyaks are skilled in the making and use of excellent vegetable dyes. The colors they thus impart to their clothing are always 'fast' and sun-proof. I never saw a faded Dyak garment, no matter how old the fabric from which it had been made" ([1927] 1991, 240).

Chemical or synthetic dyes have now, however, been widely adopted by the Benuaq weavers (fig. 3.11). As well as requiring more time and labor to prepare, natural dyes can be subject to seasonal availability. While it is unusual to find a

contemporary *doyo* textile that has been made solely using natural dyes, some textiles combine a naturally dyed central ikat panel with chemically dyed side panels. A further innovation is the mixing of cotton and *doyo* fiber in the same textile known as *ulap ampus*. The characteristic feature of this cloth is the inclusion of commercial cotton warp threads, which form contrasting side panels flanking the central panel of *doyo* fiber with an ikat motif. In contrast, traditional textiles were made totally from *doyo* fiber and natural dyes.

The Benuaq use natural dyes derived from a variety of sources to produce maroon brown, yellow, green, rust red, coral red, and black. The source of coral red is the seeds of the annatto tree (*Bixa orellana*), also known as the "lipstick tree" because of its use in cosmetics (Lemmens and Wulijarni-Soetjipto 1992, 50). A rust red is produced from a local pink stone (*ladu*), which is ground to a powder and mixed with water. The bark of the durian tree produces a reddish brown dye. The black dye source is soot, produced from burning resin and used in a dry powdered form. When black dye is to be used, the Benuaq dyers usually pre-dye the warp fibers maroon

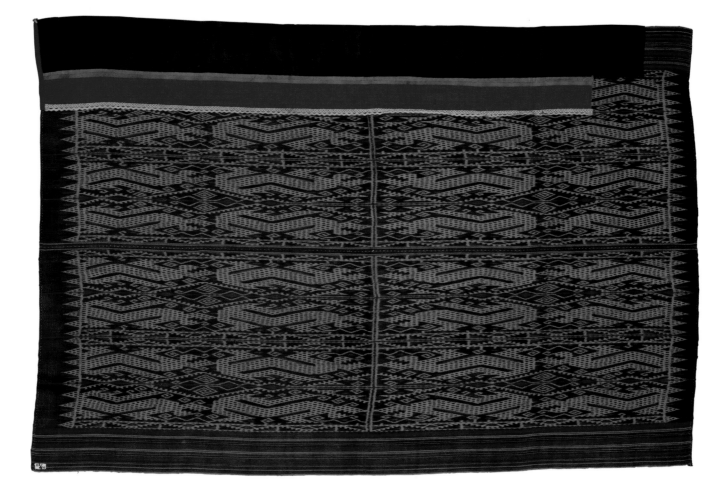

3.12 Skirt (*ulap doyo*) featuring
 the *naga*, or dragon, motif
Benuaq peoples, East Kalimantan,
collected 1910
Lemba (*doyo*) fiber
122 cm
KIT Tropenmuseum, Amsterdam, no. 48-119

brown then over-dye with black. A source of green dye is *Mimosa pudica,* a shrub known locally as *putri malu* (Taihuttu 1994/1995, 23). Yellow is derived from turmeric, *Curcuma longa.*[20] In contrast to dyeing practice in other areas of Indonesia and Malaysia, where warp threads are pre-treated with a mordant to ensure that the colors are fast, the Benuaq apply a natural fixative after the threads are dyed using the leaves of *Tricalysia* sp., a liana, known locally as *lempeke.*

In times past, weavers performed all steps of the production process. Specialization of skills has become more common in current production. Many weavers prepare their own thread, while others buy it ready-made, preferring to spend their time and energy weaving. Some specialize in tying and dyeing the motif and sell the set of warp threads ready to weave. It is estimated that about 25 percent of those weaving have the knowledge and skill to tie the ikat patterns, while only a small number of these also have expertise with natural dyes.

Traditionally, ikat design tying, knowledge of dyeing, and weaving skills were passed down from mothers to daughters.

The near demise of weaving in Tanjung Isuy broke that cycle, and during the revival of the 1980s mature women formed the majority of those learning to weave. The weaving revival has restored the traditional cycle so that young girls are once again exposed to opportunities to learn. Generally they start at about eight to ten years of age with simpler tasks such as the preparation of fiber, and by about twelve to fifteen years, they are introduced to the loom.

· Motifs

Benuaq motifs with their characteristic straight lines appear to be abstract or geometric at first viewing, but the patterns often include stylized animals or other objects associated with local myths.[21] Certain motifs are suitable for ritual events and are associated with qualities and powers appropriate for the occasion (fig. 3.12). Nieuwenhuis commented on the inclusion of the *naga* (dragon) in artistic design (1907, 2: 283). A common feature in contemporary textiles, the dragon is important to the Benuaq, who regard the goddess of the underworld as a water dragon.

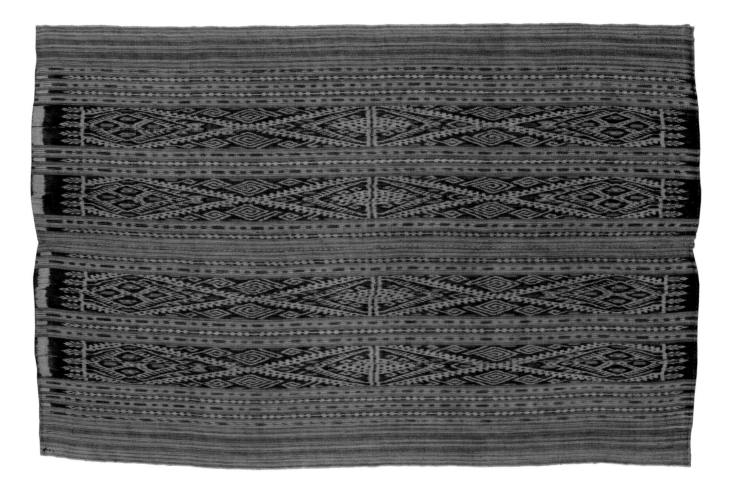

3.13 *Ulap doyo* textile featuring
 the *bati balalakn,* or snail,
 motif
Benuaq peoples, East Kalimantan,
collected 1947
Lemba (*doyo*) fiber
110 cm
KIT Tropenmuseum, Amsterdam, no. 1772-1080

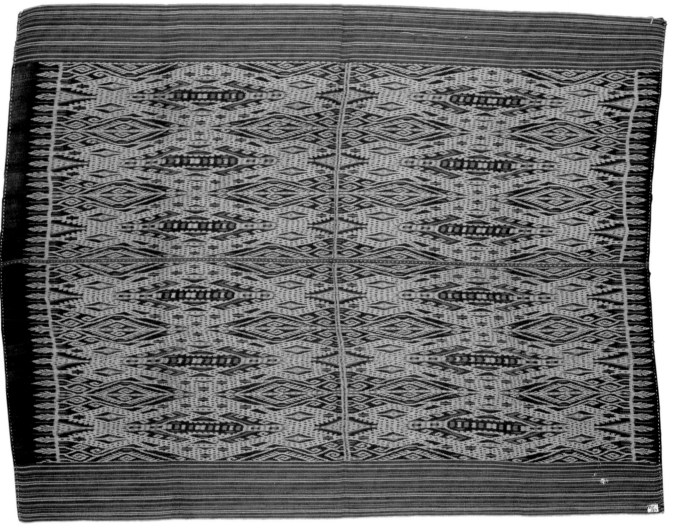

3.14

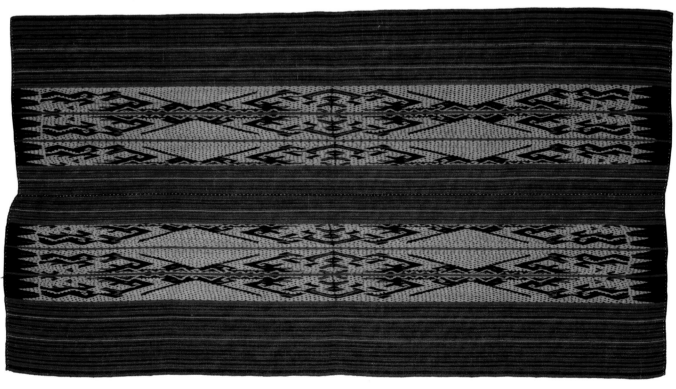

3.15

3. *ULAP DOYO*: WOVEN FIBERS OF EAST KALIMANTAN

A brochure describing *ulap doyo* and made available at weaving demonstrations in East Kalimantan lists twenty motifs used in production during the 1990s.[22] During my research, which located nineteenth- and early twentieth-century textiles held in museum collections, I identified a further twenty-eight motifs. Several of these are illustrated in figures 3.14–3.17. Museum collections in Europe, the United States, and Australia hold examples of traditional textiles with elaborate motifs, only some of which are familiar to contemporary weavers.

Antique textiles, identified during this research project, generally do not include anthropomorphic figures. An exception is the ceremonial textile held in the collection of the National Gallery of Australia (fig. 3.17). Shortly after the revival of the weaving industry, however, the human figure motif was introduced in response to the desire of visitors for

a representation of the elongated earlobes associated with the Dayak.[23] Ironically, although travelers acquire these textiles as an "authentic" souvenir of their visit, today this characteristic is very rarely seen among the Dayak who have for the most part abandoned the practice of stretching the earlobes. When dressed in traditional costumes, however, some Dayak women also wear false elongated earlobes, made from flesh-colored nylon, to contribute to what is regarded as an "authentic" look. This popular textile design now acts as a reminder of a tradition that has died out.

Following the introduction of a single human figure, two smaller figures of children flanking the central figure were added. This motif symbolizes the slogan "two children are enough" (*dua anak cukup*), drawing upon the popular imagery of Indonesia's government-sponsored family-planning campaign.

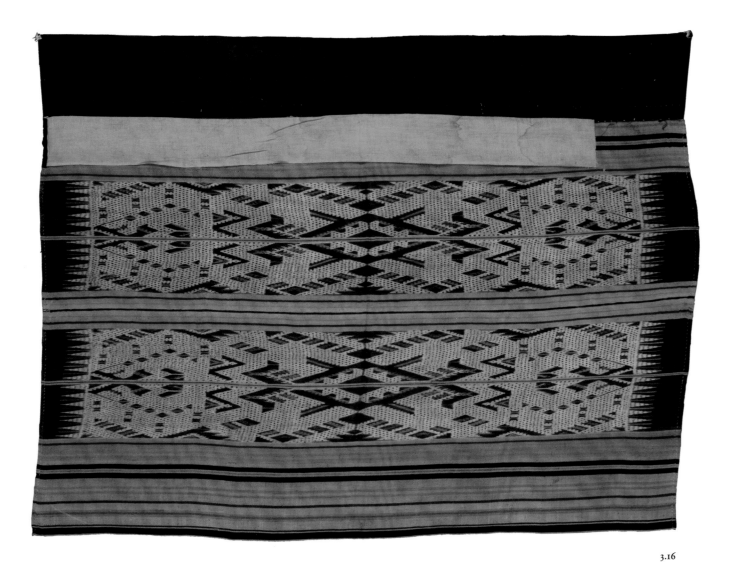

3.16

3.14 *Ulap doyo* textile featuring
the crocodile motif
Benuaq peoples, East Kalimantan,
collected 1910
Lemba (*doyo*) fiber
108 cm
KIT Tropenmuseum, Amsterdam, no. 48-121

3.15 *Ulap doyo* textile, probably
a skirt, featuring the *blaken*,
or lizard, motif
Benuaq peoples, East Kalimantan,
collected 1949
Lemba (*doyo*) fiber
104 cm
KIT Tropenmuseum, Amsterdam, no. 1944-5

3.16 *Ulap doyo* textile featuring
the *naga beranak*, or dragon
with young, motif
Benuaq peoples, East Kalimantan,
collected 1950
Lemba (*doyo*) fiber
102 cm
KIT Tropenmuseum, Amsterdam, no. 2042-5

Its known market appeal makes it the preferred motif for many weavers, and it dominates the displays of wall hangings in the Tanjung Isuy longhouse outlet, making it an emerging "traditional" motif (Hobsbawm and Ranger 1983, 1). Being relatively less detailed than traditional examples, this motif has the additional advantage of being a less-complicated design to tie.

The human figure motif is used mainly for decorative household items and would not normally appear in festive attire or ceremonial textiles. In western Borneo, anthropomorphic figures, which are frequently depicted in Iban designs, rarely appear on women's skirts (Heppell 2005, 89). The inclusion of more figurative patterns in contemporary Iban textiles is apparently a response to the visual expectations of Western observers (Gavin 1996, 12). Elsewhere in Indonesia, figurative and narrative Sumbanese textiles have also been adapted to cater to Western consumers with the former bilateral motifs being replaced with unilateral ones that can be "read" when hung vertically (Forshee 2001, 73). Other cultures, too, have modified their "traditional" decorative designs to appeal to a wider market. The Hmong (Meo) refugees from Laos now make commercialized figurative embroideries, although figurative representations were not included in their "traditional" repertoire (Cohen 1988, 380). These cases of innovation indicate the evolving process of textile design and the reality that producers are aiming to satisfy consumer demand.

The comparison of contemporary and traditional textiles reveals that changes have occurred in production methods, motifs, products, and end use. Techniques to maximize output have been introduced and materials have changed. Some weavers were sponsored by the Provincial Department of Industry to visit Troso in Central Java where they studied the non-mechanical frame loom, ATBM (*alat tenun bukan mesin*), which is much larger than the backstrap loom, in an attempt to increase output and to streamline production. Processing *doyo* fibers using the ATBM proved unsuitable, however, as the thread breaks. The group also studied chemical dyeing and other techniques aimed at increasing production. As a result, they have doubled the number of warp thread sets that they can tie and dye at one time.

Motivation for weaving has also changed. Krohn noted during the 1920s that although the manufacture of clothing was the most important industry among the Dayaks, it was undertaken primarily for individual, family, or community use and not for sale ([1927] 1991, 237–38). Trade was well established in the Mahakam River area, and while cloth was imported, handwoven textiles were not among the traded items (Krohn [1927] 1991, 237). This contrasts with contemporary production where the primary motivation is economically driven and most items are for sale. *Doyo* textiles, which were formerly confined to limited use within the Benuaq community, can now be found in homes throughout Indonesia and other countries.

THE EFFECTS OF THE WEAVING REVIVAL
Cultural tourism led to the revival of weaving amongst the Benuaq in response to a perceived demand for "authentic"

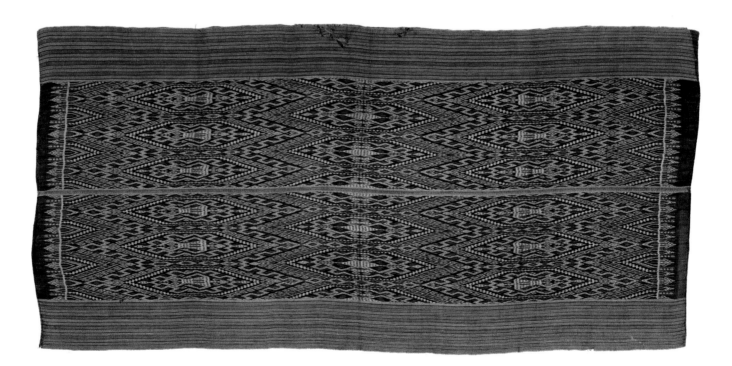

3.17 **Ceremonial cloth**
(*tawit'ng doyo*)
Benuaq peoples, East Kalimantan,
nineteenth century
Lemba (*doyo*) fiber
207 cm
National Gallery of Australia, Canberra,
no. 1985.386

cultural experience and handmade artifacts. The revival has had a significant economic impact and also benefited the community in other ways. Smith suggests that the major stimulus for the development of tourism is economic and that all new funds recirculate through the local economy in a "multiplier effect" and directly benefit local businesses that are not tourism related (1989, 6). By the end of the twentieth century, four hundred weavers and their families were benefiting directly from the sale of products. Others were also gaining from the injection of funds into the villages. "In the most visited villages, like Tanjung Isuy, a significant part of the population is involved almost full-time in craftmanship or performance. Enterprising villagers are trying to grab a share of the tourist business, feeling that tour operators from the capital and Jakarta are unduly making dollars on the villagers' backs, and want to switch from being objects of tourism to being its agents" (Sellato 1994, 19–20). An indication of the success of the Benuaq weaving revival is that *doyo* textiles have experienced the same fate as Rolex and Gucci brands with enterprising non-Dayak groups in Samarinda making and selling copies.

Cultural tourism also creates positive intangible effects, including increased pride experienced by the host community in its own culture (Sellato 1994, 19–20). Tourism generates an audience for demonstrations of cultural performances as well as a market for artistic products. Promoting culture and tourism simultaneously ensures their reciprocal development so that tourism is an agent of cultural renaissance (Picard 1993, 88–89). Benuaq culture is now an intrinsic part of cultural tourism in East Kalimantan with costumes and *doyo* textiles being featured in brochures, posters, booklets, guidebooks, and Web sites for the province.

External interest in buying handwoven textiles has raised the community's awareness of their value. Government-sponsored visits enabling weavers to attend national and international exhibitions have raised awareness of Benuaq textiles and Dayak culture. Wearing traditional costumes, the Benuaq participate regularly in the Erau, a festival that attracts Dayak groups from all over East Kalimantan to Tenggarong. These costumes, part of their collective tradition, represent the group in cultural communication giving it identity and a sense of cohesion (Honko 1995, 134). Participation in these performances and exhibitions highlights their unique skills and gives the Benuaq an increased sense of value of their own culture. It may also help to maintain that culture for future generations.

Following terrorist incidents in Bali and Jakarta, there has been a dramatic decline in tourism throughout the whole region. Other factors, such as local market saturation and changes in the number of resource-industry employees in East Kalimantan, also affect the potential market for handicrafts. Weavers may also be attracted to more remunerative work options, such as those offered by the palm oil company operating nearby. The downturn in tourist demand resulted in a dramatic decrease in the number of active weavers. By 2005 several art shops that had been outlets for *ulap doyo* and other cultural artifacts had closed down, and there was no certainty that the remaining weavers would continue to produce for a declining market. In Panama, the Kuna artisans found strategies to recover from the adverse affect on tourism caused by political events during the 1980s (Tice 1995, 68). Strategies need to be found to boost the declining tourist market in East Kalimantan without which Benuaq weavers have less incentive to continue. Currently conditions remain volatile. Following the downturn in tourism and reduction in the number of weavers noted above, however, there has been a reinvigoration of Benuaq culture that has encouraged young girls to start weaving. Thus the decline in tourist demand, which caused a reduction in the number of active weavers has been counterbalanced to some extent by the increase in demand from non-weaving Benuaq communities. The interest expressed by young girls in learning weaving suggests that the next generation may be interested in maintaining cultural traditions and prepared to invest the time and effort to learn the required skills.

The implementation of regional autonomy legislation in Indonesia has been a major factor stimulating ethnic Dayak politics and boosting the local demand for Benuaq textiles. In 1999 Rama Asia, a Benuaq bureaucrat, became Regent (Bupati) of the newly created West Kutai Regency, the first time a Dayak had been appointed to such a position in East Kalimantan. The Benuaq cultural revival is also a means of achieving social status through the bestowal of patronage in villages of origin. Successful public servants and government officials now sponsor large healing and funeral ceremonies to assert social status and gain political support (Michael Hopes, personal communication, 2005).

Since the formation of the regency with the Benuaq majority, there have been increasing textile purchases by members of non-weaving Benuaq communities. Items of material culture symbolize "Benuaqness" and affiliation with *adat* institutions that now have a higher profile in contrast to their former marginalized role (Michael Hopes, personal communication, 2005). Dayak dignitaries who live beyond the weaving areas are now commonly seen wearing *doyo* vests and hats as symbols of their identity. These include ritual practitioners, *adat* law specialists, and government members. Government officials also present Benuaq artifacts as gifts to visiting dignitaries.

CONCLUSION

The revival of the weaving industry has had a beneficial effect on Tanjung Isuy both in direct economic terms and in stimulating community cultural pride. It has heightened the community's appreciation of its material culture and unique skills and demonstrated the value of preserving them. The revival has not only been beneficial for the individual women and their families and for the Benuaq community in general but has also contributed to the maintenance and evolution of their culture. The weavers play an important role in maintaining the Benuaq traditions and contributing to the provincial culture of East Kalimantan. From an almost total demise, the weaving industry emerged during the last decades of the twentieth century to become a viable home industry. Political changes and global events since then have affected tourism. The creation of a regency with a Benuaq majority has stimulated local demand for *doyo* textiles from people living in non-weaving areas. Hopefully, communal cultural pride, combined with a viable market, will continue to sustain the Benuaq weaving tradition.

4.1 This selection of hemp
fabrics comes from Muju, North
Chŏlla Province.
Private Collection. Photograph by Bu-ja Koh.

4. *Sambe*
Korean Hemp Fabrics

Bu-ja Koh
Translated by Min Sun Hwang

KOREAN HEMP CLOTH, or *sambe* (*pe* for short), was once widely used to make everyday summer clothing. It is also commonly known as *map'o* (lit., "hemp textile"). Traditionally, the production of hemp fabrics was limited to family use, and this continued to be the case until the 1950s when the cloth fell from favor. Lifestyle changes and the adoption of mass-produced, Western-style garments reduced the demand for handwoven cloth, and traditional weaving today is largely the province of women over forty or fifty.[1]

The study of hemp weaving in Korea has largely been approached from a historical perspective with field research essentially neglected. This essay, however, is based on research initiated in 1968 that addresses the cultivation and production of hemp fiber as well as its history, recent revival, and future. The field research emphasized in the photographs was for the most part conducted in Posŏng, South Chŏlla Province (Koh 2004), and Chŏngsŏn, Kangwŏn Province, in 2003 and 2005.

HEMP IN TRADITIONAL KOREAN CULTURE

Prior to the mid-twentieth century, hemp weaving was widely practiced in Korea, and hemp was regarded as one of four traditional textile fibers, the others being cotton, ramie, and silk (fig. 4.1). Distinctive characteristics led hemp fabrics to be named after the villages where they were woven, for example, Andongp'o, Sunch'angp'o, Kangp'o,[2] or Pukp'o.[3] Hemp fabrics also had names related to their use. *Nongp'o* (*nong* meaning "farm"), for example, was intended for farmers' clothing, and *sangbe* (*sang* meaning "funeral") was used for funerary attire. *Sep'o* (*se* meaning "tax") indicated cloth that was collected as a form of taxation (see below).

Traditionally, a woman was judged by her skill in a variety of pursuits, among them weaving. As higher-quality fibers and yarns led to the production of more-refined cloth, she could expect to be evaluated not only on her proficiency at the loom but also on the fineness of the yarn she could produce. The whole procedure from yarn preparation to finished cloth is known as *kilssam*, and the yarn-making portion is particularly exhausting and time-consuming work. The production of hemp yarn is perhaps the most difficult, and a weaver who was sixty-eight at the time of the interview in 2003 recalled, "My mother-in-law, who normally fed me with poor meals, used to treat me with very good full-course meals whenever I wove because she understood the strength it required to weave on the body-tension loom."[4]

Samil (lit., "hemp work"), or the making of hemp cloth, took place between the rice harvest in November and the transplanting of the rice seedlings in June—a slack time for farmers. Weaving hemp cloth in this season guaranteed the family extra income, and this could be used to build up savings to secure a better education for children. In the fields during the summer, farmers wore *nongp'o* made of very coarse woven hemp of between 4 and 5 *sae* (a unit of warp count that is unique to Korea signi-fying eighty warp yarns).[5] It was also worn by *mŏsŭm* (farm servants), who worked primarily in the fields. *Nongp'o* was thus also known as *mŏsŭm ot* (servants' clothing). Every July fifteenth in the lunar calendar was "servants' day," and farmers gave servants hemp clothing and the day off in a show of appreciation.

Although middle-class women made at least five to ten aprons, as well as summer clothing, in hemp fabric as part of their dowries (see below), noble families never wore hemp clothing, even during hot summers. According to legend, hemp clothes were once worn only by rebels or traitors. In 936 CE, however, at the moment when the Silla dynasty (57 BCE–935 CE) gave way to the Koryŏ dynasty (918–1392 CE), the son of the last Silla king fled to the mountains and adopted hemp clothing for the remainder of his life as a demonstration of his grief. Later, he came to be known as Maŭi T'aeja, which may be translated as "prince in hemp clothing."

Because hemp cloth was the coarsest and thickest of the fabrics produced in Korea, it was regarded as symbolically appropriate for mourning dress, and its principal use was for this purpose (fig. 4.2). Hemp fabrics were worn for three, six, or nine months or one or two years—the time period being determined by the relationship of the wearer to the deceased. If a parent passed away, children wore very coarse hemp clothing for two years. Clothing made of 3 *sae* hemp fabric, the coarsest variety, was worn to a father's funeral because the children experienced feelings of "shame" and "guilt," as well as grief, when confronted with the loss of a parent, even if that parent had led a long life. Garments of 4 *sae* hemp fabric were worn to a mother's funeral (Yi 1844). Wearing hemp clothing was a symbolic act intended to "pay" for this loss and to compensate for the fact that the children had outlived their parents. The family did not wash their funeral wear for a year. Following the first anniversary of the death, males removed hemp accessories, such as hats and belts. These acts indicated that the children were "half-forgiven" for the loss of their parents. Confucian influence, which had spread throughout Korea since the fourteenth century, strengthened these rites.

Before a currency system was instituted, cotton and hemp fabrics were also collected as taxes. Prior to the 1900s, an adult man between the ages of sixteen and sixty was obligated to pay a tax and serve in the army (*Chosŏn wangjo sillok* 1392–1910). Women had to weave a significant amount of hemp fabric to meet this obligation, which was particularly burdensome if there were many men in the family. Another word for

sep'o (tax cloth) was *paekkolp'o* (*paekkol* meaning "skull"), the latter term having its origin in the government's abusive practice of collecting taxes even from the deceased.

In the past, a woman prepared everything she would wear during married life before the wedding. These items were known as *honsu* (dowry). Their advance preparation was necessitated by the fact that women lived with their husbands' families, serving them by managing both large and small family events in addition to raising their own children and making their clothing. Most married women were so busy dealing with family matters that they had no time to make clothing for themselves. Among the hemp articles they made or used were sanitary napkins (*sŏdap, kajim,* or *kŏlle*; Koh 2001). These were also used after childbirth, as the relatively cool surface of hemp aided healing following delivery.

Hemp was also used to cure rashes and other skin conditions, especially those occurring on newborns. If finely chopped hemp yarns were applied to the affected area, a rash typically disappeared in several hours. On rugged Cheju Island in the south of the Korean Peninsula mothers made their new babies hemp clothing, believing it would help them to endure the difficult life they would face in the years ahead (Koh 1994).

Beneath her traditional wedding dress, a Korean bride usually wore an unlined upper undergarment made of ramie (*mosi*) and known as a *chŏksam*. If the bride did not have a *chŏksam* to wear on her wedding night, a pair of underpants (*sokkot*) made of hemp cloth were placed under the mattress (Koh 1999). This custom may be explained by the fact that hemp stalks grow tall and straight and are also associated with integrity—attributes a newly married couple would desire for their offspring. In addition, it was believed that wearing coarsely woven hemp cloth would attract good luck and that envy and jealousy would pass through the gaps between warps and wefts.

Until the 1950s, taboos were associated with each step in the production of hemp fabric, and certain people or groups were prohibited from joining in or even being proximate to the area where hemp was being processed. Women who were menstruating, for instance, were banned from being present at the steaming procedure. It was believed that this brought bad luck and would prevent uniform steaming of the hemp stalks, ruining the resultant fabric. Men were kept away from areas where the warping and starching took place because they tended to sit with their legs crossed, which was thought to cause the yarn to tangle. Families in which a member had passed away or recently been born were also excluded from hemp making.

KOREAN HEMP TECHNOLOGY

The four different types of hemp fabrics are *musam, saengnaengi, panju,* and *ch'up'o*. *Musam* is representative of Korean hemp fabric in general. It is very coarse and thick, and the range of the quality or density of warp is from 2 to 6 *sae*. It used to be more finely woven (8 to 10 *sae*), but after it became popular for funerary shrouds, no one bothered to weave the better-quality version. Posŏng *pe*, Kangp'o, Namhae *pe*, and Muju *sambe*, all

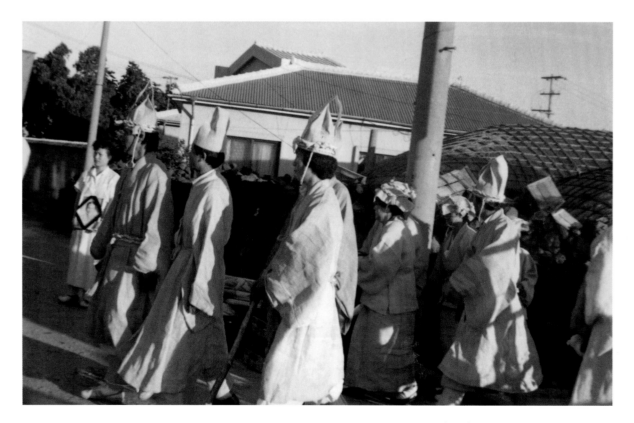

4.2 Mourners dressed in hemp garments at a traditional funeral ceremony on Cheju Island in August 1986.
Photograph by Bu-ja Koh.

of which are named after the areas where they are produced, are classified as *musam* (fig. 4.3). Kangp'o, a 5 *sae* fabric, is another name for *nongp'o*, which, as previously noted, was the most popular cloth for summer garments among farmers and their servants.

Saengnaengi hemp fabric is produced only in Andong and Ch'ŏngdo and since the beginning of the twentieth century has also been known as Andongp'o (Kwŏn and Cho 2002). The quality of the weaving of this particular cloth is superb, and since 1980 its production has increased. This well-known, fine hemp fabric ranges from 7 to 12 *sae* (fig. 4.4).

Although the same type of hemp is used for *musam* and *saengnaengi*, these fabrics involve different yarn-making procedures. For *musam*, the bast layer is peeled off immediately after steaming when the stalk is still hot and moist. The bast fiber is then hung to dry. Following this, it is retted preparatory to splitting. The split fibers are then scraped to remove any impurities. Bleach is applied before weaving. In the case of *saengnaengi*, the hemp stalks are first dried after steaming. They are then retted in small bunches for several hours. After retting, the bast fiber is peeled from the stalk and scraped to remove any impurities. It is then allowed to dry in the sun prior to splitting. Bleaching and dyeing are carried out after weaving. *Panju*, a fabric woven with silk warps and alternating hemp and cotton wefts is no longer produced. *Ch'up'o*, which is woven with silk warps and hemp wefts, is sometimes still made to order.

Because hemp plants do well in the cold weather before rice cultivation begins, they can be grown in rice fields. The seeds are generally planted between late March and early April. They are scattered by hand in the plowed field, and the soil is turned over by foot to cover them. Furrowing follows seeding. Cultivation of hemp plants requires little maintenance: simply watering and, if necessary, spraying for insects. Hemp seeds start to sprout three days after seeding.

The best time for harvesting hemp is late June or early July, a hundred days after seeding. The stems are cut close to the roots with a sharp blade known as a *nat*. The leaves are trimmed off immediately, and the hemp stalks are then sorted according to the diameter of their stems (fig. 4.5). They are divided into large bundles and stored upright in the middle of the field until they are carried to the location where steaming will take place. After the hemp stalks are harvested, rice seedlings are transplanted into the empty hemp field.

Samgut (lit., "hemp cave") refers to a steaming container or a place for steaming hemp stalks. The steaming procedure has always been regarded as men's work because it involves: constructing the *samgut*; carrying the stalks from the field and piling them on the *samgut*; providing sufficient water to steam the stalks; and afterward moving the stalks to the drying place.

Traditionally, the *samgut* was composed of two pits approximately 3 x 2.5 meters each with a tunnel connecting them. In the first pit stones were piled up and firewood was placed next to them and lit (fig. 4.6). When the stones were heated, they were completely covered with soil. In the second pit, tree branches and leaves were laid down, and hemp stalks

4.3 An example of *musam* hemp cloth known as Muju *sambe,* this textile is coarsely woven (3 *sae* 3 *kuri*). Scale is in centimeters.
Photograph by Bu-ja Koh, 2005.

4.4 This *saengnaengi* hemp cloth, also known as Andongp'o, has a characteristically fine weave (12 *sae* 4 *kuri*).
Photograph by Bu-ja Koh, 2005.

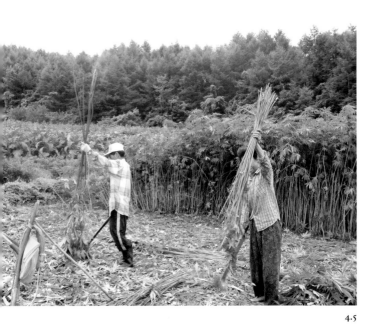

4.5

4.6

4.7

4.8

4.9

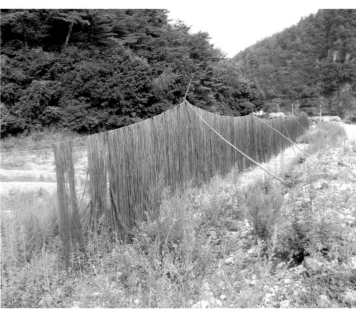

4.10

were placed on top of them (fig. 4.7). A large straw mat covered the pile, and a layer of earth sealed it all. Men dug narrow channels down through the dirt to the heated stones in the first pit, and a large quantity of water was poured into them. The heated stones generated steam, which traveled through the tunnel to the second pit, gradually steaming the hemp. Every ten to twenty minutes, more channels were made to reach different parts of the stone pile, and the procedure was repeated (fig. 4.8).

This traditional steaming method has all but disappeared since the 1950s and is practiced today in only a few villages. More modern procedures have been developed in different regions. In one locale a concrete-walled, underground steamer is equipped with an automatic heat-controlled boiler. A metal cage holding the hemp stalks fits inside the steamer with a lid at the top. Elsewhere, a pit in the ground is equipped with a place for a fire at one side. A cast iron water container goes into the pit, and four or five wooden bars are placed across the top. As the hemp stalks are piled upon the bars, the whole is covered with a plastic sheet that is tied all around to trap the steam (fig. 4.9). Steaming generally takes six to seven hours. In most cases hemp stalks are laid on top of the steaming container, but if they are tied in small sheaves, they may be placed upright within it.

After steaming, the hemp stalks are immediately soaked in water. The bast layer is peeled from the core and hung to dry (fig. 4.10). The fiber layers are then sorted by length; oriented so that their tops are all pointed in the same direction; and retted. The base ends of the fiber layers are pounded, crushing them to make splitting easier. Splitting is accomplished using

the fingers of the right hand and a long thumbnail. The quality of the hemp fabric to be woven is already a consideration in the splitting process: the fineness of the woven textile depends on the skill applied to the splitting and the quality of the raw fiber layer. It takes a day to split sufficient fibers to make yarn for a bolt of fabric 15 meters long and 35 centimeters wide. After splitting, the fibers are scraped with a metal scraper on a board to remove any impurities and are hung to dry again.

To make a continuous length of hemp yarn, the split strands must be spliced together. Two methods are used, both involving the weaver rolling the strands with her palm on her thigh. In the first instance, a strand is pulled out from the split bundle, and the tip end is wet with saliva and split into two. The base of a second strand is wet and inserted between the two split ends of the tip of the previous strand. Next, the base and one of the split tip ends are combined and twisted, first in a Z-direction. The other split tip end is then added and also twisted in a Z-direction. Finally, all three elements are twisted in an S-direction (fig. 4.11). In the second instance, two strand ends, one a tip and the other a base, are combined and twisted in a Z-direction. The twisted segment is then folded down toward the tip end of the whole strand and twisted again in an S-direction. This method may create thicker joins, making the yarn uneven (fig. 4.12).

After a length of continuous yarn is made by splicing, an S-twist is added to the rest of the yarn by rolling it on the thigh. A seated worker puts the just-twisted length of the yarn around her leg below the knee and pulls it out to loosen the twist. As

4.5 Farmers harvest hemp stalks in the field, trimming their leaves.
Photograph by Bu-ja Koh, Muju, North Chŏlla Province, 2005.

4.6 A traditional *samgut* involves preparation of two pits, one of which contains heated stones for steaming the hemp stalks.
Photograph by Bu-ja Koh, Chŏngsŏn, Kangwŏn Province, 2005.

4.7 Hemp stalks are piled atop branches and leaves in the second pit of the traditional *samgut*.
Photograph by Bu-ja Koh, Chŏngsŏn, Kangwŏn Province, 2005.

4.8 Men pour large quantities of water through narrow channels and onto the heated stones in the first pit, thereby forcing steam through the tunnel to the pit containing the hemp stalks.
Photograph by Bu-ja Koh, Chŏngsŏn, Kangwŏn Province, 2005.

4.9 A modern-style *samgut* employs a cast iron water container and plastic sheeting to trap steam.
Photograph by Bu-ja Koh, Chŏngsŏn, Kangwŏn Province, 2005.

4.10 The bast layers, removed from the stalks after steaming, undergo a first drying.
Photograph by Bu-ja Koh, Chŏngsŏn, Kangwŏn Province, 2005.

4.11 The steps in the first splicing method are illustrated here. A microscopic photograph (20x) shows all three strands twisted in an S-direction.
Drawings and photograph by Min Sun Hwang.

4.12 The steps in the second splicing method are illustrated here. A microscopic photograph (20x) shows the strand twisted in an S-direction.
Drawings and photograph by Min Sun Hwang.

4.11

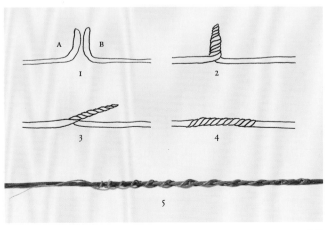

4.12

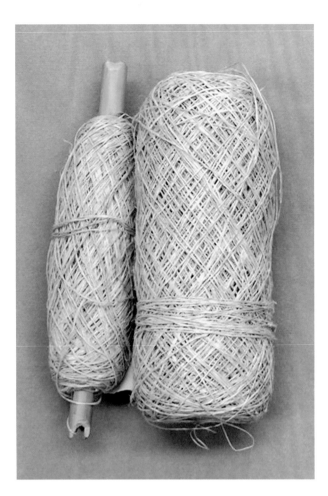

4.13 A *kkuri* is a cone of weft
yarn bundles.

Photograph by Bu-ja Koh.

4.14 In the process of warp-
ing, ten skeins are fed through the
holes in the yarn guide and wound
around two warping boards placed
at opposite ends of a long shed.
Sand is poured on top of the skeins
to prevent tangling.

Photograph by Bu-ja Koh, Muju, North Chŏlla
Province, 2005.

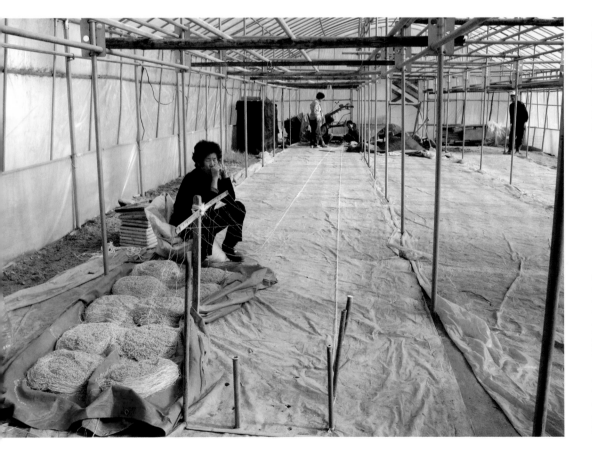

4.15 Starched warps are dried
over embers of burnt rice husks as
weavers complete the sizing process.
The round metal warp beam shown
here is for a frame loom.

Photograph by Bu-ja Koh, Andong, North
Kyŏngsang Province, 2004.

4.16 A weaver works at a body-
tension loom with a traditional flat
wooden warp beam at the back.

Photograph by Bu-ja Koh, Muju, North Chŏlla
Province, 2004.

the yarns are made, they are gathered in a basket until being transferred to a reeler. Once reeled into balls, they are put on a four-pegged skeining frame. When they have been made into skeins, the hemp yarns are bleached in a bath of a caustic soda solution and then rinsed. The caustic soda solution removes any remaining impurities from the bast fiber. The skeins are then repeatedly dried in the sun and soaked in water at night for five to six days.

The yarn skeins are then soaked in water left over from washing rice and brought to a semidry state. This first bath will be repeated three or four times to add luster and strength to the yarns. A second bath involves soaking the yarns in water left over from washing rice to which rice bran, gardenia seedpods, or yellow clay has been added; this bath lasts for two to three days. The skeins are then dried well and checked for any tangles or faults. They may be sold by weight.

Kkuri, an oblong bundle of weft yarn with a hollow center, is fit into the *puk*,[6] or shuttle (fig. 4.13). To make a *kkuri*, a bobbin-winder is used to wind yarn onto a bamboo bobbin. The yarn guide on the bobbin-winder automatically moves from one end to the other end of the bobbin, winding the yarn evenly. A bobbin can be wound manually but only a skillful weaver can do it so that the yarn unwinds smoothly in the shuttle without the slightest hitch. The weaver removes the bobbin and then soaks the *kkuri* in water for three to four hours before fitting it into the shuttle. The yarn unwinds from inside of the *kkuri*.

Warping is usually done outdoors due to space requirements (fig. 4.14). When the warping circuit is finished, the lease of ten warp units is secured with strings, and the rest of the warp length is wound into a bundle and secured with ties. Reeding-in is done before dressing the loom. One odd and one even strand are threaded in each dent of the reed. Meanwhile, the lease must be kept secured with lease sticks. The tied ends of the warp are then set up on the warp beam. The warp must be sized with cooked starch for additional strength to protect against the abrasion created by the reed and the movement of the upper and lower shed threads during weaving. The starch is prepared by mixing boiled millet grains with Korean soybean paste. It is said that salt from the soybean paste absorbs moisture in the air, keeping the warp from breaking, and that the soy waxes the surface of the warp. The warp beam is installed on a warp beam hanger, and the warp is stretched out in preparation for sizing (starching). Working over a bed of embers of rice husks, burnt in preparation for starching, the workers apply water first and then starch with a brush (*p'ulsol*), working only in the direction of the splices. As starch is applied, the reed is moved up to separate the individual threads of the warp as they are being dried above the embers (fig. 4.15). As each successive section of warp is dried, it is wound onto the warp beam with sticks laid between the layers to prevent the warps from getting stuck to each other and to keep the tension even.

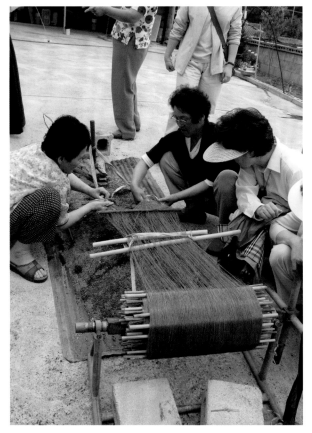

4.15

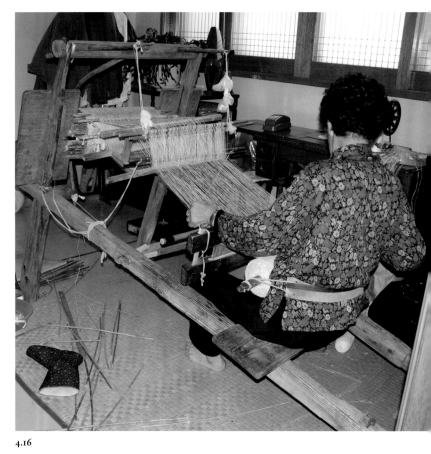

4.16

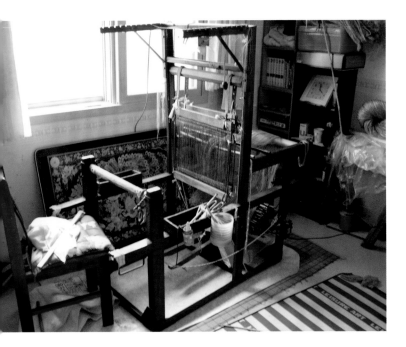

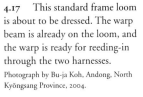

4.17 This standard frame loom is about to be dressed. The warp beam is already on the loom, and the warp is ready for reeding-in through the two harnesses.

Photograph by Bu-ja Koh, Andong, North Kyŏngsang Province, 2004.

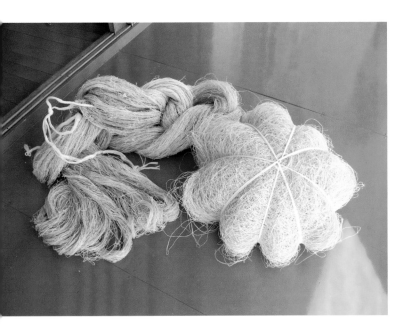

4.18 Hemp yarn (*kussam*) is also known as *silttŏk* in some regions. The skein at the right is intended for weft yarn. It is gathered in a round basket and tied to prevent tangling. The skein at the left is for the warp.

Photograph by Bu-ja Koh, Muju, North Chŏlla Province, 2005.

When the sizing process is completed, the warp beam is placed in position on a loom ready to be dressed. Two types of looms are used for hemp weaving in Korea. The first, the traditional loom (*paet'ŭl*), is a body-tension loom made of wood. The weaver wears a back strap around her upper hips and with her body pulls it back to tighten and forward to loosen the tension on the warp (fig. 4.16). The loom can be disassembled when it is not in use to save space. It is constructed of approximately thirty parts, and each has symbolic meanings, as well as associated stories. Marital problems form the subject of most of these tales. They are part of a long-standing tradition and are transmitted orally among the weavers to relieve the stress and the monotony of the work. During the Korean War, a large number of traditional looms, including *paet'ŭl*, were destroyed. Since the 1950s, a standard frame loom has also been used for weaving hemp, which it does with greater efficiency (fig. 4.17). It cannot be taken apart once assembled, however, and thus takes up space in the house. When weaving starts, the hemp warp yarns just above the weaving area must be wet. A temple, made from a branch of bush clover (*Lespedeza bicolor*) with pins in both ends, is used to maintain the width of the cloth while weaving. When a section of hemp fabric is removed from the loom, it is washed, and the final touch-up, including lining up the warps and wefts, is performed. The bolt is then ready for sale.

HEMP TEXTILES IN CONTEMPORARY KOREAN SOCIETY

In South Korea today, hemp is cultivated in Chŏngsŏn, Samch'ŏk, Kangnŭng, Ulchin, and Tonghae in Kangwŏn Province; Namhae in South Kyŏngsang Province; Andong and Ch'ŏngdo in North Kyŏngsang Province; Naju and Posŏng in South Chŏlla Province, and Muju in North Chŏlla Province (fig. 4.19). Even in these areas, however, only very few people engage in hemp production and commerce.

Four kinds of hemp products are marketed. The raw fibers before the splitting stage (*p'isam*) and hemp yarn (*kussam*, also as known as *slittŏk* in some regions; fig. 4.18) are primarily sold to those weavers who cannot afford to cultivate hemp. They are sold by weight, and 4.8 kilograms of hemp yarn, for example, sold for us$140–150 in July 2004.[7] In the majority of cases, domestic yarn products are four times as expensive as those imported from China. The third product is hemp fabric, *sambe*, the selling price of which is based on length and quality (fig. 4.20). The price also varies depending on where the hemp fabric was woven (fig. 4.21).

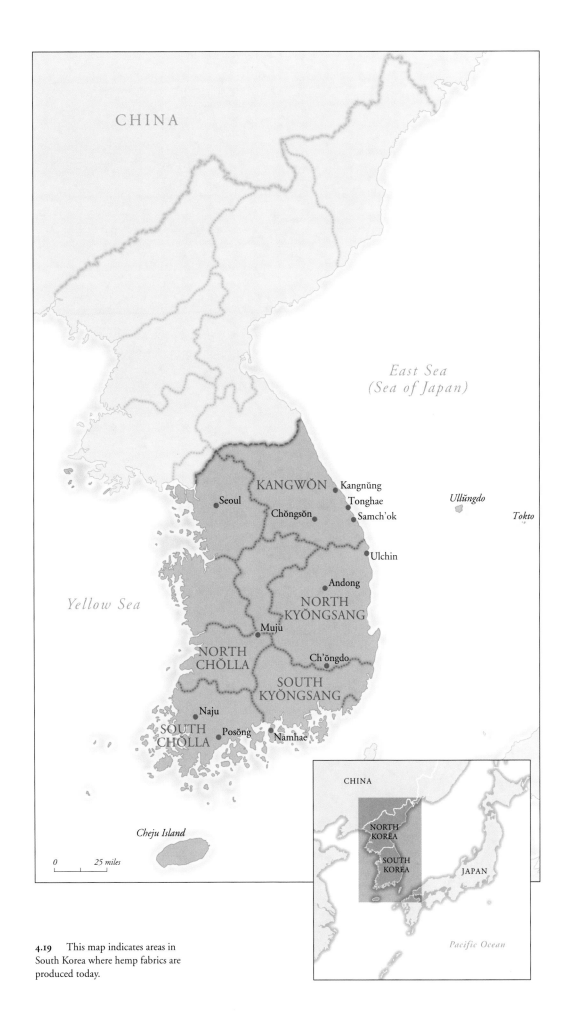

CHINA

East Sea
(Sea of Japan)

KANGWŎN Kangnŭng

Seoul Tonghae

Chŏngsŏn Samch'ok

Ulchin

Yellow Sea Andong

NORTH
KYŎNGSANG

Muju

NORTH Ch'ŏngdo
CHŎLLA

SOUTH
KYŎNGSANG

Naju

SOUTH Posŏng Namhae
CHŎLLA

Ullŭngdo

Tokto

Cheju Island

0 25 miles

CHINA

NORTH
KOREA

SOUTH
KOREA

JAPAN

Pacific Ocean

4.19 This map indicates areas in
South Korea where hemp fabrics are
produced today.

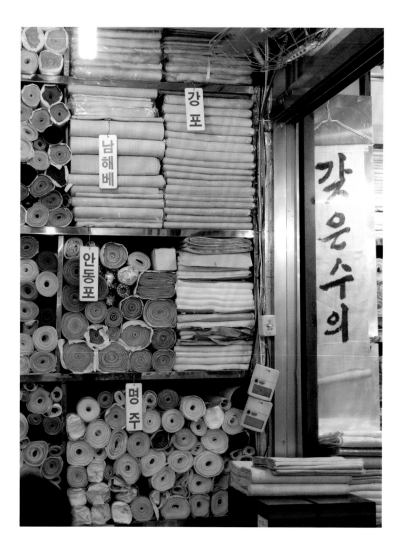

4.20 Each shelf in this hemp fabric store in Seoul bears a label indicating where the cloth was woven. Hemp fabric is traditionally sold in rolls.

Photograph by Bu-ja Koh, 2005.

4.21 The relative price of hemp fabric is based on the place where it was woven.

		Posŏng	Kangnŭng	Muju	Tonghae	Ulchin	Namhae	*saengnaengi*	
								Andong	Ch'ŏngdo
Sae	4 *sae*	$200		$250–300	x	x	x	x	x
	4 *sae* 2 *kuri*	*$200						x	
	5 *sae*	$250		$350		$500–550		x	*$700
	5 *sae* 2 *kuri*		*$500–600						
	6 *sae*	$300–350		x		*$600–650		$550	$550
	7 *sae*	x	$600–650	x				*$750	
	8 *sae*	x		x		$1,300	x	*$800	x
	8 *sae* 4 *kuri*	x	$1,300	x		$1,300	x	$900	x
	10 *sae*	x	x	x		$2,000	x	$1,500	x
	12 *sae* 2 *kuri*	x	x	x	x	x	x	$2,500	x
Standard length of 1 *cha* (cm)[8]		60	55	55	50	50	55	55	55
Selvage to selvage		35	36–37	36–37	36–37	36–37	35.5–36	36–37	36–37
Standard amount of fabric / 1 *p'il*		20	30	20 or 30	28	30	40	30	30

x indicates that a product is discontinued.

* indicates the most popular products.

The last of the four hemp products, *suŭi*, is a set of burial clothing with multiple components. The Korean equivalent of a shroud, *suŭi* is known by an assortment of names—among them *chugŭm ot*, *mŏnŭng ot*, or *hosang ot*[9]—depending on the region. Until the beginning of the twentieth century, a family would have a set of burial clothing prepared for one of its members who had reached the age of sixty. It was believed that this act would actually cause parents to live longer, and they typically felt healthier and happier when they received their *suŭi*.

In addition to the *suŭi*, the deceased was traditionally buried with extra clothing and bedding, as well as money and personal articles, for use in the afterlife (*chŏsŭng*). Although it was believed that after death, there was no discrimination between rich and poor, the *suŭi* of nobles and members of the upper class were typically made of silk with a variety of restrictions imposed on the color that could be used.[10] Members of the middle class usually had their *suŭi* made of cotton, and the *suŭi* of servants or the poor were made of hemp fabric or sometimes simply consisted of clean clothing that the person wore when alive. The body of a traitor, a rebel, or the victim of an epidemic was not clothed; instead, the body was covered with straw mats before burial. Excavations of burial sites—primarily belonging to aristocratic and upper-class families—dating from the Chosŏn dynasty (1392–1910 CE) have revealed a majority of silk burial clothes with a few examples made of cotton and hemp and none made exclusively of hemp.

Following the Korean War (1950–1953), Korea underwent a sustained period of modernization and development of its infrastructure. In the 1990s, the improvement of roads and construction of new buildings necessitated the exhumation and reburial of a number of bodies. This gave people the opportunity to see the remains of their ancestors, and to observe that not all bodies had decomposed equally well. Those that had not fully decomposed were more difficult to rebury given a lack of space. It was at that moment that hemp fabrics, which were believed to decay more quickly than others, began to be considered the most appropriate for burial clothing.

This preference for hemp *suŭi* coincided with the establishment of diplomatic relations between Korea and China in 1990 and the resultant upsurge in the importation of Chinese goods. Cheap, mass-produced Chinese hemp fabrics became widely available and weakened the competitiveness of the expensive handwoven Korean variety. Many Korean weavers began to buy Chinese hemp yarns, making it very difficult to differentiate fabric woven of genuine Korean hemp.

Meanwhile Chinese fabrics using hemp wefts but warps of ramie, cotton, or synthetic fibers began to be distributed. This was revealed during a second wave of reburials, and the discovery created an uproar. The Korean Fair Trade Commission issued a warning and began fining hospitals and funeral homes that sold *suŭi* made of these mixed-fiber fabrics. A distinct preference for the better-quality Korean hemp fabrics developed, reviving the country's hemp industry. Ironically, the revival was prompted by Koreans who no longer necessarily believe in an afterlife and simply wish to be practical in the face of a possible need to change burial sites in the future.

Depending on where it is woven, the *suŭi* and the number of pieces it entails will differ (fig. 4.22). A shroud set is composed

Region	Posŏng		Muju		Ulchin		Chŏngsŏn	
Gender	MALE	FEMALE	MALE	FEMALE	MALE	FEMALE	MALE	FEMALE
Price per *suŭi*	$2,500		$2,500–3,000				$1,200	
Quality / *sae*	4 *sae*		3 *sae* 2 *kuri*		6 *sae*		4 *sae*	
Quantity of fabric / *p'il*	7.5–8 *p'il*		6–7 *p'il*	5–6 *p'il*	3 *p'il*		3 *p'il*	
Number of pieces	18	16				12		
Cost of labor per *suŭi*	$100		$70–90	$50–60	$100			
Year	2003		2004		2004		2003	

4.22 The price and number of pieces for *suŭi* (burial clothing) differ in various regions of Korea.

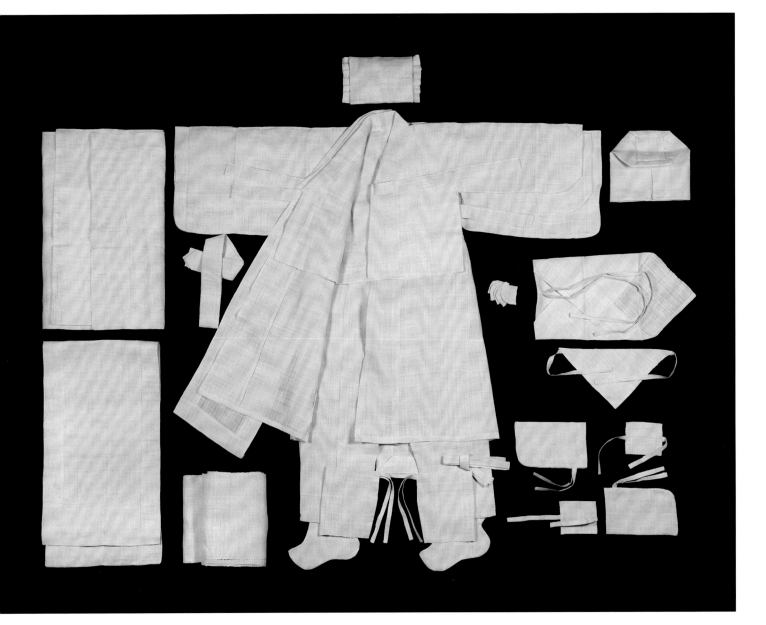

4.23 This contemporary hemp *suŭi* (burial clothing) for a man consists of nineteen pieces.

Private Collection. Photograph by Bu-ja Koh.

4.24 This funeral ceremony took place in April of 2005. The men wear bands (*wanjang*) around their right arms, which indicate their relationship to the deceased. Two stripes indicate that the wearer is a son; and one stripe, a son-in-law. Grandsons and other male relatives wear a *wanjang* without stripes. In this photograph, Christian participants stand, bending forward from the waist to pay their respects. Others, who are Buddhist, kneel down and bow on the ground before the tomb.

Photograph courtesy of the family of Sŏ Ch'ŏngwŏn.

of the basic *hanbok*,[11] the traditional Korean form of dress, as well as a complete bedding set, a face cover, and a pair of socks and gloves (fig. 4.23). An additional cloth is used to wrap the body. Generally, a shroud set is sold for US$2,500–3,000.[12] The most expensive *suŭi* is made with Andong hemp fabric.

Although hemp fabric is highly desirable for contemporary *suŭi*, the practice of mourners dressing in rough hemp garments has virtually disappeared in modern Korea. The Korean population today prefers simple and pragmatic funeral rituals to the complex formal ceremonies that were performed in the past. Furthermore, with the introduction of Christianity at the turn of the twentieth century, the less-complicated Christian ceremony was embraced by new adherents to the faith. In 1973 simplified family ritual standards[13] were declared nationwide and strongly supported by intellectuals as well as Christian groups. Today, men typically attend funerals dressed in black Western-style suits worn with a hemp armband (*wanjang*) and a hemp ribbon (*sangjang*; fig. 4.24). The armband has one or two horizontal stripes symbolizing the relationship between the wearer and the deceased. Occasionally, men wear a hemp hat and a pair of leggings, which have their origin in traditional funeral wear. Women wear the traditional Korean dress (*hanbok*) in black with a white ribbon. A *hanbok* of white cotton may also be worn with a hemp ribbon.

Since the beginning of the twenty-first century, there has been a trend in Korea toward emphasizing leisure and health over concerns of affluence and reputation. This has influenced the use of hemp fabrics for items such as summer bedding sets and ordinary summer clothing. As it is very expensive to mass-produce domestic hemp, Chinese hemp fabrics are used for these items. This new popularity may, however, positively affect the Korean hemp-weaving industry and encourage weavers of hemp fabric to keep weaving.

Korean hemp is a natural fiber and a sustainable resource. No waste is associated with it from the growing stage to making cloth to recycling. Hemp plants grow well without spraying or additional fertilizer and require only basic watering. After the bast fiber layer is removed, the white core of the hemp stalk can be utilized to make shades, floor mats, and dividers, as well as plant food. As people have begun to experience the drawbacks of synthetic fibers and become increasingly aware that we must coexist with nature, they have turned once again to natural fibers. Simultaneously, it has become very important economically and ecologically to find a fiber that does not pollute the earth in the process of its cultivation. Today, hemp fabric is again in the spotlight, and hemp fiber is recognized as one of the most desirable fibers to produce around the world.

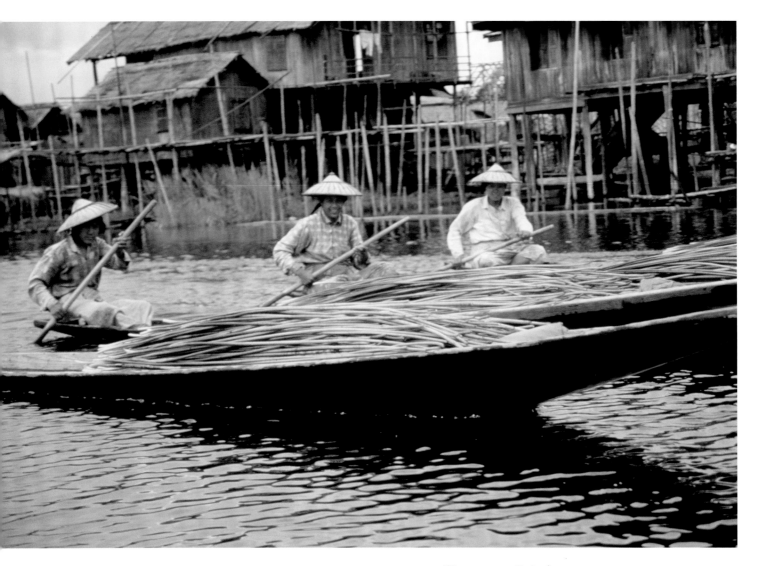

5.1 Women return to Kyaing-kan village with boatloads of trimmed lotus leaf stems, which have been plucked from In-le Lake.

Photograph by Ma Thanegi, In-le, 1999.

5. Stemming from the Lotus
Sacred Robes for Buddhist Monks

Sylvia Fraser-Lu and Ma Thanegi

ONE OF THE HIGHLIGHTS of the Burmese Buddhist calendar is an annual weaving competition held to commemorate the legend wherein Maya, the mother of the Buddha, stayed up all night in the Tavatimsa Heaven to weave her son a suitable "fresh" monk's robe (*matho-thingan*) on the eve of his Enlightenment. Looms are set up on the brightly lit platform of the Shwedagon Pagoda in Rangoon, Burma's most sacred shrine, on the evening before the day of the full moon of November (Tazaung-mon). Five teams of young unmarried women—all under the age of twenty-six and selected from various parts of Burma—work at full throttle in fifteen- to twenty-minute relays throughout the night to complete a fresh *matho-thingan*. When the weaving is done, the robes are cut into "patches," stitched together, embellished with gold-foil cutouts, and then triumphantly borne aloft in a grand procession around the pagoda prior to being reverently draped over its Buddha images. Prizes are awarded for speed and quality of workmanship (San Win n.d., 14–16; Fraser-Lu 1981, 34–36).

During the weaving competition of 1981, a team of In-tha weavers from the remote village of Kyaing-kan (fig. 5.3), some six hundred kilometers north of Rangoon, was selected to compete. Working with a rougher fiber than their competitors, who used the more easily handled, machine-processed cotton, they did not win the contest. Their sturdy, beautifully woven robe, however, caused quite a sensation among the devout onlookers when it was discovered that the yarn used had been drawn from the leaf stems of the lotus, a potent symbol of the Buddhist faith (fig. 5.2). Although the fabric, the creation of a pious In-tha woman, had been in existence for some seventy years, it was unknown outside of Shan State. Weavers and pilgrims from other parts of the country had never before seen such weaving. The rarity and nobility of the work left witnesses in awe and produced an upsurge in orders for this sacred fabric.

Religious robes are a Buddhist badge of identity, a visual reminder of the wearer's religious vows and honored status. While cotton robes are accepted and worn by monks throughout Burma, robes woven from lotus fibers are presented only to the most revered of senior monks, who, for the most part, consider them too sacred to wear. Such robes are often preserved in glass cases near the monastery shrine where they are admired and venerated with other offerings made to the Enlightened One.

5.2 This dark pink *kya-nyo* lotus (*Nelumbo nucifera*) grows wild in the shallow waters of In-le Lake. Widely scattered, it is found in clumps near other plants, such as lilies, water hyacinth, and various grasses.

Photograph by Ma Thanegi, 1999.

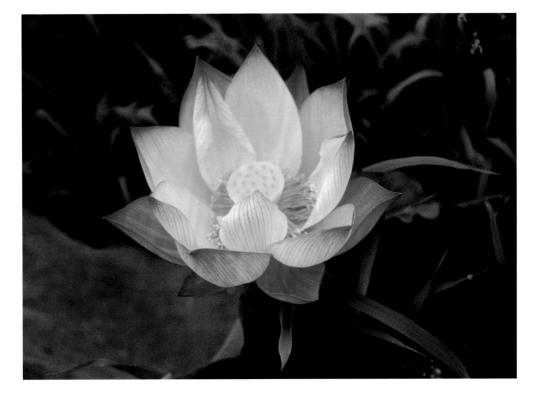

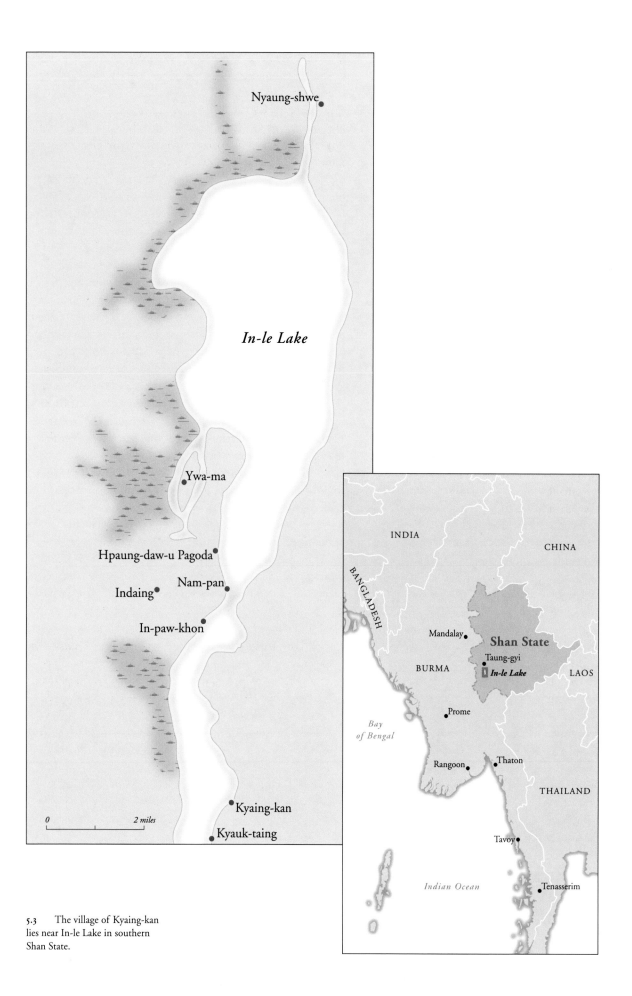

Nyaung-shwe

In-le Lake

Ywa-ma

Hpaung-daw-u Pagoda

Nam-pan

Indaing

In-paw-khon

Kyaing-kan

Kyauk-taing

0 2 miles

INDIA

CHINA

BANGLADESH

Mandalay

Shan State

Taung-gyi

In-le Lake

BURMA

LAOS

Prome

*Bay
of Bengal*

Rangoon

Thaton

THAILAND

Tavoy

Indian Ocean

Tenasserim

5.3 The village of Kyaing-kan
lies near In-le Lake in southern
Shan State.

SONS OF THE LAKE

The In-tha hail from the southern part of scenic In-le Lake, nestled between ranges of hazy blue mountains nearly 1328 meters above sea level in southern Shan State. An adaptable and industrious group, the In-tha, whose name may be translated as "sons of the lake," first settled along the shallow shoreline of this 22-kilometer-long, 11-kilometer-wide stretch of water between the fourteenth and eighteenth centuries. Originally from Tavoy (Dawei) on the Tenasserim coast far to the south, the In-tha may have voluntarily migrated to the area, or they may have been brought there as prisoners of war.[1] The In-tha language is considered a dialect of old Burmese as spoken in Tavoy, which has been greatly modified by contact with the Mon and Tai/Shan peoples among whom the In-tha have lived for the past few centuries (Scott and Hardiman 1900, 1.1: 564–65). The present-day In-tha population is able to read, write, and speak standard Burmese (Bernot 1982, 142).

Since the land bordering the lake originally belonged to the aggressive and numerically superior Shan, the In-tha had to make creative use of all available natural resources in order to survive. They built pile-supported villages that protruded into the lake, refined the art of fishing with a cone-shaped net, and developed unique leg-rowing abilities. They also cultivated a wide range of vegetables, citrus fruit, and flowers on fertile floating islands that were built up from tangled water hyacinth plants bonded and enriched by layers of silt from the lake bed. All of these adaptations attest to the success of the In-tha in coping with their new environment.

Today some 70 percent of the approximately 100,000 people who inhabit the In-le Lake area are considered to be In-tha, although many have intermarried with the local Shan population over generations. Some have also found spouses among nearby minority groups such as the Pa O and Danu peoples, who are often seen selling produce at the rotating five-day markets in the area. Unlike these minority groups, however, the In-tha cannot be distinguished by clothing. Everyday wear for women is a blouse and plain or patterned sarong (*lon-gyi*) of imported cotton fabric purchased at the local bazaar. On festive occasions In-tha women may wear the locally woven warp-striped *lon-gyi* of the southern Shan. In-tha men also wear Shan attire—loose cotton trousers with a low crotch, a Chinese-style jacket, Western shirt, and towel-like turban.

BUDDHISM AND INDIGENOUS FOLK BELIEFS

Like their Shan neighbors, the In-tha are devout Theravada Buddhists, as are 85 percent of all Burmese. The seventeenth-to eighteenth-century pagoda shrines of Indaing near Nam-pan, as well as numerous other abandoned pagoda complexes nearby, attest to the religious zeal of In-tha forebears, while the large barn-like wooden monasteries built today with public donations continue to be the most prominent buildings in lakeside villages.

Apart from observing the Five Precepts and a number of basic Buddhist rituals, however, the average villager is not overly preoccupied with the finer points of theology.[2] Individuals are primarily concerned with maintaining and possibly improving their current status within the chain of rebirths. Life is very much linked to fate, luck, chance, and destiny, known as karma, or *kan* in Burmese. Closely intertwined with *kan* is the concept of merit, or *kutho*, which accrues in the karmic bank account when good deeds are performed. Villagers believe that present existence is the total of past deeds but that the opportunity exists to redress the balance of merits versus demerits and improve karma for the next existence.

In Burmese Buddhism the accumulation of merit has traditionally revolved around acts of giving and self-sacrifice. Buddhists in Burma have been known to spend anywhere from 10 to 25 percent of their disposable income on activities intended to accrue merit. The ultimate gift is the building of a pagoda or a monastery, and while in the Burmese heartland the most famous monasteries have usually been the result of the largess of a single donor, village monasteries in Shan State have largely been financed as community projects. Some of the more affluent members of a community purchase the land and put up the seed money with the rest of the villagers contributing what they can afford in the way of cash, materials, and labor with all sharing in the merit accrued. The size of the monastery and the quality of the materials used are public statements of community wealth and well-being. The monastery also serves as the venue for most Buddhist festivities and ceremonies that distinguish a village as a unit.

Nicola Tannenbaum notes that monks and monasteries hold an especially important place in Shan folk beliefs, which revolve very much around power and protection. Monks are believed to have a "special aura" and can offer protection to those who enter into relationships with them (1995, 182). The majority of Buddhist householders, regardless of their financial circumstances, offer food to monks daily. Devotees also supply basic necessities such as robes and alms bowls[3] and are deeply honored to offer their sons as novitiates, an act that in precolonial Burma constituted a rite of passage.

To cope with everyday crises considered to be outside the scope of orthodox Buddhism, many Burmese turn to indigenous pre-Buddhist systems of belief that center on the propitiation of a host of spirits known as *nat*. These may be broadly divided into two types: nature spirits and mythical-historical guardians, including a number of celestials co-opted from the Hindu-Buddhist pantheon. Nature spirits, originally linked with the earth, sky, mountains, lakes, and trees are associated with inexplicable natural calamities, while mythical-historical guardians watch over the household, towns, and cities. The latter include an "orthodox" list of thirty-seven *nat*s associated with Burma's historical and legendary past. Most of the historical figures died tragically and were raised by royal decree to the status of *nat*. Propitiation ceremonies for various *nat*s may be held at times of individual and communal vulnerability, such as rites of passage, the planting and harvesting stages of the agricultural cycle, or when embarking on a journey or an important venture. The services of those skilled in the arts of astrology, fortune telling, the making of charms and amulets, tattooing, alchemy, magic, and other protective or divinatory systems may also be sought by individuals to circumvent misfortune.

THE SYMBOLISM OF THE LOTUS

Because it is rooted in the mire and sludge of the primordial waters of the universe, yet rises above their surface in perfect splendor, unsullied and undefiled, the lotus has become an emblem of purity, beauty, grace, divine peace, and detachment from the earthly shackles of greed, anger, lust, passion, jealousy, and ego. In a Buddhist context it may represent the Buddha himself, and equally important, it may also suggest the potential of all sentient beings to grow beyond the base desires and attachments of earthly existence and become truly enlightened. As a symbol, the lotus is ubiquitous in Buddhist art and literature (figs. 5.4, 5.5).

In Burma devotees press their palms and fingers together before their foreheads in the praying position (*namaskara mudra*), which is said to resemble a "lotus bud." Unlike other flowers, lotus blooms are not usually sold in Burma for general household or office decoration. Instead they may be purchased at stalls within close proximity to places of worship, for the flowers and buds of the lotus are also presented as votive offerings at pagodas, temples, and household shrines (Luzoe 1998, 35–37).

The termination folds of the robes on a number of nineteenth-century, dry-lacquer Burmese Buddha images are flamboyantly molded to resemble lotus leaves and petals.[4] Many such images were commissioned for veneration at monasteries and pagodas in Shan State. An even more popular auspicious

icon found in many homes and places of business throughout Burma is a statue of Dakhina Sakka. Seated in the earth-touching position (*bhumisparsa mudra*), this squat, heavyset Buddha image has a plump face that merges into the shoulders from a barely discernable neck. It represents an infant Buddha who delights in frolicking amongst the lotuses. The hairline of this image is scalloped to represent a lotus-leaf covering, while the base of the throne may have a lotus pond and fish carved in low relief. The statue is thought to attract wealth and prevent fires (Mya 1914, 220–21). This particular Buddha icon has a special place of honor in the household shrines of the lotus fiber weaving establishments of the In-tha.

LOTUS WEAVING MYTHS

Although the conquest of Thaton in 1056 by Anawrahta of Pagan (r. 1044–1077) was to place Burma firmly within the Theravada Buddhist fold, a variety of religious philosophies from India had reached Burma during the first millennium of the Common Era through missionary and trading contacts. This is significant as the lotus also figures prominently in Hindu art, mythology, and literature, and in a number of instances a connection is made between weaving and the lotus.

Of particular note is the account of how the Hindu deity Visnu in the form of the supreme god Narayana gave birth to the universe. While he was floating on the primordial waters,

5.5 A painted lotus rosette appears on the soffit of one of the corridors in the Ananda brick monastery in Pagan, Burma, which was built in 1775 CE.
Photograph by Sylvia Fraser-Lu, 1991.

5.4 Mon-style images in lacquered wood from southern Burma portray Gotama, the present Buddha, along with Maitreya, the Buddha of the future. Seated on lotus thrones, the two figures are framed by a backboard featuring a trio of lotus buds in low relief embellished with lacquer and gold paint.
Collection of Joel Greene.
Photograph by Sylvia Fraser-Lu, 1991.

reclining on the Sesha serpent in a mysterious slumber, a lotus stem sprung from his navel bearing the gods of the preeminent Hindu triad—Brahma, Visnu, and Siva—on lotus pedestals (fig. 5.6). This popular Hindu creation myth, known as the *Anantasayana Visnu*, has been taken by some Indians, among them the Devanga weaving caste of Mysore, to herald the origin of weaving on the subcontinent. This is because Manu, who was created by the god Brahma and regarded as the mythical progenitor of the human race, fetched "the thread for weaving from the heart of the lotus stems that grew out of the navel of Vishnu [Visnu], the protector" (Dhamija 2000, 121).[5]

Stone reliefs depicting the *Anantasayana Visnu* creation myth uncovered from the fifth- to ninth-century Pyu site of Sri Ksetra, near Prome, and from ninth- to tenth-century Thaton in Lower Burma attest to the fact that the early inhabitants of Burma were familiar with such popular Hindu mythology. In neighboring Thailand there is even a reference to the weaving of robes for a future Buddha from the lotus. In a central Thai version of the Hindu epic *Ramayana*, the hero Pra Ram (Rama) slays a certain powerful giant in the Lopburi area whose daughter was betrothed to Maitreya, the Buddha of the future. According to the legend, as she awaited his coming, she kept herself preoccupied each day by weaving a piece of cloth made from the filaments of lotus stalks, which she intended to present to him as a robe when he became a Buddha (Rajadhon 1961, 71).[6]

5.6 A stone bas-relief from Thaton, Burma, portrays the Anantasayana, or sleeping Visnu. According to Hindu mythology, this deity—in the form of the supreme god Narayana—gave birth to the universe while sleeping on the Sesha serpent in the waters of creation. A lotus stem springing from his navel supports Brahma, Visnu, and Siva, the three principal deities of the Hindu pantheon. Photograph by Watts and Skeen from *Temple* (1894, pl. XIVa).

A few informants well-versed in the minutiae of Burmese literature and folklore have also related that in certain versions of well-known legends, some of the great beauties of Burmese folklore, such as Ummadanti, owed their physical charms to that fact that they were weavers of lotus yarn in previous existences.[7] While the origins of the variant details of these stories are difficult to ascertain, weaving has always been a very highly respected activity for women in Burma, one formerly practiced by the majority of the female population. A woman's industriousness and skill at the loom in precolonial Burma enhanced her prospects in marriage.

Ma Mei U, the patroness of weaving in Burma, is one of the thirty-seven *nat*s. Betrothed to a forester, her comeliness attracted the attention of the lecherous Shwei-hpyin-nge *nat* who attempted to seduce her while she was working at her loom. On being rebuffed, the *nat* sent a tiger to kill her. Her virtue and integrity are greatly admired, and weavers often include an effigy of her in the family shrine.

The Burmese like to trace the weaving of sacred robes from lotus fibers to a popular nineteenth-century Buddhist tome, the *Jinattha-pakasani*, which states that when the Buddha-to-be was severing his hair to symbolize the renunciation of his former princely existence, he was offered a set of monks' robes by the Brahma Ghatikara who had found them in a lotus blossom.[8] While this text may be at variance with details of other orthodox Buddhist accounts of events, there is no doubt that lotus robes refer to a set of garments of great purity and nobility.[9] There is also a reference to the making of sheer canopies and drapes from filaments drawn from the lotus stem to keep mosquitoes away from sleeping royalty, which underscores the fact that the use of fabric created from lotus fibers was limited to exalted personages (Luzoe 1998, 36–37).[10]

IN-LE CRAFTS AND THE LOTUS FIBER WEAVING OF KYAING-KAN VILLAGE

The majority of the In-tha/Shan population of In-le lives in one of the approximately twenty-two small villages that line or extend out from the shores and hills bordering the lake. At present farming and fishing do not guarantee sufficient income for the average family in the area, and the poorest inhabitants are those who rely on farming alone. Many supplement their agricultural income by weaving traditional costumes, sewing garments, and preserving and preparing food products for sale. Best off are those who have abandoned farming and fishing

altogether in favor of full-time artisanal work (Bernot 1982, 42). Potters at Kyauk-taing make lead-glazed ceramic wares while blacksmiths at Nam-pan forge scrap iron and steel into the everyday tools needed for carpentry, farming, and silver and goldsmithing. Silversmiths and lacquer workers at Ywa-ma craft a variety of receptacles to hold the votive offerings required for an annual religious festival held each September where the sacred Buddha images from the Hpaung-daw-u Pagoda are conveyed in a crane-shaped (*karaweik*) barge powered by a contingent of leg-rowers to various lake sites for veneration. The village of In-paw-khon is famous for weaving the silk weft-ikat sarong known throughout Burma as *zin-me lon-gyi*. Shan bags for tourists are woven in the Ywa-ma area close to the Hpaung-daw-u Pagoda.

The lesser-known, but unique, lotus fiber weaving takes place at Kyaing-kan, a Shan/In-tha village, the largest settlement at the southern extremity of the lake. Informants are of the opinion that the village is around two hundred years old but do not profess to have any specific knowledge of its founding. Like many villages in Burma, Kyaing-kan is divided into east and west sections, each of which keeps very much to itself, tending to regard those living in the other section as competitors. Each side has its own monastery, and although the two edifices are situated only a few yards from each other, the villagers of each side attend their own monastery for ceremonies, feasts, meditation, and prayer. Joint activities are rare. The majority of the population is supported by trading and market garden activities with specialization in tomato cultivation.

Those associated with processing and weaving the fibers of the lotus (*Nelumbo nucifera*), known as *padonma-kya* in Burmese, are domiciled in the east section of the village, which consists of approximately seventy households. According to informants, this activity began around 1910 when a woman called Daw Sa Oo (Madame Sparrow's Egg) decided in the interest of gaining merit to attempt to produce a set of robes for her preceptor, the highly revered abbot of the nearby Shwei-u-daung-taung (Golden Peacock Feather) Monastery, from the fibers of the local *padonma-kya* lotus plant, which grew wild in shallow areas of the lake. With the help of her friends she tirelessly experimented with various filament extraction and preparation processes, eventually weaving a set of robes to her liking.[11] On receiving the garments, the delighted abbot had the weaver's name changed to Daw Kya Oo (Madame Lotus Egg) in honor of her pious achievement. Daw Kya Oo and her friends continued to weave with lotus yarn for meritorious rather than commercial purposes, producing one or two sets of robes a year for eminent local abbots. They also wove small pieces of fabric to clothe the five sacred Buddha images of the Hpaung-daw-u Pagoda, which are deeply venerated by the In-tha people. Unfortunately, no members of Daw Kya Oo's family survive, but the descendants of her friends carry on the tradition.

The surge in orders generated by the success of the weavers at the 1981 *matho-thingan* weaving competition in Rangoon meant that more women were needed, particularly for the time-consuming gathering of stems and the making of yarn. Under the socialist military government, which came to power in 1962, all Burmese enterprises employing more than a handful of people must be constituted as cooperatives—subject to the jurisdiction of the local township cooperative office, which plays a supervisory and advisory role and may also assist in locating raw materials and markets for products. A craft cooperative known as the Padonmar Kyar Thingan Cooperative was thus formed in the early 1980s, and three workshops, all managed by women—Daw Ohn Kyi, Daw Shwe Hla, and Daw Tin Shwe—soon emerged. Each one is independently operated, subject to the rules of the cooperative. The best known is the Padonmar workshop operated by Daw Ohn Kyi and her family.

Finding workers for lotus fiber weaving production in the lake area does not appear to be a problem. The wages are low, but the chance of being associated with a merit-making activity has attracted the more devout. The seasonal nature of lotus-stem gathering also means that the younger women do not have to work all year round. Their task takes place early in the morning, so many have their afternoons free for domestic chores and other activities. Weaving establishments in the area are still able to draw on women who learned how to weave from female family members when it was common for households to produce more of their own cloth requirements. Women have traditionally appreciated the flexibility that weaving allows. During the busiest times of the agricultural cycle and when their children are small, it is possible for younger women to cut back or to do piecework at home. Middle-aged women, free from child-rearing responsibilities, are able to devote more time to weaving and contribute more to the family's income.

Women in Burma not only manage the household but serve as custodians of the family's wealth and assume full responsibility for how earnings are spent. They are noted for their financial savvy, and many manage businesses as equal partners with a family member or a friend; others may own and operate enterprises in their own right as distinct from the male members of the household. At many bazaars in Burma, a majority of vendors are women. As hands-on entrepreneurs, Burmese women are quick to recognize a commercial opportunity and are adept at cultivating a web of trusted suppliers and loyal customers to further their business interests through a network of relatives, friends, former schoolmates, and other contacts.

FIBERS AND LOOMS

The lotus plant with its hardy rhizome thrives in a warm tropical climate but is able to withstand below-freezing temperatures when dormant. To bloom, lotuses require at least five to six hours of sun a day for three to four weeks with air temperatures above 80 degrees Fahrenheit and water temperatures in the 40s and 50s and above. The flower and its large silvery blue-green peltate leaves rise on 61-centimeter- to 1.9-meter-long stems above the water surface from the nodes of 15- to 46-centimeter-long, jointed, horizontal rhizomes anchored at regular intervals to the mud of the lake bed by clusters of small roots. At In-le lotus blooms appear in white, pale pink, and a highly prized deep dusky pink known as *kya-nyo*. The latter, considered the most sacred and rare, also produces the most fibers. To procure stems of optimum length, the harvesting of lotus leaf stems takes place during the rainy season from June to November when the level of the lake is at its highest.[12]

About a week prior to harvesting, popped rice is scattered on the water where the lotuses grow. Offerings of betel, pickled tea, and cheroots are made to placate the *nat*s of the locality, known here as "Guardian Spirits of the Sacred Lotus," and to seek permission to pluck the stems. At the same time, a wish is expressed that the stems will yield plenty of fibers. There is a traditional belief that it is better for men to gather the stems, as women could be considered "unclean" due to their menstrual cycles. If this task is performed by women, which usually happens today, special care must be taken not to offend by such actions as participating in the activity during menstruation. If the spirits of the locality are affronted, they could cause the lotus to disappear in favor of more isolated areas.

On the day of harvesting, the gatherers make an offering at a household shrine to their patroness and the guardian spirit of the looms, the *nat* Ma Mei U. This consists of a perfect green coconut with stem intact surrounded by three hands of bananas, along with lighted candles and rice cakes colored with white and brown sugar. Prayers are also offered to a lotus-capped Dakhina Sakka Buddha image for a bountiful harvest and to

seek his good offices in insuring that the spirits of the lake and of the lotuses do not become angry. If aroused, they may cast snakes and scorpions into the water to harass those who gather the stems. To further appease the spirits and protect the loom and its products, talismans made of checkered squares of interlaced bamboo and colored paper, along with small banana plants, are tacked to the looms prior to weaving. To ensure the sanctity of the robes about to be woven, all involved throughout the process must strictly observe the Five Precepts incumbent on all good Buddhists.

The lotus leaf stems are gathered by younger women from small boats in the morning (fig. 5.1). They grasp the plant below the leaf with one hand while the other extends down as far into the water as possible to detach the almost 2-meter-long stalk from the rhizome with a gentle but firm tug, taking care not to dislodge the parent plant from the lake bed. The purple and green stalks of the young unfurled leaves are preferred over mature examples. The stems are trimmed on-site before being transported in neat piles back to the village where they are kept moist. They must be processed within three days, before they dry out.

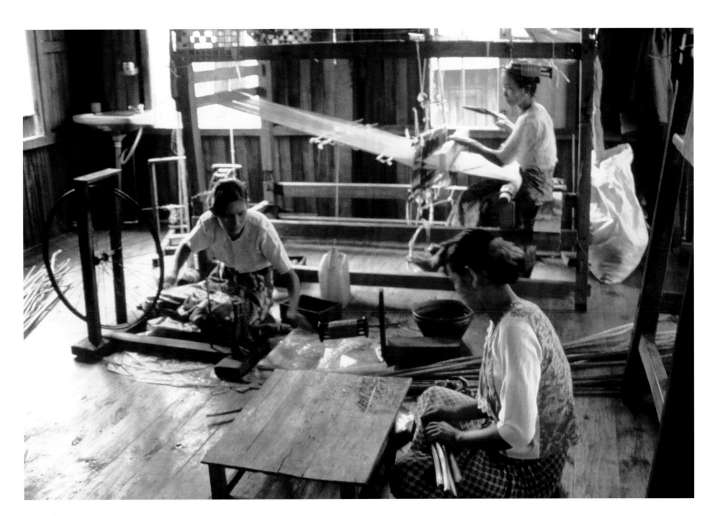

5.7 In the Padonmar Lotus workshop in Kyaing-kan, a young woman (foreground) sits at a low table removing the filaments from the lotus stems and rolling them into thread. Behind her, a woman with a spinning wheel winds and twists skeins of lotus yarn, which will then be transferred onto reels and bobbins in readiness for the weaving process. At the back of the room a weaver works at a traditional Thai/Burmese floor loom producing the lotus fiber fabric for monks' robes. Photograph by Ma Thanegi, In-le, 1999.

The stem gatherers, seated on the floor at low, long, rectangular tables, prepare the stems, first removing the nubbly prickles on the upper section by rubbing them with a piece of coconut husk (fig. 5.7). The smoothed stems are then placed to the left on the floor beside the young woman who carefully moistens the working area before taking five or six stems with her left hand. A shallow knife cut is made around these bunched stems about 12 centimeters away from the ends, which are quickly snapped off and twisted to reveal some twenty to thirty fine white filaments (fig. 5.8). These are deftly drawn from the stem and rolled into a single yarn about 25 centimeters long with the palm of the right hand. The slightly adhesive fibers from another section of cut stems are easily joined to the previous filaments with a rolling motion and the process is repeated. The

yarn produced is coiled onto a plate to the right of the preparer (fig. 5.9). At the end of the session the newly made yarn is allowed to dry before being twisted and wound into skeins, which are sold to weaving establishments for 1800 *kyat* per *viss* (which in 1999 amounted to just over US$4.50 per 3.6 lbs.).[13]

WEAVING THE YARN

The yarns are prepared for weaving by placing the skeins on a bamboo spinning frame powered by a bicycle wheel and twirling the thread onto 25-centimeter-long, runged cylindrical winders of black-lacquered wood and then onto 18-centimeter-long bamboo spindles. These are slotted onto one of six metal rods set in a vertical frame. Powered by a large hand-turned wooden wheel, the yarn from the spindles is twisted and wound

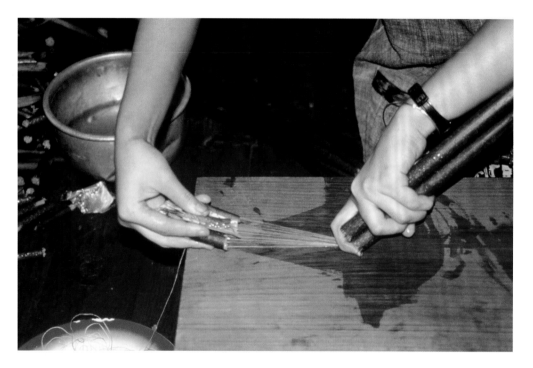

5.8 Working on the wet surface of a small, low wooden table, a woman draws the filaments from a bunch of lotus stems.

Photograph by Sylvia Fraser-Lu, Padonmar Lotus workshop, Kyaing-kan, In-Le, 2000.

5.9 Once she has extracted the twenty to thirty filaments from the bunch of lotus stems, the preparer rolls them together to form a single thread. This in turn is coiled onto a plate.

Photograph by Sylvia Fraser-Lu, Padonmar Lotus workshop, Kyaing-kan, In-le, 2000.

around large squat reels. Any broken ends are joined together (with a single carrick-bend knot), which the workers refer to as a "fish-tail" knot in deference to the lake and its bounty. The thread from the reels is then wound into skeins, which are starched with a rice gruel paste before being dried and rewound onto thick 25-centimeter-long cylinders. For warping, the cylinders of yarn are placed, twenty at a time, on a long row of small, upright metal posts in a large room, and the threads are paid out and looped at the opposite end around stakes in a weaver's cross so as to separate the threads into an upper and lower set in readiness for weaving. Taking great care to avoid any tangling, the threads (over 90 meters in length) are then gently lifted from the warping posts and coiled into huge plastic bags. Yarns designated for the weft are wound from cylindrical-shaped winders onto short, 8-centimeter-long bamboo bobbins designed to fit snugly into the central depression of the wooden, boat-shaped shuttles that carry the weft thread through the warp to create a plain-weave cloth.

Lotus fiber fabric is woven on a traditional Thai/Burmese rectangular frame loom (2 meters long x 1.2 meters wide x 1.5 meters high), which has a seat built in for the weaver (fig. 5.10). Weaving components include a cloth beam, a large warp spacer-beater, and a pair of heddles consisting of cotton leashes clamped to sticks suspended from cords passing though a pair of pulleys that are supported by a transverse bar resting on top of the frame. The heddles are connected by rope to a pair of wooden, disc-shaped foot treadles.

There is no warp beam on a Thai/Burmese loom. Prior to weaving, the new warp, consisting of approximately 1,360 individual yarns, is threaded through the heddle leashes and then painstakingly tied onto the remnants of the former warp threads left on the loom. The new warp, secured behind the heddles with a pair of laze rods, is passed under a horizontal warp bar and over the top of the loom frame to be tied with a knot around a transverse bar within easy reach of the weaver who unties it at regular intervals to release further sections of the warp as weaving progresses. The excess warp is kept in a large plastic bag behind the weaver. Such a warping method limits the width of cloth that can be woven to around 60 to 75 centimeters.

The use of a bow-shaped bamboo temple keeps the selvages straight during the course of weaving. To make weaving smoother, the warp threads are regularly rubbed with a wax-impregnated wooden stick. Water is also kept on hand to moisten the threads during the course of weaving. Given the origin of the fabric, weavers feel that the lotus fibers have a predilection for "remaining cool." The fabric is woven in 90-meter batches, which take about a month and a half to complete (fig. 5.11).

According to the "Eighth Khandhaka" of the *Mahavagga* text, monks should wear *ticivara*—three garments made from rectangular pieces of cloth: an undercloth the *antaravasaka* (*thin-baing*) wrapped around the lower half of the body and secured with a girdle or belt; the *uttarasanga* (*e-kathi*) draped over the upper torso; and the *sanghati* (*du-got*), or large shawl, which in tropical countries such as Burma and Thailand is usually worn folded on the left shoulder (Davids and Oldenberg 1885, 2: 212). The usual offering for monks' robes in Burma

consists of a set of two—the 2.5 x 2 meter *antaravasaka* and the 1.125 x 2.5 meter *uttarasanga*. Weavers have estimated that fibers from around 120,000 lotus leaf stems are required to produce a single set of monk's robes. The good intentions demonstrated by the amount of labor required to produce one set of robes earn women substantial merit.

The newly woven cloth is then sent to Taung-gyi, the largest town in southern Shan State, where it is farmed out as piecework to be dyed by local women with chemical dyes in a color specified by the donor, which may range from saffron yellow to a deep reddish brown. After being pressed, the fabric, in keeping with the original Buddhist injunction that monks wear clothing made from discarded rags gathered from dust heaps or graveyards, is cut into ten "patches" and strips of different sizes

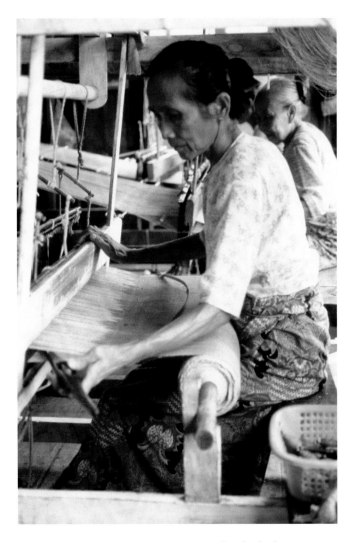

5.10 Seated at her loom, a weaver throws a boat-shaped shuttle through alternating warp threads.
Photograph by Sylvia Fraser-Lu, Padonmar Lotus workshop, Kyaing-kan, In-le, 2000.

and lengths that are machine-sewn together in rows to resemble the traditional mosaic-like appearance of community-owned rice fields prevalent at the time of the Buddha (Davids and Oldenberg 1885, 2: 193, 208–9).[14]

Remnants of various sizes are fashioned into apron-like "mini-robes" with two strings of the same yarn attached to the top to secure the cloth around the shoulders of the Buddha images that fill the shrines and niches of pagodas and monasteries. These robes are not usually cut into patches but are decorated with sequins and strips of gold foil to simulate the joins on a monk's robe (fig. 5.12). Stylized lotus rosettes may also be stitched on the fabric for further embellishment, along with the names and pious aspirations of the donor.

Not a single thread of this precious fabric is wasted. Leftover scraps of yarn and cuttings from the loom are twisted by the weavers into wicks to be used in small lamps, which are offered as gifts of merit at the various religious festivals that follow the conclusion of weaving activities. To ensure the "continuation of life," the number of wick threads are carefully counted out according to a person's age and deftly twisted and coiled in a tripod form so as to stand upright. After being trimmed, the wick coil is set in an earthenware lamp filled with sesame oil. Because of their aquatic origins, the "lotus wicks" for oil lamps are thought to "cool the flames of worries" and bestow on the donor a "cool heart," peace of mind, and blissful contentment.

WEAVING AND THE BUDDHIST CALENDAR

The weaving season for the lotus fiber fabric, which lasts from June to November, coincides with many important events in the Buddhist calendar. It spans the three-month-long Buddhist "lent," which lasts from the full moon of July (Wa-zo) to the full moon of October (Thadingyut). It is a time of spiritual retreat for all believers. Monks are confined to their monasteries, and many young men become novices. No marriages, feasts, or public amusements take place, and pious laymen try to observe more than the customary Five Precepts incumbent on all Buddhists.

Lent comes to a close with a Festival of Lights, also known as Thadingyut, to celebrate the Buddha's return to earth after preaching the "Abhidhamma" to his mother in the Tavatimsa Heaven.[15] At the end of the Buddhist lent the laity take it upon themselves to replenish the supplies of the monastic community, the most popular gift being robes. For this annual gift giving (ka-htein), triangular structures of wood known as padetha trees are erected in public places or under marquees along the roadside where the faithful may place gifts for the monkhood in the form of robes, alms bowls, water filters, and razors. Additional donations such thermos flasks, soap, umbrellas, notebooks, mats, towels, and blankets may also be offered, as well as crisp new kyat notes artfully folded to resemble lotuses. The matho-thingan weaving competition at the full moon of November is one of the highlights of ka-htein.

WHITHER THE LOTUS?

Since the success of the In-tha weavers at the matho-thingan competition in 1981, orders for monks' robes woven from lotus fibers have been steadily increasing. An enterprise that evolved from the desire of one woman and her friends to accrue merit has become a source of income for nearly a hundred women. Each workshop is currently making around twenty sets of robes a year and is not able to keep up with orders coming from Rangoon and Mandalay, as well as those from local In-tha and Shan people. A set of robes is expensive and in 2002 was retailing for 250,000–300,000 kyat (around US$400), a king's ransom for most Burmese.

5.11 The various stages of lotus fiber yarn processing are represented here: newly gathered lotus leaf stems; the loose yarn made from the filaments inside those stems; and the dried yarn wound into skeins and twisted and reeled onto winders and bobbins. These samples rest upon a folded length of woven lotus fiber fabric, which has been dyed and will be used to make a monk's robe.
Photograph by Ma Thanegi, Padonmar Lotus workshop, Kyaing-kan, In-Le, 1999.

5.12 A lotus fiber cloth— embellished with sequins in the form of lotus blooms and of parallel lines that simulate the "patches" of monks' robes—adorns a Shan dry-lacquer image of the Buddha.
Photograph by Ma Thanegi, Nga-hpe Kyaung Monastery, In-le, 1999.

With the opening up of Burma to tourism in the nineties, scenic In-le Lake has become a popular destination for foreign travelers. The establishment of hotels and guesthouses in the Nam-pan area has brought the locals in contact with foreigners. Visits in the late nineties from Japanese tourists with an affinity for natural bast fibers eventually led to contact with some haute couture designers in Japan who expressed an interest in obtaining large amounts of lotus fiber fabric in longer and wider yardages to make blazers and skirts for exclusive clothing boutiques in Tokyo.

The prospect of secularizing the product initially presented those involved with a dilemma, despite the fact that it could mean welcome additional income (cf. chapter 9 of this volume). Older and more devout weavers expressed reservations about the prospect of this sacrosanct fabric being "subverted" into women's clothing. This appeared sacrilegious to some given the fact that the lower garments of a female should never come in contact with a male. Most of the older weavers favored the status quo and the knowledge that in weaving robes exclusively for the highly revered monkhood and for sacred images, they were performing a meritorious act. Burmese people on the whole value above all an uncomplicated life free from the worries and ambiguities of committing actions intentional or unintentional that may derail them on the quest for nirvana—the ultimate goal of all devout Buddhists.

With the blessing of the Township Cooperatives Offices, a new breed of younger textile entrepreneurs has, however, set up a few workshops in the In-le area to take advantage of the economic prospects offered by selling lotus cloth to foreigners. Less encumbered by religious scruples, these newcomers have happily had gatherers scour the lake for larger supplies of lotus stems to make more yarn. When supplies have proved insufficient, they have been known to contract with groups as far away as Loikaw in Kayah State to the south to meet an increasing demand for this exclusive fabric. Some entrepreneurs have also been experimenting with mixes of silk and lotus thread with a view to selling abroad.

After some initial interest in Japan, it was found that clothing made from lotus fiber did not sell as well as hoped. With little understanding of the laborious process involved in making the lotus yarn, potential buyers found blazers retailing at US$1,500 to be too expensive. This failure to successfully retail lotus fabric clothing in Japan probably came as a relief to many of the more devout among the In-tha weavers. Instead, objects such as napkins, place mats, scarves, and bags have found a small niche market among Japanese textile buffs and tea ceremony aficionados. Similar objects also appeal to tourists who visit In-le Lake. Travelers are willing to spend the US$50–100 for a small sample once they have had a chance to observe the process first-hand in workshops attached to the retailing area and have come to realize the enormous amount of labor required to produce such fabric. Retail outlets in Rangoon have been less successful in selling lotus fiber products, which to the untutored visitor appear to be much more expensive than other handwoven products and local objets d'art such as lacquerware and wood carvings.

Although initial attempts to commodify lotus cloth for a more diverse clientele have not been as successful as initially hoped, the original demand for monks' robes from lotus fabric does not seem to be in any danger of abating. The weavers of robes have more orders than they can fulfill, and the current wait time for a set of robes can be up to two years. The weavers have been featured at craft shows and on television, and their work has become quite well known throughout Burma. Even the silk-weaving entrepreneurs of nearby Nam-pan offer demonstrations of lotus-stem processing and weaving to tourists. One of the more important underlying limits to lotus production is the fact that the lotus rhizome, which does not grow en-masse, cannot be commercially planted or mechanically harvested. The leaf stems once plucked must be processed within three days, which curtails the prospect of leaf stems being acquired from farther afield given Burma's undeveloped transportation network.

Such limitations, rather than being regarded as a disadvantage, serve to add to the mystique of this precious cloth, created by a pious woman nearly a hundred years ago in a small, remote lakeside village. As long as the lotus continues to encapsulate the nobility and purity of the Buddhist faith, the fabric woven from its filaments will live on as a unique and enchanting tradition in a deeply religious Burma.

RECENT DEVELOPMENTS

A visit to Daw Ohn Kyi on December 28, 2005, revealed that her lotus-weaving establishment, now renamed Lotus Robe Production Co-op Ltd., is doing well. She has in fact been able to convert her former boat shed into a two-story workroom. She has also remodeled her house to accommodate a showroom for her products on the ground floor. She attributes her success to her recent participation in natural dyeing courses sponsored by JETRO (Japan External Trade Organization), a quasi-governmental body operating under the umbrella of the Japan Ministry of Economy, Export, Trade, and Industry. In cooperation with Burma's Department of Cottage Industries, JETRO has sent experts in natural dyeing to Burma. They have taught the principles of extracting and fixing natural dyes as well as encouraging participants to seek out new and different plants in the environment from which to extract pigments. Daw Ohn Kyi in addition to using well-known favorites such as sappan (*Caesalpinia sappan*) and cutch (*Acacia catechu*) woods for reddish brown hues has also been working with the bark of the koko tree (*Albizzia lebbek*) for pinkish browns and *ingyin* wood (*Pentacme siamensis*) for orange-brown shades. A soft gray has also been developed from the Otaheite gooseberry (*Phyllanthus acidus*), and Daw Ohn Kyi has even managed to extract a soft yellowish green hue from lotus leaves. These dyes are applied to yarn for scarves, which retail at around US$45 and are sold to tourists. Daw Ohn Kyi has also been experimenting with combining lotus fiber with silk and banana fibers in some of her scarves. Her two daughters assist her in this enterprise. One takes orders in Rangoon, the nation's capital, while the other plans to go to Japan for further training.

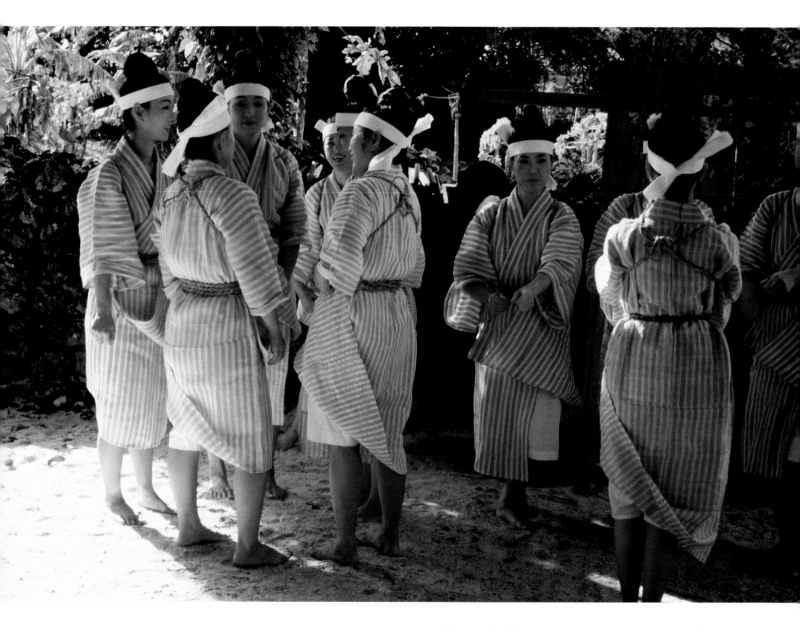

6.1 Dancers in *bashōfu* garments wait to perform at the Tanedori festival.

Photograph by Amanda Mayer Stinchecum, Taketomi Island, Okinawa Prefecture, 2000.

6. *Bashōfu,* The Mingei Movement, and the Creation of a New Okinawa

Amanda Mayer Stinchecum

ON A WARM OCTOBER MORNING—the first of two days of dance and dramatic performances dedicated to Taketomi Island's deity of prosperity—a group of young dancers stands easily in the sandy road in front of the main shrine. Poised to take their places in an offertory dance celebrating the hardworking women of the island, their figures are bathed in the golden light of the early sun's slanting rays. They wear short, simple robes of plain or striped *bashōfu,* straw sandals, and plain white headscarves. Crudely belted with ropes of twisted straw, their costumes identify them as the common people of an earlier era (fig. 6.1).

Taketomi Island is part of the Ryukyu Archipelago, which consists of 146 islands, stretching 1200 kilometers from Kyushu in the north to Taiwan in the south. The archipelago in turn forms part of the longer chain of islands that extends from Hokkaido to Luzon (fig. 6.4). About sixty of the Ryukyu Islands are inhabited today. Washed by the Pacific Ocean to the east and the East China Sea to the west, these subtropical islands are buffeted annually by devastating typhoons that aggravate their poverty.

By 1529 the islands were united as the Kingdom of Ryukyu. The kingdom was invaded in 1609 by forces of the Satsuma domain, located in southern Kyushu, and effectually remained under Satsuma domination until 1879, when it was forcibly annexed by Japan. After the annexation, most of the islands were consolidated as Okinawa Prefecture, Okinawa also being the name of the main island in the archipelago. To avoid confusion, I will use the term "Ryukyu Islands" to denote all the islands of the archipelago and "Okinawa Island" to indicate the principal island within the group of islands now known as Okinawa Prefecture.

The *bashōfu* cloth worn by the dancers described at the beginning of this essay is woven from fiber taken from the leaf bases of the fiber-banana plant (*ito bashō* in Japanese) of the Ryukyu Islands. Similar in appearance to fruit-bearing banana plants and the decorative variety common to Chinese and Japanese gardens, the *ito bashō* is now identified botanically as *Musa balbisiana.*[1] The tree-like plant with its frayed leaves and succulent stalk is characteristic of the landscape of the Ryukyu Archipelago, although not indigenous to the region. It is found around dwellings, surrounding dry fields, and in small plots dedicated to its cultivation (figs. 6.2). The "trunk" or pseudo-stem of the fiber-banana plant consists of layers of sheaths (leaf bases) that are structurally continuous with its leaves (fig. 6.3). Fibers of all species of the genus *Musa* are classified as leaf fibers, not bast fibers. To avoid confusion with other *Musa* species

6.2 A stand of *bashō* plants grows near a village street.
Photograph by Amanda Mayer Stinchecum, Taketomi Island, Okinawa Prefecture, 2000.

6.3 Taira Toshiko separates the leaf-base layers of fiber banana.
Photograph by Amanda Mayer Stinchecum, Kijoka, Okinawa Island, Okinawa Prefecture, 1981.

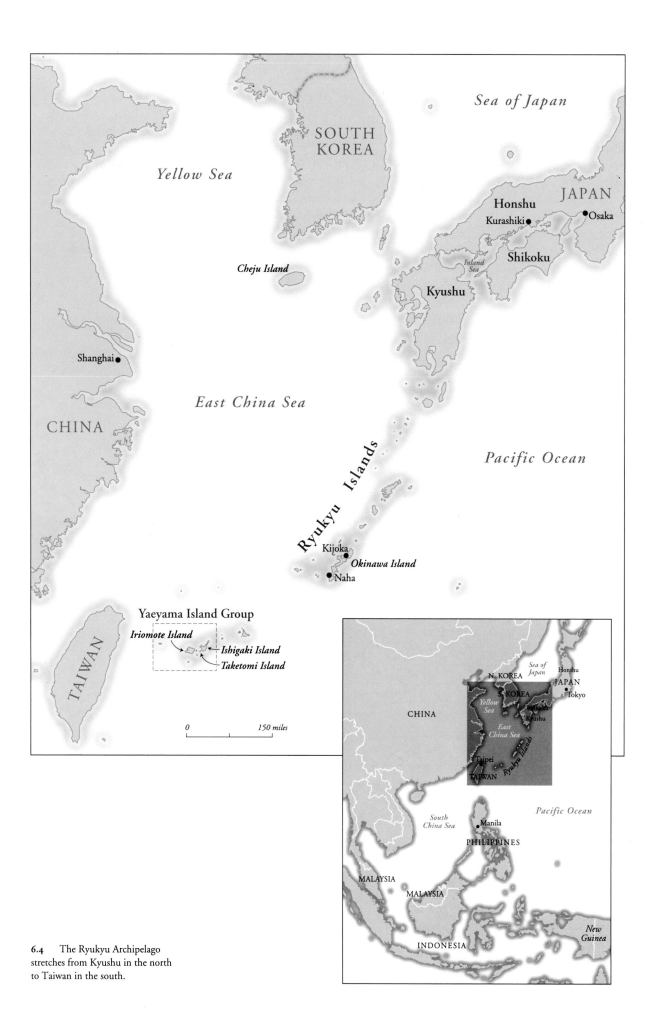

6.4 The Ryukyu Archipelago
stretches from Kyushu in the north
to Taiwan in the south.

from which textiles have been made (such as *Musa textilis*, the source of Philippine abaca), I will refer to the source of *bashōfu* by its Japanese name, *ito bashō*.

Bashōfu has clothed the people of the Ryukyu Islands since the sixteenth century. Within Lauri Honko's formulation of the relationships that exist among tradition, culture, and identity (1995, 132–35), wearing *bashōfu* constitutes a Ryukyuan tradition: an example of the mass of stuff of which cultures are made, one of the "unsystematic array of cultural elements that have been made available to a particular social group in different times and places" (1995, 133). Thus defined, this tradition has changed over time with transformations in the social, economic, and cultural contexts of Ryukyuan/Okinawan society. In contrast to the undifferentiated mass of "tradition," culture is a system that imposes order on tradition by processes of selection (Honko 1995, 134). *Bashōfu* has not only become an element of Ryukyuan culture, it has become a marker of its identity. The cultural expression *bashōfu* now represents more than itself. It represents the community. Identity symbols, writes Honko, "create an illusion of unity" within the group they represent, while at the same time emphasizing the "boundaries against other, especially neighboring, groups" (1995, 135).

The first written evidence of *bashōfu* in the Ryukyu Islands appears in an eyewitness account, dated 1546, reported by Pak Son and eleven other shipwrecked Koreans from Cheju Island. Reaching Ryukyu in 1542, they returned to Korea four years later. Their report includes descriptions of clothing, agriculture, and the cultivation of banana plants for making cloth:

> The larger trees are the size of a house pillar. These are harvested, and the outermost skin stripped off. The sheaths inside are sorted into three grades. The fineness or coarseness of the finished cloth depends on whether the fiber is taken from the outer or inner layers. The innermost layer yields the thinnest and most lustrous fiber, and its color is as pure as snow. It is incomparable. Women's clothing of high quality is made from this. [Ikeya et al. 2005, 1: 121]

Not only does this description mirror the processing of *ito bashō* today, the remarks concerning the fineness and luster of the cloth indicate that the production of *bashōfu* was technically well advanced at the time. In lists of tribute and trade goods sent to China, *bashōfu* first appears in 1587 (Okinawa Kenritsu Toshokan Shiryō Henshūshitsu 1992, 308) and continues to appear in such lists at least into the later seventeenth century (Ikeya et al. 2005, 1: 121).

By the time of the forced annexation of the Ryukyu Islands by Japan's Meiji government in 1879, *bashōfu* was worn by the broadest spectrum of the Ryukyuan population. Garments constructed from *bashōfu* ranged from finely pleated, *kakan* underskirts, culotte-like underpants, and the robes of former members of the gentry and nobility, to the ragged clothing of poor farmers. The latter is evident in photographs taken by the Japanese anthropologist Torii Ryūzō,[2] who visited Okinawa Island and the Yaeyama Island group in 1904 on his

way to Taiwan and the Philippines. The woman on the right in one of his images (fig. 6.5) is wearing a garment so stiff that it retains its crisp form even though it has obviously been subjected to hard use. Although cotton, silk, and ramie were also widely used for clothing in Okinawa, it is most likely that this garment was made of *bashōfu*.

There are solid reasons for the use of *bashōfu* among all classes of Ryukyuans before Japanese annexation. Detailed clothing regulations first issued by the Ryukyuan monarchy in 1639 specified that *bashōfu* be used for formal robes of court officials (Kyūyō Kenkyūkai 1974a, 216; 1974b, 186). Coarser *bashōfu*, however, was not forbidden to commoners of any level. Moreover, in the first half of the seventeenth century, when the royal government began levying taxes payable in cloth on some of its people (a form of taxation, known as *nintōzei*, or "poll tax," that was not abolished until 1903), *bashōfu* was excluded from these payments.[3] By 1894 Sasamori Gisuke (1845–1915) observed that all commoners wore clothing made of *bashōfu* and cotton, while the poorest among them wore rags of the same materials (Yaeyama Yakusho 1894).[4]

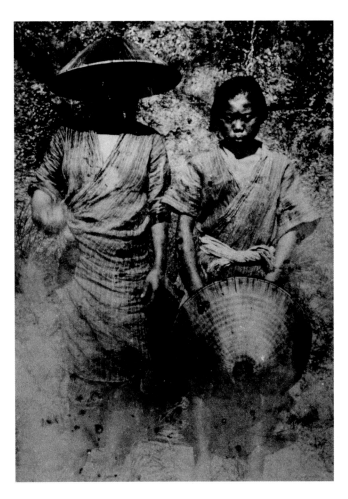

6.5 In this portrait of two farm women, the woman on the right wears what appears to be a garment made of *bashōfu*.

Photograph by Torii Ryūzō, probably Okinawa Island, Okinawa Prefecture, 1904. The University Museum, The University of Tokyo, no. UMUT 6005.

Today, *bashōfu* functions as a marker of identity in two distinct ways: first, it defines Okinawan identity from within Okinawa; and second, it defines Okinawan identity as perceived from the "outside," that is, primarily from the vantage of mainland Japan, which refers to the four main islands of Hokkaido, Honshu, Shikoku, and Kyushu. These two meanings merge in current Okinawan tourism development. The golden cloth, patterned with stripes, checks, or ikat in indigo and brown— usually made at home—is still worn for local festivals, religious ceremonies, and celebrations on many of the Ryukyu Islands (fig. 6.6). Okinawans have made it an emblem of their own identity as "simple island people." *Bashōfu* robes are worn primarily by Okinawan women and in situations where they represent themselves as the hardworking common people of the islands. These include dances, dramas, processions, rituals that occur in the context of religious festivals and ceremonies, and informally staged photographs. *Bashōfu* thus follows Honko's formulation of tradition/cultural element/identity symbol, and it has been made especially relevant to the establishment of a new Okinawan identity in the post–World War II period (1995, 135).

In contrast, the most finely made *bashōfu* has been anointed and appropriated by the Japanese government (fig. 6.7).

Produced in workshops in the village of Kijoka in northern Okinawa Island and made in very limited quantity, it is sold almost exclusively to mainland Japanese. It represents to non-Okinawan Japanese a filtered reminder of the "tropical country" that is conceived of as the treasure house of the "ancient culture" of Okinawa and Japan. *Bashōfu* is thus, in effect, a medium through which outsiders have manipulated and defined Okinawan identity.

The manipulation of an identity symbol by outsiders is not unique to *bashōfu* (Honko 1995, 134). What is significant is the agency of that manipulation. Yanagi Sōetsu (1889–1961) and the Folk Craft Movement, or Mingei Undō, in Japan promoted an image of *bashōfu* as emblematic of an idealized and homogeneous Okinawan culture.[5] The reconstruction of an essentialized Ryukyuan/Okinawan past could be simply dismissed as "tourism development," but it is inextricably bound up with building a new image of Okinawa for Okinawans as well as for others. The Folk Craft Movement exerted far-reaching influence on Okinawa that has persisted into the twenty-first century. This influence has penetrated so deeply into the consciousness of Okinawans and of mainland Japanese that, I argue, it has shaped current concepts of Okinawan identity.

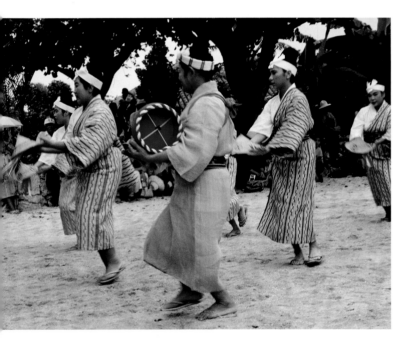

6.6 Celebrants from Ainota village (one of the three small villages on Taketomi Island) are among those attending the Tanedori festival. They wear *bashōfu* garments for a dance celebrating the ingenuity and industry of a poor island woman. According to tradition, this woman managed to clothe her ten children for a dance before the king by making them garments that had only one sleeve each (see fig. A, p. 7).

Photograph by Amanda Mayer Stinchecum, Taketomi Island, Okinawa Prefecture, 1987.

6.7 This remnant of *bashōfu* was used for a kimono by the late Kohagura Hokō, journalist and restauranteur, Naha, Okinawa Island, Okinawa Prefecture. It was woven by Taira Toshiko.

Private Collection. Photograph by Amanda Mayer Stinchecum.

YANAGI SŌETSU AND THE MINGEI MOVEMENT

Born into an elite Tokyo family, Yanagi Sōetsu—sometimes known by the Japanese reading of his given name, Muneyoshi—was the founder of the Folk Craft Movement in Japan.[6] He began collecting Korean ceramics of the Yi dynasty (1392–1910) following Japan's annexation of Korea in 1910. He and his cohorts announced their intention to collect and publicize "folk craft" in a manifesto of 1926. By that time, Yanagi had become, at least in the eyes of his followers, a champion of Korean culture. His advocacy of "folk craft," or *mingei*, was based on aesthetic appreciation of artifacts, which included architecture and streetscapes; an underlying abhorrence of industrialization; and a utopian view of craft production as capable of transforming society. In her study of the evolution of Mingei theory, Yuko Kikuchi has convincingly established the importance of John Ruskin, William Morris, and the ideals of the English Arts and Crafts movement to the development of Yanagi's thought. She also demonstrates how deeply these influences permeated the entire intellectual milieu of Yanagi and his colleagues in the early decades of the twentieth century (2004, 12–23).

In this context, Yanagi advocated the significance of regional cultures and their manifestations, including material culture, language, and what might loosely be termed "customs." He considered these to be essential components of the state:

> The spirituality of the Japanese people will not progress by denying regional cultures. Only with strong local communities can a strong state be formed. A simplistic, standardized unification is no more than a castration of regional cultures. Japan must be an aggregate that unites vigorous regions…. An Okinawa that's like a dead person, having lost all individual characteristics, is no credit to Japan. [Yanagi 1980–1992, 15: 183, quoted in Yakabi 1994, 30][7]

Yanagi argued vociferously for the cultural autonomy of Korea and Okinawa as "countries." Although both had been annexed by Japan and in the view of the Japanese government had been made part of Japan, each retained a unique aesthetic sensibility and way of life. In Yanagi's view, this made them distinct countries (from today's perspective, of course, there is no question about their cultural autonomy). Nonetheless, his writings on Korea betray his fundamental colonialist bent and nationalist intentions. These were echoed in his later collecting, writing, and leadership of craft development in Okinawa, as well as other regions colonized by Japan. Kikuchi describes Yanagi's hierarchical order of East Asia as giving "Japan the highest status in the Orient, making it the equivalent" of the Occident (Kikuchi 2004, 91, 95, 109, 115, 155–56). The hierarchy implicit in his writings takes the following form:

Occident
Mainland Japan
Song China, Kōryō/Choson Korea
Okinawa and other peripheries of Japan
Japanese colonies (Taiwan, Korea, Manchuria)
Rest of Asia

Yanagi's Social Darwinism was ultimately derived from Western Orientalism as expressed by his English colleague, the potter Bernard Leach (1887–1979), who was in turn deeply influenced by the romanticized Japan that Lafcadio Hearn (1850–1904) had depicted (Kikuchi 2004, 12–14).[8]

BASHŌFU AND THE MANIPULATION OF OKINAWAN IDENTITY

Yanagi first visited Okinawa at the invitation of the prefectural Department of Education in December 1938 and was greatly moved by the weaving and wearing of *bashōfu* that he observed there:

> Whenever I think of banana trees [*bashō*], I immediately think, "tropical country." Bathed in the fiery light and heat of that hot sun, those big, broad leaves grow so quickly even the eye can see them growing. They are said to originate in India. But no matter what island one visits in the Southern Seas, there is none where their leaves cannot be seen flapping in the wind. Banana trees have become an inseparable part of the mood of a tropical country [*nangoku no fūjō*]. [Yanagi 1943, 385]

Yanagi's poetic description, written four years after his initial visit, brings to life the image of Okinawa that was to become the model for mainland Japan's vision of the islands; for tourism development; and for Okinawans' idealized view of their own environment and themselves as inhabitants of it. I have translated Yanagi's expression, *nangoku* (lit., "southern country") as "tropical country," as I think this better conveys the associations of southern seas, islands, sandy beaches, a hot and sultry climate, and certain flora associated with the tropics and subtropics that Yanagi intended.[9] *Nangoku* was not a term restricted to descriptions of Okinawa but was applied as well to exotic tropical landscapes depicted on ceramics produced during the Japanese colonization of Taiwan for the use of Japanese residing there as well as in mainland Japan (Kikuchi 2004, 185–86).[10] Yanagi's use of *nangoku* in his account of *bashōfu* written in 1943 thus ties his thought to Japan's hegemony over its colonies, specifically to colonialist ideas of Taiwan. This expression and associated imagery were to be appropriated and applied to Okinawan tourism development during the Occupation period (1945–1972). The idea of *nangoku* as a tropical island paradise thus inextricably links tourism in Okinawa to Japanese colonialism.

Yanagi's first visit to Okinawa took place on the eve of World War II, a disaster that devastated the island, its people, and their material culture. His sojourn was an epochal event for the prefecture and the Mingei Movement, leading to the creation of an emblematic place for *bashōfu* in Okinawa's post-war recovery. Perhaps more important, however, it expanded the foundations for a new vision of Okinawa as an "island paradise" and a living museum of Japan's lost antiquity. Even before his return to Tokyo, Yanagi rhapsodized in a letter to weaver Tonomura Kichinosuke (1898–1993) about the treasure trove of crafts, particularly textiles, he found in Okinawa (Yanagi 1980–1992, 2: 161).[11] Prophetically, both Tonomura and Yanagi were to play critical roles in the fortunes of *bashōfu*.

In April of 1939, Yanagi published a short essay "Okinawa no bashōfu" (Okinawa's *bashōfu*). It described his visit to the village of Kijoka in the northern part of Okinawa Island to see how the cloth was made. Although other areas of Okinawa Island had produced greater quantities of *bashōfu* in previous years, from the mid-1920s Kijoka had been striving to expand its manufacture of the cloth. With the establishment of Okinawa Prefecture in 1879, the Meiji government set out to assimilate its newest colony and incorporate it into the nation-state (Christy 1993, 607–9). The national government sought ways to develop and exploit the meager resources of its poorest prefecture. Surges in annual *bashōfu* production for the prefecture suggest the turmoil and instability that characterized Okinawa's economy before World War II.[12] Production figures for the prefecture reached a peak of 135,409 rolls of *bashōfu* in 1895 (Okinawa-ken Naimubu Daiikka 1900, 305–11) and a lesser high point of 81,012 rolls in 1923 (Okinawa-ken Chiji Kanbō 1928, 181). Although production had fallen to 38,000 rolls of the cloth by the time of Yanagi's visit in 1938, he reported that every household in Kijoka was involved in making *bashōfu*. By 1939 Kijoka *bashōfu* had found a foothold in the mainland retail market.

Yanagi praised the "ordinariness" and "naturalness" of *bashōfu*, the effortlessness and unself-consciousness of its production, its appropriateness to Okinawa's subtropical climate, and the anonymous creation of beauty. He contrasted this with Yūki *tsumugi* (silk pongee), produced in Ibaraki Prefecture, north of Tokyo. At that time, the nubby silk cloth, often painstakingly patterned with tiny ikat motifs, was still entirely made of handspun yarns and woven on body-tension looms. Precisely because of the meticulous effort required at every stage of weaving and dyeing, Yūki pongee could be produced only in small quantities and commanded enormous prices. It was made by the few for the few. Yanagi compared this "elitist" cloth to *bashōfu*, which was cheap and could be made "by anyone." Ironically, in the decades following the war, Kijoka *bashōfu* would also become an "elitist" cloth, as will be discussed below.

Yanagi's solo trip to Okinawa was followed by group excursions of the Folk Craft Association in 1939 and 1940. These included a number of Mingei luminaries who were to become important collectors of Ryukyuan textiles and other crafts and promoters of contemporary Okinawan weaving and dyeing. In the decades following the war, they were to offer advice, direction, and practical assistance in producing and marketing new Okinawan textiles and ceramics (Brandt 1996, 279).

Yanagi found in Okinawa, its language, and culture the living evidence of Japan's ancient civilization, the "peculiar" or "characteristic" and "original" qualities of Japaneseness (Kikuchi 2004, 148–50), but he was not the first to do so. In the early 1920s folklorist Yanagida Kunio (1875–1962) established a discussion group in Tokyo about the Ryukyu Islands, which, as historian Lisbeth K. Brandt points out, began the Japanese fascination with the islands of the "Southern Seas." This interest was further enhanced by Japan's recognition of their strategic importance. Yanagi communicated his enthusiasm for Okinawa and its people, which was based in a Western Orientalism, to a far broader segment of the Japanese public than the narrow audience of earlier folklorists such as Yanagida and Iha Fuyū (1876–1947), the "father of Okinawan studies" (Brandt 1996, 273–74).

The Mingei Association's penultimate trip to Okinawa, undertaken in the winter of 1940, ended in a debacle (Smits forthcoming, 10–18). Prefectural government officials and many of the local elite supported assimilation with Japan as the only remedy for Japanese discrimination against the prefecture and its people. At a roundtable discussion organized by the Okinawa Tourism Association to discuss future development in the prefecture, criticism of the prefectural promotion of standard Japanese was first voiced not by Mingei adherents but by a representative of the tourism office in Tokyo, Mizusawa Sumio (Brandt 1996, 284). Yanagi and his followers, however, also vociferously expressed their disapproval of the campaign to force Okinawans to give up their native language in favor of standard Japanese (Brandt 1996, 290). Yanagi publicly excoriated local officials for attempting to eliminate Ryukyuan languages and other aspects of Ryukyuan culture from the islands.[13] The passion of Yanagi and his followers for what they saw as "traditional" Ryukyuan culture, and their determination to preserve its remaining vestiges and promote active participation in its future, aroused enmity in Okinawa that had widespread repercussions (Brandt 1996, 284ff.; Kikuchi 2004 150–53; Yakabi 1994, 12–15). Here again, however, Yanagi's proclaimed advocacy of Ryukyuan culture concealed an inherent Japanese nationalism. He wrote, for example, of the use of the Okinawan language as a means of "purification" of the Japanese language, which had become corrupted by Western influence (Brandt 1996, 190–91; Yanagi 1940, 24). Despite Yanagi's rhetoric, the spread of standard Japanese and other forms of assimilation to Japanese and then Western (American) cultures only increased in the decades following World War II.

Even before the visits described above, Ryukyuan textiles had found their way to the Japan Folk Craft Museum (Nihon Mingeikan) in Tokyo, possibly collected by potters Hamada Shōji and Tomimoto Kenkichi, who first visited the prefecture in 1918. We must credit the Mingei Movement with preserving precious examples of Ryukyu's material culture, albeit by carrying them away from their original geographical contexts and lifting them out of their cultural matrix to install them in Mingei museums and collections in mainland Japan. Without this intervention, all would probably have been lost to the devastation of war. These beautiful objects, according to Yanagi, embodied the simplicity and vitality of Okinawan

crafts. Although their acquisition may not have been a declared objective of these visits to Okinawa, it could not have been a casual by-product of the trips, judging from the quantities and high quality of Okinawan objects to be found in the Tokyo Mingeikan. Brandt describes the rapacious acquisitiveness of Yanagi and his cohorts during the period of Japanese colonization of Korea (1996, 226). In spite of their profession of empathy with the people of Okinawa and their admiration for Ryukyuan culture, Yanagi and his followers appear to have been motivated as strongly by a desire to possess these objects as to understand or describe the culture that produced and used them. The absence of any documentation, at least for the textiles—no notes about where, when, or from whom an object was acquired; by whom it had been used or for what purpose; or when it was accessioned by the museum—speaks eloquently of the Mingei Movement collectors' disregard for their cultural contexts.[14] That lack of documentation remains a continuing source of embarrassment to the museum's current staff.

In 1943 Yanagi published his second and longer essay on *bashōfu*, "Bashōfu monogatari" (A tale of *bashōfu*). He stated that he chose *bashōfu* as an exemplar to demonstrate the "principles of beauty that lie concealed within objects" and the creation of beauty by anonymous craftsmen. He extolled the cooperative nature of the work, the absence of "star" artists, and the accessibility of Kijoka *bashōfu* to ordinary Okinawans due to its reasonable price. He saw in the cloth the confluence of nature, necessity, and beauty, and an indissoluble connection to the land and climate of Okinawa.

In his writings about *bashōfu* as a model of folk craft, Yanagi ignored the use of finely woven and elaborately patterned examples by members of the royal court of Ryukyu before its abolition and annexation by Japan in 1879, when Okinawa Prefecture was created. Robes of brilliantly colored *bashōfu*, patterned with stripes, ikat, float and gauze weaves, as well as others made of *bashōfu* so fine and lustrous they are indistinguishable from raw silk to the untutored eye, were worn by members of the aristocracy and high-level government officials. Yanagi took *bashōfu* out of its social and historical context to use as a tool for promoting his ideas of *mingei* and as the symbol of Okinawa as a "tropical country." In "Bashōfu monogatari," Yanagi reveals again his own nationalistic prejudice in remarks about Ryukyuan-style clothing:

> Okinawans must of course become aware of the beauty of Ryukyuan dress and how it is worn. They should realize that no matter how they try to imitate the new, wearing Western-style clothing, ultimately, all they can achieve is a kind of rustic appearance. And if Westerners saw that, how they would scowl! [*Yanagi Muneyoshi zenshū* 1981, 402]

THE REBIRTH OF *BASHŌFU* AFTER WORLD WAR II
The ideas of Yanagi and the Mingei Movement exerted long-lasting influence on concepts of Okinawan authenticity and identity, concepts that now form the basis of tourism development and efforts at cultural preservation. After World War II, Okinawa was "transformed" by the tourist industry into a "tropical country," inhabited—as it had been in Yanagi's eyes—by people who produced "honest," "pure," and "simple" objects

6.8 Blouse
Okinawa Island, Okinawa
Prefecture, 1940s
Banana fiber
64.8 cm
Fowler Museum x86.4437; Gift of Dr. Harvey
C. Gonick and Gloria Granz Gonick

The fabric in this blouse is genuine *bashōfu*, but the patterning is a printed imitation of the ikat technique. The garment was once a kimono, but in the Occupation years following World War II, when American fashion was popular in Okinawa, the cloth was reworked into a 1940s-style blouse.

(and were therefore honest, pure, and simple themselves). *Bashōfu* became emblematic of that new "tropical country." The history of *bashōfu*, however, sets it apart from other cultural artifacts that have been used to symbolize part of Okinawa or its past. Shuri Castle and the richly colored, stencil-dyed textiles known as *bingata* (worn at court by members of royalty and the nobility) were closely associated geographically with the royal capital of Shuri and with Ryukyu's ruling elite. In contrast, *bashōfu* embraced all levels of Okinawan society, from royalty to the poorest islanders. This had probably been the case since at least the early seventeenth century.

Although Yanagi's ideas had taken root on the mainland in the decades leading up to World War II, the real florescence of those ideas within the Ryukyu Islands did not occur until after the near-total destruction of the Battle of Okinawa in 1945. On April 1, 1945, United States forces invaded Okinawa to fight the only land battle of World War II on Japanese soil. After months of bombing, torching, and hand-to-hand combat, the urban areas of the main island had been flattened, and most of Ryukyu's historical remains—including structures, documents, and other artifacts—had been demolished or severely damaged. One hundred fifty thousand Okinawan civilians died, and most of the main island's material culture was destroyed. This was only the culmination of a devastation that had cast its shadow over all the islands of the prefecture. Earlier bombing incidents, hunger, malaria, the military draft, and the evacuation and dislocation of many civilians had already weakened the material and social fabric of the islands. After Japan's colonization of Korea, Manchuria, and Taiwan in the late nineteenth and early twentieth century, many women from poor households in Japan's poorest prefecture had left the islands to work in the colonies. Many labored as household servants in the homes of mainland Japanese or in other unskilled jobs. As Japanese military forces spread into other areas of Asia with the advent of World War II, young women from Okinawa relocated to Osaka and other mainland cities to contribute to the war effort by working in factories there.

By 1945 commercial textile production in Okinawa had ground to a halt. Few Okinawans had time or resources to expend on activities beyond the bare necessities of survival. Women took apart Ryukyuan-style robes and kimono and fashioned the cloth into Western-style clothing for themselves

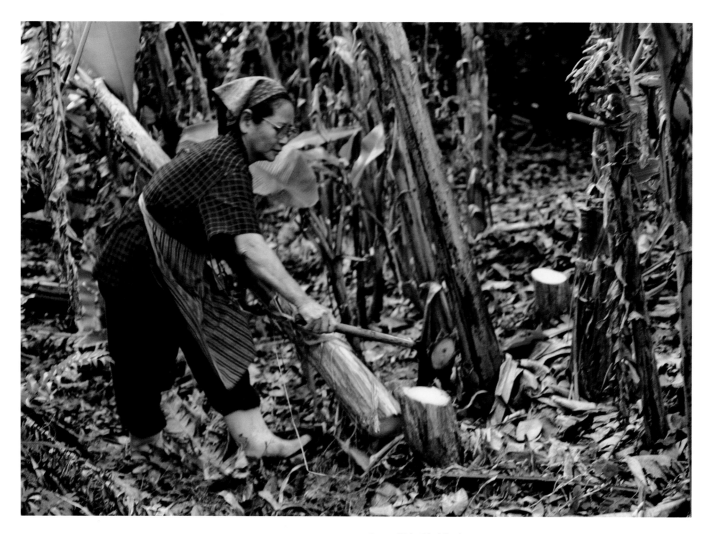

6.9 Taira Toshiko harvests *bashō* plants.

Photograph by Amanda Mayer Stinchecum,
Kijoka, Okinawa Island, Okinawa Prefecture, 1981.

and their families, as it was perceived to be more practical. They made garments from parachute silk and unraveled socks and other found cloth objects to weave fabric to clothe their families. Blouses, skirts, dresses, and trousers made from recycled traditional materials, including printed and ikat-patterned *bashōfu*, illustrate measures resorted to during and immediately after the war (fig. 6.8). With Japan's defeat, Okinawa became a U.S. Occupied Territory, known as the Ryukyu Islands. Unlike mainland Japan, where the Occupation ended in 1952, for the Ryukyu Islands, reversion to Japan did not occur until twenty years later. This left the Occupation government and the local government of the Ryukyus to develop the devastated islands.

Gerald Figal has pointed out that the annihilation of the landscape of Okinawa Island left it particularly ripe for reconfiguration, both as a "tropical country" imagined by mainland Japanese and as a re-creation of an idealized historical past (forthcoming). Figal calls attention to a report written in 1962 by the executive managing director of the Japanese National Park Association, Senge Tetsuma (forthcoming, 9). Although Senge acknowledged both the destroyed monuments of the Ryukyu Kingdom and sites of the Battle of Okinawa as

6.10 Taira Toshiko stands between Mingei potters Hamada Shōji and Bernard Leach.
Photograph by Yamakawa Gankyo, Kijoka, Okinawa Island, Okinawa Prefecture, 1964.

potentially compelling tourist attractions, he emphasized that the key to Okinawa's tourism development was to create a "mood like that of a tropical country" (*nangokuteki na kibun*). Yanagi's expression, "tropical country" (*nangoku*) lies at the root of Senge's simile. Okinawa would have to become like a tropical country, a southern island paradise, for it to prosper as a tourist Mecca.

Yanagi had elevated *bashōfu* to the stuff of legend before war descended on Okinawa, but production had ceased with the onslaught. In April of 1944, a group of about 110 young women from Okinawa Island volunteered to work in a converted spinning mill in the mainland city of Kurashiki, manufacturing airplane parts (Taira 1993, 66–67). One of these young women was Taira Toshiko (b. 1920; fig. 6.9), then twenty-four years old, who would be later credited with single-handedly reviving *bashōfu* production in northern Okinawa Island.[15] At the end of the war, factory director Ōhara Sōichirō took the young Okinawan women under his wing. In 1946 he set up a weaving workshop in Kurashiki to encourage the preservation and continuation of Okinawan textiles.[16] He invited the weaver Tonomura Kichinosuke, who had visited Okinawa with Yanagi in 1939, to teach and guide this group, which included Taira Toshiko.

By her own account, Taira had some previous weaving experience. As a child, however, she was permitted to weave only cotton, because *bashōfu* had already become a source of cash income for Kijoka households and could not therefore be entrusted to children (Taira 1993, 65–66). She had also helped the women preparing *ito bashō* fiber and made yarn. It was Tonomura, however, who set her on the path of re-creating Okinawa's *bashōfu* tradition in the image of the Mingei Movement.[17] At his instigation, Taira read Yanagi's "Bashōfu monogatari" for the first time. She later recounted that from Tonomura and Yanagi she learned the worth of *bashōfu* and the "soul of weaving" (Taira 1993, 67). Yanagi's essay is explicitly credited with determining the direction of postwar Kijoka *bashōfu* (Kijoka no Bashōfu Hozonkai 1984, 91), but the mediation of Ōhara and Tonomura was critical. When Taira left Kurashiki to return to Kijoka in 1947, Ōhara and Tonomura exhorted her to "preserve and nurture Okinawa's weaving."

Under orders from the Occupation government, a *bashōfu* workshop had already been set up in Kijoka before Taira returned. Her decision—a decision also made by some of her friends—to devote herself to making *bashōfu* seems to have had its start in Kijoka's earlier tradition, but the influence of Yanagi's writing cannot be ignored. Tonomura's direct role in the revival of *bashōfu* in Kijoka did not end at this point, nor did that of the Mingei Movement. In 1961 Taira visited Kurashiki for the first time since 1947 (Tonaki 1977, 39). She met with Ōhara and with Tonomura, who had established the Kurashiki Folk Craft Museum in 1948. When the Folk Craft Association held its national meeting in Naha in 1964, Tonomura and Ōhara (then president of the association) paid a visit to Kijoka. The same year, two of the Movement's most famous potters, Hamada Shōji and Bernard Leach, visited her as well. A telling photograph, taken by Okinawan press photographer Yamakawa Gankyo, shows Taira standing uncomfortably

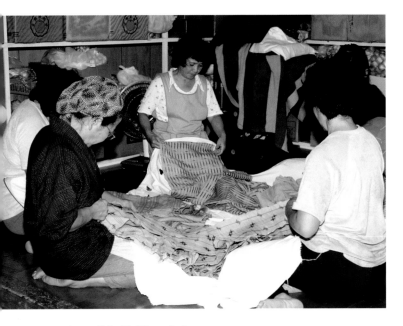

6.11 Taira Toshiko and other members of the Kijoka *bashōfu* workshop adjust finished lengths of cloth.

Photograph by Amanda Mayer Stinchecum, Kijoka, Okinawa Island, Okinawa Prefecture, 1985.

6.12 These kimono lengths of Kijoka *bashōfu* were woven in the workshop of Taira Toshiko.

Photograph by Tarumi Kengō, Kijoka, Okinawa Island, Okinawa Prefecture, 2005.

between these two luminaries (fig. 6.10). Tonomura started sending his weaving students from Kurashiki to visit and learn from Taira, and she began to exhibit her work in Folk Craft-related exhibitions in Kurashiki and Tokyo. The association between *bashōfu* and the Folk Craft Movement continued to develop after Taira's return to Kijoka.

Movement luminaries were to intervene once again in the destiny of *bashōfu* at the time of Okinawa's reversion to Japan. In recognition of Okinawa's cultural assets, the Ministry of Education's Agency for Cultural Affairs (Bunkachō) decided to designate one or more traditional arts as an "Important Intangible Cultural Property" (Jūyō Mukei Bunkazai). The year before reversion, in 1971, the agency conducted a broad survey of Okinawa's crafts to determine which might be a suitable designee. There was already considerable interest in textiles, particularly *bashōfu*, according to Ōtaki Mikio, who worked for the agency at the time and was involved in the designation process.[18] This was due to the presence on the survey committee of Mingei potter Hamada Shōji. Hamada had spent time in Okinawa before Yanagi's 1938 visit and was familiar not only with *bashōfu* but also with Taira's Kurashiki connection. Another Mingei personage whose input was critical in the selection of Kijoka *bashōfu* was weaver Yanagi Yoshitaka, Sōetsu's nephew. Although the selection committee acknowledged that *bashōfu* was produced in other areas of Okinawa, that cloth was deemed not pure enough, as it often included cotton stripes. Kijoka *bashōfu* fit the agency's criteria more closely, and its designation was urged by Hamada and Yanagi, among others. Agency requirements for selection included the following:

- the object selected is historically significant
- it has special, unusual or unique technical characteristics
- it is of artistic value
- the people who produce it are highly skilled
- one group representative (in this case, Taira Toshiko) possesses all the skills needed to produce the object

In 1974 the art of making Kijoka *bashōfu* received the agency's general designation, the first in Okinawa Prefecture, with Taira Toshiko as the representative of the group of women who were "holders" of that art (fig. 6.11). This honor is accompanied by a monetary subsidy and demands adherence to technical and artistic standards set by the agency. It also requires the establishment of a cooperative organization (in Kijoka this was the Kijoka no Bashōfu Hozonkai [Kijoka *Bashōfu* Preservation Society]); a program for training future yarn makers, weavers, and dyers; publication of a detailed account of the production process (Kijoka no Bashōfu Hozonkai 1984); and a documentary film.

The Japanese government may well have embraced the idea of designating a "folk craft" as a means of re-assimilating the Okinawan people into the Japanese state after the reversion. The term, "cultural property" (a single word, *bunkazai*, in Japanese), however, begs the question: "Whose property?" There is no "property" without an owner. The Japanese term *bunkazai* implies "property" that belongs to an owner (*zaisan*). In the case of these "intangible" properties, the property does not refer to the objects themselves but to the art/technology that produces them. Here, it can only be the state that is claiming ownership and, by extension, reasserting its proprietary claim to Okinawa, its culture, and its people.

After receiving many prizes and awards for her work, in 2000 Taira Toshiko received the ultimate agency designation, as an "individual holder of an important intangible cultural property," popularly known as a "Living National Treasure." As Ōtaki Mikio lamented, "Kijoka *bashōfu*" had now become "Taira Toshiko's *bashōfu*," a far cry from Yanagi's idea of the anonymously produced, ordinary, inexpensive object made for daily use. A kimono length of ikat-patterned *bashōfu* (fig. 6.12) made by Taira and other members of the workshop now sells

for more than US$20,000 in mainland Japan (in mainland shops her work is not distinguished from that of other members of her workshop).

Through her apotheosis as the Living National Treasure of *bashōfu*, Taira became Okinawa's Everywoman. Although she married and raised a family, her husband and children are not part of the Taira Toshiko legend, which has often been repeated in print (e.g., Taira 1993; Tonaki 1977; Kijoka no Bashōfu Hozonkai 1984). This omission has contributed, probably unwittingly on Taira's part, to the notion that she has somehow single-handedly brought about the *bashōfu* revival. In spite of her self-described privileged background and rebellious girlhood (1993, 65–66), Taira's modest comportment in public, her willingness to let her daughter-in-law, Taira Mieko, speak for her, her dedication and diligence, not to mention the fact that she really did play a major role in reviving an Okinawan tradition that touched the lives of people throughout the islands, made her acceptable to the Japanese government as well as to Okinawans. Her contribution to Japan's war effort, making airplane parts, probably did not go unnoticed, either.

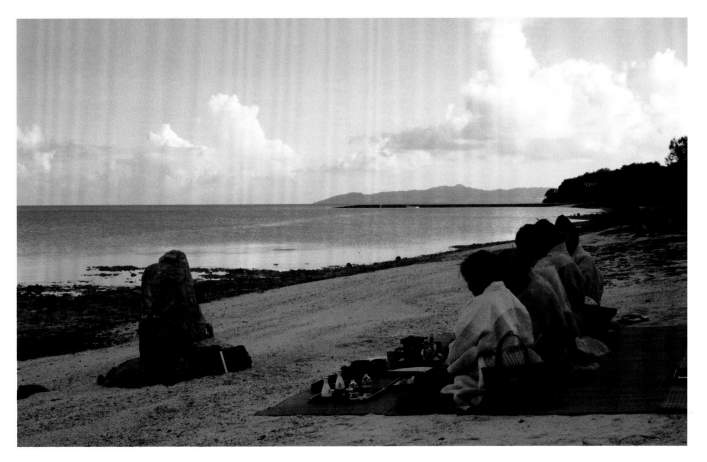

6.13 Facing the East China Sea at dawn, Taketomi's priestesses, wearing golden *bashōfu* robes—the color of which represents the color of ripe grain—celebrate the festival of Yunkai. They welcome the deity who brings prosperity from across the sea.
Photograph by Amanda Mayer Stinchecum, Taketomi Island, Okinawa Island, Okinawa Prefecture, 2000.

CREATION OF A NEW OKINAWA

During the Occupation period and the years following its reversion to Japan, Okinawa was transformed into a "tropical country," a "southern island country" where Japanese tourists could feel safe, speak Japanese, and experience the exotic Other. That country was (and still is) inhabited, in the eyes of Yanagi Sōetsu and his followers, by people who produced "honest," "pure," and "simple" objects. *Bashōfu* became emblematic of that new "tropical country"—embracing all the people of the Ryukyu Islands—both for Okinawans and for mainland Japanese. Worn today by women in religious and secular festivals (fig. 6.13), in performances of dance and drama (fig. 6.14), and in other situations where Okinawans self-consciously present themselves as toiling, humble, celebrating islanders (fig. 6.15), *bashōfu* has become a marker of identity as defined by Okinawans. That *bashōfu* is usually woven by family members.

For mainland Japanese, the luxurious *bashōfu* of Kijoka embodies that "tropical country" seen through the refining filter

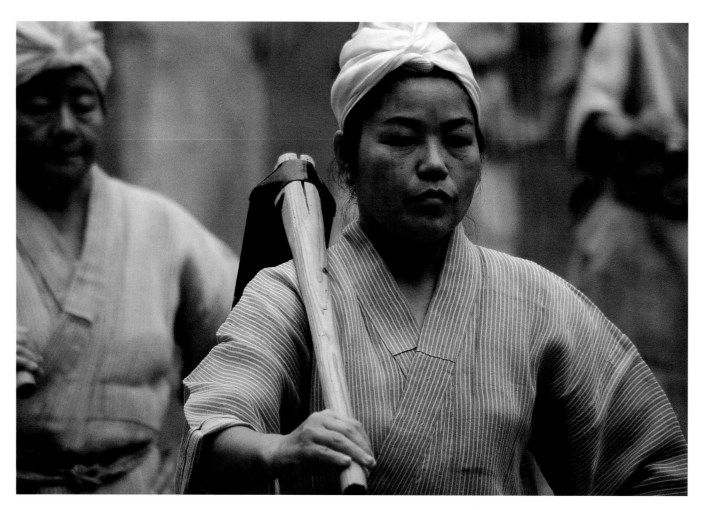

6.14 A dancer in a *bashōfu* and cotton, striped robe performs "Mamidōma," celebrating the hardworking village women of Taketomi. This dance, part of the core performance of the ten-day Tanedori festival, is considered by folklorists and other scholars to be one of a handful that are indigenous to the island and were not imported by government officials during the period of the Ryukyu monarchy.
Photograph by Amanda Mayer Stinchecum, Taketomi Island, Okinawa Prefecture, 2003.

of the Japanese government's legitimization. While designation as an Important Intangible Cultural Property appears distant from Yanagi's concept of folk craft, it was Yanagi's ideas and the activism of the Mingei Movement that led to the status of Kijoka *bashōfu*. At the same time, because its golden tan color decorated with brown and indigo patterns reflects the colors of the *bashōfu* worn by the common people in the age of the Ryukyu Kingdom, rather than that worn by aristocracy and royalty, Kijoka *bashōfu* also transcends its elite status, achieving a kind of Okinawan universality by referring back to its popular origins. In Kijoka *bashōfu*, self-defined identity and outside-defined identity merge. For Okinawans and mainland Japanese, *bashōfu* represents a timeless and idealized Okinawa, inhabited by a simple, pure, healthy people, the "common people" of an apparently unified and homogenous Okinawa, an identity very close to that imagined by Yanagi Sōetsu and the Mingei Movement.

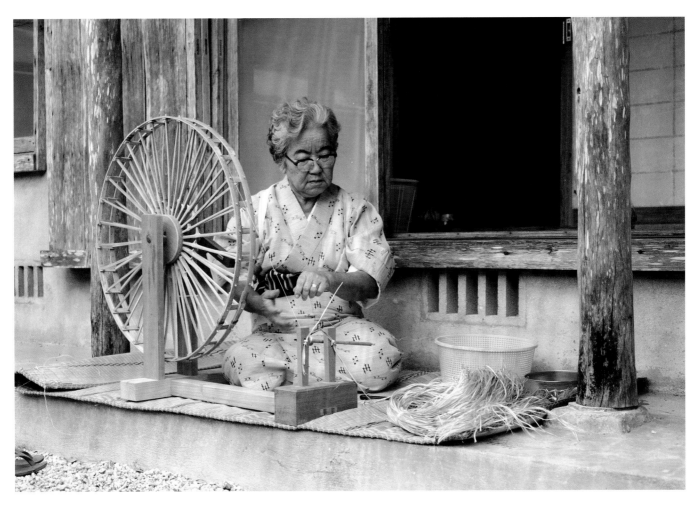

6.15 The late Yonemori Tokuko chose to wear an ikat-patterned *bashōfu* garment and a warp-ikat indigo-dyed sash—both of which are ordinarily worn for village or island celebrations or other situations in which islanders represent themselves—when she was asked to pose for this photograph making *bashō* yarn.

Photograph by Amanda Mayer Stinchecum, Maezato village, Ishigaki Island, Okinawa Prefecture, 1983.

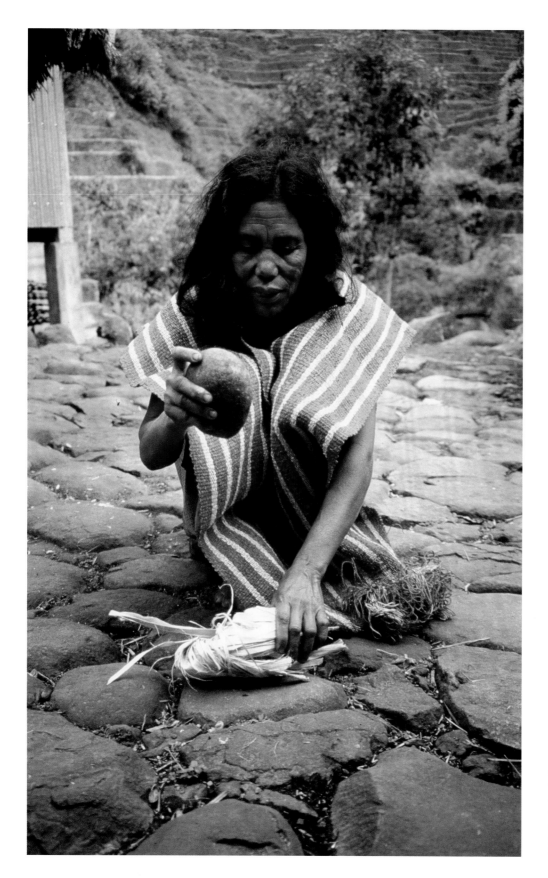

7.1 Pounding the bast fibers with a stone softens them. For this demonstration, the weaver wears a length of bast fiber that she has woven.

Photograph by B. Lynne Milgram, Cambulo, Banaue, Ifugao Province, 2000.

7. Recrafting Tradition and Livelihood
Women and Bast Fiber Textiles in the Upland Philippines

B. Lynne Milgram

TEXTILES AND CLOTHING PERFORM multiple roles in daily and ceremonial life, telling stories of identity, economics, and social change. My conversations with female weavers in the rural northern Philippines resonate with this premise as artisans explain the different ways that cloth continues to be an integral component of their everyday, ceremonial, and exchange activities. Women outline not only how they divide their working time between farming and weaving but also how they currently refashion the types of textiles they produce to meet the shifting demands of livelihood and community life. Artisans point out that the opportunity to earn additional cash by producing weavings specifically designed for the growing local-to-national tourist market makes their income more secure. However, because the demand for crafts is generally subject to seasonal fluctuations in the tourist industry, and because in the northern Philippines people continue to invest both economic and cultural value in ownership of irrigated rice land, artisans do not easily abandon their work in agricultural production.

In this chapter I analyze how female artisans in Ifugao Province, northern Philippines (fig. 7.3), move between household and market to reconfigure their culturally embedded association with weaving and cultivation. Specifically, I explore the channels through which these women build on their historical production of a type of cloth distinctive within the Philippines for local use and trade to develop alternative market-driven products woven from local bast fibers (fig. 7.2). I highlight the initiatives of those women working within independent home-based settings, as well as emergent piecework practice, in the villages of Cambulo and Pula in the municipality of Banaue, as this area has emerged as the prime site for the current revival of this historically rooted craft.[1]

Before the widespread availability of lowland trade cotton in the early twentieth century, weavers throughout the upland regions of northern Luzon used bast fibers extracted from the local paper mulberry tree (*Broussonetia* sp.) to produce the textiles and garments they needed. Artisans obtained these plant fibers from the stems or trunks of young trees growing in the village's communal forest or in a family's ancestral forest. After harvesting the trees, they removed the outer and inner layers of bark from the trunk and processed the latter into fibers for weaving through scraping, washing, and plying. As in past practice, women continue to use a back-strap loom to weave textiles such as blankets and items of dress including women's skirts, men's loincloths and vests, and belts. Before the early 1900s, garments of this sort were commonly used for everyday and special occasion clothing, but today such fabrics are reserved for festive events. Following the introduction of cotton yarn to the upland provinces in the early twentieth century,

this new fiber increasingly replaced bast for producing the traditionally patterned ceremonial textiles still required for special occasions, while Western-style, ready-to-wear garments were widely adopted as the norm for daily wear. Cotton yarn, obtained through trade with the lowland provinces of northern Luzon, was easier to weave and produced fabrics that were softer to wear than cloth made from bast fibers. Thus the demand for bast fiber textiles declined dramatically so that only a few older weavers continued to practice this craft after the mid-1900s. It was not until the late 1980s with the rise in tourism due to improved road transportation and government promotion of the area's unique mountain landscape that more artisans engaged in bast fiber production as an avenue to

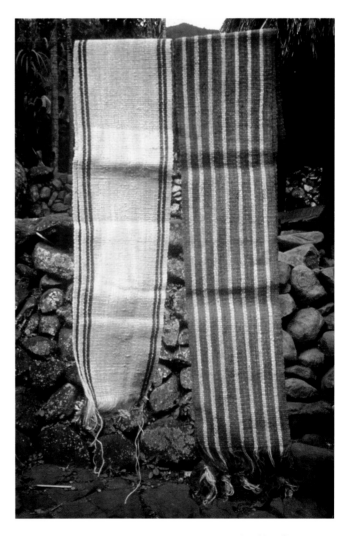

7.2 Lengths of bast fiber yardage are displayed just off the loom.
Photograph by B. Lynne Milgram, Cambulo, Banaue, Ifugao Province, 2000.

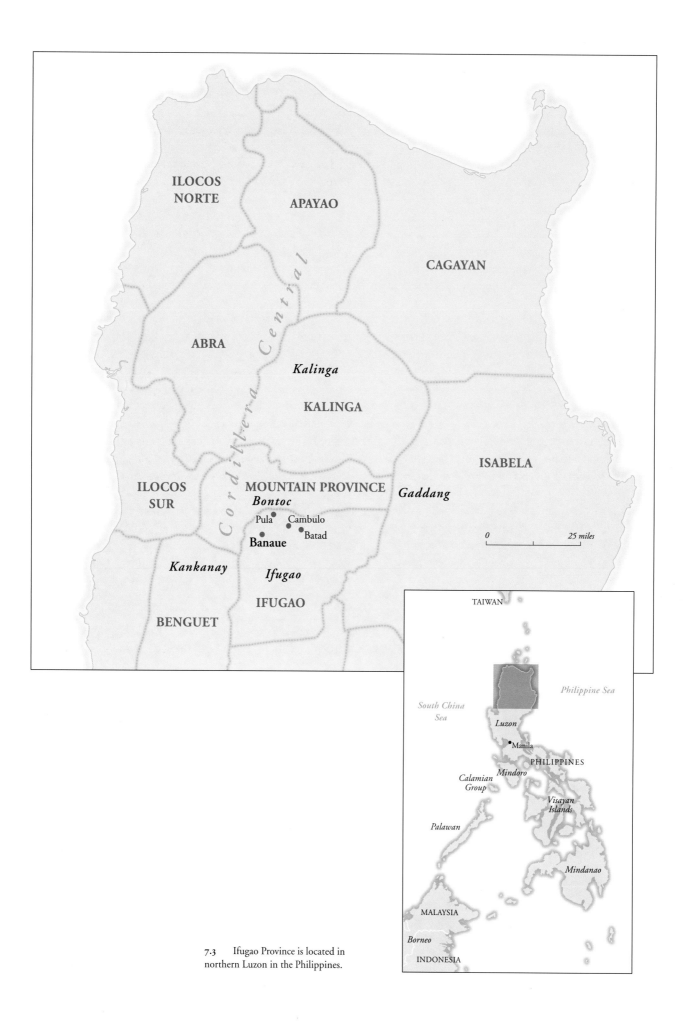

7.3 Ifugao Province is located in northern Luzon in the Philippines.

develop commercially viable goods that could still speak of their cultural heritage and practice.

As a work alternative to the farm and factory, artisan trades have increased significantly worldwide, and most prominently in countries like the Philippines that have embraced pro-market reforms and global integration. The ability of Philippine weavers to realize new opportunities within such socioeconomic change thus disputes the earlier "steamroller" model of global capital. This research argued that with dramatic economic expansion, the differential work options for men and women often resulted in women losing the autonomy they had as producers and traders (e.g., Boserup 1990; Nash 1988). Studies also suggest that this marginalization was more prevalent in household production where women often worked for low returns in order to combine their productive work with their reproductive tasks. Although some women in the Philippines have been disadvantaged by growing capitalist practice (Miralao 1986), others have overcome obstacles to participate in development by diversifying their market trade and learning skills that allow them to take advantage of the new economy.

By drawing on studies that analyze contemporary transformations in craftwork with commoditization (e.g., Causey 2003; Chibnik 2003; Femenias 2005), I argue that Banaue's female bast fiber weavers situate their current practice as one of "occupational multiplicity" (Illo 1995). Artisans continue to interweave craft activities with agricultural responsibilities as farmers and landowners and in so doing negotiate their identities as encompassing both spheres—artisan and cultivator. By reviving local bast cloth production, they reproduce indigenous cultural institutions and practices, and through risk-taking ventures in commercial endeavors, they fashion spaces of agency, innovation, and resistance to consolidate positions in "modernity" despite the potential of these positions to shift.

I begin this chapter by reviewing studies of gender and cloth production to dismantle lingering dichotomies such as "domestic" and "public" and "informal" and "formal." To highlight the avenues through which artisans reconfigure production in a so-called traditional art form, I focus on two case studies of Philippine bast fiber weavers working at the household level. This chapter makes a particular contribution to research on rural women's artisanal work by applying a gendered analysis that considers both cultural and economic practice integral to how artisans reposition their work amidst new forms of global capital.

GENDER, CULTURE, AND CLOTH PRODUCTION

Studies on regional or rural cloth production have argued that weaving is often culturally defined as women's creative work, in particular when artisans produce textiles and clothing at the household level for domestic and ceremonial use (e.g., Hendrickson 1995; Guss 1990). Through their weaving, women reproduce family, community, and regional cultural identity, thereby establishing this activity as a source of their power over spaces of production and exchange. Kathy M'Closkey, for example, in her analysis of the importance of Navajo women's weaving to the well-being of community social life equates women's life cycles and their roles as mothers to the construction of cloth. She argues that the transference of weaving knowledge between women is integrally associated with the concept of K'e (right and respectful relations with the spirits of one's ancestors). The K'e that exists between mother and child provides the foundational concept and form for all relationships in Navajo social life (M'Closkey 1998, 120). Blenda Femenias analyzes women's production of dress in highland Peru through a "lens of gender" (2005, 18). In so doing, she similarly demonstrates how women's weaving and embroidery serve as gendered symbols as well as markers of ethnicity, class, exchange, and resistance, and she argues that women's continuing control of this realm facilitates their ongoing power in domestic and economic spheres. Indeed, highland Guatemalan

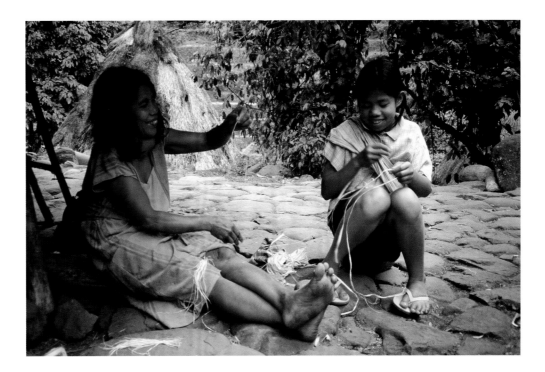

7.4 An artisan teaches her daughter how to process bast fibers in preparation for weaving.
Photograph by B. Lynne Milgram, Cambulo, Banaue, Ifugao Province, 2000.

women's production of *traje*—the indigenous dress of both men and women—emerges as the forum through which women ensure the maintenance of one of the region's principal cultural emblems. Women's decisions to maintain or change textile patterns or spatial design determine the way Guatemalan ethnicity is expressed across the region (Hendrickson 1995, 63–66).[2]

Much of the early scholarship on Southeast Asian textiles also tends to link cloth production to the female sphere on a symbolic level (e.g., Gittinger 1979; Mashman 1992). Women's textile production symbolizes those qualities embodied by women such as nurturance and the power to give life. Indeed, Janet Hoskins's research in East Sumba, Indonesia, likens the practice of dyeing cloth with indigo to the process of women giving birth (1989). Throughout Indonesia, the reciprocal exchange of gifts at rites of passage maintains both cosmic and earthly balance. In such symbolic exchanges, gifts of textiles, which are categorically regarded as "female," are balanced by gifts of metal, money, and livestock, symbols of physical strength and endurance that are categorically regarded as "male" (Gittinger 1979, 20; Hamilton 1994, 44–48).

There is very little historical documentation, however, that discusses women's symbolic or economic association with cloth production in the Philippines. Frances Lambrecht's early twentieth-century accounts of Ifugao rice-planting rites provide one of the few examples linking women, textiles, cultivation, and fertility. He explains that during planting, the first deities invoked are described as those who cover themselves completely with blankets; the gods of reproduction are then summoned to ripen the rice plants: "wrap the rice in a leaf-sheath fabric…and let it hasten and turn pink [ripen]" (1932, 52, 113; see also Conklin 1980, 14; 1964–1978). At the time of Lambrecht's research, these textiles would have been made from both cotton and bast fibers. Roy Barton similarly establishes the symbolic role of textiles by illustrating that the entire weaving process is deified. Different gods are responsible for each of the different aspects of cloth production (1946, 15–30). Filipina scholar Miriam Pastor-Roces briefly touches on this topic in her historic overview of Philippine textiles. She maintains that the complementary dichotomy of male (weapons) and female (textiles) goods has been most highly defined in the garments worn at marriage rituals throughout the Philippines (1991, 219–20). She argues, however, that the volume of such exchanges was "clearly limited, relative to that documented in many Indonesian societies" and that such "engendering of material culture elements did not appear to be an overt theme of birth and death ceremonies in the Philippines" (1991, 220).

It is important then to note that although women in the northern upland Philippines take great pride in being the major cloth producers and although textiles embody symbolic significance, both men and women give textiles as gifts at special occasions. As Roy Hamilton has similarly described for ceremonial exchanges on Flores, Indonesia, the type of textile one gives is based on one's kinship relation to the celebrant of any occasion, not necessarily on whether the giver is female or male, nor on whether the giver has produced the cloth (1994, 47–48; see also Milgram 1999). In the northern Philippines, the giving and receiving of textiles emerges both as a marker of class

and as a marker of gender. At ceremonial occasions, the wealthy tend to give more and better-quality textiles, and community and family members try to give gifts to prominent community members that are commensurate with the higher class or status of the latter.

Weavers in Banaue confirm, moreover, that at the level of practice, there remains a link between women and cloth production. One weaver explains that "this is our tradition [*ugali*] here; we have been making cloth through the generations and our daughters will continue to weave." Another weaver in her early sixties from the Banaue village of Cambulo insists that production of the village's bast fiber textiles will not die out. She goes on to outline, "I, along with some of my neighbors [*barkada*], continue to weave cloth made from our 'native' plants; we give these cloths as gifts to family members on special occasions [such as weddings] to remind them of our village heritage." One woman who retains these weaving skills explains: "Young women in the village, such as high school students, have asked me to teach them how to process the fibers and weave the stripe arrangements in these special cloths. I and my neighbors [other weavers] voluntarily instruct the younger women in this type of weaving and tell them about the significance of these cloths to village customs" (fig. 7.4). Artisans point out that there is a renewed interest in reviving bast fiber production in both Pula and Cambulo because residents want to wear their village-based, traditional-style dress at regional public celebrations such as Banaue's annual spring Imbaya (village celebration). At such occasions, the municipal government sponsors competitions for residents who best represent their village through dress. At both the opening and closing ceremonial parades, those residents choosing to march for their village bedeck themselves in the best examples of their local dress. "Donning bast fiber garments serves as a visual statement of our 'place' [village] and of our ethnic identity," one weaver explains. Female artisans thus regard weaving as a practice requiring particular skills and knowledge and assert that they are proud to reproduce their practice of bast fiber weaving, albeit in changing forms.

In Cambulo and Pula, as in other Banaue weaving villages, cloth production is also firmly rooted in economic transactions that impart exchange value as well as symbolic value to producers. Roy Barton, for example, writing on the province of Ifugao in the early 1900s, points out that people commonly paid their legal fines in weavings ([1938] 1963, 48, 204–10; 1919; see also Guy 1958). He also records the trading stories told by Bugan, a weaver in the 1880s. Barton explains that Bugan traveled to neighboring villages to sell her cloth for vegetables, salt, and livestock, "She turned to her loom as a means of acquiring other goods and made trips to neighboring regions in order to exchange the products of her work" ([1938] 1963, 206). Cloth woven in the late nineteenth century would have been constructed from bast fibers, as cotton was not widely available in the uplands until the early twentieth century.

Some Banaue weavers in their fifties and sixties similarly explain that they used to travel to neighboring municipalities— a distance on foot of two to five hours—to trade their weavings for livestock and vegetables not locally available. Still others

relate that they have traveled on their own since the 1960s to sell their textiles to specific textile and craft dealers in Manila. Indeed, my conversations with one of the most noted craft businessmen in Manila confirm that weavers whom we both know have been selling their bast fiber weavings to him since the mid-1960s when he first started his business. He continues to display rolls of differently striped bast yardage in his shop along with Cordillera textiles, furniture, and wood carvings. Such contextualized displays suggest ways in which consumers can use these cloths in contemporary home design.

Women in Banaue have always produced bast fiber textiles for both symbolic and economic purposes. By working across household and market, rural and urban spaces, and local-to-national arenas, they dissolve determinist ideas about discrete and bounded social and economic categories. Currently, artisans are using this multifaceted platform as a springboard from which to mount a line of culturally rooted yet market-oriented functional textiles in new bast fiber weaving initiatives.

THE SETTING: BANAUE, IFUGAO PROVINCE, NORTHERN LUZON

Ifugao is located in the Gran Cordillera Central mountain range that extends through much of northern Luzon (fig. 7.5). The Banaue villages of Cambulo and Pula, noted for their rugged upland terrain, are accessible only by making the four- to five-hour walk along mountain trails accessed from the municipality's single major road (fig. 7.6). The main economic activity in the Cordillera, as throughout the Philippines, is wet-rice cultivation carried out in irrigated pond-fields. As the cool climate limits both the extent of, and surpluses in, mixed agricultural production, most families combine cultivation with nonagricultural income-generating work such as producing crafts, working in the tourist and other service industries, or performing contract wage labor. The increase in tourism since the 1980s means that crafts (e.g., weaving, wood carving, and basketry) formerly made for local use and regional trade are increasingly targeted for commercial sale, especially during the busiest part of the tourist season from December to May.

Both men and women work in extra-household income-generating activities, and the region's socioeconomic systems of primogeniture and bilateral kinship and inheritance mean that women own land and inherited wealth and have ready access to new economic opportunities. Most women manage and allocate household finances and hold power in this sphere. Men, however, dominate in public positions in politics and in religious offices, and although they participate in domestic tasks, women still assume the bulk of childcare and domestic responsibilities (Milgram 2003b). Men and women thus continuously renegotiate gendered roles and power relations as they redefine their work and positions in Ifugao's commoditizing economy. Throughout the Cordillera, moreover, the differences among women—depending upon factors such as social class (landed elite, tenant, or landless) and education—mean that some may have more of an advantage than others to gain social prestige and accumulate capital through their work in new craft enterprises.

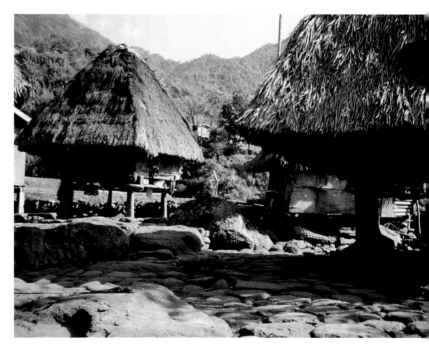

7.6 Thatched village houses are customarily constructed on rock platforms.
Photograph by B. Lynne Milgram, Cambulo, Banaue, Ifugao Province, 2000.

7.5 This rice terrace mountain landscape is typical of the upland areas of Ifugao Province.
Photograph by B. Lynne Milgram, Banaue, 2003.

HISTORY OF PHILIPPINE
BAST FIBER PRODUCTION

Inadequate archaeological evidence and documentation preclude the reconstruction of the history of cloth production generally, not only in northern Luzon but also throughout the Philippine Archipelago. We cannot state with certainty how textile traditions spread and developed between or within island areas. The following account thus encompasses the greater Philippines in an effort to contextualize bast fiber weaving practices in Ifugao.

Beaten barkcloth was most likely the earliest Philippine cloth practice. Archaeological evidence in the form of bodies wrapped in beaten barkcloth dating from 1000 BCE has been uncovered in central Philippine cave sites in Palawan Island and in the Calamian Islands (Solheim 1981, 39–40). In widely scattered archaeological sites throughout the Philippines, further evidence for the antiquity of this type of barkcloth production is based on the distribution of stone beaters, the striking surfaces of which are marked with grooves arranged in various

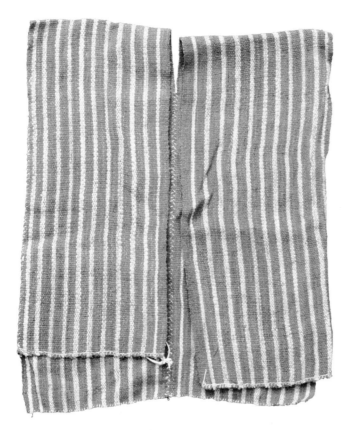

7.7 Man's Vest
Banaue, Ifugao Province, early
twentieth century
Paper mulberry fiber; plain weave
52 cm
American Museum of Natural History,
New York, no. 70.5/275

patterns (Casino 1981, 130). The material for bast fiber cloth, both beaten and woven, was readily accessible, as noted, from local and fast-growing paper mulberry trees that were planted purposely for making such cloth (Dozier 1966, 128–29; Newell 1993, 111, 583; Scott 1974, 315).

The earliest loom-woven textiles discovered in the Philippines are two remnants of red, black, and white ikat-patterned abaca (banana) fiber cloth that were used as body wrappings. They were found in a wooden coffin dating from the fourteenth or fifteenth century in Banton Cave near the island of Mindoro, central Philippines (Fraser-Lu 1988, 42). In northern Luzon, the practice of weaving seems to be associated with peoples who practice wet-rice cultivation, namely the Ifugao, Bontoc, Kankanay, and Kalinga with the Gaddang, who weave but do not grow wet rice, constituting the exception. Dry-rice cultivators tended to construct the garments they needed from cotton yardage obtained through trade with the lowlands. It is not clear from the historical record whether or not these people practiced weaving at one time, nor are the sources apparent from which they may have fashioned clothing in the absence of trade (Ellis 1981, 237; see also Keesing and Keesing 1934, 58–59).

Empirical examples and historical evidence indicate that bast fiber was the first material to be plied into yarn for weaving. During his fieldwork among the Bontoc and Ifugao from 1902 to 1908, anthropologist Frederic Starr noted that the "spinning of bark into twine was a substantial industry" (1908). Other early twentieth-century accounts repeatedly mention the "spinning" of bast fibers either with a spindle or by being rolled on the thigh (De Roy 1907–1914; Jenks 1905, 27, 1904; Robertson 1914, 525; Scott 1974, 43, 200, 220). Of note, the use of the word "spinning" in these historical accounts is inaccurate as two lengths of bast fiber that have been twisted together are actually "plied" using a drop spindle, as will be described more fully below. Otley Beyer states that in the first decade of the twentieth century, 50 percent of all Ifugao textiles were still being woven from local bast plants, most likely the paper mulberry tree (1947, quoted in Conklin 1967, 253). Indeed, Keesing and Keesing note the initial importance of bast fibers used for clothing while identifying the cloth's later demise, "The Bontoc people who three decades ago dressed in woven bark...are now variously resplendent in G-strings and tapis, clothes made locally in cotton (1934, 203; see also Lambrecht 1958, 40; Scott 1974, 315). Collections of early twentieth-century woven bast fiber blankets, loincloths, skirts, and belts housed in the United States at the Field Museum, the American Museum of Natural History, the Peabody Museum of Natural History (Yale University), and the Fowler Museum, for example, attest to the once pervasive use of bast fiber to fashion a variety of clothing and textiles (figs. 7.7, 7.8).[3]

There is no definitive historical evidence to indicate when cotton, which is not indigenous to the Philippines, began to be cultivated and woven. Aguilar and Miralao present evidence that argues for the existence of a cotton industry in the central Philippines and in the northern coastal Ilocos Provinces before the 1550s and the advent of the Spanish (1985, 6–9; see also Keesing 1962, 136). Scholars suggest, however,

that cotton textiles were not widely produced in the Cordillera until the early twentieth century, and until the mid-twentieth century, the production of woven bast and cotton fiber textiles overlapped. Upland weavers started to use lowland cotton yarn because they did not have to process the raw fibers and because, as noted, cotton cloth yields a fabric that is softer than that made from bast (Jenks 1905; Scott 1974, 200, 220).

PRODUCING BAST FIBER TEXTILES

Women working in household production in the Banaue villages of Cambulo and Pula continue to be the primary artisans engaged in preparing bast fibers and in weaving this regionally distinctive cloth. Artisans obtain bast fibers from different local cultivars of the paper mulberry tree and extract and process the bark fibers through scraping, washing, plying, and weaving. Using the local Ifugao dialects of their respective villages, weavers identify some of the cultivars or varieties of the paper mulberry tree from which they most often secure bast fibers. *Bac-hi*, the most common bast fiber, is brown in color and among the coarsest. The other bast fibers, equally as coarse, include, *gut-guto* (white), *rai* (white), *hapot-an* (brown), and *tu-yod* (brown). Most weavers prefer *hu-a*, a white bast fiber possessing the softest texture, as the processing time is less than that for the other fibers. Supplies of *hu-a*, however, are not always available, and there has not been a coordinated tree-planting scheme in the villages to increase this resource.[4]

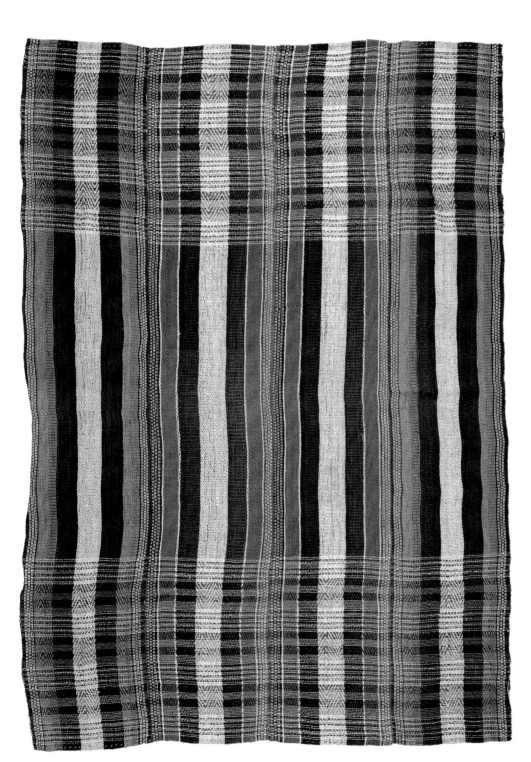

7.8 **Blanket**
Banaue, Ifugao Province,
mid-twentieth century
Paper mulberry fiber; plain weave
and warp-float weave
152 cm
Fowler Museum x76.1911: Gift of Mrs. W.
Thomas Davis, in Memory of W. Thomas Davis

Blankets of this type also functioned as funeral shrouds, used to wrap the body or, after the mid-twentieth century, to drape a coffin.

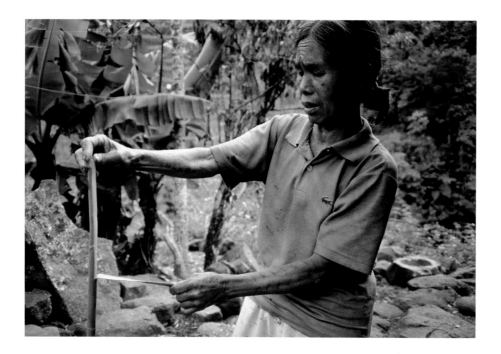

7.9 A weaver undertakes the initial step of stripping the bark from a young tree.

Photograph by B. Lynne Milgram, Cambulo, Banaue, Ifugao Province, 2000.

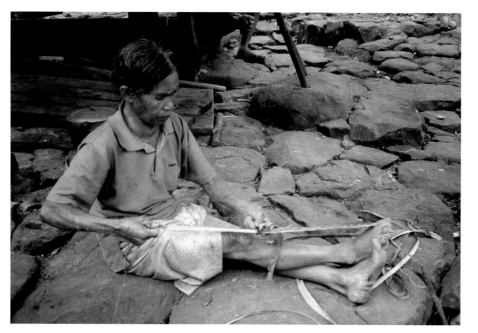

7.10 The coarse outer layer of the stripped bark is carefully scraped away with a small knife, leaving the light-colored, inner bast fiber layer.

Photograph by B. Lynne Milgram, Cambulo, Banaue, Ifugao Province, 2000.

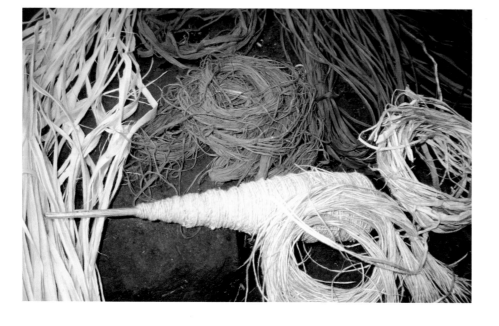

7.11 Bast fibers are left to dry outside before being processed. Some already-plied fibers appear on a drop spindle in the foreground.

Photograph by B. Lynne Milgram, Cambulo, Banaue, Ifugao Province, 2000.

Women, often assisted by their husbands or children, cut young trees from the village's community forest or the family's ancestral land and transport the saplings to their houses for subsequent processing. Following the extraction of the fibers from the trees, the remaining wood is dried and later used for the family's firewood. Transforming plant fiber into cloth begins with the task of completely removing or peeling back the thin outer layer of bark from the trunk of the young trees (fig. 7.9). Women prefer to work on this activity during the rainy season (mid-May to December/January) when the bark is easiest to remove. During the dry season (March to May), the bark tends to adhere more firmly to the trunk of the tree. Women also start to process the fibers as soon as possible after separating the bark layer from the tree to prevent it from drying out and becoming brittle due to the evaporation of moisture. Laying the length of the bark strip on the ground in front of them and using a small sharp knife, artisans scrape off the coarse outer layer from the bark taking care not to split or break the remaining inner fiber layer (fig. 7.10). The stripped fibers are wound into small loose coils (locally known as *pinggols*), beaten with a smooth stone to soften them, and then left to dry in the sun for a few days (figs. 7.1, 7.11). The dried strips are then split by hand into separate narrower strands (fig. 7.12). As the length of these finer strands depends on the height of the young saplings (approximately 3–4 meters), weavers construct longer fiber lengths by simply taking two strands end-to-end and twisting the ends together.

Using a drop spindle, artisans ply two separate strands of bast fiber together to construct a stronger two-ply yarn for weaving (fig. 7.13). Women wind the plied yarn into skeins using a skein winder, or *warangan* (fig. 7.14); and to further soften the fibers before weaving, they boil the skeins for one to four hours in pots of water to which wood ash has been added (fig. 7.15). The coarser fibers like *bac-hi* and *gut-guto* require the longest boiling time, and *hu-a* requires the shortest. After boiling, the skeins are rinsed in water, dried in the sun, and wound into balls in preparation for weaving.[5] All cloth is warp-faced plain weave, and as throughout the Cordillera, the weaving is done by women on back-strap or body-tension looms (fig. 7.16). Such weaving technology means that the width of the fabric is usually narrow—25–30 centimeters. The narrow width enables weavers to maintain an even tension in the fabric as they can comfortably pass the weft shuttle back and forth across the warp span. A large number of bast fiber textiles and garments produced by Cambulo and Pula weavers adhere to indigenous models from the past, such as men's loincloths and vests, women's skirts and blouses, and blankets, as noted earlier. Weavers in other Banaue villages who also produce these standard types of special-occasion, local Ifugao dress commonly combine cotton and synthetic yarns in the weaving process. Bast fiber weavers then see the opportunity to capitalize on their unique knowledge and skills by capturing a niche in the tourist market for innovatively woven Ifugao textiles that assert the producers ethnic identity and heritage as well as their identification with a specific place.

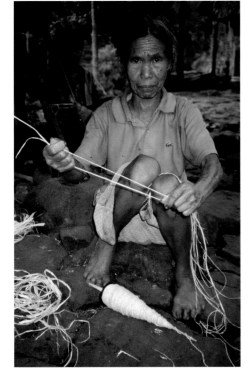

7.12 The bast fibers are split by hand into thinner strips.

Photograph by B. Lynne Milgram, Cambulo, Banaue, Ifugao Province, 2000.

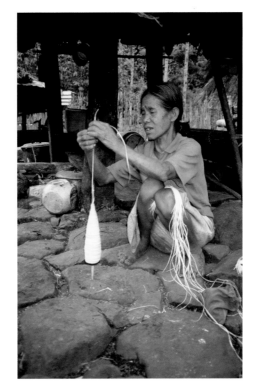

7.13 Before weaving, two separate strands of bast fiber are plied together on a drop spindle.

Photograph by B. Lynne Milgram, Cambulo, Banaue, Ifugao Province, 2000.

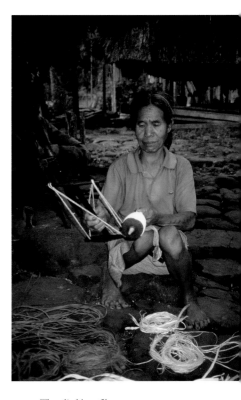

7.14 The plied bast fibers are wound into skeins using a *warangan*, or skein winder.

Photograph by B. Lynne Milgram, Cambulo, Banaue, Ifugao Province, 2000.

7.15 Boiling the skeins of bast fibers in water to which wood ash has been added further softens them.

Photograph by B. Lynne Milgram, Cambulo, Banaue, Ifugao Province, 2000.

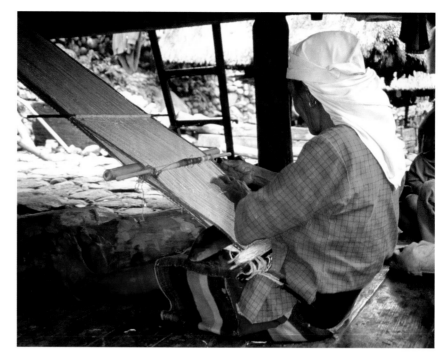

7.16 A woman weaves a bast fiber cloth on a back-strap loom.

Photograph by B. Lynne Milgram, Cambulo, Banaue, Ifugao Province, 2000.

7.17 Bast fiber textiles are displayed for sale outside a town shop.

Photograph by B. Lynne Milgram, Banaue, Ifugao Province, 2005.

NEGOTIATING OPTIONS IN WEAVING

Until the early 1980s, only a few older women in the Banaue villages of Cambulo and Pula continued the labor-intensive process of bast fiber production. Weavers with whom I have spoken emphasize that they want to retain their skills in this work because both bast fiber technology and the bast fiber products themselves are integral to the maintenance of their social and economic positions within their communities. Cambulo and Pula artisans state that by reviving the use of bast fiber cloth, they can more broadly communicate their indigenous knowledge by, in effect, employing these material goods to educate consumers about Ifugao culture (see chapter 6). In their current bast fiber production, artisans continue to use the customary narrow-width format of the back-strap-woven cloth (approximately 30 x 300 centimeters) as this technology continues to be most suitable to household production. Weavers then sell their yardage to craft shop owners who sew the fabric into different functional products such as bags, place mats, and table runners (fig. 7.17).

The fluctuating cycle of seasonal tourism, however, means that most women living in rural settings do not easily abandon their engagement in rice cultivation, which is necessary to meet the subsistence needs of their families. Female artisans have criteria they use to decide how to divide their time between cultivation and weaving and the role each activity plays in their economic and cultural life. Because Cordillera residents continue to invest their labor in activities that yield not only economic value but also cultural value in the form of ownership of irrigated rice land, the decisions of weaver-cultivators about their work vary according to their familial and community priorities.

Rice cultivation in Banaue usually begins in December with the cleaning of the rice fields and the planting of the seedling beds. The transplanting of the seedlings most often occurs in January and February, and this is the second busiest time in cultivation. As it may still rain during these months, the number of tourists visiting the municipality of Banaue at this time is not as high as in the December Christmas season or in the dry period from March to May, but it is large enough to create a small, steady demand for local handicrafts. Artisans must decide whether it is more profitable for them to engage in cultivation or to stay home to weave. This is particularly relevant for female artisans, as women assume the majority of cultivation tasks (Milgram 2003b). Most weavers indicate that if they weave functional, market-driven cotton textiles (e.g., backpacks, vests, blankets, place mats) in January and February, they can earn almost the same income as they would if they chose to plant rice in the fields. Given this option, if artisans have sufficient money to pay laborers, many choose to weave and hire other women to plant their fields. As the market for bast fiber weaving is still small, however, some weavers continue to devote their labor to rice cultivation at this time. During the harvest season from June to August, sales from weaving are minimal as this is the rainy season, and there are few tourists. Weavers prefer to participate in the harvest, not only to insure income in cash or in kind but also because harvest season is a festive time in which community relationships are renewed. Bast fiber weavers tend to do most of their production from September to December to prepare products for the busier tourist season. The following case studies of weaver households in Cambulo and Pula explore why and when artisans move between weaving and cultivation and some of the innovations they have initiated to expand markets for their unique bast products.

· *The Pindgal Household*

Anita and her husband, John,[6] both in their late thirties, have six children, all of whom live at home in Pula. Anita is a weaver, and John does contract wage labor. They do not own land but obtain their family's supply of rice through a sharecropping arrangement with their neighbor in which they farm the rice fields and then divide the harvest equally with the landowner. Anita works in both cultivation and weaving, changing the time she spends in each activity depending upon her family's needs and the market for her woven products.

During the January planting season one year, for example, Anita worked in the fields and did not weave. As a result, she felt that she lost potential income as well as personal contact with the town craft shop buyers. Thus, she decided to take advantage of the next January market for weaving. During the evenings in December the following year, she arranged sets of warp threads with her own stripe patterns on her back-strap looms. Anita then paid other women in the village to weave her cloth yardage while she planted. She also asked a friend to deliver some prearranged warps to artisan-relatives living in the Banaue town center. Having to pay other weavers for their labor meant that Anita's profit was reduced, but her income, although small, still made a contribution to the family's earnings at a time when the household did not have their own vegetables or rice. By having weavings to sell during January and February, Anita was able to keep in continuous contact with her regular town buyers. Other women in Pula, however, want to discourage the practice of giving such contract or piecework to weavers outside of the village. These women emphasize that bast fiber production is distinctive to their "place" (village) and that the women who should benefit first from this work should be neighbors and local relatives.

Anita's sixteen-year-old daughter, Kathleen, is also an excellent weaver, and she increasingly helps Anita weave on weekends and after school. Anita arranges the warp threads in the stripe arrangements she desires, and her daughter weaves the cloth. By selling weavings during the busier tourist season, Kathleen was able to earn money to pay her high school tuition fees. Anita's husband, John, assumes the responsibility for childcare during those times when Anita is busy weaving.

Many of the early twentieth-century bast fiber cloths that I viewed in North American museum collections display the most common patterning and spatial layout—equal size, alternating solid white and solid brown stripes or a white center field flanked on both right- and left-hand borders by narrow solid brown stripes (see figs. 7.2, 7.7). To increase her sales, Anita experiments with these time-honored pattern arrangements to create her own innovative stripe sequences. She has developed design layouts in which the stripes are arranged in varying widths and colors. In some stripes she alternates the color of each consecutive warp thread, which when woven in

a plain weave creates a horizontally banded pattern within the stripe (fig. 7.18). In addition, Anita is working with her buyer to weave wider and longer pieces of yardage that can accommodate the latter's manufactured items such as large tote bags and place mats. If the new products are successful, Anita intends to raise the price she asks for her woven yardage. Some younger weavers, however, are resisting this trend as they complain that the income they earn from weaving wider fabrics does not compensate them for the amount of extra time they must devote to production. Such circumstances thus highlight the ways in which buyers can exploit artisans whose need for cash at certain times of the year means selling goods at lower prices or accepting lower compensation for their labor (see also Causey 2003).

· The Tunga-an Household

Dora and David Tunga-an, both in their mid-fifties, support themselves through their farming and weaving and have two children still living with them in Cambulo. David earns cash by doing periodic contract wage labor in his neighbors' fields, and when he obtains orders, he makes baskets. With the commercial market for bast fiber textiles just developing, Dora's sales fluctuate, like those of Anita Pindgal, making her more dependent upon the produce from her garden and rice fields at certain times of the year. She has thus actively sought additional types of textile work. As her elderly neighbor has poor eyesight and thus has trouble processing the bast fibers, Dora processes the materials her neighbor requires for weaving. Although this work does not pay well (just slightly less than the rate for a day's agricultural wage), Dora feels that she can work in the evenings while watching her children.

In looking for avenues to improve the market for her bast textiles, Dora started to experiment with coloring her cloth with natural dyes. Although the range of colors is limited, she is confident that the potential of this innovative feature will meet contemporary consumer tastes. In addition to brown and white, the natural colors of Ifugao's bast fibers, Dora obtains a muted green color in varying shades, by first dyeing the threads yellow, using the local ginger, or *unig*, rhizome followed by overdyeing in a black dyebath made from the leaves and bark of the *atorba* and *blublu* trees.[7] As she dyes the yarn in an iron wok, the iron functions both as a mordant to fix the dye and as a coloring agent. Dora currently accepts commissions from neighboring weavers who want their warps dyed with natural dyes but who do not have the knowledge to do so. To further diversify her work, Dora has started to use a small portion of her rice field to plant the local ginger. She uses the yellow dye in her own work, and as her cultivation increases, she anticipates being able to sell extra ginger rhizomes to her neighbors.

In addition, on alternate Fridays, Dora makes the four-hour walk to the Banaue town center to attend the Saturday morning market. She delivers her own weavings to a relative who owns a craft shop, and she takes pieces woven by her neighbors who do not want to make the journey. Dora adds a small commission of twenty to thirty pesos (approximately US$0.50) to the pieces that she sells for her neighbors. In another initiative, Dora encouraged her son to try to sell her work in Manila. The craft businessperson who has emerged as Dora's best buyer is now working with her to develop specific patterns and colors that he can include in his new product line of "Cordillera" designed goods. Dora has made a number of prototypes such as bast fiber carrying bags or purses. Although these urban sales may total only 10 to 15 percent of her yearly sales, they expand Dora's market reach beyond the local level. Dora's occupational multiplicity in both production and marketing better situates her socially and economically to meet the challenges of a rapidly changing economy.

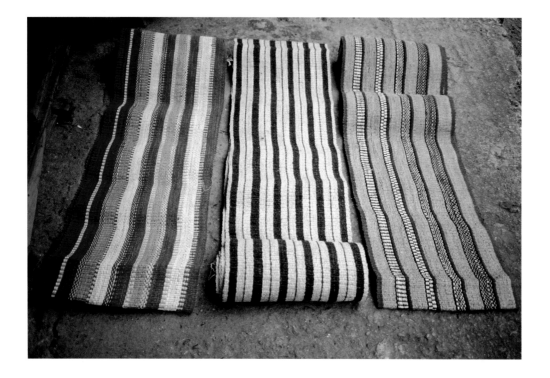

7.18 Three pieces of bast fiber cloth display new stripe arrangements.

Photograph by B. Lynne Milgram, Cambulo and Pula, Banaue, Ifugao Province, 2002.

CONCLUSION: BAST FIBER TEXTILES
AND THE POTENTIAL FOR SOCIAL CHANGE

What becomes evident from talking to weavers in Cambulo and Pula is the heterogeneity of their involvement in crafts and cultivation. The elastic demand for crafts means that weaving income alone cannot sustain the household. To ensure a household's long-term viability then, artisans, and women in particular, cultivate active support networks of relatives and neighbors and purposefully combine earnings from crafts such as weaving with those from different income-generating activities.

Studies on the commoditization of crafts generally cite many instances in which craft production is controlled by a small group of middlepeople whose economic advantage enables them to exploit artisanal production (e.g., Aguilar and Miralao 1984; Mies 1982). The trade opportunities in Banaue's emerging production of bast fiber textiles, however, are too small to support a level of middlepeople who can profit by monopolizing access to either materials or distribution channels. Yet, in the Banaue villages of Cambulo and Pula, for example, such instances of exploitation are still common. This most often occurs during the low tourist season when traders take advantage of the opportunity to reduce the prices they pay to weavers for their products.

Bast fiber weavers are beginning to challenge this situation (fig. 7.19). Because artisans have not had access to the capital needed to purchase treadle sewing machines, for example,

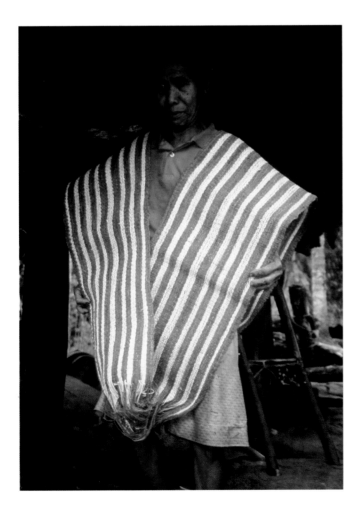

7.19 An artisan displays an example of her weaving.

Photograph by B. Lynne Milgram, Cambulo, Banaue, Ifugao Province, 2000.

augmented by the physical problem of transporting the machines to the village proper, weavers tend to sell their production solely as yardage. The town buyers then manufacture the yardage into functional items. The income earned from the sales of yardage is lower than that earned from sales of manufactured goods. To maximize their earnings, some weavers like Dora Tunga-an and Anita Pingdal have requested financial and consultative assistance from two Ifugao development agencies who are promoting different livelihood enterprises. The Central Cordillera Agricultural Programme (CECAP) and the Philippine Rural Renewal Movement (PRRM) have both agreed to assist bast fiber weavers to obtain the resources, technology, training, and market access that they need to develop new designs and innovative bast products more suitable to "Western" tastes and uses (see also Milgram 2000 and chapter 9 of this volume).

In a further initiative responding to artisans' concerns about the lack of organized planting programs for paper mulberry trees, CECAP, which has already been consulting on rice cultivation, has committed to implement planting schemes for all forest products. Weavers realize that if they are to increase their production, they must secure the sustainability of this resource. In mid-1999, PRRM also established a tree nursery in Cambulo. Each year, when the seedlings have reached a certain size, those interested in planting are paid a small fee to establish young trees throughout the village's forested area.

The opportunities fashioned by these artisans do not mean that their initiatives can provide sustainable options in work and social change for all women with the advent of global capital. Such a proposition belies the tremendous structural forces that are at work against them and the degree to which globalization (in the form of transnational, capitalist institutions and structural adjustment policies) has transformed social and economic relations at so many levels (see Balisacan 1995). I want to suggest, however, that the current acceleration of global systems still presents opportunities for artisans, such as bast fiber weavers, to capture new spaces of production and distribution. In so doing, they claim their share of expanding markets and perform in new arenas of identity construction.

The multiplicity of women's involvement in bast fiber weaving dispels the picture of artisans as a bounded category of producers who persist in traditional and unrewarding work for want of alternatives or of ability to innovate. Weavers such as Dora Tunga-an and Anita Pindgal make their work more rewarding by designing their own particular styles of weaving and by galvanizing different channels for marketing. They may also seek change through alternative avenues such as their recent initiatives with CECAP and PRRM. The various ways in which weavers operationalize options in their work ensure the continuation of this dynamic craft into the twenty-first century.

8.1 Summer kimono (*katabira*)
Niigata Prefecture, circa 1850–1925
Ramie
142 cm
Collection of Lynn S. Gibor

This example of Echigo *jōfu*
features ikat (*kasuri*) patterning
in the warp and weft, combining
geometric and pictorial motifs.

8. Preserving Echigo *Jōfu* and Nara *Sarashi*
Issues in Contemporary Bast Fiber Textile Production

Melissa M. Rinne

AS WITH OTHER GROUPS PRACTICING traditional crafts dependant on highly skilled artisans, many Japanese textile communities are in crisis. Japan's handwoven textile industries have long catered almost exclusively to the kimono consumer willing to pay dearly for quality goods to hand down from generation to generation. In an age when the kimono is no longer worn by the majority of Japanese, however, fewer consumers are willing to invest in the national costume. Handwoven kimono have endured an especially unhappy fate. Though surface-dyed (*some*) kimono—industrially woven silk with hand-painted, stenciled, or silk-screened surface dyeing—are still worn by some at formal occasions, such as weddings and coming-of-age ceremonies, thread-dyed and handwoven kimono textiles fall into the category of "everyday wear," making them virtually useless in a modern context.

These problems are compounded for woven kimono fabrics made from bast fibers (*asa*). Though the cloth of various bast or leaf fibers—including hemp (*taima*), ramie (*choma, karamushi*), wisteria (*fuji*), paper mulberry (*kōzo, kajinoki*), Japanese linden (*shina*), Japanese banana (*ito bashō*; see chapter 6), kudzu (*kuzu*), and nettle (*irakusa*)[1]—can be used to make clothing, the kimono demands a thinness and pliability that in most cases can be achieved only with ramie, banana fiber, and, rarely, hemp. As is the case with linen in the West, the crisp, sheer garments made from bast or leaf fibers are considered appropriate only in hot weather. In Japan, however, rigid rules of kimono dress restrict the wearing of *katabira* (*asa* kimono, primarily of ramie) to a few months at the height of summer, regardless of temperature (figs. 8.1–8.3).[2] In addition, *asa* garments have been deemed impractical by practitioners of the Tea Ceremony—some of the staunchest advocates of the kimono—because of their tendency to wrinkle. Finally, the costliness of bast fiber cloth made entirely from hand-spliced threads keeps it out of the range of all but the most affluent consumers: in the 1990s, a single kimono-length bolt of Echigo *jōfu*, a ramie textile that will be discussed below, retailed at between US$20,000 and US$100,000.

While such external economic and social factors make it increasingly difficult to market the finished product, a different set of internal social and economic factors plague the weaving communities in their efforts to attract, train, and retain workers to produce *asa* textiles in the first place. Highest-quality bast fiber textiles are made not from spun threads, as with linen in the West, but from hand-spliced threads that require special handling that differs from the treatment of silk or cotton. The makers of such textiles must spend many years mastering a

special set of skills, but because the processes involved are time consuming and the demand is low, such artisans rarely command a living wage in today's economic climate. It is fair to say, then, that either financial security (i.e., a wealthy household or a second income) or a willingness to live with some degree of artisanal poverty is a prerequisite to producing bast fiber textiles today.

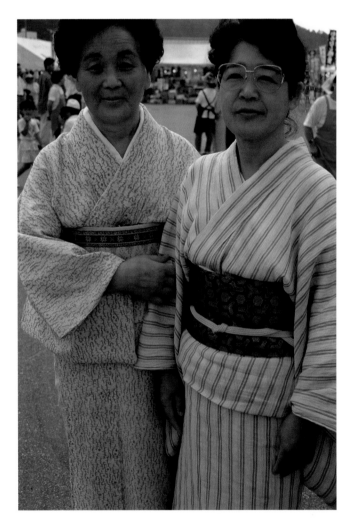

8.2 Two women wear ramie kimono while attending a summer festival. Bast fiber (*asa*) kimono are less common and more formal than the *yukata*, a cotton kimono also worn on festive occasions in mid-summer. Historically, the village of Shōwa has cultivated the ramie fibers used in the woven textile Echigo *jōfu*.

Photograph by Melissa M. Rinne, Shōwa, Onuma-gun, Fukushima Prefecture, 1994.

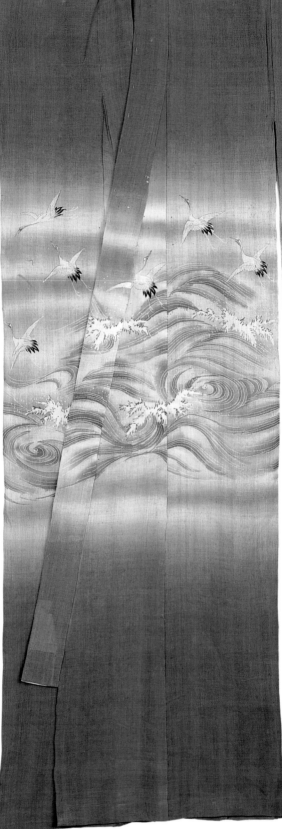

**8.3 Child's long-sleeved
 (*furisode*) summer
 kimono (*katabira*)**
Probably Niigata Prefecture,
circa 1850–1900
Ramie
95 cm
Private Collection

This long-sleeved summer kimono
is fashioned from exceptionally fine
ramie cloth, which was probably
woven in Echigo Province (present-
day Niigata Prefecture) in the late
Edo or early Meiji period. The
surface decoration of the bleached
cloth may have been done in Kyoto
or another locale.

Asa textiles that are produced by organized industries are especially at risk. The waning number of young Japanese women and men willing to devote themselves to the tedious and financially unrewarding life of a textile artisan means that there are often no successors to those expert in the less-conspicuous steps of production, resulting in whole skill sets becoming lost with the demise of single individuals. This is true not only for bast fiber weaving but also for producers of woven silk. In the Nishijin district of Kyoto, the textile community that has for centuries produced the highest-quality woven silk *obi* sashes for kimono, it is an ironic twist of fate that the very hallmark of this quality—the division of labor among discrete, highly specialized artisans for every step of the production process—has led to its decline. When one link disappears from such a complex chain, an entire industry faces the possibility of extinction.[3]

The less-conspicuous but high-volume silk kimono industry in Tōkamachi, Niigata Prefecture, is now suffering a similar decline. In spring of 2005, its prefecturally sponsored professional training school for weaving and dyeing graduated a final class before closing its doors for good. According to authorities, this closure took place because the school could no longer guarantee placement for its students in a declining industry.[4] This was the only school left in Japan devoted to professional training for the weaving industry.

Despite these difficult circumstances and varied histories of textile production, many small textile communities around Japan still cling determinedly to their ties to the past. Many of these communities were formerly the home of full-blown local industries, which now try to survive in the absence of some of their key players. Others were mountain villages in which individual households carried out most steps of production—from fiber gathering to weaving.

The ways in which these communities handle change differ. One of the most common means of attempting to preserve a local textile tradition is to form a training course to educate the younger generation (fig. 8.4). Such courses take various forms and are organized by different entities. In addition to preparing local weavers, they often attract aspiring artisans and textile aficionados from other parts of Japan.

Without the efforts of their respective communities, many of these weaving traditions would have died out years ago. At the same time, the realities of trying to preserve these skills in an industrial age present inevitable challenges and paradoxes. This essay will examine the current situation in two Japanese regions producing bast fiber textiles, and it will consider the incongruities inherent in their efforts to preserve and transmit their crafts to the next generation. The first community, comprising the townships of Muikamachi and Shiozawa in Minamiuonuma County, Niigata Prefecture—northwest of Tokyo and east of Nagano—produces a textile called Echigo *jōfu*, a fine, handmade ramie textile used almost exclusively for kimono. The second community located in the village of Tsukigase in Soekami County, Nara Prefecture, about an hour's drive through the mountains from the ancient capital of Nara in western Japan, has produced a hemp or ramie textile called Nara *sarashi* (fig. 8.5).

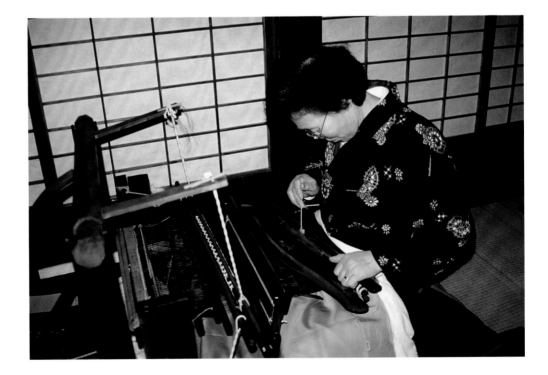

8.4 Arakawa Setsuko, instructor of the annual Echigo *jōfu* training course, dampens the weft quill in preparation for weaving at her home in Shiozawa. Once strapped into the *izaribata* loom, she works for as long as possible in order to weave an even fabric. Even short trips away from the loom can create variations in warp tension, leading to irregularities in the beaten wefts. Photograph by Melissa M. Rinne, Shiozawa, Minamiuonuma-gun, Niigata Prefecture, 1994.

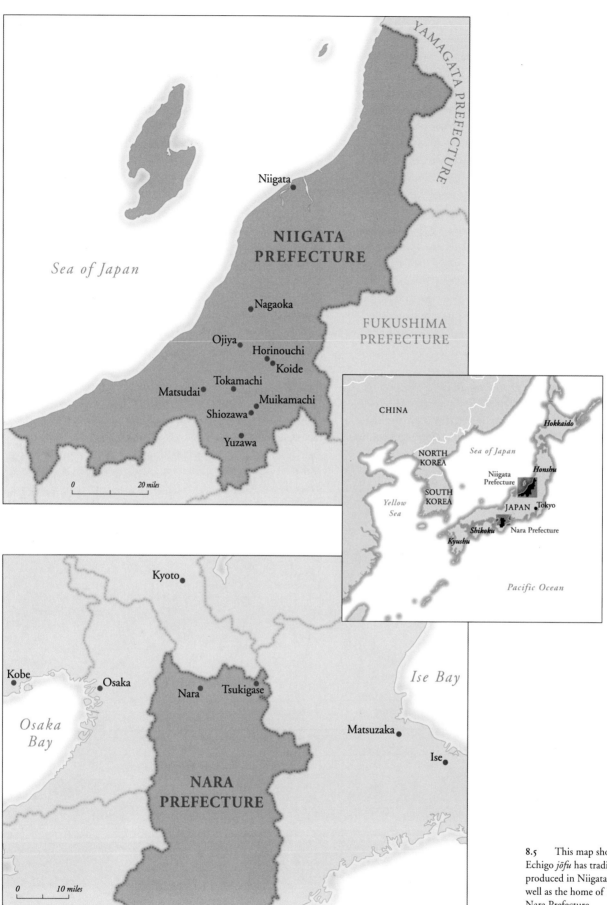

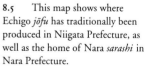

8.5 This map shows where Echigo *jōfu* has traditionally been produced in Niigata Prefecture, as well as the home of Nara *sarashi* in Nara Prefecture.

ECHIGO *JŌFU*: THE SURVIVAL OF AN ESTABLISHED INDUSTRY

Echigo *jōfu* means "superior cloth" of Echigo, the ancient name for the province corresponding to present-day Niigata Prefecture.[5] Made of the bast fiber of the ramie plant (*Boehmeria nivea*), this textile is distinctive for being incredibly fine: the ancient quality test for a 33-centimeter-wide bolt was to run it vertically through the square hole (measuring about 1 centimeter across) of an Edo period (1615–1868) coin. The cloth also boasts frequent incorporation of sophisticated warp and weft ikat (*kasuri*), a truly remarkable feat given the fragile nature of the threads from which it is woven (fig. 8.6). Each approximately 12-meter kimono-length bolt of Echigo *jōfu* is prepared separately and woven on an *izaribata*,[6] a body-tension loom with a partial frame[7] used at least since the eighteenth century (see fig. 8.4). What most distinguishes Echigo *jōfu*, however, is that both the weft and the warp are produced entirely by hand, using a highly skilled method of splitting fibers into long, hair-like strands and splicing them together end-to-end with a plied joint. This method of thread making is common, indeed predominant, throughout East and Southeast Asia, but in this region of Japan it is carried to its ultimate physical limits.

As noted above, production of this textile is now based primarily in the towns of Shiozawa and Muikamachi, located in Minamiuonuma County,[8] a broad, fertile inland valley known across Japan for its top-quality rice cultivation and sake making. Echigo *jōfu* production processes are very similar to those used for Ojiya *chijimi*, or crepe, another ramie textile from the slightly more northern city of Ojiya, which differs from *jōfu* in its highly twisted weft threads. Though the name Ojiya *chijimi* is better known among the Japanese public than Echigo *jōfu*, due to the successful branding of the town of Ojiya with the crimped textile, in reality, Ojiya weavers today produce only about three bolts of handmade *chijimi* a year compared to the seventy bolts of *jōfu* made annually in Minamiuonuma.

The geographical location of Minamiuonuma between mountains running along the Sea of Japan to the west and the Japanese Alps to the east gives the entire region a unique climate. The summers are hot and muggy, but the long winters— though relatively mild in temperature—are extremely wet, often accumulating 2 to 3 meters of snow at a time. Locals over a certain age recount how, until about the early 1970s, the only place they were able to see the sky from their homes in the winter was through the second-floor windows. During this age before global warming, children navigated their way to school through an elaborate maze of snow tunnels that connected the community during the winter months. The winter of 2005 rivaled those winters of old with snows reaching over 3 meters in height.

These climatic conditions have long been closely related to the production of ramie cloth. The high humidity of the damp winters made the area particularly appropriate for weaving the brittle, hair-like ramie threads, which are highly sensitive to sunlight and dry weather. At the same time, the copious amounts of snow kept thread makers, weavers, *kasuri* binders, and other artisans firmly rooted in their homes for six months out of the year. The ongoing battle with this ubiquitous natural element also made the people of Echigo singularly hardworking, ingenious, and forbearing, qualities without which this most delicate textile could never be produced. The continuing sunny days in late March each year, while the snow remains on the ground but temperatures remain well above freezing at midday, are perfect for the natural snow bleaching of the cloth (fig. 8.7), a highly picturesque process that was eloquently described in the novel *Snow Country* by Nobel Prize-winning Japanese author Yasunari Kawabata, published in different forms between 1935 and 1948.

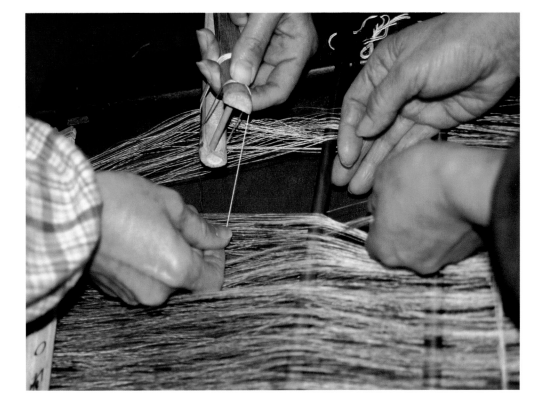

8.6 Women create string heddles for the warp of Echigo *jōfu*. The dark areas on the white warp are warp-ikat (*kasuri*) patterns, into which coordinating *kasuri* patterns and pictorial *kasuri* motifs will be woven in the weft.

Photograph by Melissa M. Rinne, Muikamachi, Niigata Prefecture, 1993.

The thread making was done in the snow, and the cloth woven in the snow, washed in the snow, and bleached in the snow. Everything from the first making of the thread to the last finishing touches was done in the snow. "There is ramie crepe because there is snow," someone wrote long ago. "Snow is the mother of ramie crepe."... The ramie crepe of this snow country was the hand-work of the mountain maidens through the long snowbound winters.... In their desire to be numbered among the few outstanding weavers, they put their whole labor and love into this product of the long snowbound months—the months of seclusion and boredom between October, under the old lunar calendar, when the threadmaking began, and mid-February of the following year, when the last bleaching was finished.... The ramie thread, finer than animal hair, is difficult to work except in the humidity of the snow, it is said, and the dark cold season is therefore ideal for weaving. The ancients used to add that the way this product of the cold has of feeling cool to the skin in the hottest weather is a play of the principles of light and darkness. [Kawabata 1966, 150–54]

As Kawabata suggests, ramie textiles have been produced in the region since ancient times. The Shōsō-in Treasury in Nara contains tax cloth (*yōfu*) from Echigo Province dating to the Tenpō Shōhō era (749–756), and other eighth-century documents suggest that the Echigo region supplied cloth for a variety of projects in western Japan.[9] The medieval record *Azuma kagami*, a history of the military government from 1180 to 1286, tells us that one thousand bolts of Echigo ramie cloth were supplied to the Kamakura Shogunate in 1192. During the Muromachi period (1392–1568) and through the early part of the Edo period, the region cultivated ramie and produced cloth under the administration of the ruling Uesugi clan. Throughout the ancient and medieval periods, it made primarily bolts of white cloth, as was common in other ramie-producing regions in Japan.

During the Edo period, the Echigo region benefited from several occurrences that served to set its ramie textile production apart from that of other provinces. In 1598, the ruling Uesugi clan, which had heavily promoted ramie cultivation in Echigo and supplied ramie-weaving communities around Japan, was transferred to Aizu in neighboring Mutsu Province (present-day Fukushima Prefecture). After this time, ramie farming went into decline in Echigo, and a new distribution system developed in which Echigo fiber merchants (*o akindo*) would travel to Aizu, as well as Yonezawa and Mogami (both in present-day

Yamagata Prefecture) and other neighboring regions, to purchase bundles of processed ramie fibers (*o*, also *aoso*) to carry back to Echigo to be made into thread and woven into cloth (figs. 8.8a–c). This system continued in one form or another until the Second World War and resulted in a focus on textile production rather than fiber cultivation in Echigo.

Technical advances during the Edo period also boosted production. Around the time of the Kanbun era (1661–1673), producers learned to put a hard twist in the warp threads, allowing them to weave crepe (*chijimi*) with seersucker-like puckers that made it comfortable in muggy summer weather. This combined with advances in *kasuri* dyeing technology during the Genroku era (1688–1704) led to the rapid growth of a new textile known as "Echigo *chijimi*." By the Tenmei era (1781–1789), the Uonuma Valley was producing over 200,000 bolts annually (Nishiwaki 1970, 32). The industry operated through four large markets in the primary production regions of Ojiya, Tōkamachi, Horinouchi, and Shiozawa, as well as smaller markets in towns that still bear names indicating when their individual markets were held.[10]

By the early nineteenth century, ramie crepe production was booming. The source for much of Yasunari Kawabata's understanding of the region was a book called *Hokuetsu seppu* (*Snow Country Tales*) by literatus and Echigo native Suzuki Bokushi. In this classic compendium of stories about life in Echigo written between 1798 and 1842 and first published in 1835, Suzuki describes the ramie cloth being produced in the first half of the nineteenth century: "The crepe woven today far surpasses what I recall from my youth and rivals brocade in its designs. All sorts of difficult patterns are woven, stripes and checks and plaids all done with great accomplishment, and many wonderful effects are produced. All this is the result of the ingenuity of the weaving women" (Suzuki 1986, 63; figs. 8.9a,b).

It is interesting to note that the bulk of the actual weaving was done by women, making them the primary breadwinners in the community. A mid-Edo period record from the region describes how "Men have no way of earning money other than to gather firewood between the farming seasons. Women earn money by weaving crepe" (Sasaki et al. 1988, 108). Even today, locals frequently reiterate the popular saying of previous generations that "A wife and three daughters will build a storehouse," meaning that having four weavers in the family was the easiest way for a man to achieve financial security.

With such a long and integrated history in the local culture, it is no wonder that a romantic image of Echigo *jōfu* producers as "preservers of tradition" has persisted into the early twenty-first century, fostered by the media, local governments, and the textile producers themselves. Moreover, the idealized perception of this cloth is not unfounded. In a country where one textile community after another has lost the ability to

8.7 Snow bleaching (*yuki sarashi*), conducted on sunny days in February or March, serves not only to remove stains or impurities but also to tighten the weave, giving the cloth a finished quality. For this reason, dark-colored bolts are also "bleached," although for shorter periods of time. Echigo *jōfu* kimono can be cleaned by "sending them back to their hometowns" (*sato gaeri*) to be unstitched, tacked together as a single length of cloth, and re-bleached on the snow, before being sewn into kimono again.
Photograph by Melissa M. Rinne, Muikamachi, Niigata Prefecture, 1994.

8.8A–C Illustrated here are various stages in the processing of ramie thread: (a) ramie stalks are harvested in the village of Showa (their skins will be stripped and saved); (b) the pulpy outer skin is scraped away to reveal the white ramie fibers; (c) the dried ramie fibers (*aoso*) are shown together with bags of hand-spliced thread.
Photographs by Melissa M. Rinne, Showa, Fukushima, and Muikamachi, Niigata Prefecture, 1994.

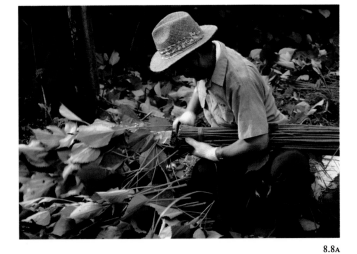

8.8A

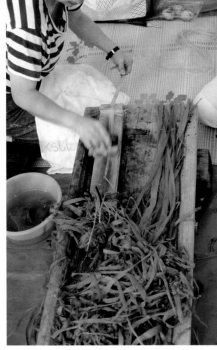

8.8B

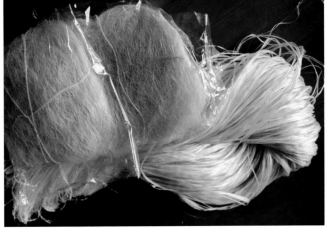

8.8C

8.9A,B *Bleaching Crepe on the Snow*, an illustration from Suzuki Bokushi's *Hokuetsu seppu* (*Snow Country Tales*; written between 1798 and 1842) evokes a lively *asa* textile industry. A note near the bottom of the panel on the right tells us that it depicts a doctor riding to the home of a patient in a sleigh.

Courtesy East Asian Library, University of California, Los Angeles.

8.10 Kimono-length bolt (*tan*) of Echigo *jōfu* (detail)
Muikamachi, Niigata Prefecture, 1994
Ramie
Private Collection

This cloth, woven by the author, bears the stamps and seals of official government registration. The *kasuri* section along the lower edge reads "Important Intangible Cultural Property Echigo *jōfu*," while the single character in the center indicates the textile company where the cloth was produced.

weave with handmade warps, replaced earlier looms with standard treadle looms, or resorted entirely to the use of power looms and industrially made thread, Echigo *jōfu* can stand proudly among a handful of Japanese bast fiber textiles in that it is almost entirely handmade from start to finish with standards of craftsmanship that are arguably some of the highest of any bast fiber textile in the world.

There is no question, however, that Echigo *jōfu* survives today only because it was designated an Important Intangible Cultural Property by the Agency for Cultural Affairs of the Japanese government in 1955. This designation, given to only a small number of outstanding crafts,[11] stipulates adherence to a set of specific production processes. Unlike the related system of Living National Treasures,[12] which essentially recognizes the achievements of outstanding craftspeople as individuals, the Important Intangible Cultural Property registration is given to an artistic process itself and can be applied to any product made in accordance with the government's criteria by members of a registered production guild (fig. 8.10). The official criteria for Echigo *jōfu* or Ojiya *chijimi* are as follows:

1. Only hand-spliced ramie thread may be used.
2. Any *kasuri* must be made using the hand-binding technique and vat dyeing (figs. 8.11a,b).
3. The cloth must be woven on an *izaribata* loom.
4. When starch removal is required (as it would be for the heavily starched wefts of Ojiya *chijimi*

crepe), it must be done by manual kneading and physical manipulation with the feet (fig. 8.12).
5. Any bleaching of the cloth must be accomplished through snow bleaching.

In order to raise successors to the Echigo *jōfu* tradition, the Agency for Cultural Affairs created two training courses in 1975. One is held during February each year and teaches thread making to women in villages that have been traditional strongholds of thread production (fig. 8.13). The other is aimed at weavers, most of whom are veterans of the silk industry and are ready to take on the intricacies of the technically more challenging ramie weaving (fig. 8.14). Held over a period of one hundred working days from November to March every year, this training course requires a five-year commitment from participants, as well as sponsorship and a moderate monetary investment from one of the local weaving companies belonging to the Echigo *Jōfu* Technological Preservation Guild.[13] Although these stipulations effectively limit the course to serious local weavers, they also insure professional standards.[14]

While the recognition and subsidies accompanying the Important Intangible Cultural Property designation have unquestionably benefited the region in preserving an industry that would otherwise have disappeared years ago, the government's guidelines and the unwritten expectations that accompany them do not always accord well with reality. Those in the industry know better than to bite the hand that feeds them,

8.11A

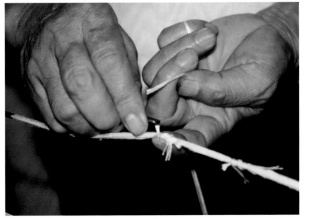

8.11B

8.12

8.11A,B *Kasuri* patterns are transferred consecutively, one weft shot at a time, onto a long paper tape (a). After transferring pattern sections from the tape to the prepared bundles of thread, *kasuri* specialist Ogawa Nobuhisa binds the pattern sections tightly with cotton thread (b). The threads will then be vat dyed, leaving the bound sections in resist.
Photographs by Melissa M. Rinne, Muikamachi, Niigata Prefecture, 1994.

8.12 Kotō Masao, a snow-bleaching specialist, kneads a completed bolt of Echigo *jōfu* with his feet in a large, boat-shaped wooden tub before laying the cloth on the snow. This process helps to remove starches applied to the thread during the weaving process, and it also cleans and softens the material. The kneading must be continued evenly for twenty minutes.
Photograph by Melissa M. Rinne, Muikamachi, Niigata Prefecture, 1994.

and therefore, instead of facing and finding solutions to the problems, they tend to keep them hidden away. The result has been the successive loss of weaving companies. Between 1993 and 2006, four of the ten producing Echigo *jōfu* in the Muika-machi and Shiozawa area have gone out of business, and one of the surviving companies no longer employs any weavers. Thus the number of actual producers has essentially been cut in half in a little over a decade.

One basic problem responsible for undermining the industry is that the Important Intangible Cultural Property designation applies only to kimono-sized bolts of cloth, measuring about 12-meters long and 33-centimeters wide. Bolts of the narrower, shorter, and infinitely more salable *obi* sashes do not qualify for the coveted title. Moreover, producers are not permitted the option of working with fashion or interior designers to create fabrics in custom widths and lengths. As long as Echigo *jōfu* is so closely tied to the kimono industry dinosaur, it is probably doomed to eventual extinction.

Another problem, influenced only indirectly by the government designation, is the ongoing desire on the part of the media and producers to sell "tradition" without regard for inevitable changes over time or recognition of the creative ingenuity of the artisans. Practical "compromises" with tradition are evident to any visitor to the weavers' training course, where the use of hair dryers in place of small charcoal braziers to dry the freshly starched warp threads inevitably causes those expecting a higher degree of purity to chuckle. Likewise, the motor-driven quill winder for weft threads is frequently the subject of moral speculation for those with little hands-on experience. The ubiquitous presence of humidifiers in the weaving room speaks worlds of the construction differences between traditional Japanese wooden structures and the modern homes or buildings in which weavers work today, if not of the climatic changes that have accompanied global warming. Honda Setsuko, who with her husband, Toshio, runs Honda Textiles, Ltd. (also known by the brand name Takiemon), developed an ingenious method

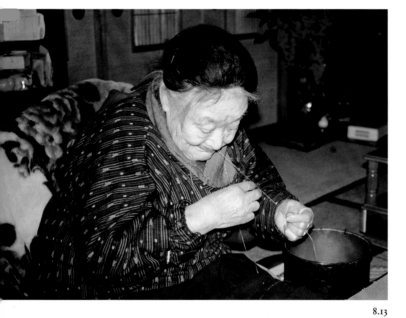

8.13

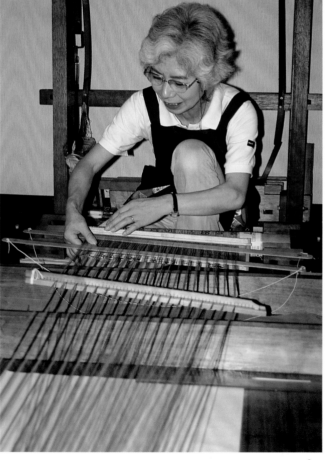

8.15

8.14

for winding a long warp of Echigo *jōfu* within the tight confines of a small hallway in her company workshop. Though originally created out of necessity from lack of space, her method produces a more evenly wound warp beam than the traditional procedure (fig. 8.15). She is certainly not the only one in the region to have developed such innovations, but her ingenuity, like that of others, goes largely unrecognized.

Limited use of mechanization can be found in other parts of the production process as well. After the bundles of hand-spliced thread come back from the thread maker, they must undergo a series of treatments before being passed on to the weaver in the form of dyed skeins. The first of these steps involves applying a twist to the thread to keep down the loose ends of the plied joints. It is hard to find anyone today, however, who can demonstrate the "traditional" technique. In fact, when I made the request in 1993, no one in the region seemed to be able to actually duplicate the Edo-period twisting method in which a drop spindle is sent spinning out from between two

blocks of wood (fig. 8.16), though a ninety-two-year-old thread maker near Ojiya was able to demonstrate an intermediary method using a spinning wheel.

One reason for the disappearance of this technique is that almost all the newly made thread used in Echigo *jōfu* since about 1960 was twisted by a Muikamachi woman using a machine that she operated in her home for thirty-five years before retiring in 1995 at the age of seventy-seven (fig. 8.17). The same machine was then used by another elderly operator for several more years. It is interesting to note that originally, this spinning machine was jointly purchased by two weaving company owners, Honda Yoshio and Suzuki Chōbōan (Torajūrō), the latter being perhaps the staunchest and most visible local advocate of Echigo *jōfu* preservation in the postwar period. Clearly, within the context of the industry as a whole, Suzuki did not view the mechanization of this step as a threat to the integrity of the textile. It is not likely, however, that he openly displayed his "spinning machine" to visiting researchers or journalists.

8.13 Ibuchi Fuji (1912–?) makes hand-spliced ramie thread at her home in Koide (now part of Uonuma City), where her husband oversees the town's thread-making training course. Located midway between Muikamachi and Ojiya, Koide has historically been a thread-making stronghold.
Photograph by Melissa M. Rinne, Koide, Niigata Prefecture, 1994.

8.14 Students work at their looms during the Echigo *jōfu* training course, a five-month-long class held over the winter months within the facilities of the Shiozawa Textile Industry Cooperative. Each weaver is sponsored by one of the textile companies in the Preservation Guild and is given a certificate of graduation after five years. The course is sponsored by the national government, and students receive a small monthly stipend.
Photograph by Melissa M. Rinne, Shiozawa, Niigata Prefecture, 1992.

8.15 Honda Setsuko prepares to wind the warp beam for a bolt of Echigo *jōfu* using a space-saving innovation of her own design. The 12-meter warp extends down the hallway in front of her and around a square frame at the opposite end. It then doubles back overhead and attaches to a strap extending from a pulley on the frame behind her.
Photograph by Melissa M. Rinne, Muikamachi, Niigata Prefecture, 2004.

8.16 **Iguchi Taka (circa 1870–?)**
Detail of a two-panel folding screen, 1890–1920
Ink and light colors on paper
Private Collection
Photograph by Melissa M. Rinne. Courtesy of Iguchi Seiichiro, Marubun Textiles

The figure at the right demonstrates a lost technique for putting an overall twist into the hand-spliced ramie thread used for Echigo *jōfu*, while the smaller figure at the left winds a skein.

8.17 Tomidokoro Kikuno (b. 1918) operates a spinning machine used to put an overall twist in hand-spliced ramie thread. At the time this photograph was taken, the machine had already lost many of its parts as a result of decades of use.
Photograph by Melissa M. Rinne, Muikamachi, Niigata Prefecture, 1994.

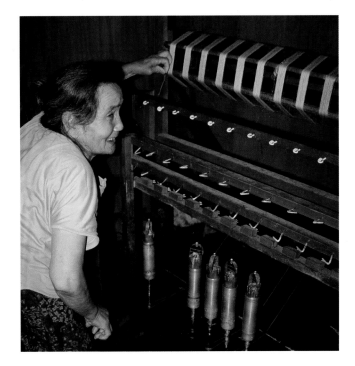

Next, let us consider the issue of *kasuri*, or ikat. The outdated wording of the governmental guidelines states that any *kasuri* incorporated into Echigo *jōfu* must be accomplished by hand binding the threads and vat dyeing. Indeed this most fundamental method of making ikat was dominant in the Edo period, when the primary dye utilized was indigo (fig. 8.18). Today, however, the most commonly used method of creating dark *kasuri* patterns on light backgrounds is not binding but the topical application of dye to pattern areas with a small bamboo spatula. This method, while technically disqualifying textiles from the Important Intangible Cultural Property status, has actually been widely used and accepted in the making of Echigo *jōfu* cloth since long before the government wrote the guidelines. At public demonstrations of the craft, it is regularly featured as a "traditional" *kasuri* technique (fig. 8.19).

In terms of actual production, however, the greatest problem besieging *kasuri* is a rapidly disappearing labor force. In the early 1960s, there were twenty-six or twenty-seven households doing *kasuri* work in the Muikamachi hamlet of Koguriyama (Koguriyama mura shi hakkan iinkai, ed., 1998, 270). In 1993, there were only three. As of 2006, only two businesses—a total of three individuals, all in their seventies or eighties—regularly accept *kasuri* work. This should not be surprising, however, as *kasuri* binding and color application are extremely exacting, highly technical, and repetitive processes requiring years of expertise. Unlike the more visible sectors of the industry, such as weaving or snow bleaching, its artisans go almost entirely unrecognized by both researchers and the media. Not inconsequentially, there is no subsidized training program for successors to this key sector of the Echigo *jōfu* industry.[15]

While most *kasuri* used for Echigo *jōfu* today combines pictorial representations in the weft with geometric elements in both weft and warp, silk textiles made in the region frequently incorporate *kogasuri*, or "small *kasuri*": minute, overall double-ikat patterns, such as hexagonal diapers or tiny crosses. *Kogasuri*, which was also seen on *asa* textiles before World War II, requires the highest technical expertise from both the *kasuri* binder and the weaver (fig. 8.20). Even for an experienced craftsperson, who might be able to tie off up to two thousand segments in a day, such textiles could take over two months to bind. Today, weaving companies produce the desirable *kogasuri* patterns for bolts of silk kimono fabric using *nassen*, a method of silk-screening *kasuri* designs onto the thread before it is woven. While still extremely rare in Echigo *jōfu*, the *nassen* technique has been incorporated on occasion into even these Important Intangible Cultural Property-designated textiles (fig. 8.21). In the future, *nassen* may be the only way for weaving companies to respond to consumer demand for Echigo-style *kasuri*.

Perhaps the greatest danger to the future of Echigo *jōfu*, however, lies in the difficulty of producing its hand-spliced thread, the element that truly differentiates it from other textiles. Visitors to the region are told how the thread used for Echigo *jōfu* comes from top-quality ramie fibers that are expertly grown in the village of Shōwa (hereafter referred to as Shōwa-mura) in neighboring Fukushima Prefecture and spliced into thread by the women of Echigo, a practice that dates back to the Edo period. When I conducted my fieldwork in 1993, however, the abundance of good-quality available thread did not seem to correspond with the few aging women who actually appeared to be making thread on a regular basis. Nor could it

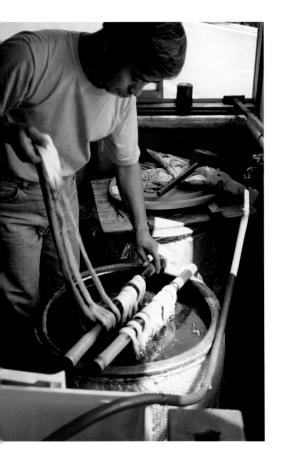

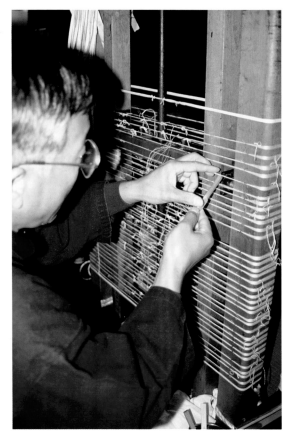

8.18 Honda Toshio dyes skeins with indigo. Honda was later named a Master of Traditional Craft (Dentō Kōgeishi) for his dyeing skills.
Photograph by Melissa M. Rinne, Muikamachi, Niigata Prefecture, 1994.

8.19 At a demonstration in Tokyo, ikat (*kasuri*) specialist Niwano Fumio applies yellow dye, demonstrating the *kasuri* technique of applying dyestuffs topically to thread with a bamboo spatula (*kori*). Though this technique does not involve resist dyeing, it has long been viewed by those in the industry as a valid form of *kasuri* for Echigo *jōfu* with dark patterns on light-colored backgrounds.
Photograph by Melissa M. Rinne, Tokyo, 1995.

explain complaints occasionally heard from fellow weavers that, while their thread was extremely smooth and fine, it was stiff to the touch in comparison to what was lovingly called "very good thread," that is, older stock that inevitably came in the old-fashioned, large-sized skeins that are unique to Echigo and no longer made today.

It took months of delicate questioning to confirm that, since the early 1980s, a dearth of local thread makers has forced thread wholesalers in the region to supplement their stock with high-quality hand-spliced ramie thread made by artisans in ramie-producing villages in neighboring Korea. Though the fibers used in Korean thread sometimes differ in texture from domestically produced ramie, the thread itself is generally spliced with a fineness and skill equivalent to available Japanese thread. The imported threads are the same used in Korea's luxury handwoven ramie textile, Hansan *mosi*, made in the town of Sŏch'ŏn, South Ch'ungch'ŏng Province, three hours south of Seoul.[16]

As long as the same high-quality standards are maintained, the use of imported thread—provided it is made entirely by hand—is not technically at odds with the government-stipulated criteria for Echigo *jōfu*, but the governmental and media presence has nonetheless inhibited open discussion about the problems of thread production with anyone, including researchers and even the weavers themselves. Thus, there is little consciousness among either the makers or the government of the reality that, though Hansan thread makers have enabled Echigo *jōfu*, Ojiya *chijimi*, and almost certainly other ramie textiles in Japan to survive as viable industries into the twenty-first century, this source cannot be relied on indefinitely. Korea is modernizing at a rapid rate (see chapter 4), and producers of Hansan *mosi*

today face the same problems of aging craftspeople and declining market as their Japanese counterparts.

Another of the main production regions for fine ramie textiles in East Asia is Hunan Province, China, where the industry continues in large part due to the demand for the finished product in the Japanese and Korean markets. In 2005 and 2006, I witnessed an interesting experiment taking place involving an Echigo *jōfu* producer and a Kyoto textile company that runs a ramie textile factory in Hunan. The Hunan thread makers have years of experience making fine ramie threads; however, as in Korea, they have traditionally made thread only from locally grown fibers. Knowing that the main problem with imported Korean-made ramie threads has been the stiffness of the fibers, the Echigo *jōfu* producer suggested the possibility of taking the softer Japanese ramie fibers grown in Shōwa-mura to China to be hand-spliced by Hunan thread makers. If successful, this combination of the finest available Japanese-grown fibers and an abundance of highly skilled artisans in Hunan might assure the survival of the Echigo *jōfu* industry for a longer period.

The results of this experiment remain unclear at the time of this writing. The Shōwa-mura ramie was taken to Hunan and spliced into thread in 2005. Even the sheerest ramie fabric traditionally woven in Hunan, however, has never been as fine as Echigo *jōfu*, and as a result, the Japanese producer has found the threads to be slightly too thick to use for kimono fabric. On the other side of the sea, the Chinese thread makers complain that the soft, pliable Japanese-grown fibers are more difficult to split into strands than their native-grown ramie. The Kyoto textile company owner adds a significant, if ominous, dimension to this endeavor by warning that even in the three-year span

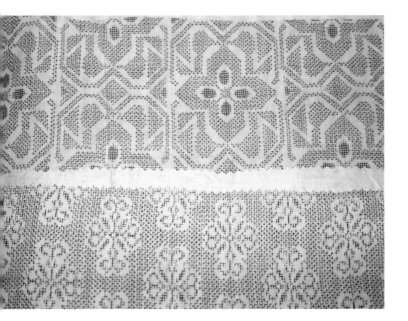

8.20 These textile fragments, circa 1920–1960, are patterned with *kogasuri* ("small *kasuri*" patterns of tiny warp- and weft-ikat crosses). Photograph by Melissa M. Rinne, Shiozawa, Niigata Prefecture, 1994. Courtesy of Takahashi Kōichiro, Yamagishi Textiles.

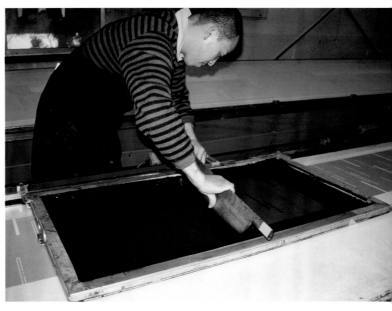

8.21 *Kasuri*-like patterns are silk-screened onto warp threads (*ito nassen*). This technique, most commonly employed on silk textiles, is occasionally used for Echigo *jōfu*. Photograph by Melissa M. Rinne, Shiozawa, Niigata Prefecture, 1995. Courtesy of Maruki Shōten.

between 2003 and 2006, he has had to go farther and farther into the mountains to find artisans to work in the textile industry. Despite having perfected their thread making and weaving skills over decades, Hunan artisans are rapidly abandoning such careers for the inviting prospect of hourly wages paid by newly arrived factories. The ramie-producing region in Hunan still has a larger active labor force than its Korean or Japanese counterparts, but the lack of value placed on craft traditions is resulting in a rapid loss of artisans to the cause of Chinese economic advancement.

This is not to say that Japanese producers of Echigo *jōfu* are driven purely by the altruistic motives of cultural preservation. Honda Toshio, president of Honda Textiles, which produces Echigo *jōfu*, as well as various other less time-consuming and more affordable silk and ramie textiles, comments that,

> Echigo *jōfu* is being produced today as a business. No matter how strongly we might value the preservation of Echigo *jōfu* as a tradition, we would never be able to continue producing this textile were it not a valid business enterprise that makes money. Especially in this industry, in which a textile company owner is financially responsible for many different artisans involved in the various steps of production, one has a financial obligation to sell the product. Without sales, this textile would die off very quickly. [Honda Toshio, personal communication, August 2006]

In fact, as of 2006, Honda Setsuko credits the business survival of Honda Textiles to the fact that it has committed part of its production to the handmade ramie cloth rather than focusing solely on the more widely produced silk kimono textiles of the region.

> Even though we still produce *tsumugi* and *omeshi* [two silk kimono textiles with intricate *kasuri* produced in the Shiozawa/Muikamachi region], many of our clients are most interested in Echigo *jōfu*. They have great admiration for the cloth because they understand that it is special, and that its production will die out in the very near future. [Honda Setsuko, personal communication, August 2006]

It is an ironic twist of fate that though Echigo *jōfu* producers have managed to build a small but stable clientele for this textile, even with all the social and economic factors weighing against them, they nonetheless hear the clock ticking more loudly than ever. When the fine hand-spliced thread runs out, when the *kasuri* binders pass away, when the snow-bleaching specialist gets sick, or any other number of conceivable scenarios, the production of this textile will necessarily come to a halt. The fact that this reality must be kept hidden from the Japanese government, media, and public at large is a source of frustration to all the weaving company owners that I interviewed. One, who wished to remain anonymous, lamented that "Little

by little we have to expose the realities of this realm and make the outside world understand. If we don't do this soon, we will end up with a disaster. People have to realize that it is no longer possible to use only ramie from Shōwa-mura if we have to rely only on the elderly local thread makers. We must look for alternative solutions." Many other weaving company owners reiterated this same message: instead of covering up what they must do to get by, they would like to be able to deal with their plight openly, while there might still be some hope of solution. As soon as the last person in any given specialty passes away, it will be too late.

NARA *SARASHI*: FROM INDUSTRY TO HOBBY

The contradictions inherent in keeping a handwoven textile industry alive when it is no longer economically feasible are manifested in a different form in the village of Tsukigase,[17] Nara Prefecture, which today is home to a very small-scale production of the bast fiber textile Nara *sarashi*.[18] Formerly, this town had an industry not unlike that producing Echigo *jōfu*, which comprised specialized artisans for different skills—thread makers, weavers, and bleaching/finishing specialists—as well as distributors who coordinated distribution and wholesale.

The term *sarashi*, or "bleached cloth," exemplifies one of the prime distinctions between this ramie textile and its Niigata counterpart: the Nara-produced textiles typically do not incorporate *kasuri* or dyed threads.[19] After being woven from unbleached threads into bolts (*hiki*) of two kimono-lengths (approximately 24 meters), the natural-colored cloth (*kibira*) is bleached using lye or, today, sodium hydroxide and other chemical bleaching agents before being stretched and dried in the sun. The snowy white, finished cloth was well suited to surface decoration techniques such as *yūzen* dyeing or delicate stencil dyeing (*komon*), much of which would have been done in nearby Kyoto.

Though hemp and ramie textiles have been produced in the vicinity of Nara since the eighth century, historical documents cite its bleached cloth as one of the finest *asa*[20] textiles in Japan from the sixteenth through the eighteenth century. During the Edo period, Nara *sarashi* was popular for use in men's *kamishimo* (a vest and *hakama* trousers worn over the kimono on formal or ceremonial occasions), as well as for men's and women's summer *katabira* (bast fiber summer kimono). The production of Nara *sarashi* declined in the eighteenth and nineteenth centuries with the growth of Echigo *chijimi*, the forerunner of today's Echigo *jōfu*. The abolishment of the samurai class at the end of the Edo period and the subsequent drop in demand for ceremonial textiles during the Meiji period (1868–1912) led to the decline and ultimate demise of textile production in most of the mountain villages that had long produced them.

Despite this, bast fiber textiles continued to be produced as an industry in the village of Tsukigase until World War II. Perhaps the most important explanation for this was that the prosperous Nara-based Nakagawa Textile Company had established several factories in the village during the Meiji period, and these continued to be used regularly until the war. The nationwide popularity of a striped ramie textile woven in

the village during the Meiji period and called Ishiuchi *shima* (Ishiuchi being the name of one of the Tsukigase hamlets) also kept the textile industry alive. Furthermore, beginning in the early Taishō period (1912–1926), Tsukigase-based households had been commissioned annually to produce textiles for Ise Shrine, as will be discussed below. After the war, however, production of Nara *sarashi* as an industry slowed dramatically. It is interesting, then, that today the term Nara *sarashi* commands wider recognition than it has had for several hundred years. In 1991, when I conducted my fieldwork, Nara *sarashi* was being produced in three locations in Tsukigase and for three different purposes. While each of these groups maintains the Nara *sarashi* weaving tradition into an age when textile production serves little practical or economic purpose in the community, none of them were without difficulties or incongruities.

The first form in which Nara *sarashi* weaving continued was in the context of the Nara *Sarashi* Technological Preservation Society, which taught a Nara *sarashi* training course twice a week over the autumn and winter months. This course was open to interested applicants from within the village, as well as to outsiders, and was taught primarily by members of the Preservation Society with the occasional assistance of weavers or thread makers from the community. Most researchers and

visitors to the village who were interested in Nara *sarashi*, were introduced to the craft through the activities of this Preservation Society, as I was.

The impetus to form a Preservation Society began with the designation of Nara *sarashi* as an Important Intangible Cultural Property of Nara Prefecture in 1979 by the prefectural government. The designation stipulated two criteria for the cloth: (1) Nara *sarashi* must use hand-spliced ramie or hemp thread (fig. 8.22); (2) Nara *sarashi* must be woven by hand (fig. 8.23). At the time of the designation, there were still twelve senior weavers in the village, most of whom were then in their mid-eighties, as well as a few experienced weavers in their fifties or early sixties (Tsukigase-mura Kyōiku Iinkai 1994, 13). It became a matter of concern that there was no system in place to pass this weaving tradition, now a recognized cultural asset of the village, on to future generations. For this reason, the Nara *Sarashi* Technological Preservation Society was established in 1980. In 1983, the society, which was chaired by former school teacher Okuda Namie, began biweekly lessons in thread making, loom preparation, and weaving skills of the village. The course attracted students from all over the Kansai region and was regularly covered by local newspapers and television networks. Courses have continued to this day (fig. 8.24), initially moving

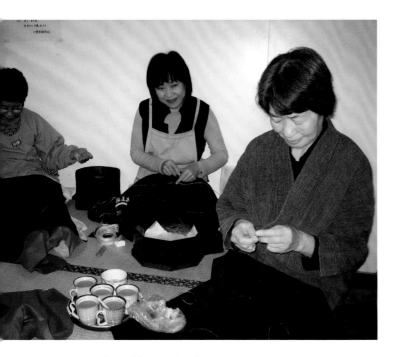

8.22 Members of the Nara *Sarashi* Preservation Society, who meet twice a week during the winter months, make hand-spliced hemp thread. Each member makes her own thread, which she will later weave herself. This practice represents a departure from that of earlier generations when women specialized in either thread making or weaving. Finished bolts become the property of the Preservation Society.
Photograph by Melissa M. Rinne, Tsukigase, Soekami-gun, Nara Prefecture, 2006.

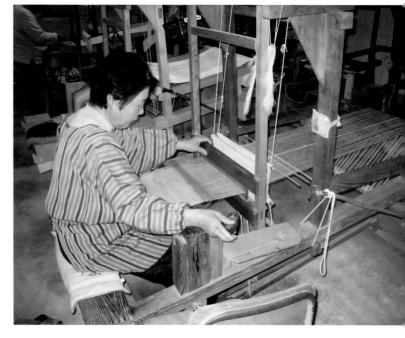

8.23 Matsumoto Hiroko, instructor for the Nara *Sarashi* Preservation Society, weaves a bolt of Nara *sarashi* at the Preservation Society's facilities in the hamlet of Nagahiki, Tsukigase. Traditionally, the natural brown cloth would be bleached white after it was taken off the loom, thus it has long been known as *sarashi* (bleached cloth).
Photograph by Melissa M. Rinne, Tsukigase, Nara Prefecture, 2006.

from their quarters in an old weaving factory to an old middle school in the center of town and then in 1996 into a spacious, new, custom-built facility located in an area popular with tourists visiting the area's famous orchards of Japanese flowering plum (*Prunus mume*).

The establishment of this organization has played an essential role in raising the awareness of Nara *sarashi* and disseminating understanding of its production processes, resulting in continued interest in the textile.[21] At the same time, the nature of the Preservation Society and its enterprises present an interesting set of paradoxes, as detailed in a provocative study by anthropologist Mariko Fujita entitled "Nuno no seisan to 'dentō' no sōshutsu: Nara sarashi hozon/denshō katsudō o meguru jendaa/sedai/chikara" ("The 'creation' of tradition and bast-fiber cloth production: Gender, generation, and power in the activities of the Nara *sarashi* preservation/transmission activities"; Fujita 1995).

Fujita points out that before the Preservation Society was established, the primary raison d'être for Nara *sarashi* in the village was economic. Weaving was part of a textile industry with a strict division of labor in the various steps of production, so that specialized weavers engaged only in loom preparation and actual weaving. Weaving was done primarily for wages, providing one of the best sources of income within the village.[22] It was a private activity, conducted at home in most cases, and by necessity it was supported by other members of the household.[23] Weaving, which was considered hard, tedious work, requiring long hours in isolated surroundings, was done by women—usually of farming families—but the textiles produced were sold under the names of their husbands, as the heads of households. This meant that although women did the work,

they had no control over the finished product. Weaving was competitive with great emphasis placed on quality and various contests and exhibitions rewarding the families that produced the best cloth.

Fujita notes that with the activities of the early 1980s, the "tradition" of Nara *sarashi* was "reinvented" by the designation of the cloth as a cultural property as opposed to a commodity for daily use. Interestingly, in a country where men are chosen as the heads of most organizations, the people chosen as the chair, vice-chair, and secretary of the Preservation Society were all women in their late seventies or early eighties who had had careers of some sort or another—the village intelligentsia—because the actual business of weaving had long existed within the female realm. Though these women did not have the long-term hands-on experience of other weavers in the village,[24] they did have the essential ability to describe the steps of the weaving process, to articulate the importance of the weaving tradition in the village, and to communicate the vision of the Preservation Society to visiting researchers, journalists, and interested parties.

According to Fujita, through these leaders and their male and female counterparts in the Preservation Society (in most cases people who had not been deeply involved with weaving or textile production up until that time), the process of weaving began a subtle transformation that would make it more consistent with the aims of the Preservation Society and more palatable to the community at large. Instead of economic gain, the weaving of Nara *sarashi* became politically and socially motivated, vested with the newly attained authority of government registration. Though weaving and thread making had been carried out in different locations by different specialists and administered by male distributors, the Preservation Society

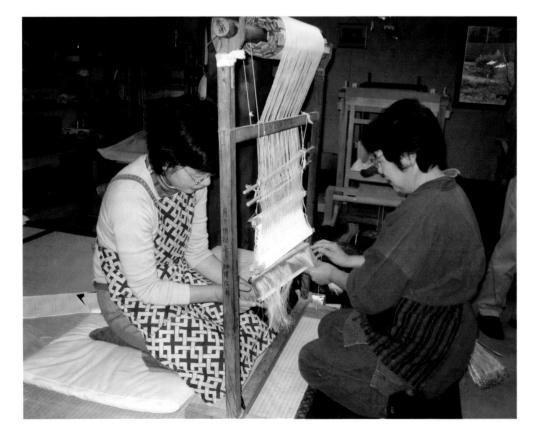

8.24 Nara *Sarashi* Preservation Society vice-chair Matsumoto Yoshiko and manager Asano Toshiko finish sleying the reed, the final step before placing the warp beam on the loom.
Photograph by Melissa M. Rinne, Tsukigase, Nara Prefecture, 2006.

courses taught students both skills, giving women power over the entire process. In fact the entire nature of the former industry as a complex enterprise run by men who paid women piecework wages was downplayed to the point of denial. Where weaving had originally been primarily an income-producing enterprise, it now moved into the realm of hobby or volunteer effort with little concern for profit. Instead of requiring hours on end in isolated quarters, the revived weaving tradition provided community and communication with the outside world with the weaver entirely in charge of when she did or did not want to weave. What had been part of the private sphere moved into the public sphere with women and elderly people receiving attention they had never had before. While there was originally competition among villagers over the quality of a finished product, focus was now placed on the production processes themselves, which evoked nostalgia for an earlier, simpler time before modernization and which took place in a cooperative group setting.

Fujita comments that because those in charge of the preservation and teaching activities chose to ignore profit and to work on a volunteer basis to disseminate information and hands-on experience with Nara *sarashi*, they changed the cloth from an economic venture into a social and cultural venture, from a symbol of drudgery in an impoverished age to the village's symbolic "Traditional Craft" created from natural materials. Though this movement has stimulated a new type of volunteerism in the village—probably due in part to the underlying realities that there is little demand for Nara *sarashi* in the modern world and that the labor practices of the past are no longer applicable in today's economic system—the chosen methods of transmitting Nara *sarashi* circumvent some crucial issues, such as how successors to this tradition will be able to support themselves in the future (Fujita 1995, 163).

The second place that weaving was being conducted within the village in 1991 was in a small factory owned by the Nakagawa Textile Company in the hamlet of Oyama. This factory—a one-room building on a slope surrounded by tea fields and overlooking a deep river gorge running through the six hamlets—had been recently built and was being supervised by a locally based administrator, Oima Seiji, on behalf of the Nakagawa Textile Company, which is based in the city of Nara. The factory had plaster walls and a dirt floor to retain humidity and contained six looms. It was used year-round by three experienced weavers who produced yardage of the natural-colored ramie cloth.

This newly built factory was in fact a reconstruction on a smaller scale of a factory built in the Meiji period, where many of the older local women in the village had woven as girls, before World War II. This made it the closest historically to the pre-war model of weaving in the village. In 1991, I wove along with the three elderly village women who wove at the factory on a regular basis:. Oimoto Hisae (b. 1921), Ishimoto Miyuki (b. 1900), and Mrs. Higashiguchi (birth date unknown). The atmosphere was highly cooperative, and despite the fact that each weaver was paid only for her own work, each spent a significant part of the day assisting the others either in warp preparation or in overcoming technical difficulties such as overly brittle threads. The weavers worked all day at the factory, returning home only for an hour or two at lunchtime, and each would be paid a weaver's fee equivalent to several hundred dollars upon completion of a 24-meter bolt, which would then be used for commercial products made by the company. Each bolt took between three and five weeks to complete, much of which was spent preparing the loom.

Though this factory and its weavers represented a continuation of the weaving tradition in Tsukigase from earlier eras, there were many differences in terms of the weavers, the completed textiles, and the commercial market. The most obvious difference was the complete absence of local weavers born or raised after World War II. Women of the postwar generation never learned to weave, and most had no interest in learning to do so. Those that did were more likely to be involved with the courses offered by the Preservation Society, which attracted researchers and textile aficionados. The more old-fashioned routine of weaving every day in an isolated workplace required a greater time commitment for a relatively small remuneration and offered little exposure to the community at large.

The Nara *sarashi* bolts produced by the Nakagawa factory (as well as by the Preservation Society and elsewhere in the village in 1991) were different from older textiles because after the Second World War, weavers in Tsukigase essentially lost the ability to weave with hand-spliced warp threads. Thus, industrially produced ramie was being used in the warps, though hand-spliced thread was used consistently in the wefts. Though there were several elderly thread makers still active in the village in 1991,[25] the weaving company—which, as a business enterprise, had to be able to produce quantity—was clearly already suffering from a shortage of locally made thread, as was the case in Niigata. Much of the handmade thread used at the weaving company at that time had been obtained from thread wholesalers, who were purchasing primarily from China. While weavers were quietly aware of this fact, occasionally commenting on the poor quality (sloppily spliced, discolored, overly thick) of certain batches, they never discussed this characteristic in the presence of visitors.

The relative thickness of the wefts did not pose a real problem for producers, however, because Nara *sarashi* woven at the factory was no longer used for kimono yardage. Instead, what little was produced was being used primarily for *chakin*[26]— the small cut and hemmed segments of handwoven cloth used to wipe out tea bowls as part of the formal Tea Ceremony— along with other low-volume decorative items. Simply being woven of hand-spliced wefts is enough to guarantee a first-rate *chakin*. Consumers in modern society do not make an issue of the subtleties of cloth quality. A larger reality looms above bast fiber production today, however, which makes the output of the Tsukigase factory even more inconsequential. The fact is that the village of Tsukigase cannot really be said to count as an important supplier for retailers of *asa* in today's market. The vast majority of small pouches, place mats, *noren* curtains, and other *asa* goods sold in the village, in Nara, and in other parts of Japan and indirectly, if not always misleadingly, associated with Nara *sarashi* are actually made from ramie or hemp cloth with hand-spliced warps and wefts, which has been imported from China.

The third type of weaving being done in the village was undertaken to supply the textile offerings for a ritual at the Grand Shrine of Ise (Ise Jingū), Japan's most important Shinto shrine, located in neighboring Mie Prefecture. The ritual, called the Kanmisosai (Festival of Divine Raiment), is conducted on May 14 and October 14 every year in the Naigū (inner shrine) and Aramatsurinomiya (sub-shrine) of Ise Jingū. When the textile offerings are replaced every six months, the older offerings are made into robes for priests serving at the shrine. The *asa* cloth, called *aratae* (rough cloth), is offered together with bolts of sacred silk cloth, called *nigitae* (smooth cloth), a combination thought to promote harmony within the dualism of Shinto symbolism (fig. 8.25).[27]

Village histories report that Tsukigase weavers have supplied the shrine since the early Taishō period, when Mr. Nakai Iichirō took over the commission from a textile dealer in Nara (Tsukigase-mura Kyōiku Iinkai 1994, 42). Since 1943, the Sakanishi family of Oyama has supplied the 240 kimono-length bolts (*tan*) per year to the shrine, to be offered as symbolic sacred vestments for deities. These textiles were said to be woven within a one-month period under purified conditions in a weaving factory in the Oyama hamlet of Tsukigase by women weavers hired for the purpose. Perhaps because of this service to the imperial shrine (and certainly also because of Tsukigase's legendary plum trees), members of the imperial family honored the village with several visits during the early Shōwa period (1926–1989), often in the month of March, when the trees were in full bloom. During these visits, the imperial entourages would pay a visit to the factory in Oyama where textiles were being woven for the shrine.

This Ise Shrine textile factory was in operation until the early 1950s, and it is perhaps due in great part to this annual commission that Nara *sarashi* weaving continued at all in the village after the war. The women of the Sakanishi family did not weave at the factory (except during imperial visits), instead working out of a small weaving house on their family compound (Sakanishi Teruyo, personal communication, November 2006). Even after the factory closed, the Sakanishi women—together with some of the remaining weavers in the village, who thereafter also worked out of their own homes—continued to produce textiles every year for the shrine. Today, Sakanishi Teruyo (b. 1933) weaves four bolts of cloth per year for the Kanmisosai ritual. Though weaving with handmade warps is no longer possible, she uses the finest available hand-spliced hemp,

8.25 Shinto priests stand before chests containing bolts of sacred silk (*nigitae*) and ramie or hemp (*aratae*) cloth during the Kanmisosai ritual at a sub-shrine of the Grand Shrine of Ise.

Photograph by Melissa M. Rinne, Aramatsurinomiya Shrine, Ise, Mie Prefecture, 1997.

sometimes salvaged from earlier stock, for use in the weft of these sacred textiles (fig. 8.26).

Sakanishi Katarō (b. 1931) is the second-generation successor to the Ise commission, but the village Ise Jingū weaving factory was already defunct when he took over the family business. For this reason, he has been forced to outsource most of the rest of the 240 bolts of ramie for the shrine each year to a company in Shiga Prefecture, located in an area long associated with the *asa* textile Ōmi *jōfu*. This cloth is woven on a power loom from high-quality, industrially spun ramie made in Southeast Asia (Sakanishi Katarō, personal communication, November 2006; fig. 8.27).

Despite the role Tsukigase has played in preserving textile tradition and the obvious pride with which villagers relate this prestigious commission, the connection to the village is underplayed by Ise Shrine, because it differs from the official account of the source for these textiles. There is little printed matter dealing with the provenance of the shrine's textile offerings, but in booklets issued by the Jingū Historical Museum and Agricultural Museum describing the various collections of shrine treasures, documents, ritual objects, and archaeological artifacts owned by Ise Shrine, as well as in brochures distributed at the shrine describing the Kanmisosai, it is related that the *nigitae* and the *aratae* textiles are woven, respectively, at the Kanhatori Hatadono and the Kanomi Hatadono Shrines in the neighboring city of Matsuzaka. These descriptions are typically illustrated with a black-and-white photograph of two men in white kimono and *hakama*, the garb of Shinto priests, weaving at a loom of the same type as used in Tsukigase. Though the Sakanishi family are among the officially approved artisans supplying the shrine, the fact that these *asa* textiles are woven by women in the distant village of Tsukigase is a reality that remains hidden behind the facade of Shinto tradition.

In truth, one bolt of cloth is in fact woven at Kanomi Hatadono Shrine each year by a man from a family that has received this commission for generations. He is not a Shinto priest nor is he a professional weaver. He goes to the shrine for fifteen days in the spring each year to weave one bolt of *asa* cloth under purified conditions. This bolt is placed on the high altar together with the bolts handwoven by Sakanishi Teruyo. The preparation of the warp for this cloth is not done by the weaver, however, but by Mrs. Sakanishi in Tsukigase, who is also called in to troubleshoot when there are any problems during the weaving process.

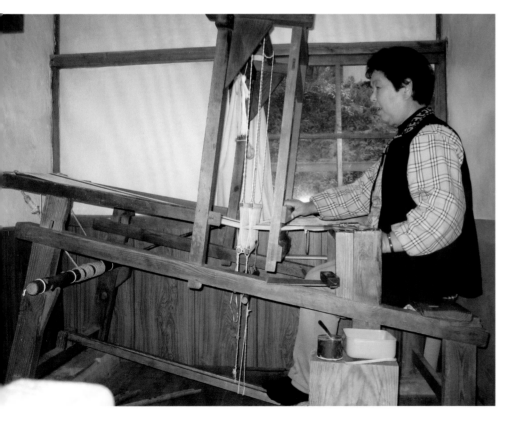

8.26 Sakanishi Teruyo has woven in the weaving chamber located outside her home since the time of her marriage. She originally wove alongside of her mother-in-law. Today she weaves four bolts of *asa* cloth a year for Ise Shrine.

Photograph by Melissa M. Rinne, Tsukigase, Nara Prefecture, 2006.

8.27 Sakanishi Katarō appears with the three types of *asa* cloth that he has supplied to Ise Shrine for the biannual Kanmisosai ritual. Counterclockwise from top are: a rare bolt of *hon'asa* cloth with hand-spliced thread in warp and weft, woven by Ishimoto Miyuki (seemingly not given to the shrine because it was considered to be the last of its kind); a bolt woven by Sakanishi Teruyo of machine-spun ramie warp and hand-spliced hemp weft (four bolts of which are offered annually to the shrine today); and a bolt of bleached white *sarashi* that is woven on a power loom in another prefecture from imported industrially spun ramie thread. (The latter comprises the bulk of the 240 bolts supplied annually to the shrine.)

Photograph by Melissa M. Rinne, Tsukigase, Nara Prefecture, 2006.

CONCLUSION

Confronting the realities of Japanese bast fiber textile production today necessarily inspires complex feelings: on one hand, there is tremendous respect for and awe in the face of the extraordinary skill, dedication, and efforts of the producers; on the other, a sense of impending loss, supported by the successive bankruptcy of weaving companies; the illness or death of local artisans; and the helplessness of knowing that without some sort of radical intervention, it simply may not be economically feasible in the highly developed industrialized nation of Japan to continue producing cloth requiring months of skilled labor to complete.

It must be stated unequivocally that this study is in no way intended as a criticism of any of the individuals involved with these textiles, who certainly deserve our deepest admiration. Instead it confronts these issues because they are not always evident to outsiders, and because, with the uncertainty of production in the future, there may no longer be insiders to tell what really happened. It is hoped that this essay will serve to shed light on the realities of textile production amidst the rapidly changing social and economic factors at this point in history.

Both of the bast fiber weaving traditions described above have faced difficult, often insurmountable barriers in the second half of the twentieth and early twenty-first centuries. Echigo *jōfu*, one of the most sophisticated and technically advanced bast fiber textile traditions in the world, is in danger because, among other things, there is not an adequate supply of locally made thread to continue producing the cloth in volume. Only volume can support the large network of specialized artisans involved in production. Ironically, the same government designation that has helped the industry continue into the present also serves to stifle open discussion about the crisis it now faces. Forced by necessity to seek alternative sources for handmade ramie thread, thread wholesalers and even weaving companies themselves have turned to other ramie-producing centers in East Asia. Though they know that without such actions they would go out of business, the guilt felt about not using entirely domestic materials has placed a blanket of secrecy over the industry. On a global level, however, looms the ominous reality that both Korean and Chinese bast fiber textile communities are rapidly turning away from handiwork production as older artisans retire and younger workers seek more lucrative career alternatives.

The future of this industry, if only on a very small scale, is encouraged by the commitment to Echigo *jōfu* production by the newest generation of at least one weaving company: Honda Eisuke (b. 1976) and Yamamoto Tomomi (b. 1981),

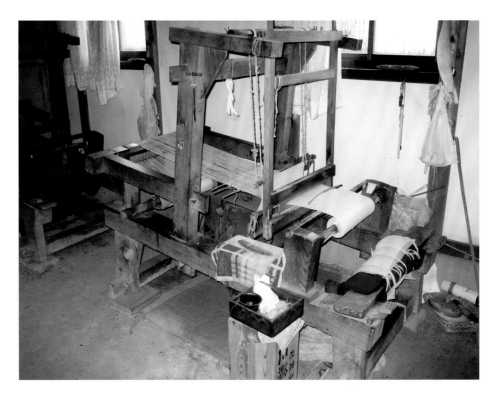

8.28 These bolts of *hon'asa* Nara *sarashi* with hand-spliced warps and wefts were woven by members of the Nara *Sarashi* Preservation Society between 2002 and 2005. The warp behind them, sleyed with string heddles and a reed, is made of hand-spliced hemp.

Photograph by Melissa M. Rinne, Tsukigase, Nara Prefecture, 2006.

8.29 Like most looms at the now-defunct Nakagawa Textile Factory in Tsukigase, this example has a partially woven bolt left on it as a display for visitors. The white color of this textile, however, betrays the fact that it is woven not of hand-spliced thread (which would be a natural beige color) but of industrially spun, bleached ramie thread.

Photograph by Melissa M. Rinne, Tsukigase, Nara Prefecture, 2006.

children of the owners of Honda Textiles, both of whom have undergone specialized textile-training courses and now work on a regular basis for their parents' company. At this time, they are the only members of their generation born and raised in the region to do so.

At the time of my fieldwork, Nara *sarashi* was being produced in Tsukigase on a very small scale driven largely by efforts in the 1980s and early 1990s of women who were not originally part of the weaving industry at all, resulting in an interesting reinvention of the craft. Though from the outside this village seemed to be maintaining a continuous line of tradition, most of the people who most passionately continued to weave Nara *sarashi* and who will carry the textile into the twenty-first century were not originally local weavers but people who learned about Nara *sarashi* through these late torchbearers, meaning that the primary lineage of artisans had doglegged from its original course and gotten back on track in a subtly different form. Because of this change, the profile of the textile had been raised to a national level, at the same time sacrificing for good any remote chance of its continuing as a viable industry.

In the beginning of the twenty-first century, however, the Nara *Sarashi* Preservation Society has made significant technical advancements that no one could have foreseen in 1991. Under the guidance of vice-chair Matsumoto Yoshiko (b. 1942) and teachers Matsumoto Hiroko (b. 1926, older sister of Sakanishi Katarō), Tanimoto Hanako (b. 1925), Nakanishi Tamiko (b. 1921), and others, the Preservation Society weavers have regained the ability to prepare and weave with hand-spliced warps, and they have produced several bolts of the so-called *hon'asa* since 2003 (fig. 8.28). Though its members still assert that the Society is a volunteer effort, some of its output is of a technical sophistication perhaps unmatched by any other nonprofessional weaving group in the country. In reality, these staunch advocates of amateurism are in fact beginning to dabble in the professional world of commissions, their current project being the production of cloth for a *noren* curtain for Sumiya, a historical Edo-period house of assignation in the Shimabara district of Kyoto, now a museum. Having mastered the most elusive bast fiber technology, it is perhaps only natural that these weavers—in keeping with the history of Nara *sarashi* as a professional industry—begin to cater to Japan's most discerning consumers.

In contrast, the small weaving factory where I worked in Tsukigase was no longer operating when I visited in 2006. The weaving fees had proved too great a financial burden for the owner. This fate seems only natural, for to make a clear distinction to the buyer between the genuine domestic product and the imported substitute would be paramount to exposing the *asa* textile industry's greatest secret: that almost all handwoven *asa* textiles sold in Japan today are imported. The factory itself remains intact and set up to be shown at a moment's notice to television crews or the rare visitor (fig. 8.29).

For both Echigo *jōfu* and Nara *sarashi*, the establishment of training courses has been an essential means of transmitting the skills needed for textile production to interested members of the next generation. While the Echigo *jōfu* training course essentially limits enrollment to local residents and serious weavers, the Nara *sarashi* course opens its doors to any interested member of the general public. Both of these models have been successful in their own way. The Niigata producers have succeeded in training enough weavers to sustain a small-scale industry, and the Nara Preservation Society members have spread knowledge and understanding of their textile, eventually leading to a remarkable technical comeback.

Other bast fiber textile communities in Japan have also found creative means of transmitting technique and disseminating information. The aforementioned ramie-producing village of Shōwa, Fukushima Prefecture, established an annual year-long training course called "Weaving Princesses" (Orihime) in the early 1990s to attract young women from outside the community. It was hoped that while learning a full range of textile production techniques—including fiber cultivation, thread making, and weaving—students would experience life in the village and possibly even decide to marry and settle there permanently. (So as not to exclude interested male participants, the name of the training course was later changed to "Weaving Princesses and Cowherd Stars" [Orihime/Hikoboshi]—a reference to the mythical meeting of two stars on the seventh day of the seventh month.) It might be noted that this region, as in Niigata, had an industry for producing fine ramie cloth for kimono, known as Aizu *jōfu*. Like Tsukigase, the strategy chosen to avoid the missing-link syndrome was to have weavers learn all steps of production so that they would be able to produce textiles entirely on their own, albeit at a much slower pace. In the hamlet of Kamiseya, part of the city of Miyazu on the Tango Peninsula in northern Kyoto Prefecture, an annual Wisteria Weaving Training Course (Fujiori Kōshūkai) begun in 1985 and initially taught by elderly weavers from the village is now staffed by a Preservation Society made up of highly organized volunteers,[28] most of whom live in other regions and come to the village for the eight weekend sessions held each year. Many of these members have fully mastered the processes of turning wisteria fibers into woven cloth and spend their free time at home making thread. Though wisteria weaving has ceased to be a viable profession for most Kamiseya locals, this solid fan base of textile enthusiasts from around Japan ensures its continuation into the foreseeable future.

The strategies selected by each of these textile communities to preserve tradition in the modern context have inevitably resulted in contradictions of one form or another. Regardless of these issues, there is no question that it has been the dedicated efforts of these producers, weavers, and proselytizers that have kept these textile traditions alive until now. As the relative value of handwoven bast fiber textiles in society becomes increasingly precarious, the continued survival of these and other similar traditions may very well depend on the ability of their producers to pinpoint problems and then re-envision their textiles within their localities, Japan, and the global community, leading them into uncharted and certainly contradictory territory.

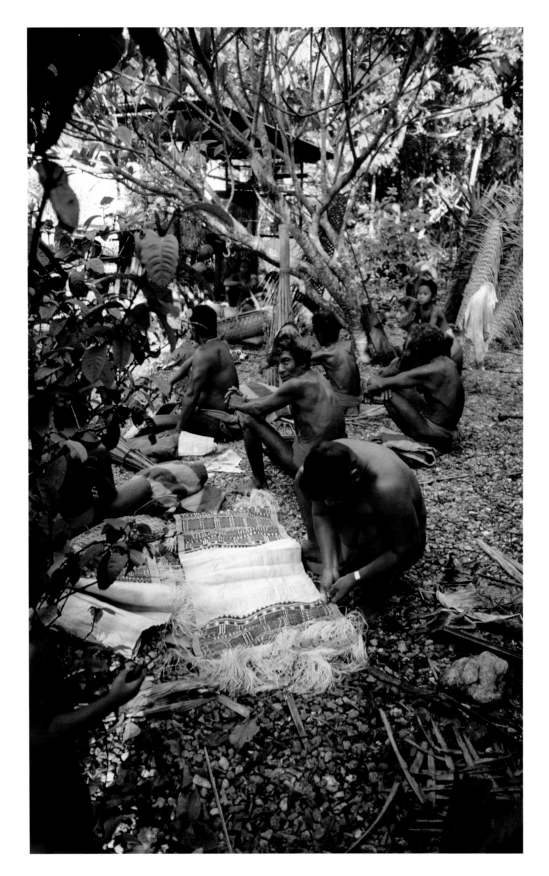

9.1 Mourners gather at a funeral in Faliyow Village on Fais Island. In the foreground, a man stitches two *machi* together lengthwise for use as a burial shroud. The commercial blankets and large, conical bundles of turmeric wrapped in split bamboo serve as funerary exchange gifts.

Photograph by Donald H. Rubinstein, 1975.

9. Reviving the Sacred *Machi*
A Chiefly Weaving from Fais Island, Micronesia

Donald H. Rubinstein and Sophiano Limol

FAIS IS A SMALL, RAISED CORAL ISLAND (fig. 9.2) with an area of barely 2 square kilometers. It is located about 260 kilometers east of Yap in the Caroline Islands, the great archipelago of low coral islands and atolls that extends nearly 1,500 kilometers between the mountainous islands of Yap to the west and the high islands of Chuuk Lagoon to the east (fig. 9.3). The fifteen Yap outer islands and atolls form a part of this larger archipelago, including Fais Island and Ulithi Atoll (located 80 kilometers to the west of Fais). Today Fais is part of Yap State, one of the four states of the Federated States of Micronesia, an island nation that only gained its independence in 1986, following forty years of administration by the United States as a United Nations Trust Territory. The Federated States of Micronesia continues to operate largely within American economic and legal frameworks.

The slightly more than three hundred people who compose the resident population of Fais consider the loom-woven banana fiber textiles known as *machi* to be the most precious and sacred objects produced on their island. Once an integral part of a set of traditional rituals and religious practices linked to chieftainship, chiefly tribute, and male status, the *machi* today retains much of its pre-Christian aura, despite the disappearance of most of its ceremonial contexts. Recent efforts to revive the former methods of local production of *machi* on Fais Island, however, exemplify some of the dilemmas and paradoxes of cultural preservation within an increasingly modernized island society and commoditized economy.

THE IMPORTANCE OF LOOM-WOVEN CLOTH
WITHIN AN INTERISLAND TRIBUTE SYSTEM

Known locally as Re-Mathau (People of the Sea), the inhabitants of the small coral islands to the south and east of Yap developed extraordinary skills as long-distance seafarers and navigators. Sailing in superbly seaworthy outrigger canoes, the islanders routinely traveled hundreds of kilometers of open ocean from island to island within the archipelago, or even longer distances north to the Mariana Islands, west to the Philippines, or southwest to Palau. Their survival depended not only upon their knowledge of ocean navigation but also upon their ability to maintain long-distance trade relations and social ties, assuring them of alternative sources of support and resources in the wake of the typhoons and droughts that periodically ravage these low-lying islands.

Within the so-called Yap Empire, a system of interisland trade and tribute linked the low outer islands with the high island of Yap (Alkire 1980; Hunter-Anderson and Zan 1996; Lessa 1950). Fais Island and nearby Ulithi Atoll lie closest to Yap of all the islands in the archipelago and were thus accorded special recognition within this political system. Once every two or

three years, emissaries from each of the low coral islands, beginning with those farthest east, sailed west to Yap. At each island along the way, additional outrigger canoes joined the fleet, until the entire armada reached Yap, where it paid tribute to the chiefs of Gagil, a district of northern Yap. In return, the coral islanders could rely on food and refuge in Yap when necessary. Although the Yapese had very limited actual hegemony over the Outer Islanders, the system of trade and tribute provided benefits to both the Yap Islanders and the Outer Islanders. It had existed for at least five centuries prior to twentieth-century colonial rule, when first the German and then the Japanese administration of the Caroline Islands forbade interisland sailing expeditions (Descantes 1998, 239).

Loom-woven cloth made from banana leaf fiber and hibiscus bast fiber was a central element in the Yap interisland trade and tribute system. In the Yap Outer Islands, women produce six different named varieties of loom-woven cloth, which they wear as wraparound skirts and which men wear as tied loincloths. Proper attire for women in the Yap Outer Islands today remains the wraparound skirt with no upper garment. Skill at loom weaving is an intrinsic aspect of female identity in these island societies, and girls as young as four or five begin learning to weave on toy looms (figs. 9.4, 9.5). By the time they reach puberty, which is signaled by the wearing of a loom-woven wraparound skirt, virtually all young island women are proficient weavers.

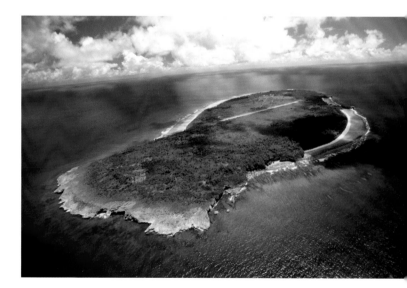

9.2 Fais Island, a small raised Micronesian coral island of about 2 square kilometers, is shown here in an aerial photograph.
Photograph courtesy of Yap Visitors Bureau, 2001.

The various cloths are all produced on the same type of back-strap loom. They are differentiated by the style and degree of decoration used. The simplest variety (*marub*) is a plain, unpatterned textile woven from hibiscus bast fiber. More decorative varieties include *hulifuy* (lit., "hibiscus"), made with alternating warp stripes of undyed and blue-dyed hibiscus fiber, and *huluch* (lit., "banana skin"), a similarly patterned cloth made from banana fiber.[1] More complex is *peig* (lit., "side"), a banana fiber cloth marked by a wide striped section in the center of the warp and several bands of supplementary-weft patterning in

dyed hibiscus fiber at the two ends. A recent variety of the *peig* is *flak* (from the English "flag"), which also displays a wide central warp stripe in addition to three or four narrower multicolored warp stripes on either side of the central stripe. The *flak* is a postwar innovation by Outer Islands women taking advantage of the design possibilities offered by multicolored commercial cotton and polyester thread. The most elaborate and complex variety of weaving produced in the Yap Outer Islands is the *machi*, in which the two ends are decorated with multiple rows of supplementary weft patterns (figs. 9.6, 9.7).

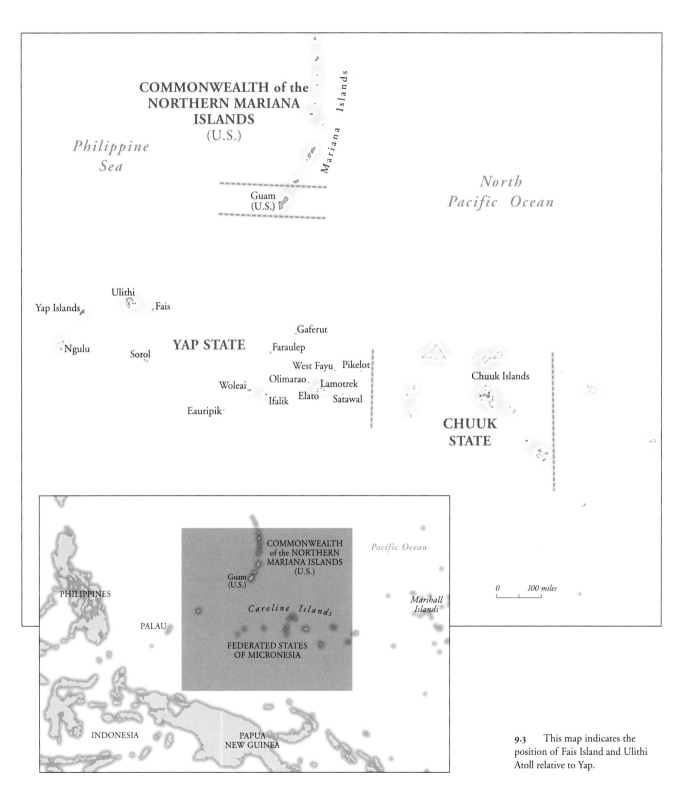

9.3 This map indicates the position of Fais Island and Ulithi Atoll relative to Yap.

9.4 Several adult women weave at back-strap looms inside a menstrual house in Faliyow Village, while two young girls learn how to weave using a toy loom.

Photograph by Donald H. Rubinstein, Fais Island, 1972.

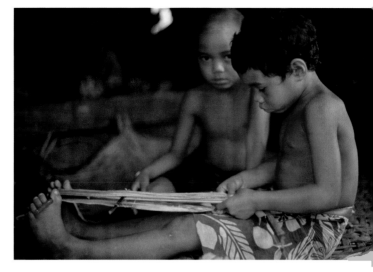

9.5 Two young girls weave on a toy loom.

Photograph by Donald H. Rubinstein, Faliyow Village, Fais Island, 1972.

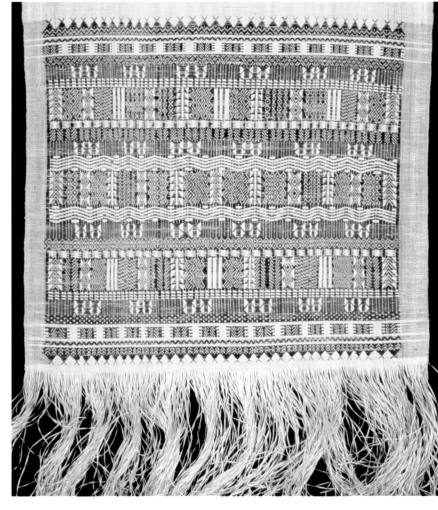

9.6 *Machi* (detail)
Woven by Josephina Waisemal
Fais Island, Yap State, 1977
Banana fiber, hibiscus fiber
Private Collection

This *machi* was commissioned from Josephina Waisemal at a time when *machi* weaving was in a decline, because she still possessed the knowledge of how to weave a variety of motifs.

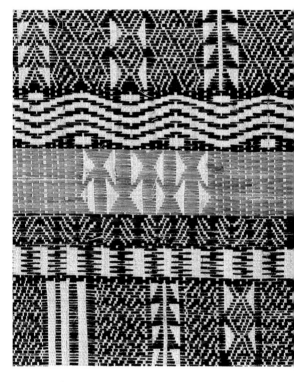

9.7 *Machi* (detail)
Woven by Patricia Rawath
Fais Island, Yap State, 2003–2004
Babana fiber, hibiscus fiber
Fowler Museum x2005.19.1; Museum Purchase

The red decorative motif known as *yeramat* (person) forms part of the supplementary weft bands of this *machi* woven by a student in the first *machi* revival class. The dyed supplementary weft is hibiscus fiber, and the undyed ground weft yarn is banana fiber. This cloth shows fewer motif variations than the cloth in figure 9.6, which was woven by a more senior weaver.

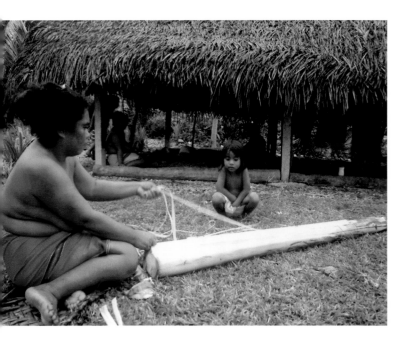

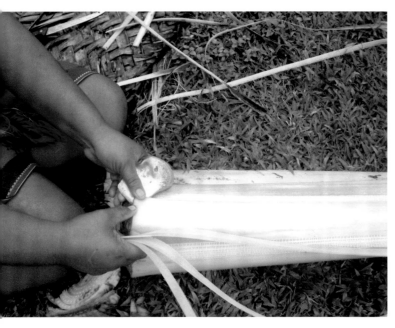

In the Yap Islands trading and tribute system, the value accorded to a textile correlates with the elaborateness and complexity of its decoration. The *machi,* which Fais Islanders consider unique to their island, is the most valuable of all the Yap Islands loom-woven cloth. Fais Islanders equate the value of a *machi* with that of a human life; if one person were to accidentally kill another, the presentation of a *machi* to the victim's family would be an adequate gesture of apology and reconciliation. No sailing canoe bound for Yap would leave Fais without at least one *machi* carefully wrapped and stowed aboard as a tribute payment to the Yap chiefs and a guarantee of protection on Yap. Other forms of tribute offerings, in addition to loom-woven cloth, included seashell and turtle shell valuables, shell belts, coconut oil, sennit rope, sails and mats of plaited pandanus leaf, and special food items (Lessa 1950).

PRODUCTION OF THE FAIS ISLAND *MACHI*

Fiber from the leaf stalks of banana plants (*Musa* sp.) is the primary material of the *machi,* comprising all the warp yarns and the ground weft yarns carried on the shuttle. One particular variety of banana (called *malug* on Fais) is preferred for its crisp, white fiber. Hibiscus (*Hibiscus* sp.) bast fiber, which takes dye more readily than banana fiber, is used for the supplementary-weft yarns. To prepare the banana fiber, the weaver first tears lengthwise strands of fiber three to four centimeters wide from a felled banana plant (figs. 9.8, 9.9). Fais women consider the outermost of the onion-like concentric layers to provide the best quality leaf fiber. Using the polished edge of a clamshell or small knife, the weaver gently scrapes the pulp from the skin. The resulting two-meter-long ribbons of silky fiber are allowed to dry in the sun, and then each ribbon is separated into thin filaments of about one to two millimeters in width, and the filaments are knotted together end-to-end to produce the continuous yarn for weaving. To prepare the hibiscus fiber, the weaver first peels the fibrous bark from the hibiscus branches and then soaks the bark for several days, weighted down by stones in a pool of seawater on the reef flat (or more recently in concrete cisterns; fig. 9.10), until the retted bast fiber can be separated from the bark (Rubinstein 1986a, 47–48). As with the banana fiber, the individual strands of hibiscus fiber must be knotted together end-to-end.

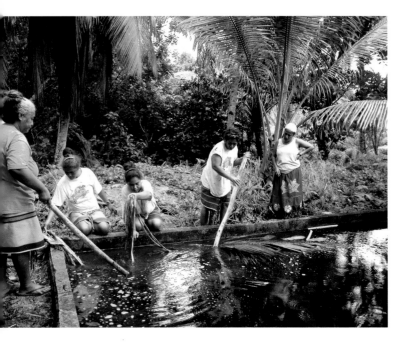

9.8 A *machi* student, seated in front of the *machi* school site, tears banana fiber into strands.
Photograph by Sophiano Limol, Fais Island, 2004.

9.9 A woman uses a clam shell to cut the banana fiber from the felled plant.
Photograph by Sophiano Limol, Fais Island, 2004.

9.10 *Machi* instructors and students remove the retted hibiscus fiber from a concrete cistern located in the interior of the island.
Photograph by Sophiano Limol, Fais Island, 2003.

The supplementary-weft yarns of hibiscus bast fiber are dyed either red or blue prior to weaving. The blue dye was originally derived from banana suckers, and the red from the roots of the *Morinda citrifolia* tree. Fais Islanders, however, abandoned their indigenous technology for producing dyes from local plant and mineral materials sometime during the Japanese colonial administration, probably in the late 1930s, when several hundred Japanese and Korean workers occupied the island and mined guano deposits (calcium phosphate) as part of Japan's prewar industrial effort. By the early 1970s, when Donald Rubinstein began fieldwork on Fais, women on the island were using blue mimeograph machine paper and dwindling caches of Japanese-era synthetic red dye to color supplementary-weft yarns. As the red dye became increasingly difficult to replace, women began substituting red cotton commercial thread for the bands of red-dyed supplementary hibiscus yarns. When the *machi* revival project began in 2003, no one on Fais retained the technical knowledge for producing natural dye, and the process had to be rediscovered through trial and error.

After the leaf and bast fiber yarns have been prepared and dyed, a Fais weaver will wind the continuous banana fiber warp yarn around four upright pegs set into a low wooden bench that serves as the warping table (fig. 9.11). She then removes the large coil of warp yarn from the warping table, substitutes the different looms parts (heddle stick, shed stick, lease rods, beams) for the upright pegs, and transfers the coil of warp yarn to the loom. The Fais loom is constructed of light, straight, round rods of hibiscus wood lashed together with sennit fiber. The weaver sits on the ground with her legs extended and her feet braced against the loom frame. In this seated position, with the loom strapped around her back, she proceeds to weave (fig. 9.12). The ground weft, also of banana fiber, is carried on a long smooth shuttle typically made from the polished wood of the orange tree. The supplementary weft of dyed hibiscus fiber is picked into the warp yarns, using a long bone needle made from a smoothed spine of a stingray or swordfish (figs. 9.13, 9.14).

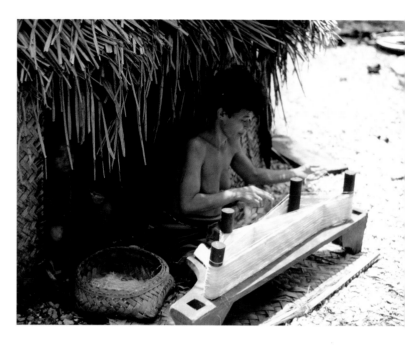

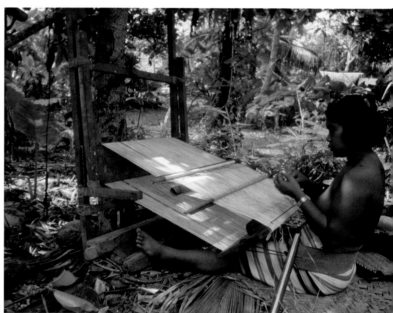

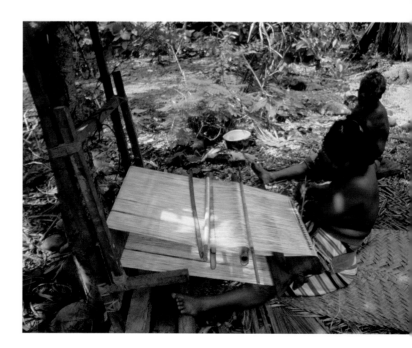

9.11 A weaver winds banana fiber onto the warping table.
Photograph by Donald H. Rubinstein, Faliyow Village, Fais Island, 1972.

9.12 A woman weaves a *machi* on a back-strap loom constructed from commercial lumber rather than the hibiscus wood used traditionally. Note the long shuttle made from orange wood on her lap. The weaver wears a style of wraparound loom-woven cloth known as *flak* or *peig*, distinguished by an embellished central warp stripe in the pattern.
Photograph by Donald H. Rubinstein, Lecucuy Village, Fais Island, 1972.

9.13 A long bone needle made from the spine of a swordfish is used to pick in supplementary-weft yarn.
Photograph by Donald H. Rubinstein, Lecucuy Village, Fais Island, 1972.

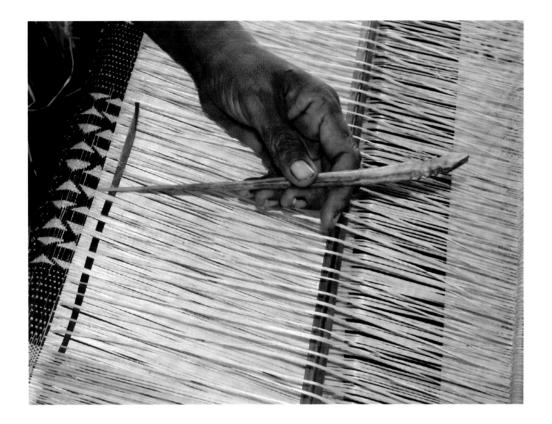

9.14 A weaver in the *machi* school uses a bone needle to pick the supplementary weft of dyed hibiscus into the warp yarns.
Photograph by Sophiano Limol, Fais Island, 2004.

THE CHIEFLY *MACHI* IN CHANGING FAIS ISLAND SOCIETY

Prior to the imposition of colonial rule on Fais in the early twentieth century and to the conversion of the islanders to Christianity immediately following World War II, the *machi* held a much more prominent place in island rituals and religion. Intimately associated with chieftainship, it belongs to a small class of objects on Fais known as *bwalungal tamol* (lit., "perquisites of the chief"). These also include valuable drift objects such as glass bottles and buoys that float onto the island and several species of marine animals considered taboo by Fais Islanders, such as sea turtles, whales, and dolphins, which must be brought to the island chief. Within this special class of objects considered the rightful property of the chief, the *machi* is the only item of local manufacture. This intrinsic link between *machi* and the status of the island chief underlies many of the problems and paradoxes encountered in recent attempts at cultural revival and preservation of the *machi* on Fais. Like the heirloom "fine mats" of Tonga and Samoa and comparable "chiefly objects" of other Micronesian and Polynesian societies, the *machi* shares aspects of inalienability from the purview of the island chief and embodies concepts of chiefly power and prestige (Weiner 1992, 44–65; cf. Kaeppler 1999, 168–70; Schoeffel 1999).[2]

The small community of Fais Islanders has a rather complex and formal social organization comprising three separate village sections, different levels of ranked chiefly positions within each village, and one paramount position of island chief. The village sections subsume about thirty-five named, localized estates, and a person's social rank depends upon his or her patrilocal estate.[3] In the past particular estates held different specialist knowledge and performed the ritual obligations associated with that knowledge, such as certain kinds of fishing or agricultural magic, canoe construction, dance leadership, and *machi* weaving. About half of all the estates—all those holding some level of chiefly rank—were responsible for providing a single *machi* annually to the island paramount chief. This was a special variety of *machi* called *mmul*, which contained a single, distinctive warp stripe down the center of the textile in addition to the supplementary-weft bands at the two ends. When the island chief received this *machi*, he would lay it upon the spirit shelf of his house for four days as an offering to the ancestral spirits. Only then could it be carefully folded, wrapped, and put away (Rubinstein 1986b, 61). *Machi* of this type were taken aboard the periodic sailing voyages to Yap, where they would be presented as tribute to Yapese chiefs. With the cessation of tribute voyages to Yap in the early decades of the twentieth century, the *mmul* variety of *machi* was no longer required as an obligatory contribution from certain Fais estates to the paramount chief, and its production ceased.[4]

Prior to the Christianization of Fais Island and Ulithi Atoll, the *machi* also functioned as an inaugural mantle in the investiture ceremonies for paramount chiefs of these two island communities.[5] At the investiture ceremony on Fais, the new chief would kneel on sacred ground beside the men's lodge in the chief's village section, while the secondary chief would hold a *machi* above the kneeling man's head, recite the inaugural chant (see top of p. 161), and lay the *machi* like a mantle over the new chief's shoulders. The chant called upon the major island deities to safeguard the new chief, and admonished the chief to rule with proper humility.

Look here from over there, all you ancestor spirits of
 the lodge!
I am about to spread out this fellow's mantle!
You, Soolal, gaze up, and you, Yalulap, gaze down![6]
And you, ——! And you, ——! And you, ——![7]
Look here, for now this man is about to come under
 your mantle!
You will watch over this man!
I spread out his mantle, and you shall grant him long life!
Grant him good fortune!
Grant him happiness during his tenure as chief!
Eastward your children, until the distant rising!
Westward your children, until the distant setting!
You, you who are to be chief, and mother of this island,
What you receive, though small, is your fare!
What you do not receive, though large, is not your fare!
You shall be as the reef's coral shoulders!
The waves may pound, pound, yet you will stir not!
Keep your ears stopped, but keep your ears sharp!
Keep your eyes covered, but keep your eyes clear!
Do not rival against others!
All of you, grant him happiness during this man's term!
Grant him long life in his chieftainship!
Grant him long life! Grant him long life!
Grant that his heart be good!
And if his heart be good, grant him long life!
And if his heart be evil, remove him!

Ha kolodog m'igalaa haamii toyidabal fal lee!

Yi be le faregi marali hallee lul!
Haladag gel Soolal ngo haladiy gel Yalulap!
Mo gel —— ! Mo gel —— ! Mo gel —— !
Ha kolodog, yi sa faregi maral lul!

Ha be kamagoya hallee!
Yi be le faregi marali hallee lul ngo ha sa hasuuleya!
Ha holobuwa!
Ha hafeeye wool mool hallee, faal tamol lee yaal!
Lamudag yee, faadagal ye laay!
Lamudiy yee, faadubul ye laay!
Gel, gel mele ho sa mel bo tamolu, mo sil faliyey,
Ye waachich ngo ye holag, mmalam!
Ye paaling ngo ye ta holag, tay mmalam!
Ho hafidig me yalung laay!
Ye pung, pung lawu, ngo gel, ho chap chog!
Ho taleng pul, ngo ho taleng chig!
Ho metafis, ngo ho metathil!
Ho toway lol tamway!
Ha be hafeeya wool mool hallee!
Ha sa hasuuleeya faal tamol le yaal!
Hasuuleya! Hasuuleya!
Ha sa la hamommay dipal!
Ye mommay dipal, ha sa gasuuleya!
Ngo taykkof dipal, ha sa hachuya!

Embodying the sacred nature of the office of island chief, the *machi* symbolically linked the incoming chief with his predecessors and with the island's ancestral spirits. Before the introduction of Christianity to the Fais community, *machi* also functioned as an emblem of adult male status within the rites of passage held for island boys. During a four-day period of seclusion at puberty, boys were decorated with floral garlands as for a dance and wore a *machi* loincloth. At the end of this period, the boy presented the *machi* to his ritual sponsor, typically an elder male relative.

At the burial of a senior man of Fais, the *machi* still functions as the most important tangible expression of love and loss offered by close female relatives such as a wife, sister, or daughter. Funerals in the Yap Outer Islands are marked by an enormous outpouring of cloth gifts of all varieties—plaited mats, loom-woven textiles, store-bought blankets or sheets—from relatives of the deceased (fig. 9.1). Some of the cloths accompany the body as burial goods or body wrappings, while many of the cloth gifts pass back and forth between the family of the deceased and their kin. *Machi* are the most valued of all the burial cloths. Fais women who anticipate the death of a close senior male relative will want to have a fine *machi* already completed in time for the burial (fig. 9.15).

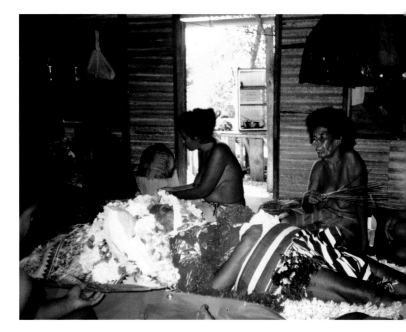

9.15 A *machi*, nearly covered by pillows and flower garlands, lies at the head of a deceased senior man on the occasion of his wake.
Photograph by Sophiano Limol, Faliyow Village, Fais Island, 1991.

In the ordering and elaboration of their complex, supplementary-weft decorative patterns, *machi* also function as an embodiment of Fais spatial and social order (see Rubinstein 1993 for a fuller discussion of this topic). Decoration of *machi* is "intrinsically functional" (Gell 1998, 74), as both the central placement and the expanding number of particular motifs are expressions of the centrality of the chief and the increasing ritual value of the cloth. Today the *machi* continues to command great respect in Yap and the Outer Islands, although it no longer functions in formal chiefly tribute and indigenous religious rituals. Textiles of this sort are never worn in everyday use. They may be given to a relative or special friend departing the island, as a keepsake and item of wealth, and they are still used as burial cloths for the senior men of Fais and Ulithi. Because of the high value they hold in island culture, they continue to be useful in ritual apology payments, when one family has wronged another or has offended the island chief. *Machi* are also being treated as "fine art" objects: encased within an expensive glass-boxed frame, one *machi* is displayed in the office conference room of the Embassy of the Federated States of Micronesia in Washington, D.C.; another *machi*, also lavishly presented and protected behind glass, decorates the lobby of Yap's sole luxury hotel. Displayed in such venues, textiles, such as *machi*, emerge as national symbols (see chapter 6 of this volume).

The traditional chiefs of the Yap Outer Islands have resisted the commoditization of the *machi*, despite their recognition and support of handicraft production for the economic development of Yap State. In the mid-1970s, the Council of Tamol (the Yap Outer Islands traditional chiefs) developed a suggested price schedule for all the various handicraft objects produced in the islands, including several types of loom-woven cloth, sennit rope, model canoes, and wooden figural carvings. The chiefs' council intentionally excluded *machi* from the list in a decision that Arjun Appadurai might call "decommoditization from above" (1986, 22). The traditional chiefs continue to treat *machi* as *bwalungal tamol*, objects that are intrinsically the property of the chief, and in which some of the sacred aspects of chiefly power and privilege still inhere. In this shifting context of persistence and change in the various attitudes and functions associated with *machi*, efforts to revive and preserve methods of earlier production of the object must negotiate careful compromises between tradition and modernity.

DEVELOPING THE *MACHI* REVIVAL PROJECT

Unlike recent projects aimed at organizing indigenous Mayan, Navajo, or Ifugao women weavers (Grimes and Milgram 2000), economic development was not the driving force for the Fais *machi* revival project. The primary motive was rather cultural preservation and the pride the community takes in producing such admired, sacred objects. Economic benefits of the *machi* revival project were a secondary goal, to some extent incompatible with the concept of the *machi* as inalienably chiefly and expressly decommoditized.

Before plans for the *machi* revival project could even be put to paper, it was necessary to establish a licensed small business in Yap State that could legally receive grant funds for this project, as well as for other related projects in cultural and economic development. In early 2001 Sophiano Limol created the Yap State Grant Research Firm (YSGRF) as an umbrella organization for a variety of environmental, cultural, and subsistence economic development projects and programs in the rural areas of Yap State.

The initial agenda of projects identified by YSGRF included the *machi* project among a number of others, such as the restoration of ancient walking trails in Yap, constructing scenic overlooks and parks in Yapese villages, recording oral histories in Yap and the Outer Islands, and rehabilitating the mined phosphate land on Fais Island. Among all the plans, the *machi* revival project received highest priority, mainly because Limol, a Fais Islander, knows the community intimately and recognized the special importance of the Fais *machi* as an indigenous cultural symbol and as a product with continuing ceremonial value. A preliminary business plan had already been drafted by a married couple from Fais who work within the Yap State government and envisioned a cultural preservation project involving the *machi*. Once this couple gave Limol permission to use their draft concept, he was able to begin developing the actual plans for the Fais *machi* revival project. Gaining the support of the Fais community and especially the blessing of the island chief for the project was another matter.

The small Fais community is divided geographically with one-quarter of the population, roughly a hundred people, residing in the state capital in Yap's main island complex, and the rest, about three hundred, residing on remote Fais Island. Those living in Yap are primarily educated government workers and wage earners and their families, while those on the home island tend to be less educated and to support themselves largely by subsistence fishing and farming—a pattern of rural-urban difference found throughout the Pacific. Transportation between Yap and Fais is limited: a government ship makes irregular monthly trips, and the local Protestant mission in Yap operates a small plane that makes weekly trips for a fare beyond most Fais family budgets. Limol resides in Yap and works with the Yap State government, but most of the key community members whose support was necessary for the *machi* revival project—including the island's elderly paramount chief—reside on Fais.

Limol spent over a year gathering community support and background information for the *machi* project. Between 2001 and 2003 he made numerous trips to Fais. Knowing that the eventual success of the project rested on the support of the elder women, Limol targeted that segment of the community. These women were aware that the production of *machi* on Fais had greatly declined in recent years. They also recognized the social and cultural value of the *machi* as a form of chiefly tribute and an emblem of Fais Island identity and pride. Some of the elder women recalled nostalgically how proud they had been to master the *machi* at an early age and how tough and intimidating the instruction had been at the hands of a mother or aunt who would berate a girl for any minor mistakes she made in the *machi* figural motifs. In earlier times Fais girls wove their first *machi* in the menstrual house during their menarcheal three-month seclusion. The older Fais women with whom Limol spoke thus recalled this traditional instruction as marking

their entrance into womanhood. They regretted its disappearance, yet few of them envisioned a way to halt the progressive loss of knowledge and skill necessary to produce *machi*. Like so much else, the *machi* seemed part of a realm of traditional cultural knowledge that was irretrievably disappearing under the impact of modernizing influences, especially Western schooling, wage economy, and urban migration.

As Limol talked to people in the community, the extent of the decline of the *machi* became apparent to him. Fewer than twenty-five Fais women still had the knowledge and skill to weave the cloth, and these were mostly women in their forties or older. On the neighboring island of Ulithi Atoll, where in the past a small number of women had learned to weave *machi*, this knowledge is now apparently lost entirely, even among the older generation.[8] No Fais woman younger than thirty could weave a *machi*, and hardly any of these young women appeared to understand its cultural significance. Whenever Limol broached the subject of *machi* with young Fais women, their typical response was to politely change the topic or suddenly remember a reason to be somewhere else.

In his series of meetings with the elder Fais women, Limol made clear to them how little the younger generation of island women knew (or really cared) about the *machi*, while he reiterated the project's objectives of reviving *machi* production and knowledge on Fais. Facing the inarguable and disturbing evidence that the Fais *machi* might well disappear with their generation, the elder women at first laid the blame on various recent social changes: the perceived want of discipline among the young women; their lack of appreciation for tradition; and the abandonment by the Fais community of the custom of having women stay in the large communal menstrual houses during their periods and after childbirth.[9] Over the course of about six months of discussions, the elder women came to accept that regardless of the social causes of the decline of the *machi*, its revitalization lay in their hands. Throughout this time Limol had continued promoting the project among the Fais women residing in Yap as well as those living on Fais. He had promised them that if they accepted the project, it would be theirs to run, and the Fais Women's Association would receive credit for the project.

After the women had finally reached a consensus to endorse the project, Limol held one more meeting with them on Fais. The women's questions concerned practical matters: How long would the project run? Who would participate? What economic benefits would the project bring to the women and their families? The women expressed the hope that the project would continue indefinitely, as a way of training future generations of Fais girls to weave *machi* and thereby ensuring the preservation of this important cultural knowledge. As one Fais woman put it, "We will do our best to ensure that this wisdom is not lost to future generations of our children; it is *our* bequest to them."[10] They decided that the first cohort of students should be young women who were in their upper twenties and thirties and had already learned some of the *machi* motifs but had not yet mastered the full pattern and acquired the related skills in preparing and working with the banana and hibiscus fibers. Limol had drafted an earlier roster of students

for the first *machi* class, including girls in their late teens to early twenties, but the older women rejected that list. They argued that the younger women with no experience weaving *machi* would be unable to complete the training within the planned nine-month period.

The women also requested their own space for the project. They wanted the *machi* training center to have its own building—a traditional thatched shelter—located near the island's cinder block elementary school. This would give the young elementary school girls an opportunity to observe the *machi* instruction and to follow the training informally. Housing the *machi* training center beside the elementary school would also allow the project to be integrated into the cultural education classes, which form part of the curriculum of the Yap State Department of Education.

At this point, the *machi* revival project was fully conceptualized and embraced by the Fais women. There would be four trainers who would take turns on a scheduled basis instructing the six trainees in the first class. Before the project could be launched, however, several hurdles remained: gaining approval of the Fais paramount chief, persuading the rest of the community to support the project, and securing the necessary funding.

GAINING APPROVAL AND SECURING FUNDING FOR THE PROJECT

In Yap and the Outer Islands, traditional chiefs continue to wield considerable influence and enjoy the respect and allegiance of the people. Among the four states within the Federated States of Micronesia, Yap is unique in formally guaranteeing the authority of the traditional chiefs as a fourth branch of government, through a provision of the Yap State Constitution (Pinsker 1997, 155–58). Because the *machi* is so intimately associated with chieftainship and male status, the Fais paramount chief's approval was essential before the project could begin.

The Outer Islands Council of Tamol meets quarterly in Yap with representatives of the chiefs from all the Outer Islands. Over the course of nine months, Limol presented the *machi* project to the Fais chief's representative on three of his trips to Yap, and each time the proposal was carried back to Fais for further discussion by the island's paramount chief and traditional advisors. By the fourth trip the chiefs had reached a consensus to approve the project. The length of time necessary to gain approval of the project is a good indication of the slow, deliberate, consensual style of leadership that the island chiefs exercise.

Despite the women's acceptance of the project and the chief's approval, several men on the island continued to balk. Their displeasure was in part personal, reflecting the sort of jealousies that are commonplace in these small island societies though rarely expressed publicly. These are intensified as new opportunities and resources come into the communities. In this case, several men claimed that the project and its public funds would mainly benefit Limol's relatives, who would be employed as *machi* teachers or would gain valuable skill as trainees. Some island men also objected to the innovative teaching method wherein elder women would teach younger women without regard to the family relationships between teacher and student. This would violate traditional protocols of *machi* instruction, as

in past generations apprentice weavers learned *machi* techniques only from close female relatives. Elder women traditionally would not entrust this important knowledge to nonrelatives. This lingering resistance on the part of several men is difficult to characterize in terms of broader social structures of male-female competition over resources and may have been motivated more by idiosyncratic traditionalism, but in any case, the men raising these objections to the project eventually acceded to the women, because the women had accepted the project design and had chosen the trainers and the trainees.

Obtaining financial assistance for the nine-month project was the next step. Limol submitted the proposal he had developed to several different aid agencies and foundations. Several expressed interest, but only one agency offered real support, the Workforce Investment Act (WIA) agency in Yap, which is federally funded by the United States. Although the WIA strongly supported the project, its guidelines precluded funding a project restricted solely to women from Fais. The training would have to be open to any interested woman from Yap State. To obtain WIA approval for the project, Limol furnished the agency director with a letter confirming that any interested woman in Yap State would be welcome to take part.

This concession created another crisis and nearly caused the cancellation of the project. The *machi* is uniquely emblematic of Fais Island, and several Fais senior men contended that if the women gave away this knowledge to other islanders, that would violate the proprietary rights that the Fais community claims over the *machi*. The men also challenged anew the economic objectives of the *machi* revival project. They argued that the *machi* represents "the island's pride" and should not be sold for money—just as the council of traditional chiefs had stated thirty years earlier.

Again the community managed to reach a consensus compromise despite the acrimony of the debate. Weighing in favor of accepting the WIA requirement was the argument for preserving the Fais women's knowledge of this sacred weaving. That women from other islands might arrive uninvited and request inclusion in the project was, for all practical purposes, quite improbable—even if officially permissible. Weighing in favor of retaining the economic objective of the project, through the sale of *machi*, was the need to compensate the hardworking women. In discussions with his challengers, Limol suggested the community explore possibilities for patenting the *machi* and its related skills, so that Fais would retain benefits even if other islands acquired the knowledge.

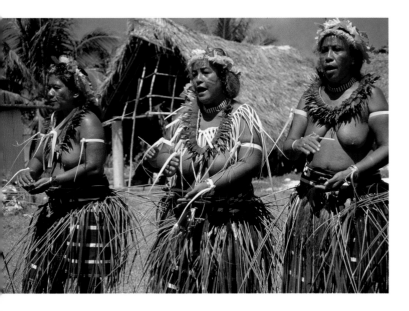

LAUNCHING THE *MACHI* REVIVAL PROJECT

The *machi* revival project began immediately after WIA had granted its approval, even though funds were not yet forthcoming. Limol's private business firm, the Yap State Grant Research Firm, footed the project's starting costs through individual contributions. By April 2003 the four selected trainers and several of the selected trainees began work on the project without pay. The first step was to prepare the natural fiber from the banana and hibiscus plants, as well as the natural dyes. Work began earlier than planned because a typhoon had recently struck the island felling many of the banana trees and uprooting the hibiscus plants. The trainers decided to salvage as much banana and hibiscus fiber as possible before the storm-damaged plants rotted. Otherwise, they would have to wait another year or longer until new plants were ready.

Preparing the natural blue and red dyes was another problem. Nobody on Fais knew precisely what the old process had entailed. Rubinstein provided Limol with some texts from old ethnographic studies conducted during the German era, but these did not provide full instructions including all the dye ingredients. The red color was especially difficult to rediscover. The elder women on Fais knew some of the ingredients but not the precise formula for producing an intense, lasting red dye. For two months, they experimented unsuccessfully with boiling

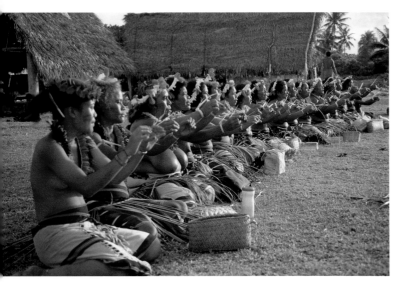

9.16 Three of the *machi* instructors lead the women's standing dance in celebration of the graduation of the second class of *machi* apprentices. In the background is the traditional-style thatched building where the *machi* revival project takes place.
Photograph by Donald H. Rubinstein, Fais Island, 2005.

9.17 Fais Island women perform a sitting dance in celebration of the graduation of the second class of *machi* apprentices.
Photograph by Donald H. Rubinstein, Fais Island, 2005.

various combinations of leaves, roots, and tree bark, but they could not achieve a permanent red dye.

This problem was solved through a strange incident. The husband of one of the trainers, a man in his mid-forties, dreamed that his deceased mother appeared and told him the missing ingredient. His mother, one of the last of the master weavers, had died twelve years earlier. When the man's wife and the other trainers tried out the instructions from the dream, the dye took. Evidently the missing ingredient had been an effective mordant. For the Fais community—nominally Catholic but still imbued with indigenous beliefs—this incident was seen as an ancestral blessing upon the *machi* training project and a reminder of the textile's enduring ties to the spirit world.

With a newly prepared supply of banana and hibiscus fiber and the newly rediscovered dyes, the project was finally ready to begin. The Fais paramount chief provided a plot of land bordering the island's elementary school for construction of a traditional thatched building to house the *machi* school. The island's three village sections donated all the materials, and the men donated their time and construction skills to build the house. The first class of six women began on June 28, 2003 (see fig. 13, p. 22), and they successfully completed the training by March 2004. Over the course of the nine months, each woman produced two *machi*, one of which included the full complement of eleven figural motifs along the supplementary weft. This was perhaps the first time in over half a century that *machi* were produced on Fais entirely from natural fiber and natural dyes. The first class culminated with a grand graduation celebration held on Fais on March 12, 2004. Limol organized the event with several of the Fais women leaders, and the entire Fais community participated, performing traditional male and female dances and preparing a bounty of local food and fish for the event. Official representatives from the Yap State Legislature and the Yap WIA office, and Rubinstein from the University of Guam flew in for the day and gave congratulatory speeches.

At the time of this writing, August 2005, a second cohort of *machi* apprentices has recently graduated in another grand ceremony held on Fais on June 19, 2005 (figs. 9.16–9.18). Several of the graduates of the first class have already begun making their own first *machi* independently. The *machi* revival project has gained widespread community acceptance and has brought a sense of renewed pride to the island, especially among the women. As one of the *machi* instructors stated, "Our knowledge of *machi* is doubly important: it both represents our identity and it gives guidance to the women of Fais."[11] Young Fais women on Yap and Fais, who had shown little interest initially, are now approaching the leaders of the Fais Women's Association and asking to be included in the next cohort of students. The list of future students includes the wives of several of the men who had been among the most vocal opponents to the project proposal.

Several collectors and regional museums have purchased *machi* produced by the first class, providing the women with some economic returns on their work and an additional incentive to continue producing *machi*. Limol has been exploring other marketing possibilities, including Internet auctions and sales and a Web site for the *machi* revival project. In so doing, it has been necessary for him to strike a sensitive balance between the Fais chief's injunction against the sale of *machi* and the need to make the project self-sustaining and economically attractive.

In past generations, the Fais *machi* served as a chiefly tribute payment, a traditional gift to outsiders, and a visual symbol of the internal order of the island society. Today the islanders continue to employ the *machi* at the interface between the island and the outside world. Efforts to preserve and revitalize the *machi* in the face of culture change and globalization reveal a new internal social dynamics of this changing island society—in the conflicting interests of men and women, youth and elders. Once carried aboard outrigger canoes as an interisland offering, today the *machi* is offered on Internet auctions to a global collectorship. As Fais Islanders seek new ways to sustain their cultural heritage and identity while navigating a course in the modern world, the *machi* continues to occupy a unique place in this island culture.

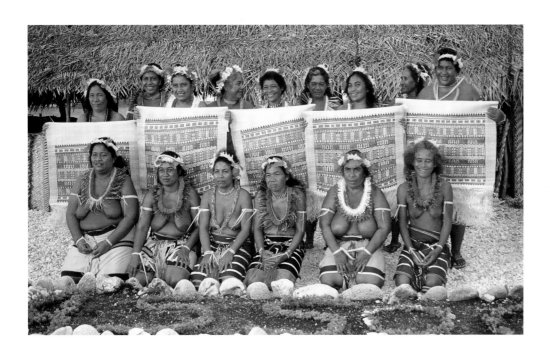

9.18 Following the graduation ceremony, instructors and apprentices proudly display the fully figured *machi* produced by the second class of apprentices.
Photograph by Donald H. Rubinstein, Fais Island, 2005.

Notes to the Text

Introduction (Milgram and Hamilton)

1. Following the industrialization of textile production, which began in Britain toward the end of the eighteenth century, imported, mass-produced textiles often undercut the price of local handwoven cloth. Studies from Sumatra (Nissan 1993) and India (Tarlo 1996, 22–61) document how patterns of dress changed in colonial societies in the late nineteenth and early twentieth centuries, particularly the selective adoption of items of Western apparel.

2. Parts of this section build on and expand insights in previously published material (Milgram 2003a; 2005b).

3. Government organizations involved with the early piña revival include: the Department of Trade and Industry, Philippine Textile and Research Institute; Fiber Industry Development Authority; National Agricultural and Fishery Council; and Aklan Agricultural College. The efforts of the Patrones de Casa Manila culminated in the establishment of the Piña Weaving Demonstration and Training Center in Balete, Aklan Province. In addition, small manufacturers gained financial support through increased access to credit as well as assistance with product development through the Department of Trade and Industry's workshops (see Milgram 2003a).

Chapter 1 (Hamilton)

1. Valerie Vantrese, January 1997, "Industrial Hemp: Global Markets and Prices" <http://www.industrialhemp.net/pdf/abs_hemp.pdf>.

2. In Japan this distinction between annual and woody plants is well developed, with a special term, *asa*, being applied only to annual bast fibers (especially ramie and hemp). Cort (1989) and Nagano and Hiroi (1999) provide discussion of these issues. Unfortunately, *asa* has been translated as "grass-bast," a term that is likely to be misleading in America where "grass" has a specific meaning. No bast fibers are taken from plants that are true grasses. To avoid this confusion, we use the terms "annual" and "woody" in this volume.

3. Botanists divide flowering plants into broad subclasses. Monocots are characterized by a single-leafed embryo and parallel-veined leaves. Dicots have two-leafed embryos and branching leaf veins. Most familiar plant families fall into the dicot subclass, but monocots include such diverse families as grasses, palms, lilies, agaves, gingers, and bananas.

4. See chapter 7 for local names. Nagano and Hiroi (1999, 81) also provide photographs and local names for four different plants, but no scientific names.

5. An African species, *Ensete ventricosum*, produces fiber for textiles (Cartledge 1999, 37).

6. See chapter 6 of this volume.

7. Another member of the family, the Himalayan giant nettle (*Girardinia diversifolia*) is used in Nepal (Dunsmore 1993, 59–65) and in neighboring regions in the eastern Himalaya.

8. Kudzu has been identified in the past as either *Pueraria thunbergiana* or *P. hirsute*, but currently these are properly regarded as synonyms of *Pueraria montana* var. *lobata* according to the United States Department of Agriculture <http://itis.usda.gov:8080/servlet/SingleRpt/SingpleRpt?search_topic=TSN&search_value=519768>.

9. See chapter 4 for illustrations of two types of splices used for hemp in Korea. See Nagano and Hiroi (1999) for detailed illustrations of many other splicing methods in use in various parts of Asia.

10. Knots can sometimes be detected through careful examination, whereas twists or splices are harder to detect. In some cases this can aid in fiber identification, for example, in distinguishing between banana fiber (which is knotted) and ramie (which is spliced) in Okinawa.

Chapter 2 (Trần)

This essay was largely written while the author was engaged in an internship at the Fowler Museum at UCLA, supported by a grant from the Asian Cultural Council, New York. The transcription of the Hmong terms in this essay follows that currently used by Hmong peoples in Vietnam. The author wishes to thank Roy W. Hamilton, the curator of Asian and Pacific collections at the Fowler for supervising the revision and editing of the original draft.

1. In China, the Miao include three subgroups: the Hmong, the Hmu, and the Kho Hsiung.

2. The Hmong live in the provinces of Cao Bằng, Hà Giang, Yên Bái, Lào Cai, Sơn La, Lai Châu, Thái Nguyên, Bắc Cạn, Hoà Bình, Thanh Hoá, and Nghệ An.

3. The Hmôngz Suar, or "Chinese Hmong," are said to show the most influence of Chinese culture. The Na Miảo differ sharply in language and customs from the other Hmong subgroups and might be more accurately considered another branch of the Miao (Ng 2001).

4. The term *lênhl*, for example, does not actually mean "flower," but rather indicates "a loud or coarse manner of speech." Nevertheless the English translation "Flower Hmong" and the Vietnamese language equivalent "Hmông Hoa" have become established in the ethnographic literature. The translations are linked to the use of multicolored patterns on the garments of this subgroup. Similarly, the term *siz* means "soft spoken" rather than "red," but the English translation Red Hmong and the Vietnamese language equivalent Hmông Đỏ are established.

5. The name Mù Cang Chải is a composite term that defines the boundaries of the district. It unites Mù Cang, the name of a mountain in the southern part of the district meaning "many dry trees," with Lao Chải, the name of the district's most northerly commune.

6. The census was carried out by the Mù Cang Chải District People's Committee.

7. I have not had samples of this plant identified by specialists, but it may be *Indigofera tinctoria*, the most common species of indigo in Asia, which has compound leaves made up of small leaflets.

8. This is the Vietnamese name used to refer to the majority lowland Vietnamese peoples.

Chapter 3 (Oley)

This essay is based on a research project documented in my thesis "Benuaq Textiles of East Kalimantan: The Impact of Cultural Tourism on Their Revival," which was submitted to the School of Fine Arts, Classical Studies and Archaeology at the University of Melbourne in June 2001 in partial fulfillment of the requirements for the Postgraduate Diploma in Art Curatorship and Museum Studies.

Among the many people I would like to thank for their help with my research project, I would particularly like to pay tribute to Ibu Sumiyati (1956–2006) and the other weavers and dyers of Tanjung Isuy. Ibu Sumiyati, to whom I am indebted for her generous and patient sharing of information, did so much to revive and to promote interest in Benuaq textiles. She was given two presidential awards for her contribution to the community—from President Suharto in 1993 and President Abdurrahman Wahid in 2000. I would like to dedicate this essay to her memory.

1. Weinstock notes that "The Luangan, previously referred to by the misnomer Lawangan, are one of the largest Dayak groups in Borneo" and estimates that the group numbered a quarter of a million people in the early 1980s (1983, iv).

2. Several Benuaq textiles have been attributed to the Bahau, another Dayak subgroup in the Mahakam region, further contributing to the obscurity of the Benuaq. Anthropologist Bernard Sellato confirms that even now "Bahau" is a common attribution given by antique dealers in Indonesia to artifacts from the Mahakam River region (personal communication, 2001).

3. "These myths, or *temputn*, have been passed down through the generations and have been retained in a form close to the language in daily use during the 19th century" (Hopes, Madrah, and Karaakng 1997, 1).

4. Museums holding textiles from the region include: the National Gallery of Australia (Canberra); the Museum Nusantara (Delft); the Tropenmuseum

(Amsterdam); the Wereldmuseum, formerly the Museum voor Land- en Volkenkunde (Rotterdam); the Victoria and Albert Museum (London); the Museum of Fine Arts, Boston; the Los Angeles County Museum of Arts; the University of Pennsylvania Museum of Archaeology and Anthropology (Philadelphia); and the Textile Museum (Washington, D.C.).

5. Gönner notes that the first permanent missionary came to Tanjung Isuy in 1978, more than seventy years after the Catholic Church had started a mission on the Upper Mahakam (2002, 76). An indigenous Dayak religion, Kaharingan was recognized by the Indonesian government as an official state religion in 1980 (Weinstock 1987, 73). This recognition extends to Central Kalimantan only, where there is a Dayak majority population, not to the other provinces of Kalimantan. Gönner notes "even if the expression *kaharingan* is not used in Lempunah [a Benuaq village near Tanjung Isuy], the major features of this religion, including secondary mortuary rites and shamanistic curing rituals, are found among all of the Barito-speaking Dayak groups of South-East Borneo" (2002, 47).

6. The Dayak use the blowpipe with poisonous arrows for hunting. In describing Luangan rituals and ritual objects, Weinstock mentions the use of cloth in the Balian Bawo curing ritual. Shamans beseech the curing spirits to descend a piece of cloth and long palm fronds hung from the rafters of the house and to accept the offerings laid out below (1987, 85).

7. Red signifies the *liau* and white the *kelelungan* spirits of the dead. The *liau* (or *liaaw*) is the spirit or emanation of the body or trunk of the dead person. It is generally considered "ugly" or "unclean." The *kelelungan* are spirits of the skulls or the heads. These are the "clean" ones, credited with sentience and the finer feelings (Hopes, Madrah, and Karaakng 1997, 187).

8. Massing describes "two baskets" covered with red and white cloth (1983, 92), but Michael Hopes confirms (personal communication, 2005) that these are rice containers made of bark (*pasoq* or *pasok*).

9. For example, Gittinger notes that "Among the Batak, all major gift exchange operates in a prescribed pattern between the lineages of wife and husband.... All gifts from the bride-givers or the maternal lineage are called *ulos*, the generic Batak term for hand-crafted textiles. Gifts from the husband's lineage, the bride-takers, are called *piso*, meaning knife or sword. To some degree this term is metaphorical, in that knives are rarely given, but rather goods considered to be masculine, for example money, buffalo, and pigs" (1990, 19).

10. Little is known about the function of a rare nineteenth-century Benuaq cloth (*tawit'ng doyo*) in the National Gallery of Australia's collection (see fig. 3.17 in this essay), though its structure and size suggest it was used as a ceremonial hanging (Maxwell 1990, 52).

11. Christian Gönner observed this ritual being performed twice in Tanjung Isuy on October 11, 1989, and on May 24, 1996 (personal communication, 2001).

12. Of note, the Saribas Iban use cloths with very powerful designs to cover a cross-generational incestuous pair (uncle with niece or aunt with nephew) to prevent the pestilence associated with this transgression from invading the land (Heppell 2005, 84).

13. Herman Diener, the project manager for the building of the Benakutai Hotel in Balikpapan and its initial manager, acting as a consultant to the provincial government together with a local travel agency, established river trips to Tanjung Isuy that included accommodation packages at the Benakutai Hotel (Diener, personal communication, 1997).

14. These included exhibitions during the 1980s and 1990s in Samarinda, Balikpapan, and Tenggarong in East Kalimantan and in the national capital, Jakarta, as well as international exhibitions in Paris, Berlin, and at Expo 1988 in Brisbane.

15. In the past the Benuaq had carved large wooden figures (*sepatukng*), which were placed in front of longhouses to protect the inhabitants. Herman Diener (see above, note 13), wishing to avert the complete loss of carving skills in the region, employed a Javanese carver on the payroll of the Benakutai Hotel who was engaged to live in Mancong for five months and to teach the local youths how to carve Benuaq motifs (Diener, personal communication, 1997).

16. The statistics for weavers given here are derived from local anecdotal evidence gathered from the weavers themselves and not from any formal census or survey.

17. The son of one weaver, however, is now a very productive weaver.

18. Exceptions include Dayak weaving groups in West Kalimantan who make warp-ikat skirts that they wrap around the waist.

19. According to Sellato "In Sarawak and East Kalimantan, tourism has helped maintain traditional hat, basket, and beadwork production and has even revived dying arts, like Benua' [Benuaq] weaving. However the quality of artefacts for sale is often inferior. Handicraft cooperatives have created new forms, using new techniques to satisfy tourist needs, and antique shops

are full of fake 'Dayak' carvings, basketry, and jewelry, some of which is manufactured outside Borneo" (1989, 24).

20. Natural sources of red and blue in many textile-producing regions of Indonesia are derived from *Morinda citrifolia* and indigo respectively. A natural source for blue is rarely used in East Kalimantan, although Bock noted that it was one of the favorite colors: "they also make their own vegetable dyes, the favorite colors being blue, red, and yellow" ([1881] 1991, 208). Blue dye may be obtained from the leaves of a *kebauw* tree, which are pounded and mixed with mud. *Kebauw* is a Benuaq term and no translation is available to date.

21. Details of these are beyond the scope of this discussion but are described in my thesis "Benuaq Textiles of East Kalimantan: the Impact of Cultural Tourism on Their Revival" (2001).

22. The one-page brochure was published by the Provincial Office of the Department of Industry, East Kalimantan, in 1992.

23. Bock describes the Dayak tradition of stretching the ears by using earrings of graded weights from an early age ([1881] 1991, 186). Bernard Sellato suggests that the former practice of the Benuaq may have differed from that of other Dayak groups (personal communication, 2001). He observed that "Old photos show that they [the Benuaq] wore wooden disks in their pierced lobes but not the heavy rings which produced very elongated earlobes."

Chapter 4 (Koh)

This essay was translated by Min Sun Hwang, Textile Conservator, Metropolitan Museum of Art, New York, who brought her own considerable research and knowledge of Korean hemp production to the effort and wrote the section of the essay on "Korean Hemp Technology." Korean names and terms have been transcribed for the most part using the McCune-Reischauer system. We would like to thank Dr. Robert Buswell, Professor of Chinese and Korean Buddhism, Department of Asian Languages and Cultures, UCLA, for his assistance in transcribing these terms—Eds.

1. Of note, the availability of new detergents and washing machines led to the abandonment of the traditional method of clothing care, which entailed taking apart the sleeves, front, back, ties, and other components of straight-cut clothing and then boiling, washing, starching, and resewing them.

2. Andong and Sunch'ang are names of specific areas in South Korea, and *kangp'o* is the shortened version of *kangwŏnp'o*.

3. *Pukp'o* was very fine hemp cloth produced in North Hamgyŏng Province, North Korea. Because *puk* means "north," every hemp fabric from North Korea was called *pukp'o* after Korea was divided in 1953.

4. Sŏng Wŏl-sun was interviewed by Bu-ja Koh in Muju on March 19, 2003.

5. This unit of measure is expressed in the form 1 *sae*, 2 *sae*, and so forth within the standard width of a bolt (usually between 35 and 37 centimeters). This unit of warp count was obviously originated by weavers based on their visual sense. The number of *sae* range up to 15. A number lower than 5 means the weave is very coarse, and higher than 8 means the cloth is very fine, requiring more time and skill and a good quality of fine hemp yarns. Presently, there are only a limited number of weavers who can weave 12 to 15 *sae* hemp fabric. A smaller measurement unit than *sae* is called *kuri*, *chosi*, or *mo*; 1 *kuri* includes 10 warp strands. Thus, the total warp count of a 4 *sae* 3 *kuri* hemp fabric is 350 warp strands from selvage to selvage in the standard bolt width of 35–37 centimeters.

6. The inside walls of the shuttle are grooved to prevent the cone of weft yarn from sliding forward as the yarn is delivered from inside one end of the cone. A bamboo strap is also clamped lengthwise across the top of the cone of weft yarn to hold it down.

7. The price is based on on-site research conducted at Chŏngsŏn in Kangwŏn Province in July 2004.

8. The length can be 1 or 2 *p'il*. *P'il* is a traditional Korean unit used to measure fabrics. One *p'il* is the standard quantity of fabric required to make an outer jacket that reaches below the knees. The quantity varies in the different areas. For example, 1 *p'il* is 20 *cha* in Posŏng and Muju; 30 *cha* in Kangnŭng, Ulchin, Andong, and Ch'ŏngdo; 28 to 33 *cha* in Tonghae; and 40 *cha* in Namhae. *Cha* is a traditional Korean unit used to measure the length of fabrics: 1 *cha* is 50, 55, or 60 centimeters depending on the region. For example, 1 *cha* is 50 centimeters in Seoul and Tonghae; 55 centimeters in Kangnŭng; and 60 centimeters in Posŏng.

9. *Chugŭm ot* and *hosang ot* may both be translated as "death clothing"; the latter is from a dialect used on Cheju Island. *Mŏnŭng ot* is from a dialect used in Kyŏngsang Province, and this term may be translated as "clothing for the long way to heaven."

10. The color red, for example, was restricted to the king and his family; yellow was banned to any Korean because it symbolized the Chinese emperor; and

jade green and white were worn only on an occasion of national mourning.

11. For a woman, this includes a *chŏgori* (blouse), a *ch'ima* (skirt), an inner blouse, an underskirt, several pairs of underpants, and an outer jacket. For a man, it includes a *chŏgori*, a *paji* (a pair of pants), a vest, and an outer jacket. The number of pieces varies according to the season.

12. 2,500,000–3,000,000 Korean *wŏn*.

13. Known as *Kajŏng ŭirye chunch'ik*, these standards, which were announced May 17, 1973, as Presidential Decree no. 6680, set forth new procedures for marriage ceremonies, funeral rites, memorial services, religious ceremonies, ceremonies for one's sixtieth birthday, etc. See Pak (1973).

Chapter 5 (Fraser-Lu and Thanegi)

1. Some of the legends pertaining to In-tha origin date back to the Pagan period (1044–1287 CE) and the reign of Alaung-sithu (r. 1112–1167). Known as Mani thesu in In-tha, this ruler was reputed to travel to the Shan states in a magic barge. Before embarking on his travels, he purportedly stopped off at Tavoy and took on a number of local craftsmen who remained behind to look after the sacred Phaung-daw Buddha images left by the king (Scott and Hardiman 1900, 1.1: 566). This story has also been told of Alaung-sithu's grandson Narapati-sithu (r. 1173–1210). A later story, which attests to the industriousness of the In-tha, relates that two brothers from Tavoy were invited to serve the prince (*saw-bwa*) of Nyaung-shwe in 1359. The ruler was so delighted with the hardworking pair that he had them invite some thirty-six more In-tha families to settle in the area. Present-day In-tha are thought to be descendants of these migrant families (Cummings and Wheeler 1996, 310).

 It has also been suggested that the In-tha freely migrated from Lower Burma in the eighteenth century to escape the endemic warfare amongst the Mon, Burmese, and Thai or that they were forcibly brought to the area as prisoners of war (Enriquez 1933, 16). A less-favorable theory suggests that the In-tha might have been convicts expelled from Tavoy in the seventeenth century.

2. The Five Precepts forbid the taking of life, stealing, lying, adultery, and the use of intoxicating liquor or drugs.

3. Traditionally, a monk was allowed to own only "eight requisites" (*parikkhara*): an alms bowl, three robes, a girdle, a razor, a needle, and a water strainer. Optional gifts include rosary beads, an umbrella, a palm-leaf fan, slippers, and a mat. Today, people also contribute some modern conveniences such as thermos flasks, electric fans, radios, and television sets.

4. These probably owe some vestigial influence to Mahayana Buddhism, which was prevalent prior to the Pagan period (1044–1287 CE). Interview with U Than Tun, Professor of History, Rangoon University, August 22, 2000.

5. Jasleen Dhamija (2000, 121) states that the Padmasali weavers of southern India claim that their progenitor, Bhavana Rishi, appears from the ashes of a great sacrifice holding a ball of yarn made from the stem of the lotus emerging from Visnu's navel. It was from this thread that the first cloth was woven, thus they are called Padmasalis, or "the lotus born."

6. The authors are indebted to Roy Hamilton for providing them with the Rajadhon reference.

7. In the Cowell edition of the *Jataka Stories* (1969, 5: 108–9, no. 527), Umma-danti owed her great beauty to having given a special scarlet robe to a monk in a previous existence. No mention is made of her being a weaver. In Burmese folklore one of the signs of a noble and beautiful woman was breath that smelled minty and fresh like the perfume of the dark pink *kya-nyo* lotus.

8. Many versions of the *Jinattha-pakasani* (The life story of the Buddha) exist. The most popular was written by Hsaya-daw, Kyee Thair Lay Htut (Abbot Kyee Thair of Lay Htut Monastery, Shwe-taung, near Prome), who lived from 1817 to 1894. Although this mythical account of the life of the Buddha does mention the finding of a complete set of monk's robes in a lotus flower, it probably should not be regarded as the historical basis for the advent of lotus fiber weaving in Burma. Weaving, although praised as "women's work," does not even receive mention in the "Ten Flower Arts," an official list of crafts in Burma. The list is confined largely to crafts practiced by men. There are few references to weaving as a religious activity in Burma. By contrast, there is much more in Burmese literature pertaining to weaving as an act of love. Weaving and spinning songs associated with love abound. Ma Mei U, the patroness of weaving in Burma, was weaving a sarong for her fiancé, Yin Maung, when the tiger devoured her.

9. Originally monks wore only *pansukula* robes, those sewn together from rags taken from a dust heap or from the cemetery. Robes given to monks today at a funeral in honor of the deceased are referred to as *pansukula* robes.

10. The association of the lotus with feminine beauty has also led to a few salacious connotations. In Burmese the saying "to loiter near the lotus" means a "come hither" look (Luzoe 1998, 37). In Chinese symbolism,

sexual references to the lotus are even more explicit. The red lotus blossom symbolizes female genitalia, and references to it may be associated with committing adultery, while the expression "flinging out the lotus" equates the lotus stem with male genitalia. Love may be symbolized by juxtaposing a lotus, suggesting a woman, with a fish, representing a man. The lotus seed head, like the fruit of the pomegranate, carries connotations of fertility. A courtesan was sometimes referred to as a "red lotus." To come across a "lotus with a double style" meant that one had met up with an old flame (Eberhardt 1986, 169).

11. Daw Ohn Kyi, our main informant, was emphatic that Daw Sa Oo invented lotus fiber weaving in Shan State. Her claim seems plausible in that to date there are no known eighteenth- or nineteenth-century references to lotus fiber weaving in Burmese, Shan, or English. Among colonial administrators, Sir George Scott, an avid and perceptive observer of local phenomena who spent much of his career in Shan State, makes no mention of lotus fiber fabric in his encyclopedic tome *Gazetteer of Upper Burma and the Shan States* (1900), although elements of weaving and textile production are described in great detail (see 2.1: 363–99). He also briefly lists numerous villages and their main economic activities. Kyaing-kan is not mentioned.

12. In addition to providing yarn (the least-known of its uses), the lotus is employed in a variety of ways. The rhizome, which may be eaten, is an excellent source of starch. The seeds, also edible, may be roasted, boiled, or eaten raw. On drying, they may be pulverized, and when mixed with sugar, the ground seeds make an excellent paste for desserts. The dried yellow stamens of the flower may be used for medicinal purposes, as an astringent, and as a cosmetic. The leaves when dried are used by food vendors to wrap up their goods for customers to carry home (Williams 1932, 256). Children like to play games with the seedpods, which may also be cut into segments for a child's necklace (Luzoe 1998, 37).

13. A *kyat* is the basic unit of Burmese currency. In 1999–2000 US$1 was approximately equal to 400 *kyat*. By 2002–2004 the rate had jumped to approximately US$1 to 800 *kyat*. The exchange rate in 2005 was around US$1 to 1,000 *kyat*. This floating exchange rate is determined by outside markets and differs from the official government rate, which is pegged much lower. A *viss* is an Indian unit of weight approximately equal to 3.6 lbs. or 1600 grams.

14. Burmese Buddhist monks' robes are rectangular and are composed of five columns demarcated by 8-centimeter-wide strips of cloth. The columns are composed of a larger rectangular and smaller square strips of fabric similarly joined. The square and rectangular components are alternately aligned to create an overall brickwork effect. In Burma the column at the center is usually a little wider than the side columns of cloth. The robe is reinforced by an extra strip of cloth around the perimeter. This arrangement of "patches" is very similar to that worn by Buddhist monks in Thailand (Gittinger and Lefferts 1992, 98). The *kesa* robes of Japanese Buddhist monks vary in the number of columns and in the number of patches per column (Lyman 1988, 45; Kennedy 1990, 123).

15. The "Abhidhamma" is the third section of the Pali *Tipitaka*, which is a collection of systematically arranged doctrines representing the essence of the Buddha's teaching. The Tavatimsa is the second of the six heavenly realms of the Buddhist universe.

Chapter 6 (Stinchecum)

1. Catling and Grayson provide a technical description of the leaf structure of Philippine abaca (Manila hemp)—another species of banana from which fiber for cloth is taken—that is generally applicable to the genus *Musa* (1982, 58–64). A discussion of the botanical identification and possible sources for the fiber-banana tree is beyond the scope of this essay. For a detailed survey of the genus *Musa*, see the Web site of David Constantine: <http://www.users.globalnet.co.uk/~drc/genusmusa.htm#ethnobotany> (2004).

2. More than eight hundred of his photographs have been preserved in the archives of the University Museum of the University of Tokyo (Tokyo Daigaku Sōgō Kenkyū Hakubutsukan) and can be viewed on the museum's Web site: <http://www.um.u-tokyo.ac.jp/>.

3. For a brief overview of cloth production under the poll tax system, see Ono (2003). An extended study of this extremely important topic awaits the attention of scholars. In commemoration of the abolition of the poll tax in 1903, numerous studies of the poll tax system in Ryukyu have appeared recently (for example, Okinawa Kokusai Daigaku Nantō Bunka Kenkyūjo 2003; Yaeyama Nintōzei Haishi 2003).

4. Sasamori Gisuke (1845–1915) was a former local government official from Aomori Prefecture in northern Honshu who traveled on his own through the Ryukyu Islands in the late nineteenth century to see for himself how the people of Japan lived. His moving narrative of his observations, *Nantō*

tanken (Sasamori [1894] 1982), remains one of the most important secondary sources for the study of Okinawa in the modern period.

5. Louise Allison Cort notes the role of the Folk Craft Movement in the acknowledgment of *bashōfu* by the Japanese government and its connection with Okinawan identity (1989, 397). Her groundbreaking essay on *bashōfu* and two other Japanese textiles made from long vegetable fibers demonstrated to me the potential of textile studies in terms of broad social and cultural meanings. In her important critique, *Japanese Modernisation and Mingei Theory: Cultural Nationalism and Oriental Orientalism* (2004), Yuko Kikuchi places the Mingei Movement squarely within the context of the utopian, socialist ideas of Ruskin, Morris, and Tolstoy—particularly those relating to "peasant art"—and the expression of those ideas in other Japanese utopian, "folk art" or "peasant art" theory, production, and communities in the first quarter of the twentieth century. Lisbeth K. Brandt's study of the Mingei Movement, based on her dissertation, is forthcoming from Duke University Press (Brandt 2007).

6. The terms, "Mingei," *"mingei,"* and "Folk Craft," below, refer specifically to Yanagi's ideas, movement, the people belonging to that movement, and institutions established in its name.

7. I am grateful to Gregory J. Smits for drawing my attention to Yanagi's statement and Yakabi's article (personal communication, May 2, 2005).

8. In his 1997 reevaluation of the Mingei Movement's influence in pottery production, Brian Moeran also comes to the conclusion that Yanagi has imposed European stereotypes on Japan (223–26), but he places more emphasis on European Orientalism and seems to use the term without irony in applying it to Japanese values.

9. Gerald Figal goes further in translating the term, rendering it "southern island" (forthcoming, 9), although this is the literal translation of another Japanese term, *nantō*, that came to be used as a proper noun denoting the Ryukyu Islands. Figal demonstrates the origin of Okinawan tourism in tours of World War II battlegrounds, conjoined with the "southern island" image and augmented in the 1990s with the revival of Ryukyu Kingdom history and monuments. The expression, "Southern Islands" (in Japanese, Nantō), appeared as early as 1894 in the title of Sasamori Gisuke's extraordinary account of his travels through the archipelago (Sasamori [1894] 1982) and appeared often thereafter in academic titles to denote all the islands of the Ryukyu Archipelago. Yanagi (and Figal) must have been familiar with a number of these works.

 The origins of the term, *nangoku,* and of the concept of the Ryukyus as both the repository of ancient Japanese culture and at the same time an exotic southern island country must be sought in the works of earlier ethnologists, including Yanagida Kunio (1875–1962), who visited Okinawa in 1921. This inquiry must await future study.

10. A new volume of essays includes extended discussions of the idea of "*nangoku*" in relation to colonial Taiwan (Yuko, ed. 2007).

11. I am indebted to Lisbeth K. Brandt for bringing to her readers' attention significant letters, including this one (Brandt 1996, 271, n. 2), written by Yanagi and other members of the Folk Craft Movement, in her dissertation on the role of the Folk Craft Movement in Japan's quest for national identity and modernization. Since my research has been confined to textiles, I cannot comment on the availability of documentation for other types of objects, but I suspect that textiles are not the exception.

12. Although these surges require further analysis for a complete understanding of their significance, additional data from 1923 are provocative: of the 81,012 rolls of *bashōfu* produced in Okinawa that year, 77,359 rolls were made for personal use and only 3,653 for other uses (Okinawa-ken Chiji Kanbō 1928, 181), i.e., for sale. And of the latter, only 251 rolls were exported from Naha (Okinawa-ken Chiji Kanbō 1928, 206–7), presumably for sale in mainland Japan. The fluctuations in production figures, therefore, seem to have little relation to market demands in Japan or efforts to establish a viable textile industry in the new prefecture.

 One roll (1 *tan*) of cloth—the traditional Japanese measure of cloth woven for clothing—is the amount needed for one kimono, approximately 40 centimeters in width and 10 to 12 meters in length. The measurements varied with historical period and also according to the material.

13. For a brief account of the language dispute (*hōgen ronsō*) and its background, see Smits (forthcoming, 10–18); see also Brandt (1996, 283–92). There are five distinct languages spoken in the Ryukyu Archipelago. They are related to Japanese through a common root.

14. I have not determined whether or not Korean artifacts in the Japan Folk Craft Museum and other collections met a similar fate. I have conducted research at the Nihon Mingeikan in Tokyo on numerous occasions and always received the full cooperation of the museum staff.

15. From my observation a shy and modest woman, Taira has always stressed the cooperative nature of *bashōfu* production and has never claimed this distinction for herself.

16. Ōhara was particularly knowledgeable about Okinawan culture and sympathetic to the young women who had come to work for him, according to Taira.

17. Tonomura would also instigate the development of the commercial production of a warp-ikat indigo-dyed cotton sash called *minsa*. Made only in Yaeyama, the southernmost island group in Okinawa, the sash and its motif have become a regional symbol (Stinchecum 2002).

18. Personal communication, March 2, 2005.

Chapter 7 (Milgram)
Field research for this chapter has been conducted over several periods from 1995 to 2005. Financial support for this research was provided by the Canada/ ASEAN Centre, Academic Support Program (1994–1995), by the Social Sciences and Humanities Research Council of Canada (SSHRC), Doctoral Fellowship (1992–1996), Post-Doctoral Fellowship (1997–1999), and Standard Research Grants (2000–2003; 2004–2007), and by the Ontario College of Art & Design Faculty Research Grants (2003–2005). In the Philippines, I am affiliated with the Cordillera Studies Center (CSC), University of the Philippines Baguio, Baguio City. I thank my colleagues at CSC for their generous support of my research. I also wish to thank Roy W. Hamilton for his thoughtful comments on this chapter and for his invitation to participate in this book project. To the residents of Banaue, Ifugao, I owe a debt of gratitude. All translations appearing in this essay have been made by the author in consultation with the respondants.

1. In the past, bast fiber textiles were also widely produced in the neighboring Banaue village of Batad. At the time of my research, however, only one woman continued to engage in this practice, and she tended to weave only when tourists visited the village to view Batad's renowned terraced mountain landscape. Cambulo and Pula are the villages in which weavers are most actively initiating the current revival of bast fiber textile production.

2. Some studies use technology to analyze the gendered aspect of cloth production. Where men engage in weaving, they tend to use upright or floor looms, while women use back-strap or body-tension looms (see Milgram 1999). In much of West African weaving, on the other hand, men predominate in the practice of narrow-strip weaving used for clothing and blankets, and in many cases, men tend to weave in so-called "public" rather than household-based practice when cloth production is geared for commercial sale rather than for domestic use (see Gilfoy 1987).

3. Throughout the 1990s, I conducted research on the Philippine textile collections of these major United States museums. I analyzed a wide selection of both cotton and bast fiber textiles from the Cordillera provinces of northern Luzon (Milgram 1999).

4. Unfortunately, no scientific identifications of these plants are available (see chapter 1 regarding the genus *Broussonetia*). The local names for cultivated bast fiber plants vary among villages within Banaue and within Ifugao generally, as residents of different villages speak their own specific local dialect of Ifugao. Thus, the same type of plant or tree may be known by a different name in different villages. Leonard Newell's comprehensive and ethnographically annotated *Batad Ifugao Dictionary* clearly illustrates this point. Newell defines the word *agut* as "the thin outer skin of the following plants and trees [used in weaving]: *bate'el, damuy, gutgutu, hu'a, laphi, lungi palengwah,*" and later in his definition, he additionally notes the names of other bast fibers, *gudah* and *alinaw* (1993, 111). Newell's documentation also establishes weavers' skills in this type of cloth production as he identifies the key terms used in the multistage preparation of bast fibers as well as the terms for the parts of the loom (1993, appendix 27: 583–85).

5. The sequence of steps that I observed artisans follow to process bast fibers in Cambulo, for example, is similar to that documented by Newell's terminology for this practice in Batad (see note 4, above).

6. All names used for individuals are pseudonyms.

7. Yellow ginger, or "*unig*," also known by the common name "*luyang dilaw,*" grows widely throughout the Philippines. It is part of the Zingiberaceae family of plants. The yellow dye is obtained from the roots of the plant (Katutubong Kulay Project 1998, 97).

Chapter 8 (Rinne)
1. A detailed description and technical analysis of the production processes of thirteen different Japanese bast fiber textiles can be found in Nagano and Hiroi (1999).

2. Bast fiber textiles fall into a category of kimono considered appropriate

primarily during July and August, at the height of the summer heat. This category includes any kind of *jōfu* (fine woven ramie), *chijimi* (ramie crepe), *bashōfu* (woven banana fiber), or other fine bast fiber textiles, as well as silk complex gauze (*ro*) and more recently developed sheer silk textiles, which serve as less-expensive and easier-care alternatives to *asa* (e.g., Natsu Shiozawa, a silk crepe made in the same region as Echigo *jōfu*).

3. A sensitive study of the plight of Nishijin weavers can be found in Hareven (2002).

4. This is a personal communication of March 2005 from Yamamoto Tomomi, a graduate of the final class. Yamamoto is the youngest daughter of the owners of a weaving company in Muikamachi, the president of which also learned the fundamentals of his craft at this school. Unlike many of her classmates, Yamamoto was guaranteed a job in the local textile industry by virtue of her family's business.

5. An excellent overview in English of the history and production processes of the handmade ramie textiles made in this region—formerly known collectively as Echigo *chijimi* and today called Echigo *jōfu* and Ojiya *chijimi*—can be found in Takeda (1996, 38–47).

6. *Izaribata* may be literally translated as "loom that is sat in." Due to the connotations of the term *izari* with being handicapped (i.e., not being able to use one's legs), however, the newer and more politically correct name for this loom is *jibata*, or "ground loom."

7. The loom used in Niigata rests low to the ground and has a frame to support the warp beam and the single harness with its string heddles, suspended from a rotating castle. To change the shed, the weaver bends one leg, pulling on a rope looped around her foot. This pulls down an arched beam extending perpendicularly from the back of the castle, thereby rotating the castle back and the harness up to open the counter-shed. What is especially unusual about this loom is its lack of a rigid beater. Instead of being attached to the loom—either suspended from above or extending from below—the reed is inserted into a rectangular frame that is attached to the loom only by means of the warp threads passing through the dents in the reed. The use of this frame, which is free to move horizontally and vertically, requires a high degree of skill if the weaver is to maintain an even weft line, but it allows for maximum control of tension. The weft thread is wound on small bamboo spools and inserted into a small chamber in the upper face of a sword-shaped shuttle, which also serves as a beater.

8. In November 2004 and October 2005, the former towns of Muikamachi, Yamato, and Shiozawa were conglomerated into the newly created Minamiuonuma City as part of a nationwide attempt to streamline local government administration. With this change, the geographic names Muikamachi and Shiozawa were lost. For the purposes of this article, however, I will use the older place names, which have long defined the textile industries of the area.

9. For example, Echigo Province supplied ramie cloth to Ishiyama Temple in 762. See the chronology in Shishi Hensan Iinkai, ed. (1990). For a list of the tax cloth in the Shōsō-in, see Shōsōin Jimusho, ed. (1987–1989).

10. Muikamachi, for example, means "Town of the Sixth Day," and next to it is Itsukamachi, or "Town of the Fifth Day." The names are indicative of the days of the month that each community hosted a market.

11. Five textiles (three of them bast fiber textiles) have been registered as Important Intangible Cultural Properties: Ojiya *chijimi*/Echigo *jōfu* (Ojiya ramie crepe/Echigo fine ramie cloth, designated in 1955, Niigata Prefecture), Yūki *tsumugi* (Yūki spun silk cloth, designated in 1956, Ibaraki Prefecture), Kurume *gasuri* (Kurume ikat, designated in 1957, Fukuoka Prefecture), Kijoka *no bashōfu* (Kijoka banana fiber cloth, designated in 1974, Okinawa Prefecture), and Miyako *jōfu* (Miyakojima fine ramie cloth, designated in 1978, Okinawa Prefecture). Of these, all but Kurume *gasuri* require the use of hand-spliced or hand-spun yarns in both the warp and the weft.

12. The term "Living National Treasure" is a popular name for the official title, "Holder of an Important Intangible Cultural Property." The Living National Treasure designation and the Important Intangible Cultural Property designation are managed by the same department within the Agency for Cultural Affairs.

13. As of 2006, this guild comprised six weaving companies: Honda Textiles, Hayashi Textiles, and Ogawa Textiles from Muikamachi and Hoshino Textiles, Nakadaya Textiles, and Kuwabara Textiles in Shiozawa.

14. In 1993, through the auspices of the Agency for Cultural Affairs, Kyoto City University of Arts, the Echigo *Jōfu*/Ojiya *Chijimi* Technological Preservation Guild, and Honda Textiles, I was fortunate to be allowed to participate in this course as a special auditor for a single year. The course was taught by veteran weaver Arakawa Setsuko and comprised six students, including me.

15. The aforementioned professional training school in Tōkamachi, which closed in 2005, did teach its students the fundamentals of *kasuri* binding; however, the emphasis of this school was on silk textile production instead of ramie, and only rudimentary *kasuri* skills could be taught amidst the many other requirements of its curriculum.

16. For a detailed overview of the thread-making and weaving processes for Hansan *mosi*, see Nagano and Hiroi (1999, 70–73, 240–44).

17. As part of a nationwide administrative centralization movement, Tsukigase-mura officially became part of Nara City on April 1, 2005, and the word *mura* (village) was dropped from the name. For the purposes of this article, however, Tsukigase will continue to be referred to as a village.

18. The information in this section relies heavily on my unpublished annotated translation of a monograph (Tsukigase-mura Kyōiku Iinkai, ed., 1994) included in my A.B. thesis, "Nara *Sarashi*: A Traditional Japanese Hemp Textile," in East Asian Studies at Brown University, April 1992. The primary authors of this monograph are Shikatani Isao and Inaba Osateru, though it was published under the auspices of the Tsukigase Village Board of Education. I lived in Tsukigase for six months in 1991, weaving daily at the Nakagawa Textile Factory under the instruction of senior weaver Oimoto Hisae.

19. According to *Bankin sugiwai bukuro* of 1732, however, the village was also producing striped and even a few *kasuri*-patterned *asa* textiles during the early eighteenth century. Quoted in Tsukigase-mura Kyōiku Iinkai, ed. (1994, 13).

20. There is some uncertainty as to whether hemp or ramie has been the primary material for Nara *sarashi* through the various stages of its history, as it seems that both have been used interchangeably in the past. Today, the cloth in Tsukigase is woven exclusively of ramie, and for the purposes of this section, the terms ramie and *asa*—a broad term that comprises both hemp and ramie—will be employed loosely. Nagano and Hiroi note that, except for a short period during the war, the weavers in Tsukigase were not involved in the cultivation of fibers and received all the thread they needed for a bolt from a thread supplier. Some distributors might provide thicker hemp thread for *chakin* (small segments of handwoven cloth used to wipe out tea bowls in the Tea Ceremony), while other distributors would provide thinner ramie thread to be used for kimono bolts, but the weavers themselves were able to work with both fibers. See Nagano and Hiroi (1999, 194).

21. There have been numerous small and large exhibitions featuring Nara *sarashi*, including a special exhibition in 2000 held at the Nara Prefectural Ethnographic Museum (Nara Kenritsu Minzoku Hakubutsukan), *Nara Sarashi: The Cloth That Supported the Capital in the Edo Period*.

22. Okuda Namie, first chair of the Preservation Society, who was raised in the neighboring village of Yamazoe, Yamabe-gun, recalled her surprise in early married life that unlike the men in her nearby home village, Tsukigase husbands actually helped with child care. She credited this fact to the high value placed on weaving output, a goal that could only be achieved by the women in a family (personal correspondence, June 1991).

23. Katherine Uno finds that the "origins of the intensive style of mothering characteristic of the post-war urban middle class can be traced to the early twentieth century." She suggests that in pre-modern, rural Japanese society, men were significantly more involved in child rearing, housework, and other "woman's work" (Uno 1991, 17–40).

24. In the beginning, these leaders of the Preservation Society participated in the course as students in order to learn the necessary skills to pass on.

25. Thread makers were more likely to live in the remote and mountainous hamlets of the village, such as Momogano, Dake, and Tsukise, which were less prosperous due to their inability to cultivate rice. In contrast, women from the flatter and more affluent hamlets of Oyama, Nagahiki, and Ishiuchi were more likely to be weavers.

26. When I worked for the Nakagawa Textile Company for six months in 1991, I was informed that the bolts of cloth that I wove would be used for *chakin*, as would cloth woven by other weavers in the same workshop.

27. For more on the symbolism of rough and smooth, see Cort (1989).

28. I was a member of the Wisteria Weaving Training Course in 1993 and continued to attend sessions for several years after.

Chapter 9 (Rubinstein and Limol)

1. In recent decades weavers have increasingly made use of imported cotton and polyester thread in a variety of colors. While taking advantage of the wide palette of available colors, they have nonetheless retained the visual pattern of alternating light and dark warp bands.

2. In other ranked Micronesian island societies, textiles function similarly as public symbols of chiefly power and status. "In the highly ranked society of Pohnpei, the use of certain kinds of woven sashes, plaited belts,

and dyed grass skirts was the special prerogative of the nobility, and a commoner could be put to death, in earlier times, for putting on a chief's belt" (Rubinstein 1986b, 59). Likewise in the Marshall Islands "there are chiefly mats with designs that could only be worn by chiefs as well as chiefly fiber skirts different from the ones that commoners could wear" (personal communication, Carmen Petrosian-Husa, May 20, 2005).

3. Customarily on Fais, a young couple upon marriage settles on the husband's estate, although individuals inherit land from and retain rights with respect to both their mother's and father's side of the family (Rubinstein 1979).

4. How the Yapese chiefs who received *machi* as tribute actually used these textiles is uncertain today. They may have worn the *machi* as loincloths on special occasions, according to some elderly Fais informants, although for a Fais man to wear a *machi* in that fashion would be a serious breach of respect for the chiefs. The only time that Rubinstein or Limol has seen a Yapese man attired in a *machi* loincloth was at the Yap Day celebrations in 2001, when the Yapese Jesuit priest who delivered the opening invocation from the V.I.P. stand wore a *machi* as his outer loincloth. Whether this was an "invented tradition" in keeping with the emphasis on cultural preservation in the recently established Yap Day celebrations (see Aoyama 2001; Hobsbawm and Ranger 1983), or whether the wearing of *machi* loincloth has more ancient antecedents, is not certain.

5. As Rubinstein (1992, 8) has noted, "The sacred *machi* of Fais may be part of an archaic Micronesian tradition of ritual textiles that formerly were more widespread in the Western and Central Caroline Islands, and were used in ceremonies relating to chiefs and in agricultural rites such as blessings over the breadfruit harvest." The *machi* also functioned in the initiation ceremonies (*pwo*) for master navigators in the Yap Outer Islands; we thank Eric Metzgar (personal communication, August 3, 2005) for that information.

6. The chant was translated by Rubinstein. Soolal and Yalulap are the two major deities, of the underworld and the heavens.

7. The recently deceased chief and his predecessors would be named here.

8. Reportedly, Ulithian weavers' knowledge of *machi* design motifs was imperfect. A Fais master weaver pointed out to Rubinstein in 1975 that the important motif representing human figures (see fig. 9.7) is produced incorrectly by Ulithian weavers, through an apparent figure-ground reversal.

The Ulithian women treat the small ecru triangles as figure, and all the triangles within one row point in the same direction. The Fais women treat the ecru triangles as ground, and the alternating direction of the triangles produces the pattern of human figures in the red supplementary weft. The human figures alternate head-up and head-down.

9. The abandonment of the custom of menstrual houses can be dated to 1987, when a violent typhoon hit Fais, wrecking most of the living houses and destroying the three large, communal menstrual houses, which were situated near the beach and hence more vulnerable to wind and wave damage. In past decades, other great storms had wrecked the menstrual houses, but the community always rebuilt them. After the 1987 typhoon a number of factors contributed to the community's postponement and eventual abandonment of plans to rebuild the menstrual houses. Many young men were away from the island for school or work, and the necessary labor force for large-scale rebuilding efforts was depleted. Also, the islanders were relying increasingly on U.S. federal disaster assistance programs for post-typhoon rebuilding, but these programs gave priority to rebuilding private homes rather than community structures. Additionally, a generation of Western education, Catholic missionization, and wage economy had undermined the cultural rationale for secluding women during their menstrual periods and had attenuated suprafamilial authority and village-wide social exchanges of food and labor, which were vital to the village men's house and menstrual house institutions. Typhoons can be powerful catalysts for social change in the Yap Outer Islands, as Lessa pointed out more than twenty-five years earlier for Ulithi Atoll, Fais Island's closest neighbor (1964).

10. This quotation from Teres Peyelifar, one of the *machi* instructors, is the English translation of her statement "*Si bwe yethimagiliy bwo yagili meke loechu wagai ngo ye the pungu tangiiri mele repiyache. Yiwe ngo giichi ngaliiriy*" (translation by Limol and Rubinstein).

11. This quotation from Meggy Yokulimar, one of the eldest *machi* instructors, is the English translation of her statement "*Yiwe sewo repii palingi iye chili mele irech. Machi iye ila ye hathabuthu ruwow: iye mele giichi ngo foloiulu faifele Fais*" (translation by Limol and Rubinstein). The key term *foloiulu* connotes "to give advice or instruction; to lecture or preach; to counsel someone" (Jackson and Marck 1991, 63).

References Cited

Aguilar, Filomeno V., and Virginia A. Miralao
1984 *Handicrafts, Development, and Dilemmas over Definition (The Philippines as a Case in Point)*. Handicraft Project Paper Series, no. 1. Manila: Ramon Magsaysay Award Foundation.
1985 *Igorot Handloom Weaving in the Philippines: A Case Study*. Handicraft Project Paper Series, no. 4. Manila: Ramon Magsaysay Award Foundation.

Alano, Ching M.
2000 "Beadtime Stories." *Philippine Star* (April 13): 39–42.

Alkire, William H.
1980 "Technical Knowledge and the Evolution of Political Systems in the Central and Western Caroline Islands of Micronesia." *Canadian Journal of Anthropology* 1, no. 2: 229–37.

Anderson, Benedict
1991 *Imagined Communities: Reflections on the Origin and Spread of Nationalism*. London: Verso.

Andrews, Henry C.
1797 *The Botanist's Repository, for New, and Rare Plants....* Vol. 8. London: Henry C. Andrews.

Aoyama, Toru
2001 "Yap Day: Cultural Politics in the State of Yap." *Occasional Papers* 34: 1–13. The Progress Report of the 1999 Survey of the Research Project "Social Homeostasis of Small Islands in an Island-Zone." Kagoshima University Research Center for the Pacific Islands.

Appadurai, Arjun
1986 "Introduction: Commodities and the Politics of Value." In *The Social Life of Things: Commodities in Cultural Perspective*, edited by Arjun Appadurai, 3–63. Cambridge: Cambridge University Press.
1996 *Modernity at Large: Cultural Dimensions of Globalization*. Minneapolis: University of Minnesota Press.
2000 "Grassroots Globalization and the Research Imagination." *Public Culture* (special issue on globalization, edited by Arjun Appadurai) 2, no. 1: 1–19.

Arasaratnam, S.
1996 "Weavers, Merchants and Company: The Handloom Industry in Southeastern India, 1750–90." In *Cloth and Commerce: Textiles in Colonial India*, edited by Tirthankar Roy, 85–114. New Delhi: Sage.

Babb, Florence E.
1989 *Between Field and Cooking Pot: The Political Economy of Marketwomen in Peru*. Austin: University of Texas Press.

Balisacan, Arsenio
1995 "Anatomy of Poverty during Adjustment: The Case of the Philippines." *Economic Development and Cultural Change* 44, no. 1: 33–62.

Barton, Roy Franklin
1919 "Ifugao Economics." *University of California Publications in American Archaeology and Ethnology* 15, no. 1: 385–446.
[1938] 1963 *Philippine Pagans: The Autobiographies of Three Ifugaos*. New York: University Books.
1946 *The Religion of the Ifugaos*. Memoir Series 65. Menasha, Wisc.: American Anthropological Association.

Becker, Howard S.
1982 *Art Worlds*. Berkeley: University of California Press.

Bernot, Lucien
1982 "The Two-Door House: The Intha Example from Burma." In *The House in Southeast Asia: Anthropological and Architectural Aspects*, edited by K. G. Izikowitz and P. Sorensen, 41–48. Scandinavian Institute of Asian Studies Monograph Series, no. 30. London: Curzon.

Beyer, H. Otley
1947 "Outline Review of Philippine Archaeology by Islands and Provinces." *Philippine Journal of Science* 77: 205–390.

Bhachu, Parminder
2004 *Dangerous Designs: Asian Women Fashion the Diaspora Economies*. New York: Routledge.

Blanco, Manuel
1877 *Flora de Filipinas*. Manila: Estab. Tip. De Plana y ca.

Bock, Carl
[1881] 1991 *The Head-Hunters of Borneo: A Narrative of Travel up the Mahakkam and down the Barito; also, Journeyings in Sumatra*. Singapore: Oxford University Press. (Orig. pub. London: Sampson Low, Marston, Searle and Rivington, 1881.)

Bolton, Lissant
1996 "Tahigogona's Sisters: Women, Mats and Landscapes on Ambae." In *Arts of Vanuatu*, edited by Joel Bonnemaison, 112–19. Bathurst, Australia: Crawford House.

Bosch, F. D. K.
1960 *The Golden Germ: An Introduction to Indian Symbolism*. The Hague: Mouton.

Boserup, Ester
1990 "Economic Change and the Roles of Women." In *Persistent Inequalities: Women and World Development*, edited by Irene Tinker, 14–24. New York: Oxford University Press.

Bourdieu, Pierre
1977 *Outline of a Theory of Practice*. Cambridge: Cambridge University Press.
1984 *Distinction: A Social Critique of Judgment of Taste*. Translated by Richard Nice. Cambridge, Mass.: Harvard University Press.

Bowden, Ross
2004 "A Critique of Alfred Gell on *Art and Agency*." *Oceania* 74, no. 4: 309–24.

Brandt, Lisbeth K.
1996 "The Folk-Craft Movement in Early Shōwa Japan, 1925–1945." Ph.D. diss., Columbia University.
2007 *Kingdom of Beauty: Mingei and the Politics of Folk Art in Imperial Japan*. Durham, N.C.: Duke University Press.

Brenner, Suzanne April
1998 *Women, Wealth and Modernity in Java*. Princeton, N.J.: Princeton University Press.

Broudy, Eric
1979 *The Book of Looms*. New York: Van Nostrand Reinhold

Bruner, Edward M., and Barbara Kirshenblatt-Gimblett
2005 "Maasai on the Lawn: Tourist Realism in East Africa." In Edward M.
 Bruner, *Culture on Tour: Ethnographies of Travel*. Chicago: University
 of Chicago Press.

Burkill, Isaac Henry
1935 *A Dictionary of the Economic Products of the Malay Peninsula*. London:
 Crown Agents for the Colonies.

Cartledge, Daniel M.
1999 "The Management of *Ensete Ventricosum* in the Gamo Highlands of
 Southwest Ethiopia." *Culture and Agriculture* 21, no. 1: 35–38.

Casino, Eric S.
1981 "Arts and Peoples of the Southern Philippines." In *The People and Art
 of the Philippines*, edited by Father Gabriel Casal and Regalado T. Jose
 Jr., 85–122. Los Angeles: Museum of Cultural History, University of
 California.

Catling, Dorothy, and John Grayson
1982 *Identification of Vegetable Fibers*. London: Chapman and Hall.

Causey, Andrew
1999 "The *Singasinga* Table Lamp and the Toba Batak Art of Conflation."
 Journal of American Folklore 112, no. 445: 424–36.
2003 *Hard Bargaining in Sumatra: Western Travelers and Toba Bataks in the
 Marketplace of Souvenirs*. Honolulu: University of Hawaii Press.

Chatterjee, Partha
1993 *The Nation and Its Fragments: Colonial and Postcolonial Histories*.
 Princeton, N.J.: Princeton University Press.

Chibnik, Michael
2003 *Crafting Tradition: The Making and Marketing of Oaxacan Wood
 Carvings*. Austin: University of Texas Press.

Chosŏn wangjo sillok
1392–1910 [The Annals of the Chosŏn Kingdom].

Christy, Alan S.
1993 "The Making of Imperial Subjects in Okinawa." *Positions* 1, no. 3:
 607–39.

Classen, Constance, and David Howes
1996 "Epilogue: The Dynamics and Ethics of Cross-Cultural Consumption."
 In *Cross-Cultural Consumption: Global Markets, Local Realities*, edited
 by David Howes, 178–94. London: Routledge.

Cohen, Erik
1988 "Authenticity and Commoditization in Tourism." *Annals of Tourism
 Research* 5: 371–86.

Conklin, Harold C.
1964–1978 Unpublished field notes. The Peabody Museum of Natural History,
 New Haven, Conn.
1967 "Some Aspects of Ethnographic Research in Ifugao." *New York
 Academy of Sciences, Transactions* 30.
1980 *Ethnographic Atlas of Ifugao: A Study of Environment, Culture, and Society
 in North Luzon*. New York: American Geographical Society of New York.

Cook, J. Gordon
1959 *Natural Fibers*. Vol. 1 of *Handbook of Textile Fibers*. Shildon, England:
 Merrow.

Cort, Louise Allison
1989 "The Changing Fortunes of Three Archaic Japanese Textiles." In
 Cloth and Human Experience, edited by Annette B. Weiner and Jane
 Schneider, 377–415. Washington, D.C.: Smithsonian Institution Press.

Cowell, E. B., ed.
1969 *The Jataka; or, Stories from the Buddha's Former Births*. 6 vols. Reprint.
 London: Luzac for the Pali Text Society.

Cummings, Joe, and Tony Wheeler
1996 *Myanmar (Burma)*. 6th ed. Australia: Lonely Planet Publications.

Curtis's Botanical Magazine
1818 *Curtis's Botanical Magazine* 45-4 [London].

Dahlan, H. M.
1990 "In What Way Can Culture Serve Tourism." *Borneo Review* 1, no. 1:
 129–48.

Davids, T. W. Rhys, and Hermann Oldenberg, translators
1885 *Vinaya Texts*. 3 vols. London: Clarendon.

Davis, Marian L.
1991 "Piña Fabric of the Philippines." *Arts of Asia* 21, no. 5: 125–29.

De Roy, Lt. Benjamin
1907–1914 Unpublished field notes. Archives, The Newark Museum,
 Newark, N.J.

Descantes, Christophe
1998 "Integrating Archaeology and Ethnohistory: The Development of
 Exchange between Yap and Ulithi, Western Caroline Islands." Ph.D.
 diss., University of Oregon.

Dhamija, Jasleen
2000 "Woven Incantations (Abstract of a Paper)." In *Approaching Textiles:
 Varying Viewpoints*, 121. Proceedings of the Textile Society of America
 Seventh Biennial Symposium. Earleville, Md.: Textile Society of
 America.

Dodge, Chas. Richards
1897 *A Descriptive Catalogue of Useful Fiber Plants of the World*. Washington,
 D.C.: Government Printing Office.

Dozier, Edward P.
1966 *Mountain Arbiters: The Changing Life of a Philippine Hill People*.
 Tucson: University of Arizona Press.

Dunsmore, Susi
1993 *Nepalese Textiles*. London: British Museum.

Eberhardt, Wolfram
1986 *A Dictionary of Chinese Symbols: Hidden Symbols in Chinese Life and
 Thought*. London: Routledge.

Edensor, Tim
2002 *National Identity, Popular Culture and Everyday Life*. Oxford: Berg.

Ellis, George R.
1981 "Arts and Peoples of the Northern Philippines." In *The People and Art
 of the Philippines*, edited by Father Gabriel Casal and Regalado T. Jose
 Jr., 183–263. Los Angeles: Museum of Cultural History, University of
 California.

Enriquez, C. M.
1933 *Races of Burma*. 2nd ed. Delhi: Manager of Publications, Government
 of India.

Errington, Shelly
1990 "Recasting Sex, Gender, and Power: A Theoretical and Regional
 Overview." In *Power and Difference: Gender in Island Southeast Asia*,
 edited by Jane Monnig Atkinson and Shelly Errington, 1–58. Stanford,
 Calif.: Stanford University Press.
1998 *The Death of Authentic Primitive Art and Other Tales of Progress*.
 Berkeley: University of California Press.

Featherstone, Mike
1991 *Consumer Culture and Postmodernism*. London: Sage.

Femenias, Blenda
2005 *Gender and the Boundaries of Dress in Contemporary Peru.* Austin: University of Texas Press.

Figal, Gerald
Forthcoming "Between War and Tropics: Heritage Tourism in Postwar Okinawa." *Public Historian.*

Fine, Ben, and Ellen Leopold
1993 *The World of Consumption.* London: Routledge.

Forshee, Jill
2001 *Between the Folds: Stories of Cloth, Lives, and Travels from Sumba.* Honolulu: University of Hawaii Press.

Fraser-Lu, Sylvia
1981 "Robes for the Buddha." *The Asia Magazine* (Dec. 20): 34–36.
1988 *Handwoven Textiles of South-East Asia.* Singapore: Oxford University Press.

Freeman, Carla
2001 "Is Local: Global as Feminine: Masculine? Rethinking the Gender of Globalization." *Signs: Journal of Women in Culture and Society* 26, no. 4: 1007–37.

Friedman, Jonathan
1994 *Cultural Identity and Global Process.* London: Sage.
1999 "The Hybridization of Roots and the Abhorrence of the Bush." In *Spaces of Culture: City, Nation, World,* edited by Mike Featherstone and Scott Lash, 230–56. London: Sage.

Fujita Mariko
1995 "Nuno no seisan to 'dentō' no sōshutsu: Nara sarashi hozon/denshō katsudō o meguru jendaa/sedai/chikara." *Hiroshima Daigaku Sōgō Kagakubu kiyō* 1, *Chiiki bunka kinkyū*: 139–67.

García Canclini, Néstor
1995 *Cultural Hybridity: Strategies for Entering and Leaving Modernity.* Minneapolis: University of Minnesota Press.

Gavin, Traude
1991 "Kayau Indu, the Warpath of Women." *Sarawak Museum Journal* 17, no. 63: 1–41.
1996 *The Women's Warpath: Iban Ritual Fabrics from Borneo.* Los Angeles: UCLA Fowler Museum of Cultural History.

Gell, Alfred
1998 *Art and Agency: An Anthropological Theory.* Oxford: Clarendon.

Gibson-Graham, J. K.
1997 *The End of Capitalism (As We Knew It): A Feminist Critique of Political Economy.* Malden, Mass.: Blackwell.

Gilfoy, Peggy Stoltz
1987 *Patterns of Life: West African Strip-Weaving Traditions.* Washington, D.C.: Museum of African Art, Smithsonian Institution.

Gittinger, Mattiebelle
1979 *Splendid Symbols: Textiles and Tradition in Indonesia.* Washington, D.C.: The Textile Museum.
1990 *Splendid Symbols: Textiles and Tradition in Indonesia.* Singapore: Oxford University Press.

Gittinger, Mattiebelle, and Leedom Lefferts
1992 *Textiles and the Tai Experience in Southeast Asia.* Washington, D.C.: The Textile Museum.

Gönner, Christian
2002 *A Forest Tribe of Borneo: Resource Use among the Dayak Benuaq.* Man and Forest Series, no. 3. New Delhi: D. K. Printworld.

Gordon, Beverly
1986 "The Souvenir: Messenger of the Extraordinary." *Journal of Popular Culture* 20, no. 3: 135–46.

Graebner, F. von
1909 "Völkerkunde der Santa-Cruz-Inseln." In *Ethnologica*, vol. 1, edited by W. Foy, 71–184. Leipzig: Karl W. Hiersemann.

Grimes, Kimberly M.
2005 "Changing the Rules of Trade with Global Partnerships: The Fair Trade Movement." In *Social Movements: An Anthropological Reader*, edited by June Nash, 237–48. Malden, Mass.: Blackwell Publishing.

Grimes, Kimberly M., and B. Lynne Milgram, eds.
2000 *Artisans and Cooperatives: Developing Alternative Trade for the Global Economy.* Tucson: University of Arizona Press.

Guss, David M.
1990 *To Weave and Sing: Art, Symbol, and Narrative in the South American Rain Forest.* Berkeley: University of California Press.

Guy, George Sy-Chuan
1958 "The Economic Life of the Mountain Tribes of Northern Luzon." *Journal of East Asiatic Studies* 7, no. 1: 1–88.

Hall, Stuart
1996 "Introduction: Who Needs Identity?" In *Questions of Cultural Identity*, edited by Stuart Hall and Paul du Gay, 1–17. London: Sage.

Hamilton, Roy W.
1990 "Local Textile Trading Systems in Indonesia: An Example from Flores Island." In *Textiles in Trade.* Proceedings of the of the Textile Society of America Biennial Symposium. Los Angeles: Textile Society of America.

Hamilton, Roy. W., ed.
1994 *Gift of the Cotton Maiden: Textiles of Flores and the Solor Islands.* Los Angeles: UCLA Fowler Museum of Cultural History.
1998 *From the Rainbow's Varied Hue: Textiles of the Southern Philippines.* Los Angeles: UCLA Fowler Museum of Cultural History.

Handler, Richard
1985 "On Having a Culture: Nationalism and the Preservation of Quebec's Patrimoine." In *Objects and Others: Essays on Museums and Material Culture*, edited by George W. Stocking Jr., 192–217. Madison: University of Wisconsin Press.
1986 "Authenticity," *Anthropology Today* 2, no. 1: 2–4.

Hannerz, Ulf
1990 "Cosmopolitans and Locals in World Culture." *Theory, Culture and Society* 7 (June): 237–51.

Hansen, Karen Tranberg
2000 *Salaula: The World of Secondhand Clothing and Zambia.* Chicago: University of Chicago Press.

Hareven, Tamara K.
2002 *The Silk Weavers of Kyoto: Family and Work in a Changing Traditional Industry.* Berkeley: University of California Press.

Hendrickson, Carol
1995 *Weaving Identities: Construction of Dress and Self in a Highland Guatemala Town.* Austin: University of Texas Press.
1996 "Selling Guatemala: Maya Export Products in U.S. Mail-Order Catalogues." In *Cross-Cultural Consumption: Global Markets, Local Realities*, edited by David Howes, 106–21. London: Routledge.

Heppell, Michael
2005 *Iban Art: Sexual Selection and Severed Heads.* Amsterdam: KIT Press.

Heyne, K.
1950 *De nuttige planten van Indonesie.* Vol 1. 3rd ed. Bandung, Indonesia: N. V. Uitgeverij W. van Hoeve.

Hiller, Susan, ed.
1991 *The Myth of Primitivism: Perspectives on Art*. London: Routledge.

Hobsbawm, Eric, and Terence Ranger, eds.
1983 *The Invention of Tradition*. Cambridge: Cambridge University Press.

Honko, Lauri
1995 "Traditions in the Construction of Cultural Identity and Strategies of Ethnic Survival." *European Review* 3, no. 2: 131–46.

Hopes, Michael, Madrah, and Karaakng
1997 *Temputn: Myths of the Benuaq and Tunjung Dayak*. Jakarta: Puspa Swara and Rio Tinto Foundation.

Hoskins, Janet
1989 "Why Do Ladies Sing the Blues? Indigo Dyeing, Cloth Production, and Gender Symbolism in Kodi." In *Cloth and Human Experience*, edited by Annette B. Weiner and Jane Schneider, 141–73. Washington, D.C.: Smithsonian Institution.

Howes, David
1996 "Introduction: Commodities and Cultural Borders." In *Cross-Cultural Consumption: Global Markets, Local Realities*, edited by David Howes, 1–18. London: Routledge.

Hunter-Anderson, Rosalind L., and Yigal Zan
1996 "Demystifying the *Sawei*: A Traditional Interisland Exchange System." *ISLA: A Journal of Micronesian Studies* 4, no. 1: 1–45.

Ikeya Machiko, Uchida Akiko, Takase Kyōko, eds.
2005 *Chōsen ōchō jitsuroko Ryuku shūsei*. 2 vols. Okinawa: Yōju Shorin.

Illo, Jeanne Frances
1995 "Redefining the *Maybahay* or Housewife: Reflections on the Nature of Women's Work in the Philippines." In *"Male" and "Female" in Developing Southeast Asia*, edited by Wazir Jahan Karim, 209–25. Oxford: Berg.

Illo, Jeanne Frances, and Jaime B. Polo
1990 *Fishers, Traders, Farmers, Wives: The Life Stories of Ten Women in a Fishing Village*. Quezon City: Institute of Philippine Culture, Ateneo de Manila University.

Inda, Jonathan Xavier, and Renato Rosaldo, eds.
2002 *The Anthropology of Globalization: A Reader*. Malden, Mass.: Blackwell.

Jackson, Frederick H., and Jeffrey C. Marck, comps.
1991 *Carolinian-English Dictionary*. PALI Language Texts: Micronesia. Honolulu: University of Hawaii Press.

James, Allison
1996 "Cooking the Books: Global or Local Identities in Contemporary British Food Cultures." In *Cross-Cultural Consumption: Global Markets, Local Realities*, edited by David Howes, 77–92. London: Routledge.

Jenks, Albert E.
1904 "Bontoc Igorot Clothing." *American Anthropologist* 6, no. 5: 695–705.
1905 *The Bontoc Igorot*. Manila: Bureau of Public Printing.

Jones, Carla, and Ann Marie Leshkowich
2003 "Introduction: The Globalization of Asian Dress: Re-Orienting Fashion or Re-Orientalizing Asia?" In *The Globalization of Asian Dress: Re-Orienting Fashion*, edited by Sandra Niessen, Ann Marie Leshkowich, and Carla Jones, 1–48. Oxford: Berg.

Kaeppler, Adrienne L.
1999 "*Kie Hingoa*: Mats of Power, Rank, Prestige and History." *Journal of the Polynesian Society* 108, no. 2: 168–232.

Kapchan, Deborah, and Pauline Turner Strong
1999 "Theorizing the Hybrid." *Journal of American Folklore* 112, no. 445: 239–53.

Karim, Wazir Jahan
1995 "Introduction: Genderising Anthropology in Southeast Asia." In *"Male" and "Female" in Developing Southeast Asia*, edited by Wazir Jahan Karim, 11–34. Oxford: Berg.

Katutubong Kulay Project
1998 *Katutubong Kulay: The Revival of Philippine Natural Dye*. Manila: Coca-Cola Foundation.

Kawabata, Yasunari
1996 *Snow Country*. Translated by Edward G. Seidensticker. New York: Vintage International.

Keesing, Felix
1962 *The Ethnohistory of Northern Luzon*. Stanford, Calif.: Stanford University Press.

Keesing, Felix M., and Marie Keesing
1934 *Taming Philippine Headhunters: A Study of Government and of Cultural Change in Northern Luzon*. London: George Allen and Unwin.

Kennedy, Alan
1990 *Japanese Costume: History and Tradition*. New York: Rizzoli.

Kijoka no Bashōfu Hozonkai
1984 *Kijoka no bashōfu*. Ōgimi-son, Okinawa: Kijoka no Bashōfu Hozonkai.

Kikuchi, Yuko
2004 *Japanese Modernisation and Mingei Theory: Cultural Nationalism and Oriental Orientalism*. London: RoutledgeCurzon.

Koguriyama mura shi hakkan iinkai, ed.
1998 *Koguriyama-shi*. Muikamachi, Niigata: Koguriyama-ku.

Koh, Bu-ja
1994 "Chejudo ŭisaenghwal ŭi minsokhakchŏk yŏn'gu" [Research on Cheju Island's traditional costumes]. Ph.D. diss., Seoul Women's University.
1999 "Kyŏngsangdo ŭi ŭisaenghwal" [Clothing of Kyŏngsang Province]. In *700 Years of Kyŏngsangdo*, no. 3. Kyŏngsangdo Ch'ilbaengnyŏnsa P'yŏnch'an Wiwŏnhoe.
2001 *Kyŏnggi pukpu ŭi ŭisaenghwal* [Clothing style in north Kyŏnggi Province]. Kyŏnggido: Kyŏnggido Pangmulgwan.
2004 "Research on Hemp Fabrics Produced at Boseong." *The Research Journal of Costume Culture* 12, no. 1: 168–81.

Kopytoff, Igor
1986 "The Cultural Biography of Things: Commoditization as Process." In *The Social Life of Things: Commodities in Cultural Perspective*, edited by Arjun Appadurai, 64–94. Cambridge: Cambridge University Press.

Krohn, William O.
[1927] 1991 *In Borneo Jungles: Among the Dyak Headhunters*. Singapore: Oxford University Press. (Orig. pub. New York: The Bobbs-Merrill Company).

Kuhn, Dieter
1988 "Textile Technology: Spinning and Reeling." Part 9 of *Chemistry and Chemical Technology*. Vol 5 of *Science and Civilisation in China*, edited by Joseph Needham. Cambridge: Cambridge University Press.

Kwŏn Tugyu and Cho Kyubok
2002 "Andongp'o ŭi yŏksa." In (*Andong Sambe yon'gu*), *Andong taehakkyo pangmulgwan ch'ongsŏ*, 4–17. Annals of the Andong University Museum. Andong: Andong University Museum.

Kyee Thair, Hsaya-daw (Abbot of Lay Htut Monastery, Shwe-daung)
1997 *Jinattha-pakasani*. 5th ed. Rangoon: Khin Cho Tun, Sarpay.

Kyūyō Kenkyūkai, ed.
1974a *Kyūyō* [comp. 1743–1876]: *Genbun hen*. Okinawa Bunka shiryō shūsei 5. Tokyo: Kadokawa Shoten.
1974b *Kyūyō: Yomikudashi hen*. Okinawa Bunka shiryō shūsei 5. Tokyo: Kadokawa Shoten.

Lambrecht, Frances

1932 "The Mayawyaw Ritual: Rice Culture and Rice Ritual." *Publications of the Catholic Anthropological Conference, Washington, D.C.* 4, no. 1: 1–167.

1958 "Ifugaw Weaving." *Folklore Studies (Society of the Divine World, Tokyo)* 17: 1–53.

Lemmens R. H. M. J., and N. Wulijarni-Soetjipto, eds.

1992 *Plant Resources of South-East Asia.* Bogor, Java: Prosea Foundation.

Lessa, William A.

1950 "Ulithi and the Outer Island World." *American Anthropologist* 52, no. 1: 27–52.

1964 "The Social Effects of Typhoon Ophelia (1960) on Ulithi." *Micronesica* 1, nos. 1 & 2: 1–47.

Littrell, Mary Ann, and Marsha Ann Dickson

1999 *Social Responsibility in the Global Market: Fair Trade of Cultural Products.* London: Sage.

Lockwood, Victoria S.

1993 *Tahitian Transformation: Gender and Capitalist Development in a Rural Society.* Boulder, Colo.: Lynne Rienner.

Löfgren, Orvar

1993 "Materializing the Nation in Sweden and America." *Ethnos* 58, nos. 3–4: 161–96.

Logan, J. R.

1848 "Preparation of Pineapple Fibers in Singapore for the Manufacture of Piña Cloth." *Journal of the Indian Archipelago and Eastern Asia* 2: 528.

Long, Norman

1992 "From Paradigm Lost to Paradigm Regained? The Case for an Actor-Oriented Sociology of Development." In *Battlefields of Knowledge: The Interlocking of Theory and Practice in Social Research and Development,* edited by Norman Long and Ann Long, 16–43. London: Routledge.

Lumholtz, Carl

[1920] 1991 *Through Central Borneo: An Account of Two Years' Travel in the Land of the Head-Hunters between the Years 1913 and 1917.* Singapore: Oxford University Press. (Orig. pub. New York: Charles Scribner's Sons).

Luzoe

1998 "Lotus Lotus Everywhere." *Myanmar Perspectives* 3, no. 4: 35.

Lyman, Marie

1988 "Distant Mountain: The Influence of Funzoe-e on the Tradition of Buddhist Clerical robes in Japan." In *Festival of Fibers: CWAJ Lecture Series 1988.* Tokyo: The College Women's Association of Japan.

Mashman, Valerie

1992 "Warriors and Weavers: A Study of Gender Relations among the Iban of Sarawak." In *Female and Male in Borneo: Contributions and Challenges to Gender Studies,* edited by Vinson H. Sutlive, 231–70. The Borneo Research Council Monograph Series, vol. 1. Williamsburg, Va.: Borneo Research Council, Inc.

Massing, A.

1983 "The Journey to Paradise: Funerary Rites of the Benuaq Dayak of East Kalimantan." *Tribus, Jahrbuch des Linden-Museums* 32: 85–105.

Mathews, J. Merritt

1913 *The Textile Fibers.* New York: John Wiley and Sons.

Maulana, A.

1982 *Tenun Tradisional: Suku Dayak Benuaq "Ulap Doyo."* Samarinda: Departemen Pendidikan dan Kebudayaan Direktorat Jendral Kebudayaan, Mularwarman Museum Negeri Propinsi Kalimantan Timur.

Maxwell, Robyn

1990 *Textiles of Southeast Asia: Tradition, Trade, and Transformation.* Melbourne: Oxford University Press.

McKean, Philip Frick

1989 "Towards a Theoretical Analysis of Tourism: Economic Dualism and Cultural Involution in Bali." In *Hosts and Guests: The Anthropology of Tourism,* edited by Valene Smith, 119–38. Philadelphia: University of Pennsylvania Press.

M'Closkey, Kathy

1998 "Weaving and Mothering: Reframing Navajo Weaving as Recursive Manifestations of K'e." In *Transgressing Borders: Critical Perspectives on Household, Gender, and Culture,* edited by Lynne Phillips and Suzan Ilcan, 169–88. Westport, Conn.: Bergin and Garvey.

Mies, Maria

1982 *The Lacemakers of Narsapur: Indian Housewives Produce for the World Market.* London: Zed Press.

Milgram, B. Lynne

1999 "Locating 'Tradition' in the Striped Textiles of Banaue, Ifugao." *Museum Anthropology* 23, no. 1: 3–20.

2000 "Organizing Production for Global Markets: Women and Craft Cooperatives in Ifugao, Upland Philippines." In *Artisans and Cooperatives: Developing Alternative Trade for the Global Economy,* edited by Kimberly M. Grimes and B. Lynne Milgram, 107–28. Tucson: University of Arizona Press.

2003a *Islands of Embellishment: Transforming Traditions in Philippine Textiles.* Toronto: Textile Museum of Canada.

2003b "Women, Modernity, and the Global Economy: Negotiating Gender and Economic Difference in Ifugao, Upland Philippines." In *Gender at Work in Economic Life,* edited by Gracia Clark, 95–113. Walnut Creek, Calif.: Altamira.

2005a "Fair(er) Trade for Global Markets: Capitalizing on Work Alternatives in Crafts in the Rural Philippines." In *Petty Capitalists and Globalization: Flexibility, Entrepreneurship, and Economic Development,* edited by Alan Smart and Josephine Smart, 227–51. Albany: SUNY Press.

2005b "Piña Cloth, Identity and the Project of Philippine Nationalism." *Asian Studies Review* 29, no. 3: 233–46.

Miller, Daniel, ed.

1995 *Acknowledging Consumption: A Review of New Studies.* London: Routledge.

Miralao, Virginia A.

1986 *Labor Conditions in Philippine Craft Industries.* Research and Working Papers. Manila: Ramon Magsaysay Award Foundation.

Moeran, Brian

1997 *Folk Art Potters of Japan: Beyond an Anthropology of Aesthetics.* Honolulu: University of Hawaii Press.

Monier-Williams, M.

1899 *A Sanskrit-English Dictionary.* London: Oxford University Press.

Montinola, Lourdes R.

1991 *Piña.* Manila: Amon Foundation.

Morioka, Michiyo, and William Jay Rathbun

1993 "Tsutsugaki and Katazome." In *Beyond the Tanabata Bridge: Traditional Japanese Textiles,* ed. by William Jay Rathbun, 129–68. Kyoto: Shikosha.

Mya, Maung

1914 "Notes and Reviews: Our Museum." *Journal of the Burma Research Society* 4, no. 3: 219–24.

Nagano Gorō and Hiroi Nobuko

1999 *Base to Tip: Bast-Fiber Weaving in Japan and Its Neighboring Countries* (*Orimono no genfūkei: Juhi to sōhi no nuno to hata*). Kyoto: Shikosha.

Nash, June

1988 "Implications of Technological Change for Household and Rural Development: Some Latin American Cases." In *Lucha: The Struggles of Latin American Women*, edited by Connie Weil, 37–71. Minneapolis, Minn.: Prisma Institute.

1993 "Introduction: Traditional Arts and Changing Markets in Middle America." In *Crafts in the World Market: The Impact of Global Exchange on Middle American Artisans*, edited by June Nash, 1–22. New York: State University of New York Press.

Nash, Manning

1963 *The Golden Road to Modernity: Village Life in Contemporary Burma.* Chicago: University of Chicago Press.

Newell, Leonard E., comp.

1993 *Batad Ifugao Dictionary with Ethnographic Notes.* Manila: Linguistic Society of the Philippines.

Ng Van Thang

2001 "Ambiguity of Ethnic Identity: The Case of Na Mieu in Vietnam." Ph.D. diss., University of Washington.

Nicks, Trudy

1999 "Indian Villages and Entertainments: Setting the Stage for Tourist Souvenir Sales." In *Unpacking Culture: Art Commodity in Colonial and Postcolonial Worlds*, edited by Ruth B. Phillips and Christopher B. Steiner, 301–15. Berkeley: University of California Press.

Nieuwenhuis, Anton Willem

[1900] 1994 *Di Pedalaman Borneo: Pejalanan dari Pontianak ke Samarinda 1894.* Translated by Theresia Slamet and P. G. Katoppo. Jakarta: PT Gramedia Pustaka Utama and Borneo Research Council. (Orig. pub. as *In Centraal Borneo*, Maatschappij ter Bervordering van het Natuurkundig Onderzoek der Nederlandsche Kolonien, Leiden: E. J. Brill).

1907 *Quer durch Borneo: Ergebnisse seiner reisen in den jahren 1891, 1896–97 und 1898–1900.* Vol 2. Leiden: Brill.

1914 "Die Veranlagung des Malaiischen Volker des Ost-Indische Archipels." *Internationales Archiv für Ethnographie*, 22.

Nishiwaki Shinjirō, ed.

1970 *Echigo no chijimi.* Ojiya: Ryōgensha.

Nissan, Sandra A.

1993 *Batak Cloth and Clothing: A Dynamic Indonesian Tradition.* Kuala Lumpur: Oxford University Press.

Noor, H. M., A. Djebar, Sukarni, and H. A. Darda

1990 *Pakaian Adat Tradisional Daerah Kalimantan Timur.* Samarinda: Departemen Pendidikan dan Kebudayaan.

O'Kelly, Hilary

1992 "Reconstructing Irishness: Dress in the Celtic Revival, 1880–1920." In *Chic Thrills: A Fashion Reader*, edited by Juliet Ash and Elizabeth Wilson, 75–83. London: Harper Collins.

Okinawa-ken Chiji Kanbō, ed.

1928 *Okinawa-ken tōkei sho: Taishō 15 shōwa gan* [1925]. Naha: Okinawa-ken.

Okinawa-ken Naimubu Daiikka, ed.

1900 *Okinawa-ken tōkei sho: Meiji 28–29* [1885–1896] Naha: Okinawa-ken.

Okinawa Kenritsu Toshokan Shiryō Henshūshitsu, ed.

1992 *Rekidai hōan: Kōtei bon.* Vol. 2. Naha: Okinawa-ken Kyōiku Iinkai.

Okinawa Kokusai Daigaku Nantō Bunka Kenkyūjo, ed.

2003 *Kinsei Ryūkyū no sozei seido to nintōzei.* Tokyo: Nihon Keizai Hyōronsha.

Oley, Elizabeth

2001 "Benuaq Textiles of East Kalimantan: The Impact of Cultural Tourism on Their Revival." Postgraduate Diploma in Art Curatorship and Museum Studies, University of Melbourne.

Ono Masako

2003 "Dentō shakai no naka no josei: Kōnō sareru nuno to joseitachi." In *Ryūkyū/Okinawa shi no sekai*, edited by Tomiyama Kazuyuki. Nihon no jidaishi 18. Tokyo: Yoshikawa Kōbunkan.

Ōshiro Shizuko and Uezu Toshio.

1989 "Okinawa no orimono." In *Okinawa bijutsu zenshū 3: Senshoku*, edited by Okinawa Bijutsu Zenshū Kankō Iinkai, 217–28. Naha: Okinawa Taimususha.

Pak Tongsil, ed.

1973 *Kajŏng ŭirye chŏnch'ik.* Seoul: Dongson.

Pastor-Roces, Marian

1991 *Sinaunang Habi: Philippine Ancestral Weave.* Manila: Nikki Coseteng Filipiniana Series.

Phillips, Ruth B., and Christopher B. Steiner

1999 "Art, Authenticity, and the Baggage of Cultural Encounter." In *Unpacking Culture: Art Commodity in Colonial and Postcolonial Worlds*, edited by Ruth B. Phillips and Christopher B. Steiner, 3–19. Berkeley: University of California Press.

Picard, Michel

1993 "Cultural Tourism in Bali: National Integration and Regional Differen-tiation." In *Tourism in South-East Asia*, edited by Michael Hitchcock, Victor King, and Michael Parnwell, 71–98. London: Routledge.

Pinsker, Eve C.

1997 "Traditional Leaders Today in the Federated States of Micronesia." In *Chiefs Today: Traditional Pacific Leadership and the Postcolonial State*, edited by Geoffrey M. White and Lamont Lindstrom, 150–82. Stanford, Calif.: Stanford University Press.

Plattner, Stuart

1996 *High Art Down Home: An Economic Ethnography of a Local Art Market.* Chicago: University of Chicago Press.

Rajadhon, Phya Anuman

1961 *Life and Ritual in Old Siam: Three Studies of Thai Life and Customs.* Translated and edited by William J. Gedney. New Haven: HRAF.

Robertson, James A.

1914 "The Igorots of Lepanto." *Philippine Journal of Science* 9, no. 6: 465–529.

Rosaldo, Renato

1989 *Culture and Truth: The Remaking of Social Analysis.* Boston: Beacon.

Roth, H. Ling

1977 *Studies in Primitive Looms.* McMinnville, Ore.: Robin and Russ Handweavers.

Roulac, John W.

1997 *Hemp Horizons: The Comeback of the World's Most Promising Plant.* White River Junction, Vt.: Chelsea Green.

Rubinstein, Donald H.

1979 "An Ethnography of Micronesian Childhood: Contexts of Socialization on Fais Island." Ph.D. diss., Stanford University.

1986a "Fabric Arts and Traditions." In *The Art of Micronesia*, by Jerome Feldman and Donald H. Rubinstein, 45–57. Honolulu: The University of Hawaii Art Gallery.

1986b "Cultural Fabrications: Woven Symbols of Identity, Power and Wealth." In *The Art of Micronesia*, by Jerome Feldman and Donald H. Rubinstein, 58–66. Honolulu: The University of Hawaii Art Gallery.

1992 *Power and Enchantment: Ritual Textiles from the Islands.* Mangilao, Guam: Isla Center for the Arts at the University of Guam.

1993 "The Social Fabric: Micronesian Textile Patterns and Social Order." In *Art in Small-Scale Societies: Contemporary Readings*, edited by Richard L. Anderson and Karen L. Field, 70–83. Englewood Cliffs, N.J.: Prentice-Hall.

Rumphius, Georgius Everhardus
1750 *Herbarium Amboinense*. Vol. 5. Amsterdam: Meinard Uytwerf.

San Win
n.d. "Robes for the Buddha." In *Burma Golden Country*, 14–16. N.p.: Horizons.

Sasaki Shunsuke et al., eds.
1988 *Furusato no hito to chie Niigata*. Tokyo: Nōrin Gyoson Bunka Kyōkai.

Sasamori Gisuke
[1894] 1982 *Nantō tanken: Ryukyu manyūki 1*. Tōyō bunko 411. Annotated by Azuma Yoshimochi. Tokyo: Heibonsha.
[1894] 1983 *Nantō tanken: Ryukyu manyūki 2*. Tōyō bunko 428. Annotated by Azuma Yoshimochi. Tokyo: Heibonsha

Schoeffel, Penelope
1999 "Samoan Exchange and 'Fine Mats': An Historical Reconsideration." *Journal of the Polynesian Society* 108, no. 2: 117–48.

Schrift, Melissa
2001 *Biography of a Chairman Mao Badge: The Creation and Mass Consumption of a Personality Cult*. New Brunswick, N.J.: Rutgers University Press.

Scott, J. George, and J. P. Hardiman
1900 *Gazetteer of Upper Burma and the Shan States*. 5 vols. Rangoon: Superintendent of Government Printing.

Scott, William Henry
1974 *The Discovery of the Igorots: Spanish Contacts with the Pagans of Northern Luzon*. Quezon City: New Day Publishers.

Seligmann, Linda J.
2001 "Introduction: Mediating Identities and Marketing Wares." In *Women Traders in Cross-Cultural Perspective: Mediating Identities, Marketing Wares*, edited by Linda J. Seligmann, 1–24. Stanford, Calif.: Stanford University Press.

Sellato, Bernard
1989 *Naga dan Burung Enggang: Hornbill and Dragon*. Jakarta: Elf Aquitaine Indonesie.
1994 "Culture, History, Politics, and the Emergence of Provincial identities in Kalimantan," unpublished ms.

Shishi Hensan Iinkai, ed.
1990 *Kashiwazaki shishi*. 3 vols. Niigata-ken Kashiwazaki-shi: Kashiwazaki-shi Shishi Hensanshitsu.

Shōsōin Jimusho, ed.
1987–1989 *Shōsōin ho motsu. Kunaicho zo ban*. 3 vols. Tokyo: Asahi Shinbunsha.

Silverstein, Cory
2001 "Clothed Encounters: The Power of Dress in Relations between Anishnaabe and British Peoples in the Great Lakes Region, 1760–2000." Ph.D. diss., McMaster University.

Simon, Scott
2003 *Sweet and Sour: Life-Worlds of Taipei Women Entrepreneurs*. Lanham, Md.: Rowman and Littlefield.

Smith, Valene
1989 *Hosts and Guests: The Anthropology of Tourism*. Philadelphia: University of Pennsylvania Press.

Smits, Gregory
Forthcoming "The Politics of Culture in Early Twentieth-Century Okinawa." In *Identity and Emigration in Okinawa*, edited by Josef Kreiner and Hans-Dieter Oelschleger, 1–18.

Solheim II, Wilhelm G.
1981 "Philippine Prehistory." In *The People and Art of the Philippines*, edited by Father Gabriel Casal and Regalado T. Jose Jr., 17–83. Los Angeles: Museum of Cultural History, University of California.

Spooner, Brian
1986 "Weavers and Dealers: The Authenticity of an Oriental Carpet." In *The Social Life of Things: Commodities in Cultural Perspective*, edited by Arjun Appadurai, 195–235. Cambridge: Cambridge University Press.

Spyer, Patricia
1998 "Introduction." In *Border Fetishisms: Material Objects in Unstable Spaces*, edited by Patricia Spyer, 1–12. London: Routledge.

Starr, Frederick
1908 Frederick Starr Papers. Unpublished Philippine notebooks. The University of Chicago, Department of Special Collections, The Joseph Regenstein Library, Box 11. Chicago, Ill.

Stephen, Lynn
2005 *Zapotec Women: Gender, Class and Ethnicity in Globalized Oaxaca*. 2nd ed. Durham, N.C.: Duke University Press.

Stinchecum, Amanda Mayer
2002 "Minsa-obi/kagan nu bu: Yaeyama tategasuri momen hoso-obi no zenshi josetsu, ge." *Yaeyama Hakubutsukan kiyō* 19: 1–53.

Subramanian, Lakshmi
1998 "Power and the Weave: Weavers, Merchants and Rulers in Eighteenth-Century Surat." In *Politics and Trade in the Indian Ocean World*, edited by Rudrangshu Mukherjee and Lakshmi Subramanian, 52–82. New Delhi: Oxford University Press.

Summerfield, Anne, and John Summerfield, eds.
1999 *Walk in Splendor: Ceremonial Dress and the Minangkabau*. Los Angeles: UCLA Fowler Museum of Cultural History.

Suzuki Bokushi
1986 *Snow Country Tales: Life in the Other Japan*. Translated by Jeffrey Hunter with Rose Lesser. New York: Weatherhill.

Taihuttu, Charles K.
1994/1995 *Tenun Doyo Daerah Kalimantan Timur*. Tenggarong: Departemen Pendidikan dan Kebudayaan.

Taira Toshiko
1993 "Bashōfu to tomo ni—'watakushi no rirekisho' yori." In *Bashōfu to Taira Toshiko*, edited by Okinawa Kenritsu Hakubutsukan Tomo no Kai, 65–74. Naha: Okinawa Kenritsu Hakubutsukan Tomo no Kai.

Takeda, Sharon Sadako
1996 "Offertory Banners from Rural Japan: Echigo-Chijimi Weaving and Worship." In *Sacred and Ceremonial Textiles: Proceedings of the Fifth Biennial Symposium of the Textile Society of America, Inc.*, 38–47. Minneapolis: Textile Society of America.

Tannenbaum, Nicola
1995 *"Who Can Compete against the World?" Power-Protection and Buddhism in Shan Worldview*. Ann Arbor: Association for Asian Studies.

Tarlo, Emma
1996 *Clothing Matters: Dress and Identity in India*. Chicago, Ill.: University of Chicago Press.

Temple, R. C.
1894 *Notes on the Antiquities in Ramammadesa (The Talaing Country of Burma)*. Bombay: Education Society's Steam Press.

Tice, Karen E.
1995 *Kuna Crafts, Gender and the Global Economy*. Austin: University of Texas Press.

Tillema, H. F.

[1938] 1989 *A Journey among the Peoples of Central Borneo in Word and Picture*, edited and with an introduction by Victor King. Singapore: Oxford University Press. (Orig. pub. as *Apo-Kayan: Een filmreis naar en door Centraal-Borneo, met 336 afbeeldingen*, Amsterdam: van Munster's Uitgevers-Maatschappij).

Tonaki Akira

1977 "Kijoka no bashōfu." In *Kijoka no bashōfu: Kijoka no Bashōfu Hozonkai*, edited by Kijoka no Bashōfu Hozonkai, 34–40. Ningen kokuhō shirīzu 41. Tokyo: Kōdansha.

Tsing, Anna

1993 *In the Realm of the Diamond Queen: Marginality in an Out-of-the-Way-Place*. Princeton, N.J.: Princeton University Press.

2000 "The Global Situation." *Cultural Anthropology* 15, no. 3: 327–60.

Tsukigase-mura Kyōiku Iinkai, ed.

1994 *Nara sarashi*. Tsukigase, Nara: Tsukigase-mura Kyoiku Iinkai.

Uno, Katherine S.

1991 "Women and the Changes in the Household Division of Labor." In *Recreating Japanese Women, 1600–1945*, edited by Gail Lee Bernstein, 17–40. Berkeley: University of California Press.

Urry, John

1990 *The Tourist Gaze: Leisure and Travel in Contemporary Societies*. London: Sage.

Vergara, Alex Y.

2002 A Wedding with Trademark Tesoro Touches." *Philippine Daily Inquirer* (January 31): E1–2.

Watt, George

1891 *A Dictionary of the Economic Products of India*. London: W. H. Allen.

Weiner, Annette B.

1989 "Why Cloth? Wealth, Gender, and Power in Oceania." In *Cloth and Human Experience*, edited by Annette B. Weiner and Jane Schneider, 33–72. Washington, D.C.: Smithsonian Institution Press.

1992 *Inalienable Possessions: The Paradox of Keeping-While-Giving*. Berkeley: University of California Press.

Weinstock, J. A.

1983 "Kaharingan and the Luangan Dayaks: Religion and Identity in Central-East Borneo." Ph.D. diss., Cornell University.

1987 "Kaharingan: Life and Death in Southern Borneo." In *Indonesian Religions in Transition*, edited by Rita Smith Kipp and Susan Rodgers, 71–97. Tucson: University of Arizona Press.

Welters, Linda

1997 "Dress as Souvenir: Piña Cloth in the Nineteenth Century." *Dress* 24: 16–26.

Williams, C. A. S.

1932 *Outlines of Chinese Symbolism and Art Motives: An Alphabetical Compendium of Antique Legends and Beliefs as Reflected in the Manners and Customs of the Chinese*. Shanghai: Kelly and Walsh.

Yaeyama Nintzōzei Haishi Hyakunen Kinen Jigyōkiseikai Kinen Shibukai, ed.

2003 *Asapana: Nintōzei haishi hyakunen kinenshi*. Ishigaki. Okinawa: Yaeyama Nintzōzei Haishi Hyakunen Kinen Jigyōkiseikai.

Yaeyama Yakusho, comp.

1894 [Sasamori Gisuke] "Okinawa-ken guntō no uchi Yaeyamajima no bu, Ishokujū heijō no jissaini tsuki jōchūge wo kubetsu torishiraburu koto." Kanagawa Daigaku Jōmin Bunka Kenkyūjo. Unpublished report.

Yakabi Osamu

1994 "Okinawa hōgen ronsō ni okeru Yanagi Sōetsu no shisō." *Okinawa bunka* 29: 1–2, 12–53.

Yanagi Sōetsu

1939 "Okinawa no bashōfu." In *Yanagi Muneyoshi zenshū chōsaku-hen dai jūgokan*, 26–30. Originally published in *Ho-mu raifu*, April 1939.

1940 "Kokugo mondai ni kanshi Okinawa-ken Gakumubu ni kotaeru sho." *Gekkanmingei* 2: 3.

1943 "Bashōfu monogatari." In *Yanagi Muneyoshi zenshū chōsaku-hen dai jūgokan*, 383–409. Originally published privately in March 1943 and in July 1943 in the magazine *Kōgei* 113.

1980–1992 *Yanagi Muneyoshi zenshū*. 22 vols. Tokyo: Chikuma Shobō.

Yi Kwangjōng

1844 *Saryep'ŏllam* [Manual of the Coming-of-Age Ceremony, Marriage, Funerals, and Ancestor Worship].

Yoshida, Shin-Ichiro, and Dai Williams

1994 *Riches from Rags: Saki-Ori and Other Recycling Traditions in Japanese Rural Clothing*. San Francisco: Craft and Folk Art Museum.

Ypeij, Annelou

2000 *Producing against Poverty*. Translated by Peter Mason. Amsterdam: Amsterdam University Press.

Yuko Kikuchi, ed.

2007 *Refracted Modernity: Visual Culture and Identity in Colonial Taiwan*. Honolulu: University of Hawaii Press.

Zorn, Elayne

2004 *Weaving a Future: Tourism, Cloth, and Culture on an Andean Island*. Iowa City: Iowa University Press.

Contributors

Sylvia Fraser-Lu has spent many years as an educator and has held a variety of positions in East and Southeast Asia. A growing interest in Asian art and crafts led her to begin writing articles for *Arts of Asia* and eventually a number of books for Oxford University Press, including *Handwoven Textiles of South-East Asia* and *Indonesian Batik: Processes, Patterns, and Places*. In recent years she has turned her attention to Burma with publications on wooden monasteries, lacquerware, and textiles. Her recent publications include *Splendour in Wood: The Buddhist Monasteries of Burma*.

Roy W. Hamilton is Curator of Asian and Pacific Collections at the Fowler Museum at UCLA. His previous books include *The Art of Rice: Spirit and Sustenance in Asia*; *From the Rainbow's Varied Hue: Textiles of the Southern Philippines*; *and Gift of the Cotton Maiden: Textiles of Flores and the Solor Islands*. He is currently involved in the video documentation of the lives of weavers and batik makers in Indonesia. Hamilton was awarded a Curatorial Fellowship by the Getty Foundation in 2006 for the study of Timorese textiles.

Bu-ja Koh is a professor in the Department of Traditional Costume at Dankook University in Seoul and a curator in the university's Seok Joo-Sun Museum. She is also a member of the special committee of the Korean Cultural Properties Administration. Koh initiated her research on the cultivation and production of Korean hemp in 1968. Since 2002 she has conducted extensive fieldwork in close association with weavers in several regions of Korea. Her recent publications include *Hemp in Posŏng, South Chŏlla Province* and *Hemp in Muju, North Chŏlla Province*.

Sophiano Limol was born and raised on Fais Island in Yap State. He attended the University of the South Pacific in Fiji and received degrees in Management and Public Administration and Tourism Management. After graduating from college, he returned to Yap, where he has worked in both the public and private sectors, as a business development specialist for Yap State Department of Resources and Development, as General Manager of the Yap Visitors Bureau, and as Director of the Yap State Outer Islands Cultural Education program. Currently, he runs his own business as President of Pacific Micronesia Corporation and General Manager of Micronesia Sportfishing Association. He continues to oversee the Fais *machi* training program, which is in its fourth year of operation as of spring 2007.

B. Lynne Milgram is Professor of Anthropology at Ontario College of Art and Design, Toronto, Canada. Her research on gender and development in the Philippines analyzes the cultural politics of social change with regard to fair trade, women's production and trade of crafts, material culture, and microfinance. She has published in a number of edited volumes and scholarly journals and has co-edited (with Kimberly M. Grimes) *Artisans and Cooperatives: Developing Alternative Trade for the Global Economy*. Milgram's current research explores issues in gender and globalization with regard to Philippine women's work in the transnational trade of secondhand clothing between the Philippines and Hong Kong.

Elizabeth Oley developed a special interest in traditional textiles while living in Balikpapan and Jakarta, Indonesia, during the 1990s. Her research on the textiles of the Benuaq people of East Kalimantan was a component of her art curatorial studies at the University of Melbourne and was documented in a thesis submitted in 2001. Oley is presently a Ph.D. candidate in anthropology at Monash University, Australia, with a research focus on the revival of natural dye use in India, specifically the linkage that intermediaries provide between artisans and the marketplace

Melissa M. Rinne is Assistant Curator of Japanese Art at the Asian Art Museum of San Francisco, where she is in charge of the museum's large collection of Japanese bamboo art and other artistic genres. Educated at Brown University, Kyoto City University of Arts, and Kyoto University, Rinne lived in Japan for nearly sixteen years, researching Japanese textiles and working on the staff of two Japanese national museums. She is the author of *Masters of Bamboo: Artistic Lineages in the Lloyd Cotsen Japanese Basket Collection*.

Donald Rubinstein is Professor of Anthropology and Micronesian Studies at the University of Guam, where he teaches in the graduate program on Micronesian Studies. He has a forty-year association with the people of Fais Island in Yap, Federated States of Micronesia. Rubinstein has conducted fieldwork throughout Micronesia and published on a variety of topics including social organization, child socialization, migration, adolescent suicide, health care practices, and ethnographic arts. He has also curated exhibitions on Pacific Island arts at the University of Hawaii Art Gallery and the University of Guam Art Gallery.

Amanda Mayer Stinchecum is a historian specializing in the cloth and clothing of Ryukyu/Okinawa. An independent scholar, she has focused on textiles made of the primary bast and leaf fibers (ramie and fiber banana) used for cloth making throughout the archipelago. Ikat-patterned plant fiber textiles and their past and present roles in the culture and society of the Ryukyu Islands have been of particular interest. For the past eight years Stinchecum has been engaged in fieldwork and archival research relating to the production, use, and meaning of a warp-ikat sash unique to the islands.

Ma Thanegi is a well-known Burmese artist and writer. Her paintings have been exhibited in individual and group exhibitions since 1967. An acknowledged authority on Burmese culture, she is the author of numerous books and articles on puppetry, travel, spirit cults, art, architecture, and local cuisine.

Trần Thị Thu Thủy is Vice-Head of the Department of Education at the Vietnam Museum of Ethnology in Hanoi. She received her doctoral degree in anthropology from the Vietnam Institute of Ethnology. Her research to date has focused on Hmong communities in Mù Cang Chải District, Yên Bái Province, Vietnam. Trần completed an internship at the Fowler Museum at UCLA in 2001 and has represented her museum in conferences in Thailand, the United States, and Canada.

Index

tribute
machi as, 158, 162, 173n4
Yap's system of, 155, 158
tritik, 36, *36*
Tsing, Anna, 13
tsutsugaki, 38, 39

ulap doyo, 63. *See also* lemba
Ulmus laciniata. *See* elm bast fiber

veil (*kazuki*), *38*, 39
Vietnam. *See also* hemp (*Cannabis sativa*); Hmong; Mù Cang Chải District
Black Hmong hemp in, 11, *11*
Craft Link, 61

warp-float weave, 125, *125*
warp ikat, 14, *28*, 29, 37, *37*, 63, *65*, *66*, *68*, 68–70, *70*, *71*, *72*, *73*, *74*, *75*, *76*, 117, *117*, 137, *137*
weavers. *See also* training
as artisans, 22, 23, 119–20, 131, *131*
of bast fiber, 118, *118*, 129–30
in Cambulo, 130
choices of, 21–22
cultural identity for, 21
culture and, 13, 15
of Echigo *jōfu*, 135, *135*, 136, *136*, 137, *137*
economics/gender and, 148, 149
of lotus leaf, *94*, 95
"occupational multiplicity" for, 120
opportunities for, 131
payment for, 130, 131
of Philippines, 110, *110*, 119, 123, *123*

Pula's bast fiber, 129–30
rice cultivation and, 129
subcontractors for, 129
weaving. *See also* looms; spinning; thread makers; warp-ikat; weft
economics of, 13–14
within menstrual house, 157, *157*, 162–63, 173n9
minority groups for, 12
for subsistence, 11
weft, 9, *9*, *30*, 31, 135, *135*, *137*, *141*, 144
machi supplementary, 156, 157, *157*, 158, 159, 160, *160*, 162, 165, 173n8
weft ikat, 98
wisteria bast fiber (*Wisteria brachybotrys*), 20, *20*, 34, *34*, 35, *35*
women
in Burma, 98
in China, 11, 12
in Guatemala, 121, 122
Japanese, 14, 139
leadership for, 22, *22*
socioeconomics and, 13
wrapping cloth (*uchikui*), 39, *39*

Yanagi Sōetsu, 109–11, 114, 117
Yanagida Kunio, 110
Yap, 155, 156, *156*, *157*, 158, 162, 164
Yap State Grant Research Firm (YSGRF), 162, 164
Yasunari Kawabata, 137, 138, 139
Ygnacio, Teodora Devera, 17, *17*
Ypeji, Annelou, 14
YSGRF. *See* Yap State Grant Research Firm

zone dyeing, 4, *166*